SEURAT

RICHARD TILSTON

SMITHMARK

Published by Smithmark Publishers
112 Madison Avenue
New York, New York 10016

Produced by
Brompton Books Corp.
15 Sherwood Place
Greenwich, CT 06830

ISBN 0-8317-7749-4

Printed in Hong Kong

10 9 8 7 6 5 4 3 2 1

Page 1: *The Eiffel Tower,* 1889
Page 2-3: *The Bridge and the Quays, Port-en-Bessin,*
1888

Contents and List of Plates

Introduction 6

Copy after 'The Poor Fisherman' 30
Sunset 31
The Forest at Pontaubert 33
Man Leaning on a Parapet 34
Suburb 36
Stonebreakers, Le Raincy 38
Stonebreakers and Other Figures,
 Le Raincy 40
Houses and Gardens 42
Place de la Concorde, Winter 43
The Mower 44
The Stonebreaker 45
Farm Women at Work 46
Standing Female Nude 49
Boy Seated on the Grass 50
Woman Seated on the Grass 52
Houses among Trees 54
Watering Can in the Garden at
 Le Raincy 55
Horse and Cart 56
The Ruins of the Tuileries Palace 58
The Anglers 60
Man Painting His Boat 62
Study for 'Une Baignade': The Rainbow 64
Study for 'Une Baignade': Seated and
 Reclining Figures, Black Horse 66
Study for 'Une Baignade': Seated Youth 69
Study for 'Une Baignade': Final
 Compositional Study 70
Une Baignade, Asnières 72
Une Baignade, Asnières (detail) 74
Rue Saint-Vincent: Spring 77
The Painter at Work 78
Study for the 'Grande Jatte' 80
Study for the 'Grande Jatte' 82
Lady with a Monkey 83

Study for the 'Grande Jatte' 84
Study for the 'Grande Jatte' 87
Final Study for the 'Grande Jatte' 88
Un Dimanche à la Grande Jatte
 (1884) 90
Un Dimanche à la Grande Jatte
 (1884) (detail) 92
Un Dimanche à la Grande Jatte
 (1884) (detail) 94
Un Dimanche à la Grande Jatte
 (1884) (detail) 96
Family Group (Condolences) 98
Fishing Boats, Low Tide 99
Le Bec du Hoc, Grandcamp 100
The Seine at Courbevoie 102
Grandcamp, Evening 104
Lucerne at Saint-Denis 106
End of a Jetty, Honfleur 108
The Beach of Bas-Butin, Honfleur 110
Corner of a Dock, Honfleur 112
The Hospice and the Lighthouse,
 Honfleur 114
The 'Maria', Honfleur 116
The Seine Estuary, Honfleur, Evening 118
Le Pont de Courbevoie 120
Study for 'Les Poseuses': Standing
 Model 122
Study for 'Les Poseuses': Model from
 the Front 123
Study for 'Les Poseuses': Model in
 Profile 124
Study for 'Les Poseuses': Model from
 Behind 125
Les Poseuses (small version) 126
Eden Concert 128
A la Gaîté-Rochechouart 129
Study for 'La Parade': The Trombone
 Player 130
La Parade de Cirque 131

Banks of the Seine (Island of La
 Grande Jatte) 134
Port-en-Bessin: The Outer Harbor,
 Low Tide 136
Les Grues et la Percée, Port-en-Bessin 137
The Entrace to the Outer Harbor,
 Port-en-Bessin 138
The Bridge and the Quays,
 Port-en-Bessin 140
Port-en-Bessin, the Outer Harbor, High
 Tide 142
Port-en-Bessin, Sunday 144
Temps Gris, La Grande Jatte 146
The Eiffel Tower 147
Le Crotoy, Downstream 148
Le Crotoy, Upstream 149
Study for 'Jeune Femme se Poudrant' 150
Jeune Femme se Poudrant 151
Jeune Femme se Poudrant (detail) 153
L'Homme à Femmes 154
Study for 'Le Chahut' 155
Study for 'Le Chahut' 156
Le Chahut 157
Le Chahut (detail) 159
The Beach and a Boat, Gravelines 160
Study for 'The Channel at Gravelines' 161
The Channel at Gravelines, Evening 162
The Channel at Gravelines, Petit
 Fort-Philippe 164
The Channel at Gravelines, Grand
 Fort-Philippe 166
The Channel of Gravelines, Towards
 the Sea 167
Study for 'Le Cirque' 168
Le Cirque 174
Le Cirque (detail) 173

Index 174
Acknowledgments 176

Introduction

Georges Seurat remains the least well-known of the great Post-Impressionist painters working in France in the last two decades of the nineteenth century. A contemporary of Paul Gauguin and Vincent van Gogh, Seurat has not received anywhere near the critical attention that has been devoted to this illustrious pair. Living his life entirely in Paris he did not share in the exotic travels of Gauguin and, outwardly maintaining the appearance of the Parisian bourgeoisie, his life was one of order, unlike that of the ever-restless van Gogh. Both Gauguin and van Gogh left long, written accounts of their lives; van Gogh in his letters to his brother Theo and Gauguin in his various histories of his life written in Tahiti. In contrast, Seurat remained secretive throughout his life, obsessively so, in fact, and after his premature death in 1891 his family destroyed virtually all personal documents left in his studio. Thus, just as Seurat remained aloof from all but a few close friends, his life is still shrouded in mystery and much detail remains unknown. Descriptions written by friends and discussions concerning his artistic interests were occasionally recorded, but much written about him remains pure conjecture. Seurat's character refuses to be pinned down in the same way that his paintings defy precise analysis. In the words of John Russell, Seurat was a 'supreme master of the poetic imagination.'

When compared with paintings by van Gogh and Gauguin, Seurat's art may appear to be cool, mathematical, and precise. Nowhere is there the free use of paint, of forms sculpted out of pure pigment that characterizes van Gogh's style; nor are there the broad planes of bright, unmodulated color that typify Gauguin's art. Like them, Seurat developed his own style, one which, given those that copied him, remained distinctive and wholly his own. For van Gogh Seurat was undoubtedly one of the most important artists working in Paris in the second half of the 1880s, and van Gogh attributed to him the position of leader of 'le petit boulevard,' a group of painters including van Gogh himself, Gauguin, Emile Bernard, and Henri de Toulouse-Lautrec. Even so Seurat was largely forgotten soon after his death, although his reputation was kept alive in the 1890s by a small, dedicated group of friends, in particular Paul Signac. In 1894 Signac complained of the 'oblivion' that Seurat's art had fallen into although he did much to rectify the situation when he published the first history of the Neo-Impressionist movement, *From Eugène Delacroix to Neo-Impressionism*, in 1898. Briefly admired by Picasso and the other Cubist artists before 1914, Seurat's art received more critical attention in the 1920s from those artists associated with the Purist group. In the classical revival which characterized so much art in the 1920s, the so-called 'return to order,' Seurat's art was admired for its classical qualities, for the preciseness of form, and for its underlying geometry. In Britain Roger Fry praised Seurat's art for its abstract qualities; content was subservient to form. To see Seurat as both a precursor of modern art and still as an important mentor of a classical tradition remained fashionable in critical circles from the 1920s to the 1960s. Analysis of the subject matter of Seurat's art was, apart from in the writings of the

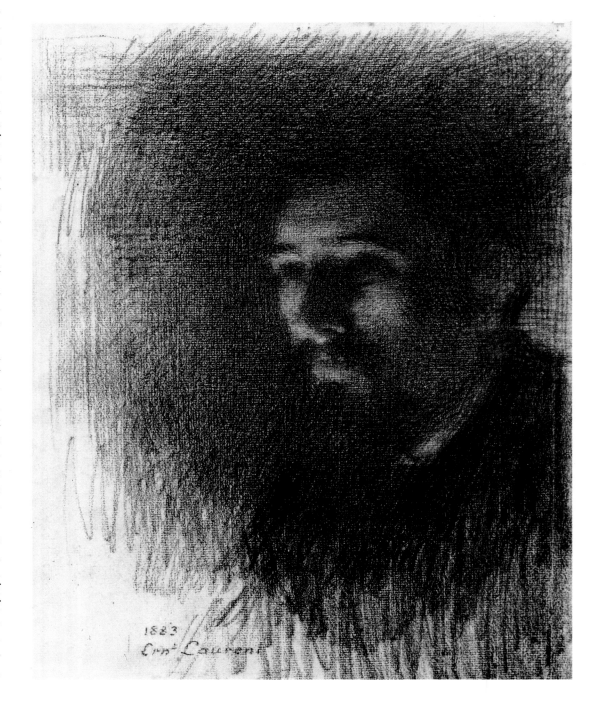

1883
Ernst Laurent

6

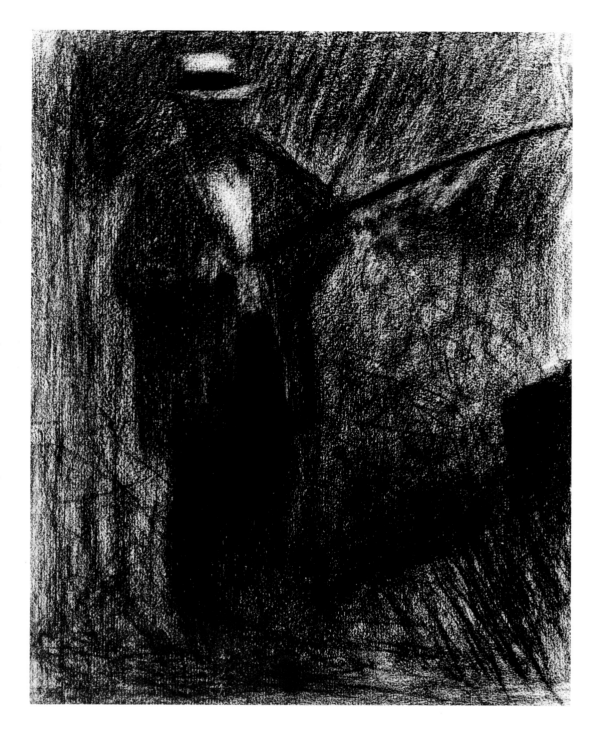

American critic Meyer Shapiro, either ignored completely or discussed in a most cursory manner. For most commentators Seurat's art continued the tradition of Parisian modern-life painting advocated initially by Baudelaire and practiced by the Impressionist painters. Thus Seurat has long been seen as a late Impressionist, an artist whose researches were quickly overshadowed by those of his contemporaries, Vincent van Gogh and Paul Gauguin.

Nothing could be further from the truth, however. Seurat was without doubt one of the most original artists of his day and, with notable exceptions, it is only since the 1980s that his art has received the critical attention it deserves. In developing the Neo-Impressionist technique he formulated a style that, for him, was relevant to the 1880s, a modern style which could represent modern Parisian life. His vision of contemporary life revealed an acute awareness of Parisian society, its structure and its conflicts. Seurat was one of the great observers of late nineteenth-century life. In praising the formal qualities of his art, critics such as Roger Fry were totally unaware of his sharp social vision. Perhaps Seurat should be seen as the Hogarth of 1880s' Paris. Paraded in his paintings and drawings is the full panoply of Parisian life and, as with Hogarth, once the surface is scratched the complexities of social customs, of social relationships, of class conflict are revealed to the onlooker. Unlike Hogarth's, however, Seurat's vision avoided the exaggerations of caricature. Instead he adopted the role of the detached observer. Just as he believed the pointillist technique to be based upon scientific laws so, too, he developed a critical awareness of his surroundings, although speculation concerning his political views suggests that he may have shared anarchist sympathies. Little was known of him before he exhibited *Une Baignade, Asnières* in 1884; by making this large canvas his first exhibited painting, it would seem that at the tender age of 24 Seurat was already aware of the originality of his vision and it was thus a new artistic genius came of age. It is in this context that the work of Georges Seurat should be studied and enjoyed.

From contemporary descriptions it is possible to build up an image of Georges Seurat. Many of his friends remarked on his upright, military appearance. Gustave Kahn, one of Seurat's closest friends, described him:

He was tall and well-proportioned. His dark, abundant beard and thick, slightly curly hair gave him the face of one of those mitered Assyrian priests one sees on bas-reliefs. His large eyes, extraordinarily calm normally, narrowed and became mere luminous spots under blinking lashes whenever he painted or looked at subjects. . . . His appearance almost gave an impression of coldness, in his very dark blue or black clothes with the look of symmetry and neatness which made Degas call him once in a moment of ill humor 'the notary.' Seurat was kind and impulsive by nature. He normally remained silent in a crowd of people but, when among his close friends, he would talk at great lengths about art, its aims and techniques. Then, the slight coloring of his cheeks denoted his excitement, and he would discourse without drawing breath, comparing the progress made by painting and music respectively and seeking to find unity between his own efforts and those of contemporary poets and musicians.

Another poet friend, Teodor de Wyzewa, likened Seurat to masters of the past and saw him very much in the tradition of the great Renaissance painters. He described:

From the very first day of our acquaintance, I realized that his was a soul belonging to the past. He lived free from the disenchantment which nowadays affects artists. He believed in the importance of theories, in the absolute value of methods, and in the future of revolutions. I was overjoyed to find, in a corner of Montmartre, a specimen of a race which I thought extinct, the race of painters who practice their own theories and combine orderly minds with unselfconscious fantasy. Indeed, I felt very acutely the affinity between Seurat and Leonardo, Dürer and Poussin. I never tired of listening to him describing his future experiments in their order of importance, and the number of years he would need for them. He never tired, either, of talking to me on the subject.

Emile Verhaeren, the Belgian symbolist poet who regularly corresponded with Seurat and purchased paintings from him, provided the following portrait of Seurat:

To hear Seurat explain and reveal himself in front of his latest painting was to be led by his sincerity and overcome by his persuasion.

Calmly, with restrained gestures and looking at you the whole time, he would in a slow, monotonous, almost professorial voice describe to you the results of his experiments and the clear convictions which he called 'the basis.' Then he would ask you for your opinion, challenge you, and wait for a sign indicating that he had been understood; all this with great modesty, almost diffidence, and yet his self-pride was evident. He never attempted to destroy in his friends their admiration for someone else's work, even though he might not share their taste; one felt his modesty and lack of envy. He never complained, either, about the success of others, even though that success was his by right.

Such praiseworthy sentiments are given here as insights into the character of Georges Seurat, but these descriptions must be balanced by more critical com-

mentaries. There is no doubt that Seurat was intensely secretive and jealously guarded his artistic theories. That he did not get along with the older Impressionist painters, with the exception of Pissarro, is made clear by the wranglings over whether or not his paintings should be exhibited at the eighth Impressionist exhibition. So determined was he that no-one should steal his artistic theories that Camille Pissarro wrote in exasperated tones to his son Lucien: 'He is so cautious. But we, or rather I, can see no disadvantages in it, since I consider nothing *secret* in painting beyond the artist's own artistic personality which is not easily swiped!!!' An article published in August 1888, written by a friend of Seurat, Arsène Alexandre, suggested that Seurat's 'unscrupulous colleagues,' were stealing his ideas. This led to a significant rift emerging between Seurat

and Signac which was not fully healed, although Seurat disclaimed any connexion with the offending article.

His career can be divided into a number of identifiable phases. From his initial drawing trips with an uncle, Seurat undertook a formal artistic training, first at a municipal school and then at the Ecole des Beaux-Arts between 1877 and 1879. This period of education was interrupted by a years military service in 1879-1880. Between 1880 and 1883 Seurat familiarized himself with developments in nineteenth-century French painting, firstly in the classical tradition and then in the naturalist tradition of the Barbizon painters. In 1883 he started his first major project, *Une Baignade, Asnières*, in which he experimented more and more with Impressionist technique and shared their interest in modern contemporary subject matter. Such in-

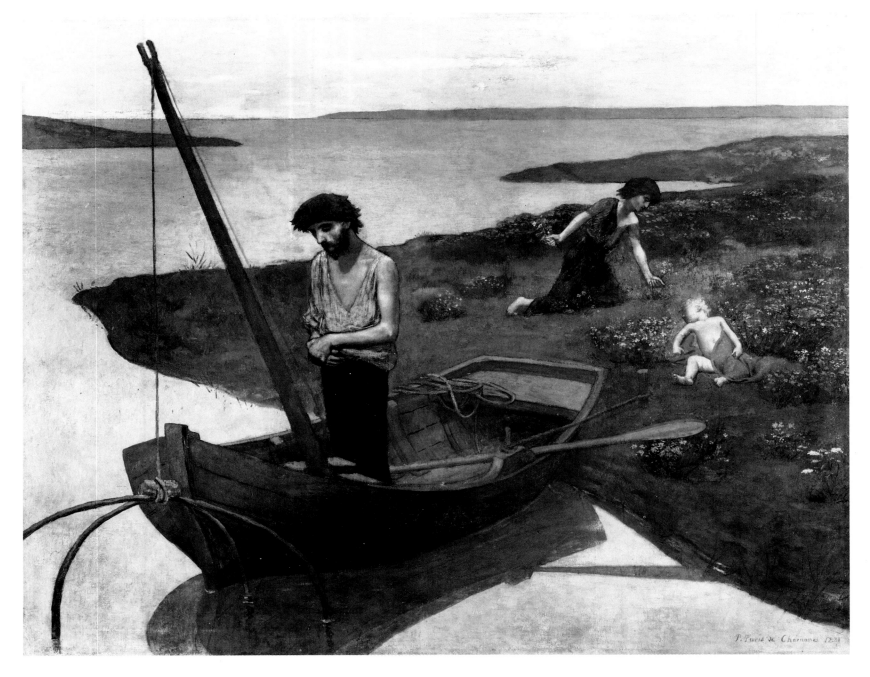

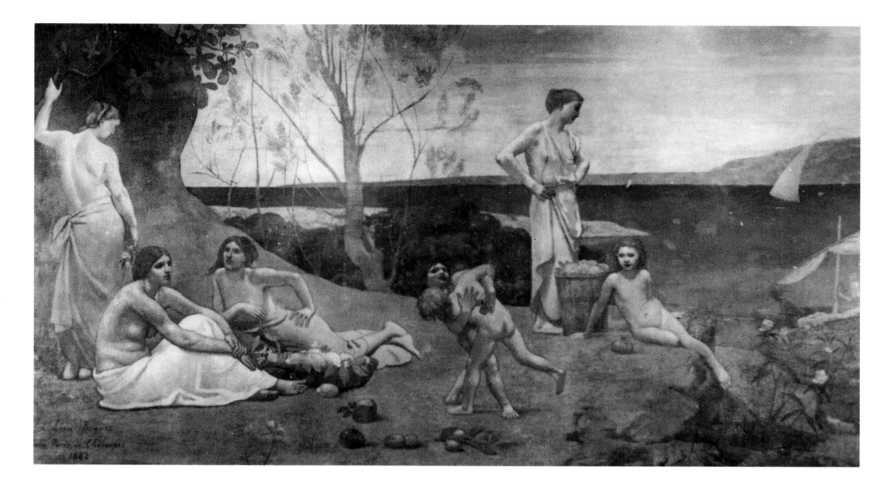

terests continued throughout 1884 and 1885 while he worked on his second major project, the *Grande Jatte*. However, this painting and the year it was exhibited, 1886, marked the emergence of Seurat's mature and individual style of painting and his first significant critical attention. The year 1886 was also a turning point for Seurat. He started to mix with the newly formed literary circles associated with the Symbolist movement and it was from these circles that Seurat received his most fervent support and established his most intimate friendships. In particular the support of Félix Fénéon and Gustave Kahn was crucial to the development of Seurat's art between 1886 and 1891. He shared with them a strong interest in modern life and explored this theme in a series of paintings of night-time Parisian entertainment, culminating in his unfinished *Le Cirque*, 1891.

Seurat was born on 2nd December 1859, and something of his character can be gained from his family background. He was the third of four children whose parents had married in 1845 after their father, Antoine Seurat, had moved to Paris to further his career. He worked as a legal official at the public tribunal of the Seine at La Villette and was sufficiently successful at his job that he could sell his notary business in 1856 and retire on the proceeds. With part of this money he purchased a small home at Le Raincy, twelve kilometres to the east of Paris, in addition to maintaining the family apartment at 110 Boulevard de Magenta. By the time Seurat was born in 1859 his father was spending an increasing amount of time on his own at Le Raincy, leaving his wife to bring up the

children in Paris. Thus Seurat was born into a secure, if not altogether harmonious family. The lengthy absences of his father resulted in a close attachment between Seurat and his mother, an attachment lovingly rendered in later drawings. Throughout his life Seurat returned to eat his evening meal at the family apartment whenever his mother was there.

It would appear that Seurat's interest in art was stimulated by his uncle who took the young Georges on drawing lessons with him. Such encouragement resulted in Seurat enrolling in the municipal drawing school in 1875 at the age of fifteen, where he was taught by Justin Lequien. While at this school Seurat met Edmond Aman-Jean, a fellow student, and the two were to become firm friends for life. From there both went to the Ecole des Beaux-Arts where Seurat began his studies in February 1878. There he was encouraged to draw from plaster casts and it was there that his love of antique sculpture, and classical art in general, began. An interest in classicism would have been encouraged by his master at the Ecole, Henri Lehmann who, in turn, had been a student of Ingres. Lehmann's career had been a successful one: he was a member of the *Institut*, and culminated in his election as a Professor of the Ecole des Beaux-Arts in 1875. Lehmann, without doubt, encouraged the young Seurat to study the work of Ingres. Among the other artists Seurat copied were Raphael, Poussin, Piero della Francesca, and Bellini. He does not appear to have been an outstanding pupil, however, and was generally rated low or, at best, in the middle of his class. However, the Ecole was to have a

lasting influence upon him and, as late as 1888 Camille Pissarro complained of Seurat's continuing association with his formal background. Pissarro noted 'Seurat is of the Ecole des Beaux-Arts, he is impregnated with it . . .'

Seurat's studies at the Ecole were ended by a year's military service which he served at Brest in Brittany. After his return to Paris Seurat visited the Salon of 1881 where he saw a painting by Pierre Puvis de Chavannes which made an immediate impact. Like Henri Lehmann, Puvis maintained the classical tradition in his work and had made decorative schemes for architectural interiors a particular speciality. In the early 1880s Puvis was regarded as the most important decorative artist working in France, a reputation that has only recently regained something of its former status. Gustave Kahn, later a close friend of Seurat, recorded the widespread praise for Puvis when he stated 'Puvis was the major painter as to whose merits we were most nearly unanimous. With his integrity, his noble ambition, and his new and delicate sense of harmony, he was beyond and above discussion.' Seurat painted a curious acknowledgment of Puvis when he included the latter's *Poor Fisherman* (page 30) in a landscape of 1881-82. He was, along with his friend Aman-Jean, a regular visitor to Puvis' studio near the Place Pigalle, although the precise dates of such visits remain uncertain. It is possible that they took place in 1879 but it is more likely that they date from after Seurat's return from military service in 1880. At that time Puvis was working on one of the paintings exhibited at the Salon of 1882, *Doux Pays*

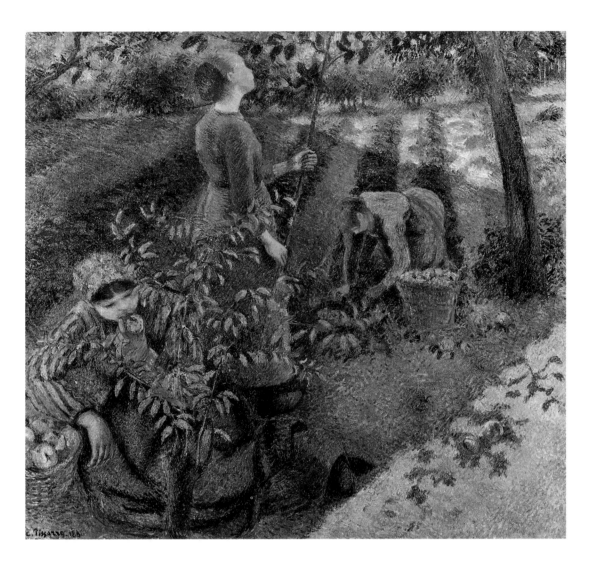

(page 9). With its group of figures located on a promontory of land, the precise drawing style and its restful mood, there can be no doubt that this painting impressed Seurat and it clearly foreshadows his *Baignade.* For example the seated woman at the left echoes the young boy seated on the river bank in Seurat's painting. Puvis also influenced Seurat's approach towards his choice of subject in that *Doux Pays* is clearly an allegory of contemporary life set in some distant and timeless place. A contemporary moral waiting to be updated by the young protegy. It is clear that Seurat wanted to translate the classicizing qualities of Puvis into a contemporary setting, marrying the immediacy of Impressionist art with the more static. Like Cézanne, Seurat was keen to turn Impressionism into something more enduring, something more solid.

While Puvis was to provide a decisive influence on Seurat another artist, Jean-François Millet, was equally important in

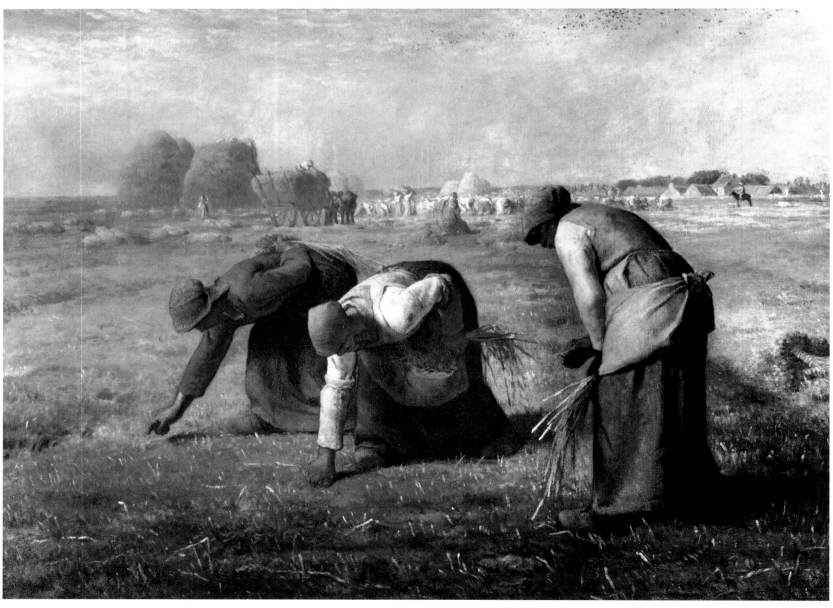

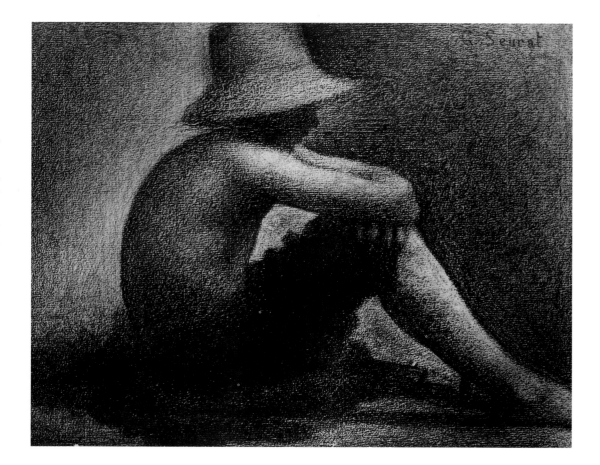

the development of Seurat's art in the early 1880s. Although Millet had died in 1875 there was a considerable revival of interest in his art in the early 1880s. Particular attention focused upon the auction of the *Angelus* in March 1881 when it was sold for 160,000 francs. Millet's choice of subject matter was important for Seurat as it provided him with a model on which to base his developing interest in peasant and rural subjects. Having familiarized himself with a classical tradition Seurat was learning now from the example of Millet and the other Barbizon artists and their concerns for a more naturalistic form of art. Between 1881 and 1883 Seurat painted many scenes of rural figures engaged in ploughing the ground and tilling their fields eking out a meager existence. Common themes connect the two artists. For example, drawings such as *The Gleaners*, c. 1883, are derived from Millet's own painting of the same title (page 10, below), while the bending figures in Seurat's *Farm Women at Work* c. 1883 (page 46) recall the two women gleaning in Millet's painting. In addition to providing Seurat with an important source for his choice of motifs, Millet's art was essential in the development of Seurat's drawing technique in the early 1880s. As Seurat's drawing style developed from the rigid academicism of his early years to the much freer conté drawings, the example of Millet's drawings was essential. A comparison between Millet's *Sheepfold by Moonlight* and Seurat's *The Gleaner* shows their similarities. In his search for a more evocative style, one in which the pressure of crayon on paper resulted in subtle changes of light and dark, Seurat owes a clear debt to the drawings of Millet.

In 1883 Seurat was successful in having a work accepted for exhibition at the Salon of that year, his large drawing of his friend and fellow student Aman-Jean. But just as he was experiencing his first official success Seurat was already planning his first major project which was to result in the painting *Une Baignade, Asnières* (page 72). It was the exhibition of this painting, not at the annual Salon from which it was rejected, but at an exhibition of the newly formed Groupe des Artistes Indépendants, which brought Seurat his first but extremely limited critical attention. One unkind critic dubbed the new independent artists as 'the rejected, the misunderstood, the bewildered, the incoherent, the anemic, the unheard-of, the frauds and fops of painting.' However, the exhibition of *Une Baignade, Asnières* caught the attention of a poet-critic who was to become

Seurat's confidant and most active supporter for the next four years. The critic was Félix Fénéon. Seurat had planned this painting in a most systematic way from the moment he selected the subject. Having chosen a suburban subject, the river bank of the river Seine at Asnières, Seurat produced at least fourteen painted panels and nine drawings as preliminaries to the completed painting. Most of these preparatory works must have been worked on throughout 1883, but it is possible that Seurat began planning *Une Baignade, Asnières* as early as 1882. These studies show how Seurat approached this ambitious project. Panels painted in the open air established the main compositional arrangement, the diagonal of the river bank, the positioning of the factories in the background, etc., while the drawings, made in the studio, established the details of the poses of the leading figures and allowed Seurat to refine the small details of the painting. It was also in the drawings that Seurat explored the tonal values of the main figures and, in particular, to develop his interest in the effects of tonal contrast. Examination of the picture surface suggests that Seurat actually pinned some of these drawings to the canvas in order to transpose directly the tonal values into the final painting. Whatever the precise meaning, the overall mood of *Une Baignade, Asnières* is one of the serene calmness of a sunny summer's day. Such a mood of peace and contentment shows Seurat's indebtedness to Puvis de Chavannes. The subject, however, is unmistakably contemporary and is clearly related to the modern-life paintings of the Impressionist artists.

As stated *Une Baignade, Asnières* was not

exhibited at the Salon in 1884 but instead at the Groupe des Artistes Indépendants. This group of independent artists was formed because the 1884 Salon jury proved to be extremely harsh in its selection policy that year, with the result that many paintings were rejected. Thus the rejected artists formed themselves into a loose-knit organization and called themselves the Groupe des Artists Indépendants. Their exhibition was held between 15 May and 1 July 1884 in a temporary building near the burnt-out remains of the Tuileries palace. In all, 402 artists participated and *Une Baignade, Asnières* was displayed in a bar area and, as such, seems to have been unnoticed by any critics other than Fénéon and a few artist friends. It was an inauspicious beginning for Seurat.

However the establishment of the Groupe des Artistes Indépendants proved to be a major turning point for Seurat. Among other artists exhibiting in the show were Paul Signac, Albert Dubois-Pillet, and Henri-Edmond Cross who were, with Seurat, to form the nucleus of the future Neo-Impressionist movement that was to emerge between 1884 and 1886. Paul Signac was to become a close acquaintance of Seurat and was to play a significant role in the development of the new style. By all accounts the Groupe des Artistes Indépendants was a ramshackle affair with no coherent policy and no central organization. Dubois-Pillet organized a new Société des Artistes Indépendants in June 1884 which became established as an artists co-operative in which artists could exhibit their paintings without having to submit them to a jury for selection. Seurat was actively involved in this society and con-

Right: *The Gas Tanks at Clichy*, 1886, by Paul Signac. It was Signac who encouraged Seurat's interest in suburban and industrial scenes.

Below: *Saint Michel d'Aiguilhe in the Snow*, 1890, by Albert Dubois-Pillet. He was the founder of the Groupe des Indépendants in 1884.

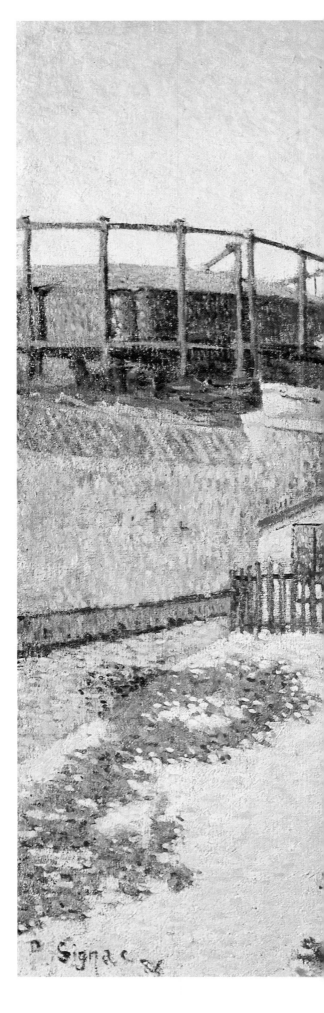

tinued to exhibit his paintings and drawings at their annual exhibitions for the rest of his life. Never again did he seek the favor of the official Salon.

In December 1884 the newly formed society held its first exhibition. Seurat exhibited a number of works including a series of studies he had been working on throughout 1884. These studies were a series of views painted on an island sit-uated in the middle of the river Seine. As Seurat later acknowledged, he had begun, on Ascension day 1884, studies for a second large canvas. He had started *Sunday Afternoon on the Island of La Grande Jatte* which he was hoping to exhibit in the spring of 1885. Subsequently he provided his own chronology of the evolution of the *Grande Jatte*: work on the final version was under way by August 1884; in December

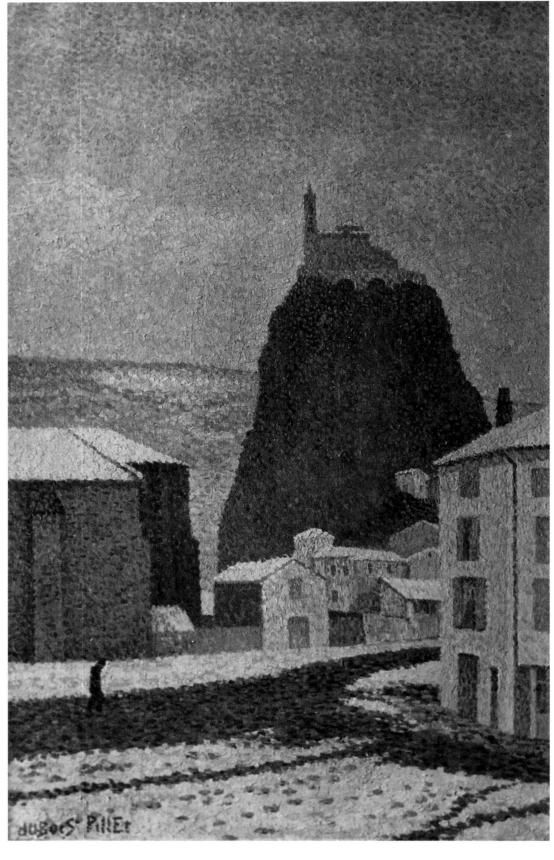

1884 a landscape study of the island was exhibited; by March 1885 the painting was ready for exhibition. Here events were to interrupt Seurat's plans, for the exhibition of the Société des Artistes Indépendants proposed for March 1885 was cancelled because of lack of funds. This cancellation proved to be decisive in the development of Seurat's technique and his growing in-

terest in color theory. Had the *Grande Jatte* been exhibited in March 1885 it would have been very different in appearance from the painting as we know it today, for Seurat repainted much of it during the fall and winter of 1885-86. In its new form the *Grande Jatte* revealed for the first time the new Neo-Impressionist technique. It is important to examine the events of the summer of 1885 in order to explain how Seurat arrived at what is now regarded as his mature style.

The cancellation of the March 1885 exhibition left Seurat at a loose end. His friendship with Paul Signac now proved crucial. Unlike Seurat, Signac possessed an outgoing gregarious character and though younger, Signac had become aware of Impressionist art in the early 1880s and had started to work *en plein air* on the banks of the river Seine. His enthusiasm had been fired as a seventeen year old when he saw an exhibition of Claude Monet's paintings at the gallery of *La Vie Moderne*. So struck was he by Monet's canvases that he tried to arrange a meeting with him; more importantly he emulated Monet's working

Below: This view of the river Seine at Courbevoie includes the island of the Grande Jatte in the center of the river and the factories of Asnières in the distance. In the foreground images of leisure are juxtaposed with the industrial background, a contrast explored by Seurat in his paintings of 1884-1886.

method to the extent of following Monet to the Normandy coast to paint.

Having painted in Normandy, it must have been Signac who persuaded Seurat to spend some time visiting the coast, particularly as Seurat had time to spare. Persuaded by Signac, Seurat went to Grandcamp, a small fishing port close to Bayeux for his first visit. Five canvases were painted on this trip, but Seurat maintained his working method of first painting small studies to establish the main compositional arrangements and then completing the canvases in the studio. Although paintings such as the *Bec du Hoc* (page 100) reveal an awareness of Monet's cliff scenes of the early 1880s, as well as a shared interest in Japanese prints, with the dominating form of the rock outcrop filling most of the pictorial space, the most significant aspect of this summer visit was that it provided Seurat with the opportunity to refine further his Neo-Impressionist technique. Completed in the studio after his return to Paris, the *Bec du Hoc* is Seurat's first fully developed painting in the new style. The paint is much more uniformly applied to the canvas, a dramatic contrast to the exuberant style adopted by Monet in the 1880s. Having refined his technique Seurat immediately began to rework the *Grande Jatte* providing the painting with a 'pointillist' effect during the fall and winter of 1885-86. When the painting was ready for exhibition in 1886 it had been completely transformed from its state of the previous spring.

With the display of the *Grande Jatte* and some of his Marines from Grandcamp at the Eighth, and last, Impressionist exhibition at a well-known restaurant, the Maison Dorée, in May 1886, Seurat showed publicly for the first time paintings which were painted in the new manner. With their dotted surfaces and their precise definition of form these paintings represented the development of a new style. Variously called Neo-Impressionist, Divisionist, Pointillist, Seurat himself preferred the label chromo-luminism as a more valid and accurate description of his new style. Seurat was keen to emphasize the scientific basis of the new style and, later, in a letter to his friend Maurice Beaubourg, he explained the reasons for the development of this style:

The means of expression is the optical mixture of tonal values and colors (both local color and the color of the light source, be it sun, oil lamp, gas, etc), that is to say, the optical mixture of lights and of their reactions (shadows) in accordance with the laws of contrast, gradation, and irradiation.

This new style consisted of applying pigment in small dotted brushstrokes across the surface of the canvas so that some form of optical fusion can take place. Unlike the intuitive approach of the impressionist artists, Seurat believed that by following certain scientific laws in the application of colors his paintings would be brighter and more luminous. He wanted to emulate in paint the working of natural light.

Central to this approach is the theory of optical fusion. That is, that pure colors applied in small touches to the canvas will act like the colors of the spectrum which when viewed from a certain distance will fuse thus creating a more luminous effect. Although Seurat was reluctant to explain his ideas, the *Grande Jatte* was described in a lengthy review by a close friend, the critic Félix Fénéon. There can be no doubt that Fénéon's account received the tacit support of Seurat himself. It was in this review that the idea of optical fusion first appeared, and in it Fénéon provided the most substantial analysis of Seurat's work to date. Fénéon described:

If you consider a few square inches of uniform tone in M Seurat's *Grande Jatte*, you will find on

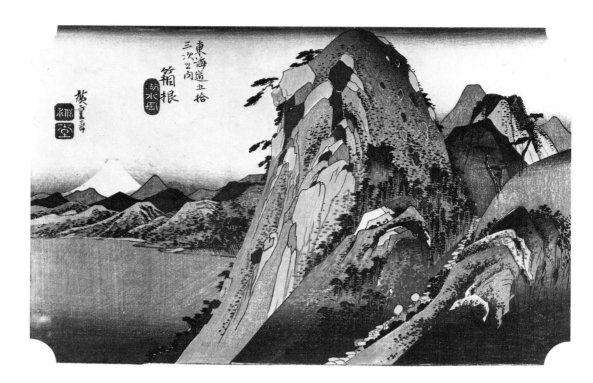

each inch of its surface, in a whirling host of tiny spots, all the elements which make up the tone. Take this grass plot in the shadow: most of the strokes render the local value of the grass; others, orange-tinted and thinly scattered, express the scarcely felt action of the sun; bits of purple introduce the complement to green; a cyanic blue, provoked by the proximity of a plot of grass in the sunlight, accumulates its shiftings toward the line of demarcation, and beyond that point progressively rarifies them. Only two elements come together to produce the grass in the sun; green and orange-tinted light, any interaction being impossible under the furious beating of the sun's rays . . . These colors, isolated on the canvas, recombine on the retina: we have, therefore, not a mixture of material colors (pigments), but a mixture of differently colored rays of lights.

This review, as have many subsequent accounts of Seurat's artistic theories, maintained the centrality of the idea of optical fusion in his mature paintings. However,

such beliefs are erroneous and Seurat himself misunderstood the scientific ideas which he thought to be the basis of his Neo-Impressionist paintings. One of the sources consulted by Seurat was the book *Modern Chromatics*, written by an American, Ogden Rood, in 1879 and translated into French in 1881 when, he later claimed, Seurat read it. Fénéon stated:

Need we recall that even when the colors are the same, mixed pigments and mixed rays of light do not necessarily produce the same result? It is also generally understood that the luminosity of optical mixtures is also superior to that of material mixture, as the many equations worked out by M Rood show.

Thus in an effort to obtain optical fusion,

Seurat was convinced that the qualities of light could be captured by the artist. Traditionally the mixing of pigments to create different hues and values had resulted in a dulling effect. This process is known as subtractive mixture. The fusing of the colors of the spectrum occurs as a result of additive mixture, where the resultant effect is one of lightness. Rood believed that the colored light reflected from the paint surface would recombine and fuse on the retina of the viewer resulting in a far more luminous effect. Thus Seurat developed a palette and technique which would emulate the process of additive mixture by applying pigment in a series of small, uniform touches. For fusion to take place it was believed that there was a correct viewing distance for Seurat's paintings. Pissarro believed that distance to be three times the diagonal of the canvas, whereas Signac felt that if fusion did not take place at a certain distance then the artist should develop a technique of blending brushstrokes in order to assist the process.

However, any examination of Seurat's paintings from 1886 onward shows a great variety of types of brushstrokes and the idea of a uniformity of touch is a false one. Why, therefore, did Seurat persist in a pointillist approach? It would seem that Seurat, lacking any sort of scientific training, genuinely believed that Rood's theories, systemmatically applied, would result in brighter, more luminous paintings. While this view received a certain support there were those who cast doubts over the new technique; the critic Emile Hennequin noted of the *Grande Jatte* that 'you cannot imagine anything more dusty of lusterless.' Signac, so close and very much an admirer of Seurat in 1886, had revised his opinions by the time he attacked mindless 'pointillism' in his history of Neo-Impressionism published in 1898. Signac accurately recorded that the dotting of the paint surface was done to give the painting a vibrant, lively surface effect; the spectator's eye would flit across the surface. As regards luminosity Signac dismissed excessive dotting as producing a gray and colorless quality.

Just as Seurat's techinique was the cause of much consternation to his critics, so too the subject of the *Grande Jatte* proved difficult to understand. Something of the painting's complexity can be gained from the review of a friend, the critic Jules Christophe. Christophe wrote:

Monsieur Georges Seurat, finally, with the temperament of a Calvanist martyr who has

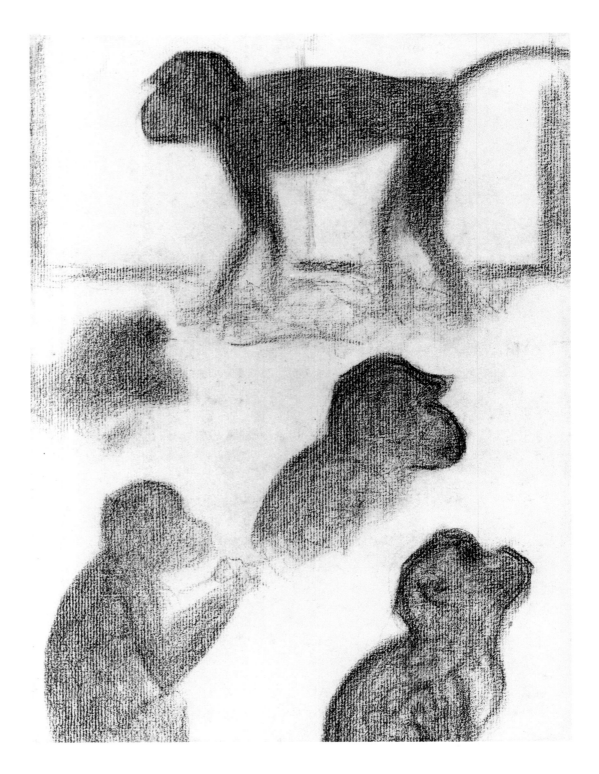

planted . . . fifty people, lifesize, on the banks of the Seine at La Grande Jatte one Sunday in the year 1884, tries to seize the diverse attitudes of age, sex, and social class: elegant men and elegant ladies, soldiers, nannies, bourgeois, workers. It is a brave effort.

Describing it as Seurat's manifesto painting, Christophe, here, hinted at the meaning of the painting. Paul Signac, writing some years later, attempted to summarize the critical response. He stated:

When Seurat exhibited his manifesto painting, *A Sunday on the Grande Jatte*, in 1886, the two schools that were then dominant, the naturalist and the symbolist, judged it according to their own tendencies. J K Huysmans, Paul Alexis, and Robert Caze saw it as a Sunday spree of drapers' assistants, apprentice charcutiers, and women in search of adventure, while Paul Adam admired the pharaonic procession of its stiff figures, and the Hellenist (Jean) Moreas saw panathenaic processions in it.

For Fénéon the painting represented a random population unified by Seurat's hieratic treatment. He was keen to underline the connexion with Puvis de Chavannes:

It is four o'clock on Sunday afternoon in the dog-days. On the river the swift barks dart to and fro. On the island itself, a Sunday population has come together at random, and from a delight in the fresh air, among the trees. Seurat has treated his forty or so figures in summary and hieratic style, setting them up frontally or with their backs to us or in profile, seated at right-angles, stretched out horizontally, or bolt upright: like Puvis de Chavannes gone modern.

Seurat's most ambitious painting to date certainly caused confusion as to an interpretation of its meaning. Some critics chose to write about the new technique while others did attempt to unravel the many layers of this picture, a far from easy task and one that still divides scholars today. The setting was the island of La Grande Jatte which was located in the

Left: *Five Monkeys*, 1884-85, by Georges Seurat. Seurat has observed the monkeys in different poses and has varied his technique accordingly.

Below: *Lady Fishing*, c.1884-5, by Georges Seurat. This delicate sketch is of the female figure fishing in the *Grande Jatte* (page 90).

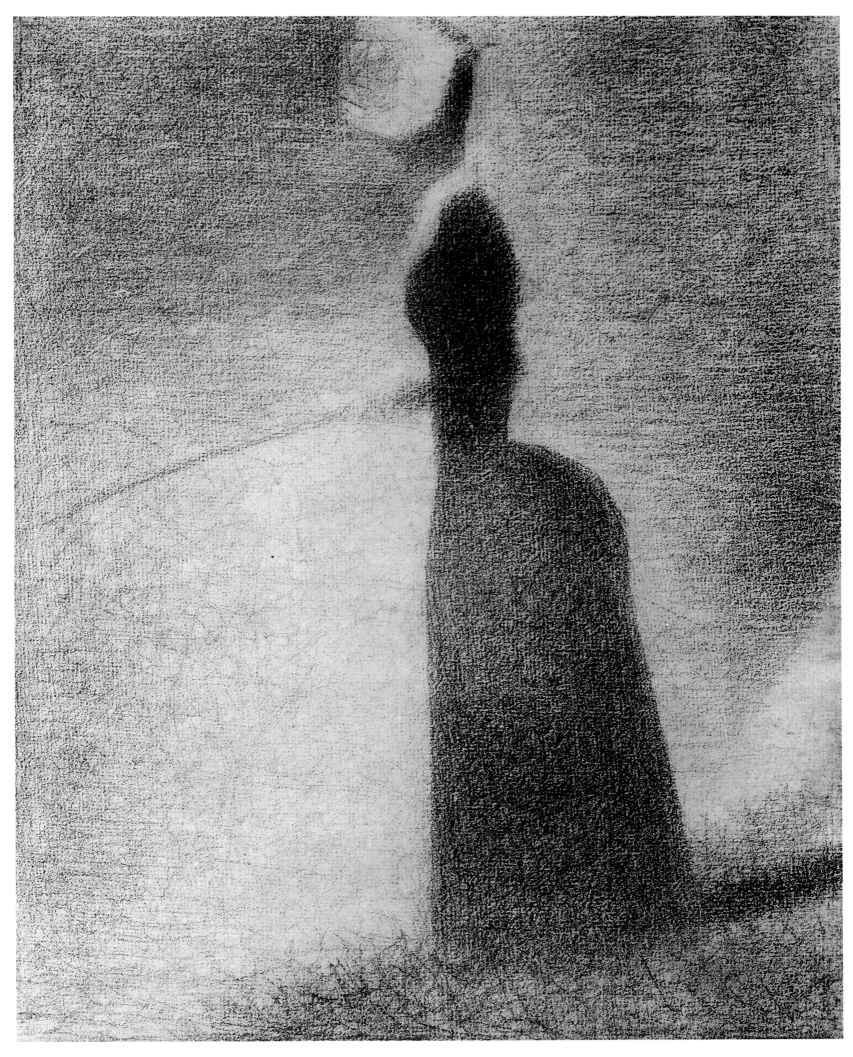

Below: Roger Jourdain's *Le Dimanche* and *Le Lundi*, 1878 (these are engraved copies), were exhibited at the Salon in 1878 as a pair and depict a fashionable picknickers on the Grande Jatte and a group of workers drinking by the Seine. The contrasting subjects may have encouraged Seurat to explore similar themes.

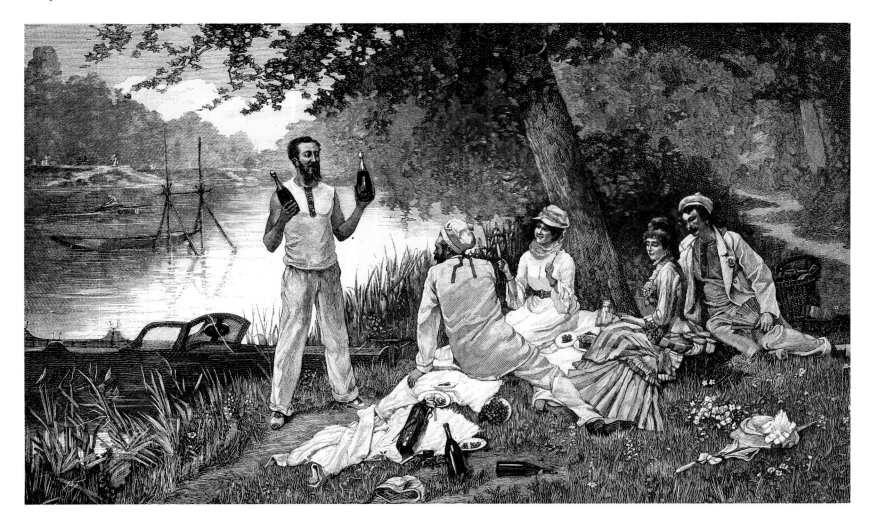

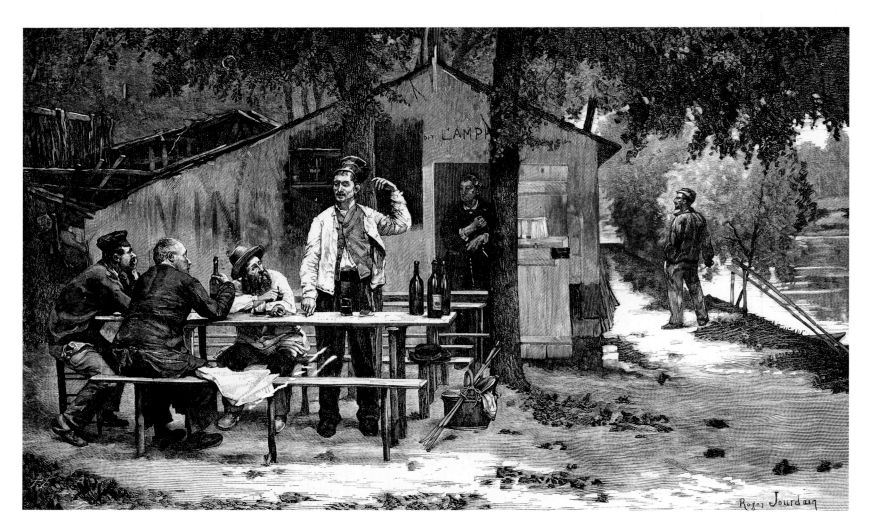

Seine at Asnières. It had a reputation as a meeting place, an island on which to promenade or rest on a Sunday afternoon. Included is a whole range of Parisian types. For some, the picture is concerned with certain aspects of Parisian low-life. Although masking as the Parisian bourgeois many are not what they appear at first sight. In particular, much attention has been focussed upon the standing figures on the right of the picture. A top-hatted man accompanies the exaggeratedly dressed woman walking with a monkey. It is often suggested that this woman was a coquette and that the island was a well-known focus of low-life activity. In contemporary slang a *singesse,* a female monkey, meant prostitute and the idea of the island as a center of promiscuous behavior is further suggested by the young woman fishing. 'To fish,' *pêcher* in French, was a pun on the French verb 'to sin,' *pécher*.

Another vexed question concerning this painting is its relationship to *Une Baignade, Asnières*. Much evidence exists to suggest that the two paintings are closely connected and that Seurat intended them to be read as a pair. Both were originally the same size. They depict banks of the river immediately opposite one another; in fact, the tip of the Grande Jatte can be seen in *Une Baignade, Asnières*. The ferry boat with its over-large tricolor is common to both paintings as it ploughs its path across the river. Finally, Seurat himself encouraged a combined reading. He stressed the starting date of the *Grande Jatte* as 1884 both as the date when he began working on it and, by including the date 1884 in the title when it was exhibited in 1886, he firmly established that the scene depicted was set in the same year as *Une Baignade, Asnières*. Thus there is strong evidence to suggest that the two should be seen together. If so, how does this affect our reading and understanding of them? One interpretation is that they represent different days of the week, *Une Baignade, Asnières* a working day, *La Grande Jatte* a Sunday. To make such a contrast was not without precedent in paintings exhibited in the 1870s or 1880s. For example Seurat may have been familiar with one such pair (see left) by Roger Jourdain which were exhibited at the Salon in 1878. But in both Seurat's and Jourdain's paintings the contrast between work and leisure is unclear. Certainly both represent leisure activity on the Sunday but Jourdain's depiction of Monday shows a group of working men drinking and not actively engaged in any form of work whatsoever, just as the figures in *Une Baignade,*

Asnières are relaxing by the river's edge. If there is any reference to work it is certainly not explicit.

The exhibition of *La Grande Jatte* confirmed the emergence of the new type of painting described as chromoluminist by Seurat, and now generally known by the more neutral-sounding label of Neo-Impressionist. Fénéon's description of the new style cemented a friendship between artist and critic. It is not known when the two met, although one story suggests an initial encounter in front of *La Grande Jatte* at the eighth Impressionist exhibition. It is more likely that the two met some time before this. Fénéon had seen *Une Baignade, Asnières* in 1884 and had started to associate with a group which included the painter Albert Dubois-Pillet, the president of the Société des Artistes Indépendants. Clearly Fénéon recognized the genius of Seurat, one totally dedicated to his art. Fénéon's reviews in 1886 marked him as the spokesman of the new movement and

even involved him in various artistic rivalries which surfaced at this time. In the preliminary organization of the last Impressionist exhibition there was already resentment that the young group of emerging Neo-Impressionists should be included in the exhibition. Both Monet and Degas were particularly vehement in their hostility to Seurat and his colleagues. Paul Gauguin also resented the support given to Seurat by Fénéon as he felt that his position, as he saw it, as leader of a new avant-garde was being undermined. A misunderstanding between Seurat and Gauguin in 1886 concerning the latter's access to Signac's studio only exacerbated the situation further. Seurat's increasingly dominant position as a member of the avant-garde can be seen by the way that Vincent van Gogh, recently arrived in Paris, not only adopted the Neo-Impressionist style of painting in early 1887 but also selected similar locations for his subjects in paintings such as *Factories at Asnières* (page 20).

Below: *Breton Women*, 1889, by Emile Bernard. Although a follower of Paul Gauguin, Emile Bernard acknowledged the significance of Seurat in some of his paintings. Here Breton peasants are shown working in the fields around Pont Aven. The flat, unmodulated areas of color are in marked contrast to Seurat's pointillism.

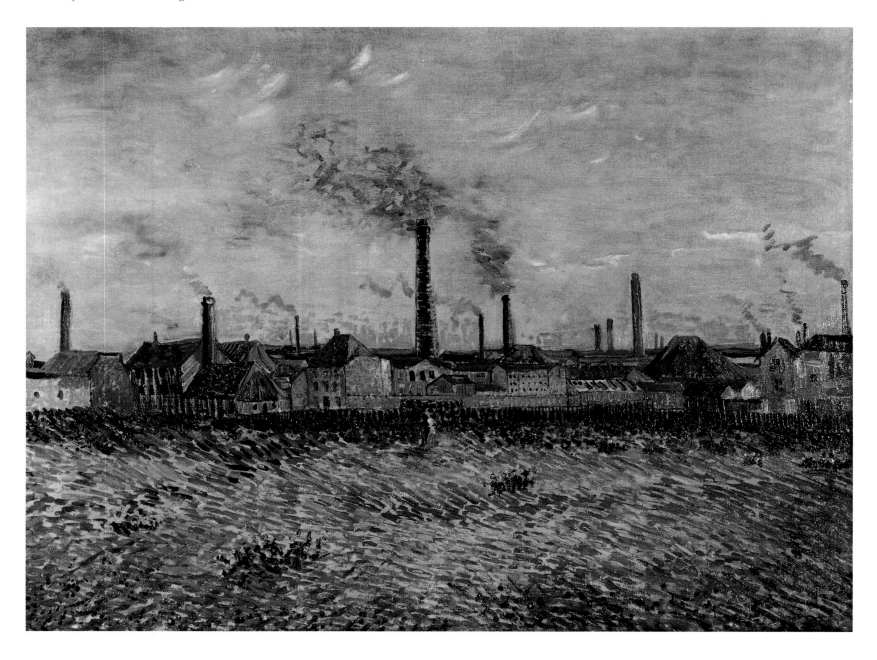

Félix Fénéon was crucial to the development of Neo-Impressionism in general and specifically to Seurat's emergence as an artist of great stature. His reviews from 1886 onwards became the forum where Neo-Impressionist ideas were aired and with his close friendship with Seurat there can be little doubt that Seurat tacitly approved of Fénéon's statements as faithfully representing his own. Fénéon was a curious character. His appearance, like that of Seurat, was sober; formally dressed he was recognized by his top hat, cape, and little goatee beard which he allowed to grow into a few whispy strands later in life. He has been described as a dandy and yet he worked by day in the French War Office where he established a reputation for being a model worker. His artistic criticism, and other writings, were conducted in his spare time. He was also an anarchist. The full extent of his anarchist activities are still a matter for conjecture, but there is no doubt

that he supported anarchist activity, wrote for anarchist publications, and was arrested in 1894 on suspicion of conspiracy. It has been suggested that he was responsible for the bombing of the Foyot restuarant in the spring of 1894, a crime that remained unsolved. Given his anarchist views it is tempting to suggest that these were views that Seurat also shared. Although he never spoke openly about his political views, there can be no doubt that paintings such as *La Grande Jatte* were a savage commentary on the nature of contemporary Parisian life. Seurat's close friend Paul Signac became actively involved in anarchist politics, producing drawings for anarchist periodicals in the early 1890s. In his paintings and drawings he often alluded to an anarchist ideal. His *Pleasures of Summer*, 1895-96, which shows groups of people at work and at rest in some idealized Mediterranean setting. Henri-Edmond Cross's *Evening Air*,

1893-94, shows that this idealized type of subject became a standard feature in Neo-Impressionist art in the 1890s.

Fénéon was also responsible for another important development in Seurat's art in 1886, one that was to have a dramatic impact on his art for the remaining five years of his life. Fénéon had become interested in the writings and ideas of a scientist named Charles Henry and offered to introduce the two men to each other in 1886. Henry's ideas were to captivate Seurat. His theories had been first reported in the pages of *L'Artiste* in 1874 where it stated that 'here is an attempt at the geometric representations of expression. By means of changes in the direction of lines and the amplitude of angles, M Henry has arrived at an abstract representation of feeling.' His ideas were more fully developed in his book *Introduction to a Scientific Aesthetic* which was published in Paris in August 1885. Henry believed that the movement of

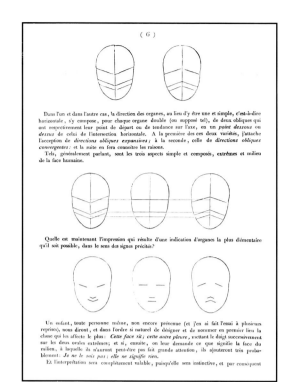

lines could produce complex pyschological effects, claiming that lines possessed what he termed dynamogenic qualities. Depending on the direction of lines certain emotional effects would be experienced by the viewer. Henry had developed his ideas from those of Humbert de Superville who had written on the emotional value of linear expression in an essay published in the late 1820s. Simply put, Humbert de Superville sought to demonstrate in diagrammatic drawings of faces, that lines moving in an upward direction were stimulating and suggestive of happiness, while lines moving downwards expressed sadness. Charles Henry intended to further the researches of Humbert de Superville and to prove them to be incontovertible fact. Henry also applied his theory of dynamogenic lines to the color circle to show that colors could produce similar emotional responses. Henry believed that lines moving upward and to the right when overlaid on a color circle would cover the red-orange yellow segment. These warm colors would produce the same sensation of happiness. In contrast the blue-violet to

blue-green segment would be equivalent to lines moving downward and to the left, thus resulting in a mood of sadness. Seurat was clearly interested in Henry's writings and with *Les Poseuses*, his next major painting after *La Grande Jatte*, he introduced some of Henry's ideas.

Les Poseuses (small version, page 126) was exhibited at the Indépendants in 1888.

Three naked models, or possibly one model in three different positions, are shown, posing in Seurat's studio on the boulevard de Clichy. In the background, along one wall, is the *Grande Jatte*. The juxtaposition of these two images explores the differences between artifice and reality; the models are placed 'in their natural simplicity,' according to Paul Adam, in the artificial setting of the artist's studio – how else was the artist to depict the nude in the 1880s? On the other hand, the figures in the *Grande Jatte* are in a natural setting, but their costumes and gestures transform them into something other than their own reality. Fénéon, reviewing the exhibition, related the painting to the ideas of Charles Henry. He wrote:

By a piece of pseudoscientific fantasy, the red parasol, the straw-colored parasol, and the green stocking are orientated in the directions by the red, yellow, and green on Henry's chromatic circle.

Whether *Les Poseuses* should be seen as a painting evoking moods of happiness or sadness remains a much-debated issue.

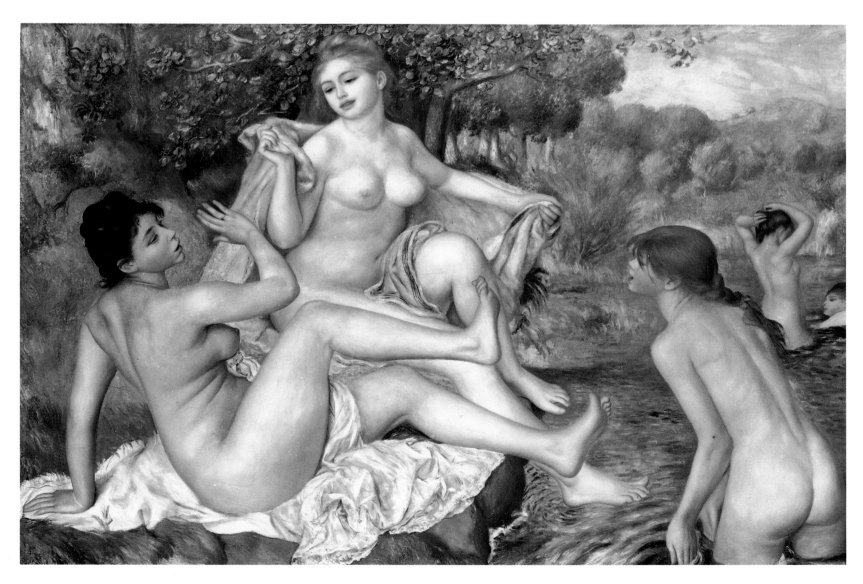

Below: *Synoptic Table*, 1827-32, Humbert de Superville. In this diagram de Superville's ideas concerning the emotional values of line and color were explained. Upwardly moving lines produced feelings of happiness and such lines were associated with the color red. Black and downward-moving lines suggested sadness.

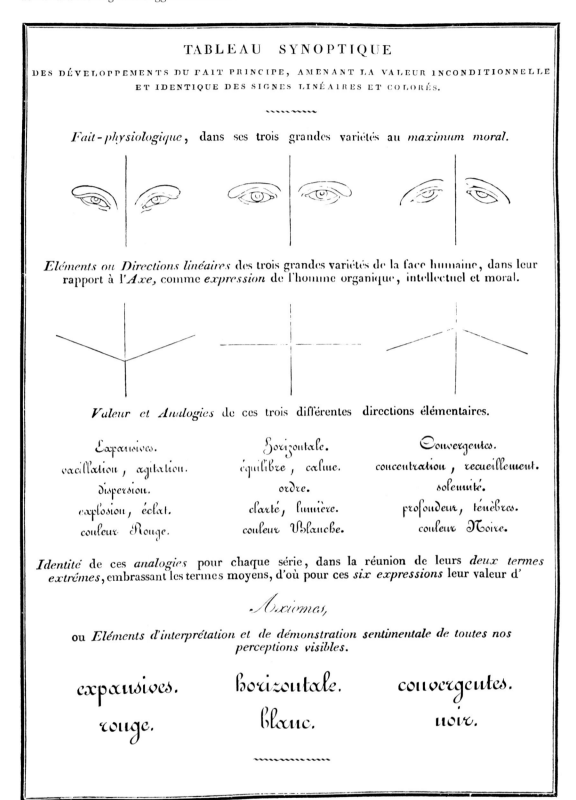

TABLEAU SYNOPTIQUE

DES DÉVELOPPEMENTS DU FAIT PRINCIPE, AMENANT LA VALEUR INCONDITIONNELLE ET IDENTIQUE DES SIGNES LINÉAIRES ET COLORÉS.

Fait-physiologique, dans ses trois grandes variétés au *maximum moral*.

Eléments ou Directions linéaires des trois grandes variétés de la face humaine, dans leur rapport à l'*Axe*, comme *expression* de l'homme organique, intellectuel et moral.

Valeur et Analogies de ces trois différentes directions élémentaires.

Expansives.	Horizontale.	Convergentes.
vacillation, agitation.	équilibre, calme.	concentration, recueillement.
dispersion.	ordre.	solennité.
explosion, éclat.	clarté, lumière.	profondeur, ténèbres.
couleur Rouge.	couleur Blanche.	couleur Noire.

Identité de ces *analogies* pour chaque série, dans la réunion de leurs *deux termes extrêmes*, embrassant les termes moyens, d'où pour ces *six expressions* leur valeur d'

Axiomas,

ou *Eléments d'interprétation et de démonstration sentimentale de toutes nos perceptions visibles.*

| expansives. | horizontale. | convergentes. |
| rouge. | blanc. | noir. |

Essentially Henry's ideas were a reworking of those of Humbert de Superville and it is likely that Seurat responded to the more simply expressed diagrams of the latter rather than the more elaborate, pseudo-scientific pronouncements of Henry. Certainly *Les Poseuses* was well received by Seurat's friends. Signac felt that the painting had achieved perfection. Many pointed to Seurat's relation to the antique and how, in this painting, he had managed to fuse the eternal qualities of classical art within a contemporary context.

Les Poseuses marks the culmination of one group of large figure paintings; it was also a turning point in Seurat's artistic concerns. For three of his major late paintings are concerned with forms of urban entertainment and these three paintings can be grouped together. When *Les Poseuses* was exhibited in early 1888 it was enthusiastically written about by Félix Fénéon. At the same Indépendants exhibition of February 1888 Seurat displayed the first of his compositions devoted to urban entertainment, *La Parade*, which was coolly received by

Fénéon. He merely stated that the coloring of this night scene was interesting, and he was never to write so endearingly about Seurat's painting after this date. Thus a warm and supportive friendship waned. But just as Fénéon's support declined, the Symbolist poet Gustave Kahn emerged as one of the more acute observers of Seurat's late work, particularly the scenes of urban entertainment.

In *La Parade* Seurat shows a single trombone player. He plays his tune in order to attract an audience who will buy their entrance ticket (at the booth at the extreme right-hand edge of the painting) to hear the full band performing inside. The painting is characterized by its extreme geometry, the very definite vertical and horizontal divisions which, if based on Henry's ideas, should suggest a mood of calmness. Gustave Kahn, in his obituary of Seurat, referred to this painting as 'his first night effect in the cities, so willfully pallid and sad.' A strict application of Henry's ideas does not seem to be fully evident in this example. The choice of subject is derived from the Cirque Corvi, one of the attractions of the annual Foire du Trône held in the spring of each year. A poster for the circus clearly shows the gathering of people outside; centrally located is the trombone player performing his solitary act. Behind are the rest of the performers and the architectural setting with the line of gas lamps showing how faithfully Seurat remained to this source. Of particular significance is the headgear of the assembling audience, fancy and sophisticated to the right, plain and unadorned to the left. The wealthy can afford to pay to go inside to experience the full performance while those less well off have to listen outside to the lone trombone player. Thus in turning to night scenes of urban entertainment Seurat continued his interest in observing the fluid nature of Parisian society.

Seurat turned his acerbic gaze to urban entertainment in a second painting, *Le Chahut*, which was exhibited at the Salon des Artistes Indépendants in 1890. The subject, a fashionable high-kicking dance, is set in a café-concert. Café-concerts had first emerged as a popular form of entertainment in the 1840s and were generally located in the more affluent parts of Paris, such as the Champs Elysées. Often they were outdoor entertainments performed at cafés throughout the summer months. By the 1880s the number of café-concerts had proliferated, and geographically they had spread to other parts of Paris. With the building of new boulevards under the mas-

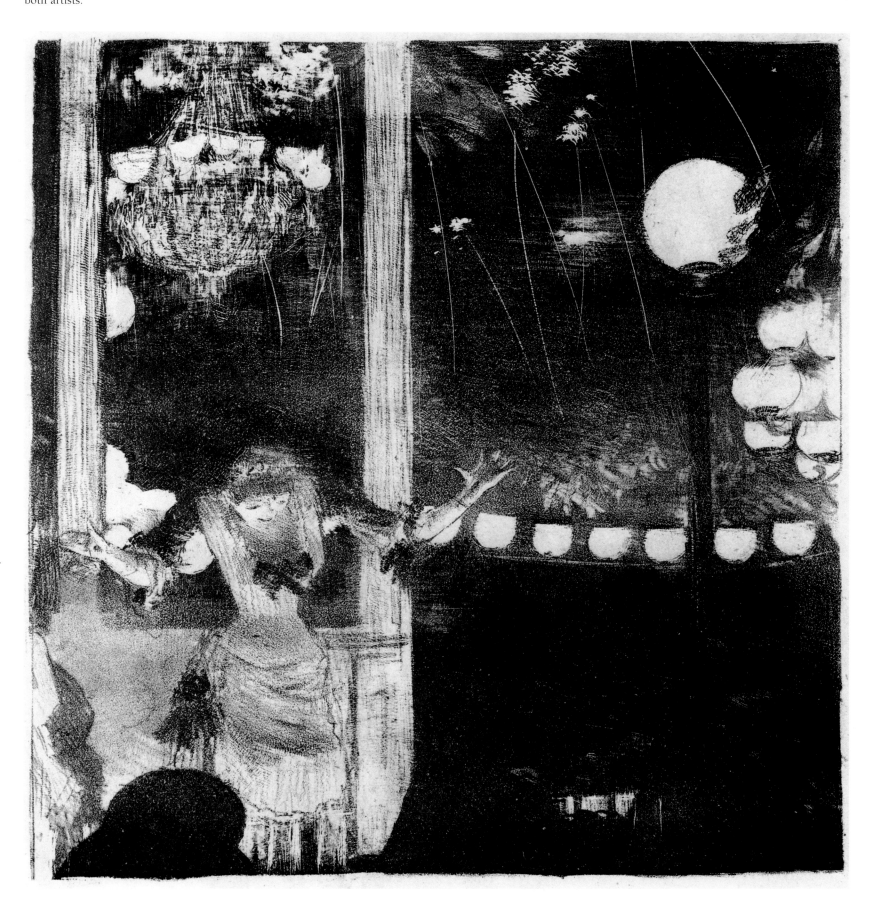

sive urban modernization programme of Baron Haussmann, and the gradual outward expansion of the city of Paris, new café-concerts opened up on the outer boulevards such as the boulevard de Clichy and the area around the base of the hill of Montmartre. Such café scenes had been painted by the Impressionist artists, for example Renoir's *Moulin de la Galette* which showed an assembled crowd drinking and dancing. Manet and Degas in particular painted a whole series of such subjects. Degas, for example, depicted the subject in his *Aux Ambassadeurs: Mme Bécat*, 1877 (above). The Ambassadeurs was regarded as a fine establishment and regularly catered for 1200 customers each night during the summer season. Degas frequented this café in the 1870s and produced a series of drawings, prints, and paintings of performers and especially of one performer, Emilie Bécat. In the example illustrated here Degas depicts Mme Bécat performing on stage, her body

23

Below: *Corner in a Café-Concert*, 1878-79, Edouard Manet. In the late 1870s Manet started to paint a whole series of café-concert subjects. The dancing figure in the background acknowledges his debt to Degas, although Manet displays a much greater interest in the figures drinking in the foreground.

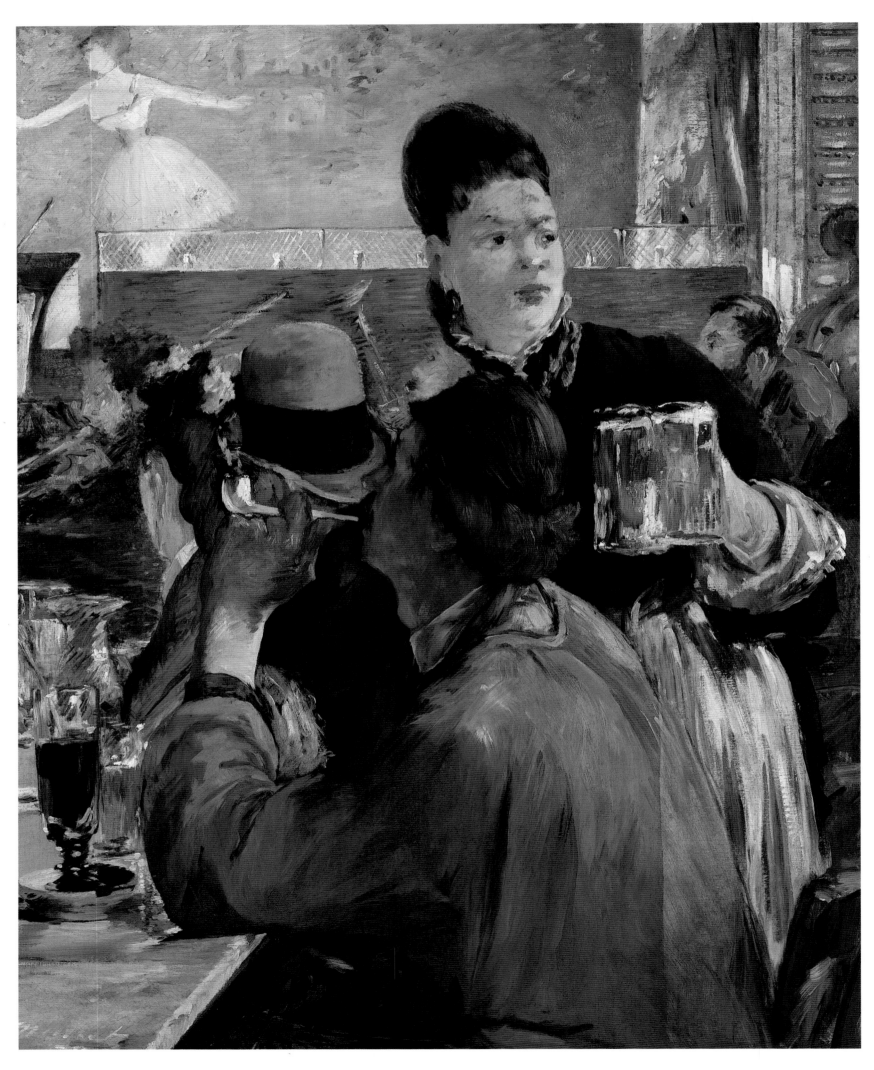

and face lit from below by the floor lights. The performance is seen from the audience and in the foreground are silhouetted the shadowy forms of people sitting in the front row of seats, a similar pictorial device that Seurat was to adopt in his *La Parade*. Something of the nature of a typical concert evening can be seen by the description of an American visitor, Edward King, to Paris. King described:

The songs are local, glaring with coarse mannerisms and rude gestures..; a fat woman rises, making a short, ungraceful bow, and sings a burlesque song. It is an echo of boulevard life . . . The audience are more enthusiastic here than under roofs; they rise and swing hats and bonnets, they scream and throw bouquets, and sometimes a daring suitor goes to the footlights and hands to his goddess, in person, his offering of flowers or epistle of love.

Manet, too, became captivated by the subject of café entertainment from the mid-1870s until his death in 1883. His *Bar at the Folies Bergères* was the culmination of a series of café scenes and one that attempts to capture the full complexities of café life. The example illustrated here, *Corner in a Café-Concert*, 1878-79 (see left), acknowledges a debt to Degas' paintings of the same theme with the inclusion of a ballet dancer, in the manner of a Degas, in the background. In contrast to Degas, Manet concentrates his attention not on the performer but rather on the audience and the waitress. The blue-smocked figure in the immediate foreground is identifiable as a working figure and the serving of large glasses of beer suggests a less fashionable establishment than the Ambassadeurs. By the 1870s and 1880s the number of café-concerts had proliferated to the extent that they were frequented by an increasing proportion of the Parisian population, veritable centers of modern life. Gustave Geoffroy described them in 1893:

The café-concert is at once a meeting place, a *salon de conversation*, a café, and a smoking-room; in addition one can find there both instrumental and vocal music, droll songs in the choruses of which one may join, comic actors, singers in glittering costumes, sleeveless and *decolletés*, with flowers in their hair and bouquets in their hands.

By the late 1880s and early 1890s a new trend emerged among the audiences of the café-concerts. Traditionally the more exclusive concerts were in the fashionable parts of Paris whereas those establishments catering for working people were located away from the city center. The

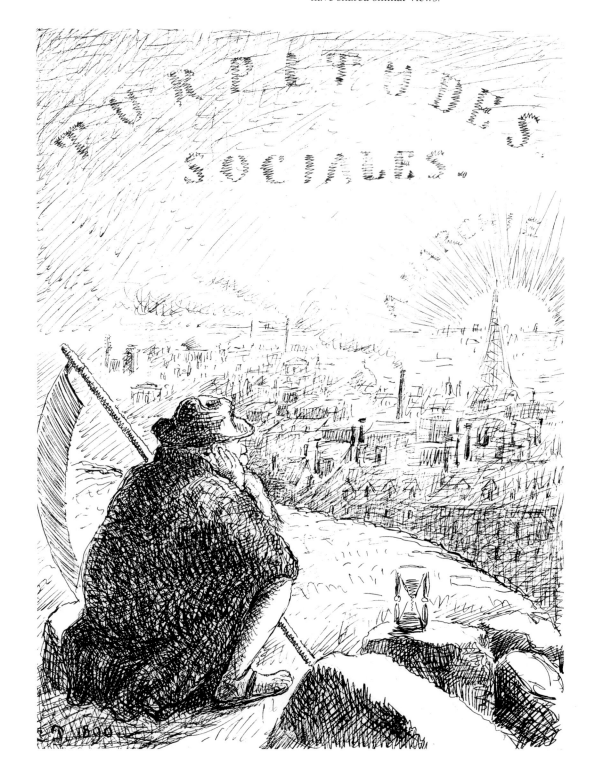

upper classes frequented the exclusive concerts while the shopkeepers and the clerks attended establishments where, for one franc, they could particpate in an entire evening's entertainment. This social division became blurred in the late 1880s to the extent that the cheaper and rowdier concerts began to attract the fashionable classes as well as their traditional customers. As one commentator said: 'Today there is a new and faithful clièntele drawn from the upper classes . . . the ladies attend in elaborate gowns and the gentlemen in formal evening dress.'

It is precisely this new development that Seurat explored in the second of his paint-ings of Parisian nighttime entertainment, *Le Chahut*. Seurat has painted a group of dancers performing the Chahut, a fashionable high-kicking dance performed widely in Paris at this time and made famous by dancers such as Louise Weber, known as *La Goulue* (the Glutton), and immortalized by Toulouse-Lautrec in his poster advertising the Moulin Rouge. In front and below the dancers are the musicians, a conductor, and members of the audience. It is one of Seurat's most stylized paintings in which he makes use of caricature; the finely turned ankles of both the male and female dancers, their exaggerated gestures, the upturned lips of the women and the mon-

Below: *Les Girard*, 1879, by Jules Chéret. Seurat was fascinated by Chéret's poster designs and incorporated some of their features into his own work. Always interested in forms of popular imagery, Seurat in his paintings of Parisian entertainment captured the same dynamic effects as illustrated in this poster.

Right: *The Ladies of the Chariots*, 1883-85, by James Tissot. This painting depicts the Roman chariot race which was held at the Hippodrome de l'Alma. The charging chariots contrast in a humorous manner with the stiff figures of the women driving them. It was part of a series by Tissot showing Parisian women in varied roles.

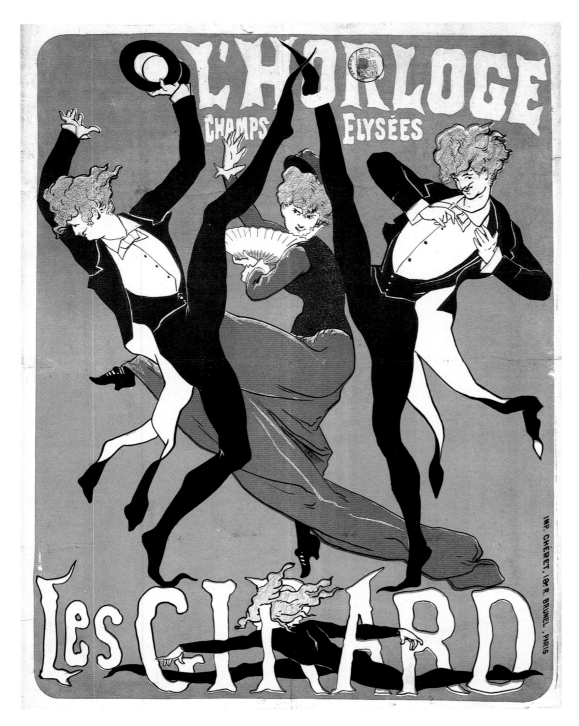

Dancers in a single rhythm, animated by the direction of the movement, congealed because it is the dominant movement, the leitmotif of the only action that interests us in these dancers, their dance. The female dancer's head, made admirably beautiful by the contrast of its official smile, almost priestly, with the tired delicacy of its small, fine features, marked by desire, conveys to us that this beauty has its complete meaning only in this principle activity of this feminine mind, thus to dance: this act becomes for the dancer something solemn because it is habitual. The male dancer is ugly, ordinary, a banal coarsening of the feminine physiognomy next to him. The smiling light of the female figure diminishes him, for he is not exercising an aptitude peculiar to his sex; he is merely plying an ignoble trade. His coat tails are forked, like the devil's tail in pictures by the old visionaries. The orchestra leader, chance director of this solemnity, closely resembles the male dancer; they are stamped out of the same mold and are both there by trade. As a synthetic of the public, observe the pig's snout of the spectator, archetype of the fat reveller, placed up close to and below the female dancer, vulgarly enjoying the moment of pleasure that has been prepared for him, with no thought for anything but a laugh and lewd desire. If you are looking at all costs for a 'symbol,' you will find it in the contrast between the beauty of the dancer, an elegant and modest sprite, and the ugliness of her admirer; between the hieratic structure of the canvas and its subject, a contemporary ignominy.

Although not concerning himself with the class differences so evident in *La Parade*, Seurat has provided a telling insight into the seedy life of the male onlooker as he experiences the cheap thrill of staring at the legs of the dancers so dramatically revealed in the high-kicking dance. Just as Seurat turned to the poster as a compositional source for *La Parade* so he turned to popular caricature to elucidate the meaning of *Le Chahut*.

Popular imagery was also important for the third of his studies of urban entertainment, *Le Cirque*, which was exhibited in an unfinished state at the Indépendants in 1891. The free-flowing style that characterizes these late works is partly derived from the poster designs of Jules Chéret, an artist whose genius was said to have been adored by Seurat. Chéret had established a considerable reputation as a poster artist by the mid-1870s and many of his designs, as in *Les Girard*, foreshadow the Art Nouveau style, hints of which maybe also seen in *Le Cirque*. The circus had also interested

strous mustaches of the men. Characteristic with the dance this is the most vibrant of paintings, in dramatic contrast to the calm and stillness of *La Parade*. The application of Charles Henry's theories would suggest that we are looking at the happiest of subjects. All lines are moving in an upward direction: the movement of the dance itself; the exaggerated features of the dancers already alluded to; the gesture of the conductor; the rhythm of the double bass echoing the kicking legs of the dancers; and the gas lights on the far wall. The warm colors add to a lively, happy scene of entertainment. Yet there may be a darker side to this painting; all may be not what it appears.

Paul Signac, writing in the anarchist journal *La Révolte* in 1891, described this painting as representing a decadent subject and one highlighting social conflict. For Signac such paintings 'by the synthetic representation of the pleasures of decadence – balls, chahuts, circuses, such as those done by the painter Seurat who had such a keen sense of the debasement of our age of transition – they bore witness to the great social conflict which is beginning between Capital and the workers.' Such a sociopolitical interpretation of *Le Chahut* had already been suggested by Gustave Kahn who purchased this painting from Seurat. Given their close friendship it is tempting to assume that Kahn's analysis was derived from discussions with Seurat. Kahn described:

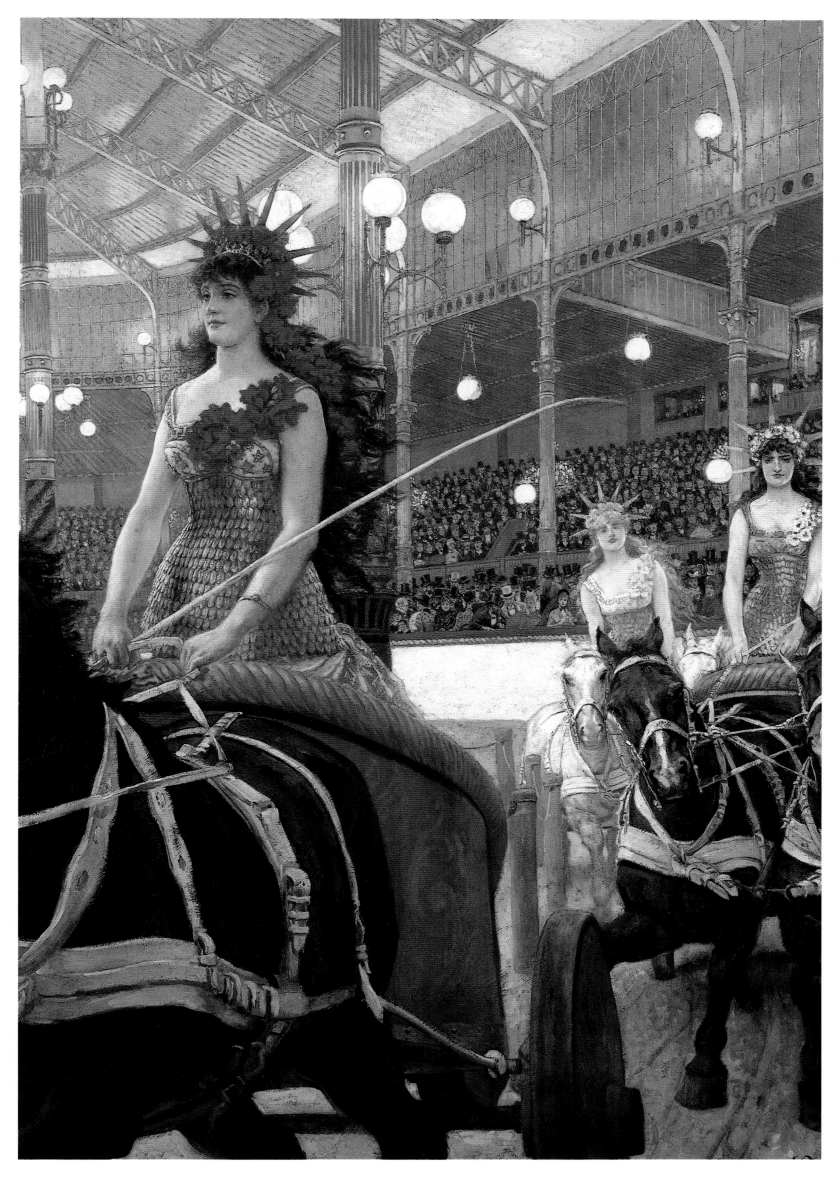

similar to that of the bass player in *Le Chahut*, while the cross-section of Parisians in the audience recalls the queuing customers in *La Parade*. Unfortunately *Le Cirque* has not received the same critical commentary as the other two paintings and much remains to be discovered about the full extent of its iconography.

Alongside his series of large urban paintings Seurat had, since his visit to Grandcamp in 1885, continued to paint seascapes. These are usually referred to as his marines. The marines have not received the critical attention they deserve and have been much overshadowed by the large figure paintings. Often they have been regarded as paintings produced during his summer vacations as a form of relaxation, and have been seen as a contrast to the complex studies that dominated most of his working year. Such dismissal of the marines is to underestimate the crucial and central role they play within Seurat's oeuvre. It has already been shown how the pictures painted at Grandcamp in the summer of 1885 were crucial to the development of the Neo-Impressionist technique; the later marines suggest that Seurat approached his subjects with the same incisive and critical eye that he brought to his urban subjects and it would appear that many of the marines have complex sub-

other artists as a subject suitable for treatment at this time. James Tissot painted a series of circus pictures in the 1880s, one of which, *The Ladies of the Chariots*, 1883-85 (page 27), was set in the Hippodrome de l'Alma and shows a Roman chariot race with female charioteers. In the use of cut-off forms Tissot, like Seurat, alludes to the combined influences of Degas and his circus paintings and to Japanese prints. Closer to Seurat's painting is Toulouse-

Lautrec's *At the Cirque Fernando*, 1887 (see right), in which the circus ring dominates the compositional space and the ringmaster, situated in the left foreground, controls the activities taking place around him. In Seurat's painting the Ringmaster too assists the female horseback rider in her act but it is the silhouetted clown in the foreground who appears to hold the key to unravelling the events depicted in the painting. His position in the painting is

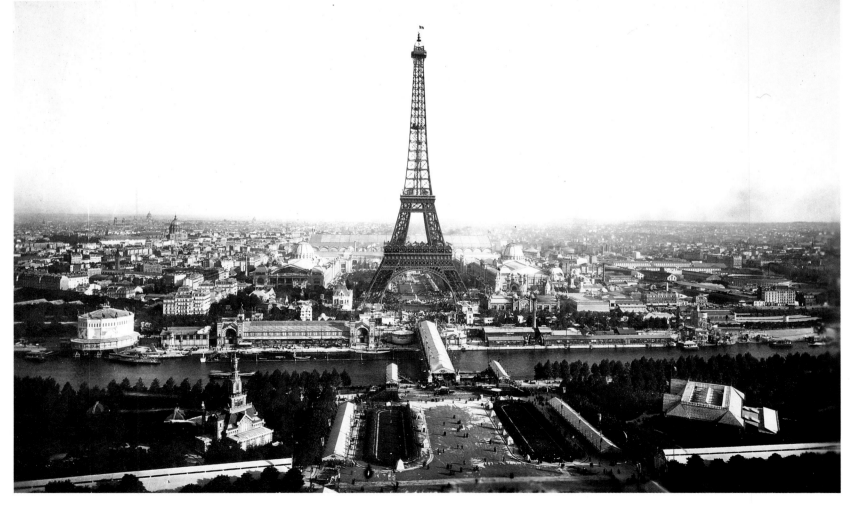

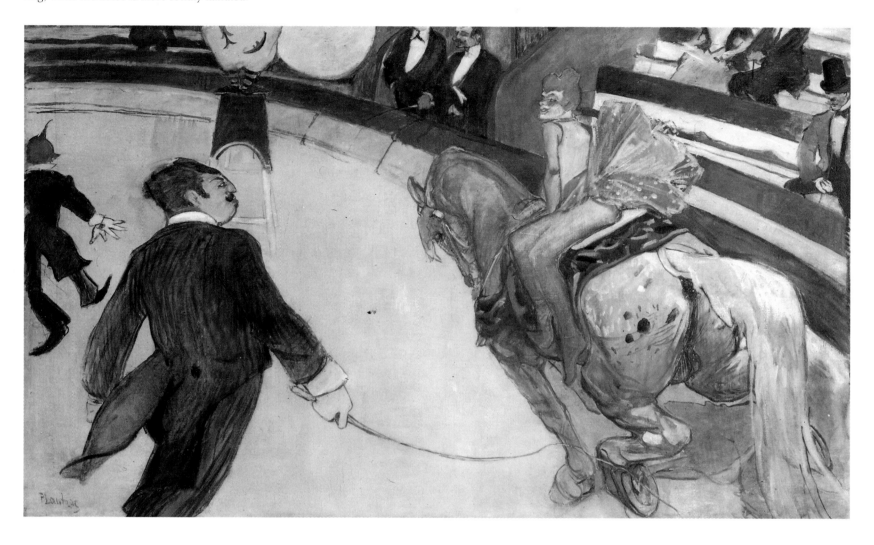

jects which critics are now only beginning to understand.

After 1885 Seurat visited the coast every summer except in 1887. Most frequently he journeyed to the Normandy coast and northwards toward the border with Belgium. In 1886 he stayed at Honfleur, in 1888 at Port-en-Bessin, in 1889 at Le Crotoy and in 1890 at Gravelines. Apart from the visit to Le Crotoy, which he had to cut short for domestic reasons, Seurat appears to have approached his subjects in a most systematic way. Having familiarized himself with the local geography he often painted his pictures in related groups, an example of which is the series of dockscenes at Honfleur. What is certain is how faithful he remained to the motif in front of him, and how accurately he reproduced lighting conditions. Not only is it possible to identify the scenes, many unchanged to this day, it is also possible to pinpoint at what times of the day Seurat worked on particular canvases. Thus the systematic, programmatic approach that he brought to his large-scale urban subjects is also evident in the approach he took in his marines.

Seurat's reason for returning early from Le Crotoy in 1889 – only two paintings date from the visit – was that he had learned that his mistress, Madeleine Knobloch, was pregnant. Seurat had kept secret this liaison from all but two of his friends, Paul Signac and Charles Angrand. To keep news of his imminent fatherhood secret Seurat moved with Madeleine Knobloch to a smaller and more inaccessible studio near the Place Pigalle, where he painted the only identifiable portrait of her, *Jeunne Femme se Poudrant* (page 151). As with some of his other paintings of the late 1880s this picture borders on caricature in the absurdity of the contrast between the figure of Knobloch and the tiny dressing table at which she performs her toilette.

The isolation which Seurat sought at this time emphasized the secrecy with which he lived much of his life. Seurat jealously guarded the theories of his Neo-Impressionist technique, and his life consisted of maintaining the trappings of a bourgeois life in his habits and daily routine. And yet his paintings, combined with the friends he kept, show Seurat to be one of the most acute observers of his age and to be a radical artist of great genius. In March 1891 Seurat fell ill and turned to his mother for support and died in her apart-

ment on 29 March 1891. When he arrived at her apartment a couple of days before he brought with him his mistress and infant son. Their existence was completely unknown to his family. Soon after his son died of the same illness. This double tragedy and the shock of discovering the secrets of their son's double life led the family to destroy all Seurat's private papers and little survives in the form of letters.

Despite a century of assessment and reassessment, Seurat remains one of the most enigmatic of artists. Perhaps the final epitaph should be written by Félix Fénéon, as he did more than most to support Seurat in his lifetime and to keep his memory alive after his death. At a retrospective exhibition of Seurat's work in 1908 Fénéon recorded:

If one knows how to look, this exhibition will establish a reputation that has been slowly, quietly, and irresistably growing since 1891. In March of that year, Georges Seurat died. But he had produced definitive works that give the complete measure of his power. A career of seven or eight years, agreed, is a short span: no, for in the history of art there have been few painters for whom almost as short a time has sufficed.

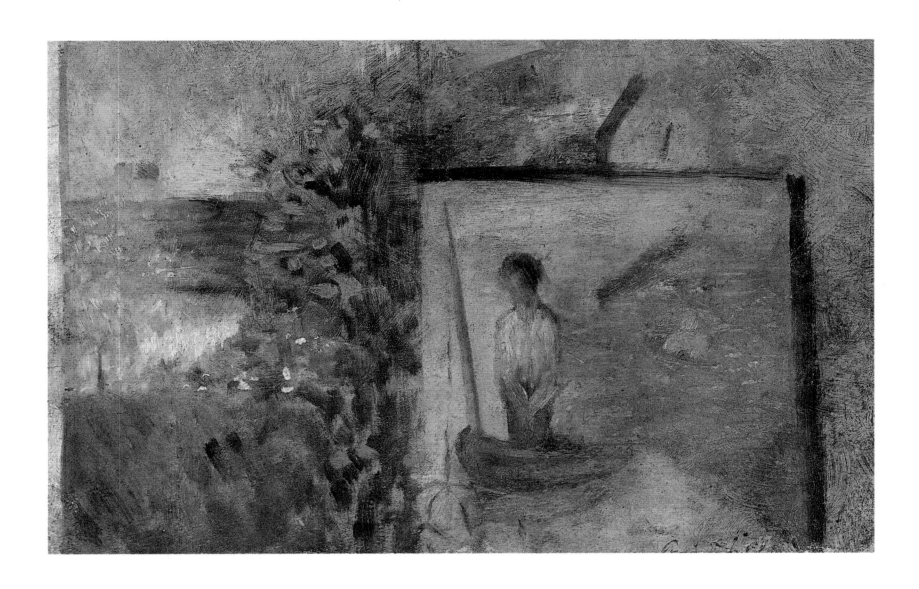

Copy after 'The Poor Fisherman', c.1881

Oil on panel
6¾×9⅞ inches (17×25 cm)
Mme Huguette Berès, Paris

In this small panel Seurat acknowledged the importance that the work of Pierre Puvis de Chavannes held for him. In 1881 Puvis exhibited *The Poor Fisherman* at the Salon after which Seurat made this copy incorporated into a landscape setting. It is not clear why he chose to place the copy in a landscape but it is possible that it was to contrast the more traditional, studio-based approach of Puvis with that of his developing interest in the Impressionist practice of painting out-of-doors. Whatever the reason, Puvis was a major influence on the young Seurat. Puvis had a significant reputation in France at the beginning of the 1880s, particularly for his large-scale murals such as those he painted for the Panthéon between 1874 and 1878. Given the classicizing tendencies of his work, it is not surprising that a student of the Ecole des Beaux-Arts should become interested

in his work. Although it is not clear whether Seurat met Puvis, there is evidence that his fellow students and close friends not only visited Puvis' studio, but also assisted in the preparation of some of his paintings. Edmond Aman-Jean's son has suggested that both his father and Seurat helped Puvis in the preparation of a painting exhibited in 1884, *The Sacred Wood*, by squaring up the preparatory drawings. Certainly the classicizing qualities of Puvis' paintings and murals foreshadow Seurat's own large-scale paintings. Later, in the mid 1880s, Gustave Kahn noted that:

Puvis was the major painter as to whose merits we were most nearly unanimous. With his integrity, his noble ambition, and his new and delicate sense of harmony, he was beyond and above discussion.

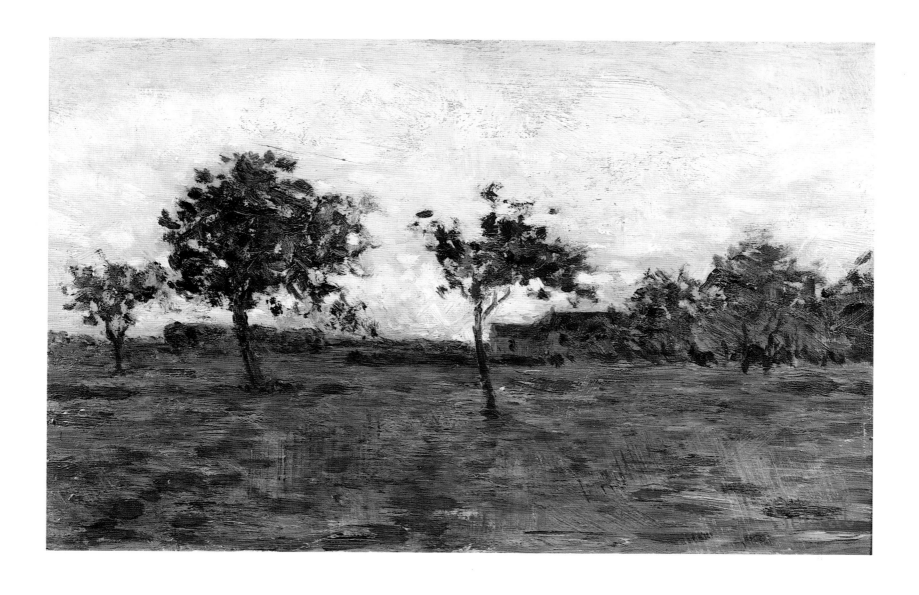

Sunset, 1881
Oil on panel
6¼×9⅞inches (16×25cm)
Bristol Museum and Art Gallery

This small panel must be one of the earliest painted by Seurat after his return from military service in November 1880. Painted during the following year this example is characteristic of Seurat's early career. Probably painted near Barbizon, in the forest of Fontainebleau, it reveals the bold handling evident in other panels painted at this time and his debt to artists such as Théodore Rousseau and Charles-François Daubigny. Unlike his later paintings which rely on contrasting touches of primary and secondary colors for their effects, this panel is characterized by the strong tonal contrasts and the contre-jour effect of a dark foreground and a light background. The dominance of the earthy tones in the foreground suggest that Seurat was still relatively unaware of Impressionist painting at this time as this panel possesses a rather dark, somber tone unlike the light, ephemeral effects so characteristic of Impressionist painting. Seurat's handling of the paint is also quite different. He has applied it in a series of freely handled and bold brushmarks rather than the smaller, divided brushmarks associated with Monet and Pissarro for example. This panel does share certain features with Pissarro's paintings of the same period. During the early 1880s Pissarro painted a series of peasant subjects located around his home in Osny and then Eragny. Many are characterized by their open foreground, a setting of one or two trees, the horizon centrally placed, and occasionally a human figure. Such a compositional arrangement is not particularly characteristic of Barbizon paintings, but is used here by Seurat. Although the color and technique is derived from the example of the Barbizon painters, perhaps Seurat was already revealing an awareness of contemporary French painting in this panel.

The Forest at Pontaubert, 1881

Oil on canvas
30¾×24¾ inches (78×63 cm)
Private Collection

This wooded scene is a curious early work by Seurat, one which eventually was owned by the late Sir Kenneth Clark. There is considerable disagreement concerning its date. In the choice of subject, a wooded landscape consisting entirely of the trunks of silver birch trees and their foliage, it is characteristic of Seurat's work of the early 1880s. The silvery treatment and the evocative mood are particularly reminiscent of the work of the Barbizon artists, Jean-François Millet and Théodore Rousseau, who had specialized in painting scenes in the forest of Fontainebleau in and around the village of Barbizon in the 1840s and 1850s. However, this particular example is closer to the paintings of Camille Corot, one of the leading landscape artists working in France in the middle of the nineteenth century. Corot's late landscapes possessed dream-like qualities and were given titles evocative of memory and idyllic thoughts, such as the *Recollection of Mortefontaine*, a reproduction of which hung above his bed. Clearly such paintings inspired the young Seurat. What has confused historians is the dappled effect and an apparent uniformity of the dotted paint surface, a style and technique associated more commonly with Seurat's work of the mid to late 1880s. In all probability this painting is an early work which has been subsequently repainted. The underlying colors are earth colors, characteristic of Seurat's work in the early 1880s, quite broadly applied to the canvas. Over this surface has been added a layer of pigment applied in the 'pointillist' manner. The painting was not exhibited during his lifetime and must be considered an experimental work. None the less it is still an exquisite example of Seurat's acknowledgment of the importance of Camille Corot.

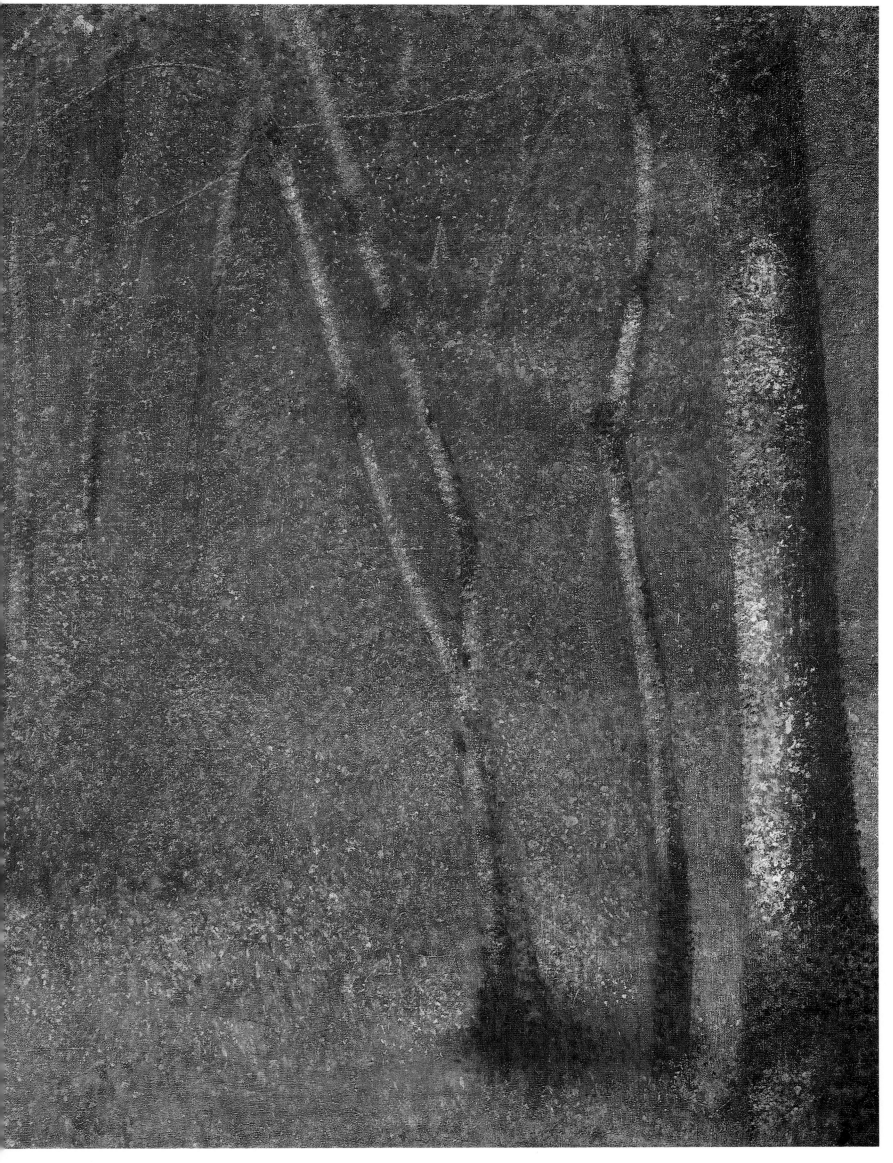

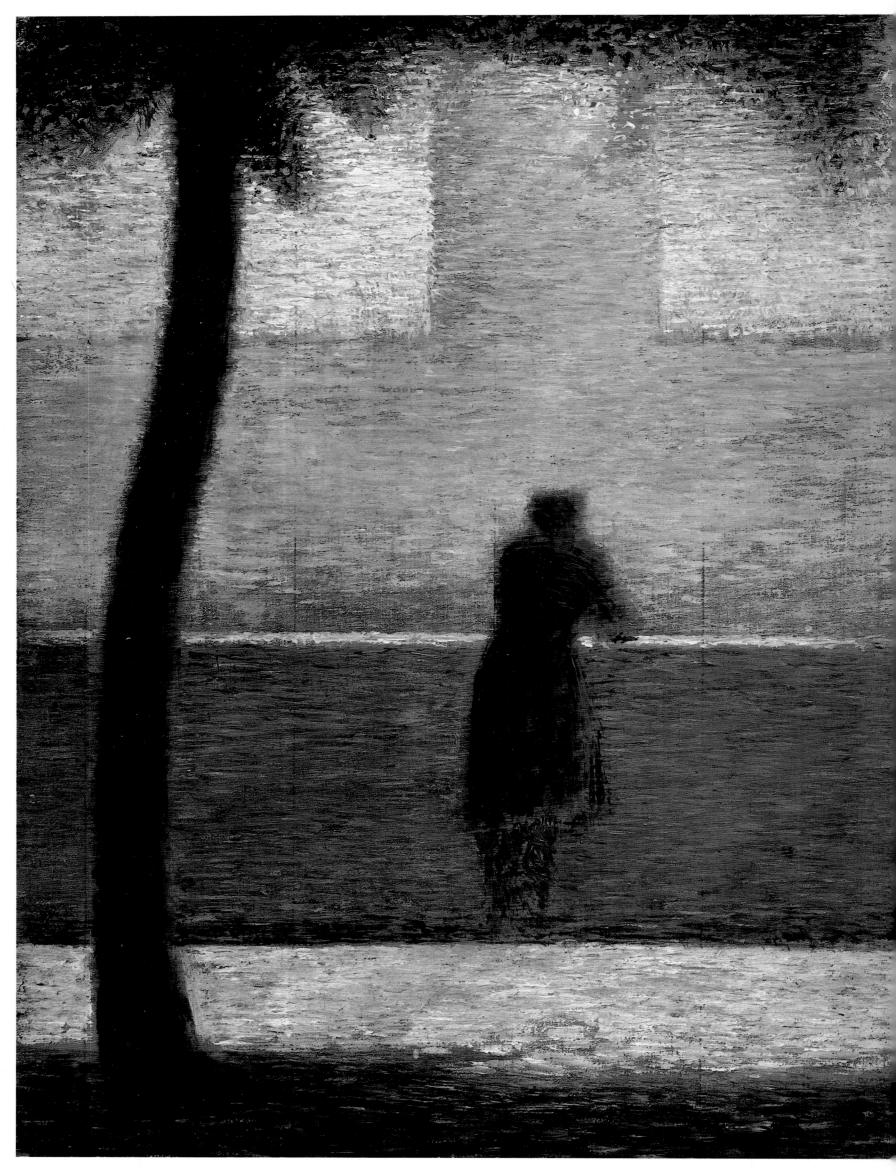

Man Leaning on a Parapet,
c. 1881

Oil on panel
9⅞×6¼ inches (25×16 cm)
(Reproduced larger than actual size)
Private Collection, New York, on loan to
the Metropolitan Museum of Art, New
York

Much debate has focused on the date of this panel. A lack of documentary evidence has made it very difficult to establish a clear chronological sequence of Seurat's work before 1884. One historian has dated this panel prior to Seurat's military service in Brest, suggesting its date as 1879. Most sources, however, suggest a date of about 1881, making this one of the first panels painted after his return from Brittany. A solitary male figure is represented leaning on a wall, or parapet, looking at a scene hidden from the viewer's eye. Beyond, an ill-defined architectural structure looms, unidentifiable from its outline. Possibly the man is depicted looking over one of the river Seine embankments towards the Left Bank, and the domed structure is that of the Institut de France. There is no evidence, however, to suggest that Seurat ever painted subjects in the center of Paris.

Even his large paintings of contemporary life were located around his studio in the north of Paris, or were situated in the outer suburbs. In the foreground a tree defines the left edge of the panel and the curve of the trunk is repeated by the pose of the figure as he leans forward over the parapet. Dark tones dominate throughout, partly the result of the warm tones of the panel itself which show through in places. Painted *contre-jour*, the dark forms of the figure and the tree make this one of the most curious of Seurat's panels. Considerable reworking can be seen around the outline of the figure suggesting that this part of the panel proved difficult to resolve. Also, an underlying grid structure can be seen in parts of the panel, a device used to facilitate transferring the composition from preparatory drawings. The paint has been applied in a series of vertical bands.

Suburb, c. 1881-2

Oil on canvas
12⅝×16⅛ inches (32×41 cm)
Musée d'Art Moderne, Troyes

With his father owning property in Le Raincy, Seurat displayed an interest in the new Parisian suburbs in his paintings from the early 1880s onwards. In this painting new factories and houses are grouped together in the middle distance, with an open area in the foreground presumably awaiting further developments. Such images of these new industrial scenes possess an eerie quality with their lack of any reference to human presence or activity. They foreshadow similar subjects painted by the Italian Futurist group in the years leading up to World War I, particularly the paintings of the suburbs of Milan by Umberto Boccioni. This example appears to have been abandoned by Seurat in an incomplete state, as the style is not characteristic of his paintings of the early 1880s. Slightly larger than many of the small studies painted at this time, it might represent an attempt by Seurat to paint a more ambitious painting depicting the new Parisian suburbs. The technique owes a great deal to Impressionist painting, particularly to Monet's work of the 1870s and, to a lesser extent, to certain paintings by Camille Pissarro. The paint has been applied thinly to the surface of the canvas leaving many areas only partially covered. It is the weave of the canvas which gives the surface its texture and by leaving areas of canvas exposed, it is the darker, warmer tones of the canvas which establish the overall harmony of the painting. This technique of dragging the paint across the canvas surface is derived from Impressionist practice. Industrial subjects are relatively rare in Impressionist painting although Camille Pissarro did paint a series of small-scale industrial scenes in the early 1870s when he was living in Pontoise. These paintings might have provided a model for Seurat to follow.

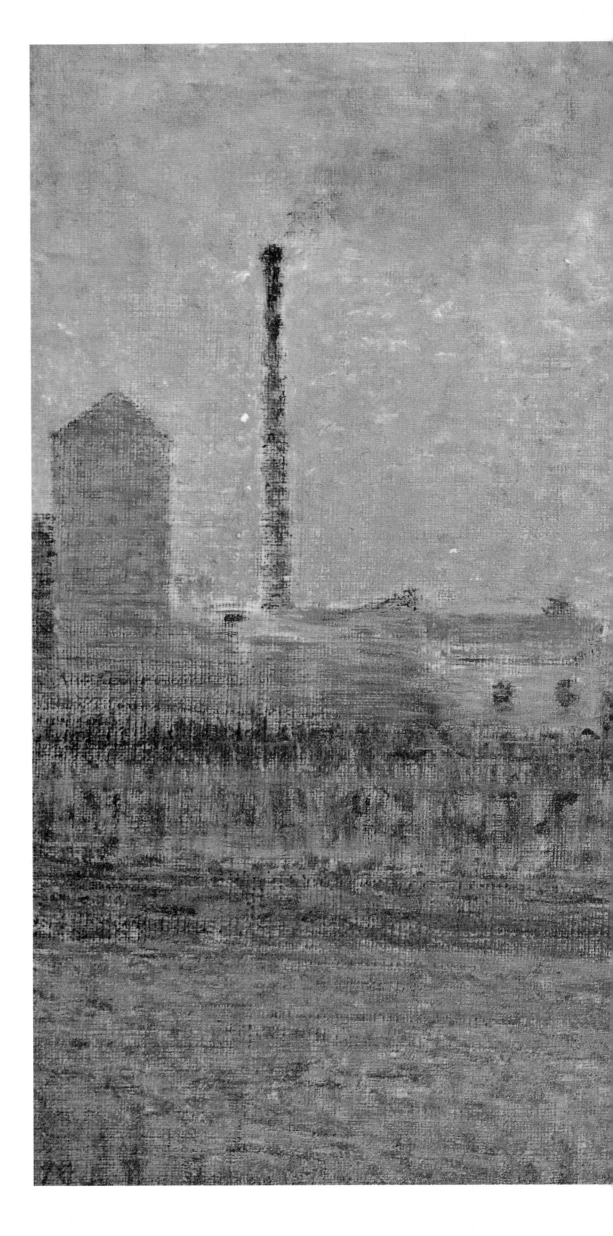

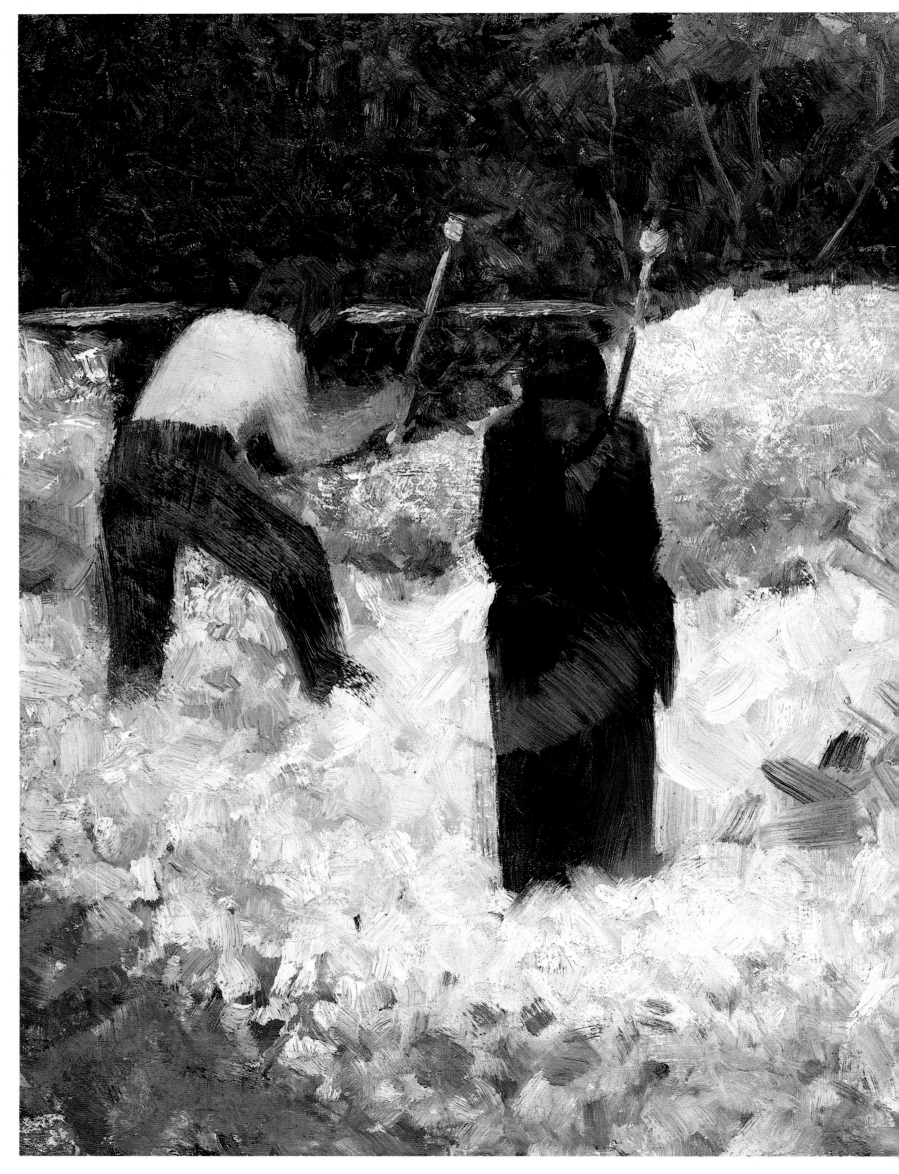

Stonebreakers, Le Raincy, c.1882

Oil on canvas
14⅛×17¾inches (36×45cm)
Norton Simon Art Foundation, Pasadena,
California

Seurat's father had purchased a second
home in the suburb of Le Raincy where he
spent much of his time, and it is evident
from the number of drawings and paint-
ings produced in 1881 and 1882 that Seurat
fils was also a regular visitor. The vast
building-program undertaken by Baron
Haussmann during the Second Empire had
had a dramatic effect on the areas sur-
rounding Paris as well as those in the city
center. This effect was twofold. Firstly,
locations such as Le Raincy attracted a new
bourgeois population keen to move into
new suburban villas built by speculative
developers. Antoine Seurat was one such
figure. Secondly, by forcing industry out of
the central parts of Paris, Haussmann
created, in the 1880s, a ring of new in-
dustrialized communities attracted by the
lower rents. The process of suburbaniza-
tion was described by one commentator as
resulting in a haphazard development,
with villas and smallholdings 'mixed up in
the most incoherent fashion.' For those
commentators who observed the creation
of new industrialized areas a darker image
was painted; Louis Lazare, for example,
criticized Haussmann for creating ghettoes
of poverty around the edges of Paris. He
noted, 'we have built within Paris two
cities, quite different and hostile: the city of
luxury, surrounded, besieged by the city of
misery.' In a related drawing (page 40; Col-
lection, The Museum of Modern Art, New
York), Seurat depicted a group of stone-
breakers working against a background of
newly built houses in a bleak setting. How-
ever, in this painting the location is less
specific. Three figures, two female, are
shown breaking rocks. The two flanking
figures are seen in profile while the central
woman is shown from the front.

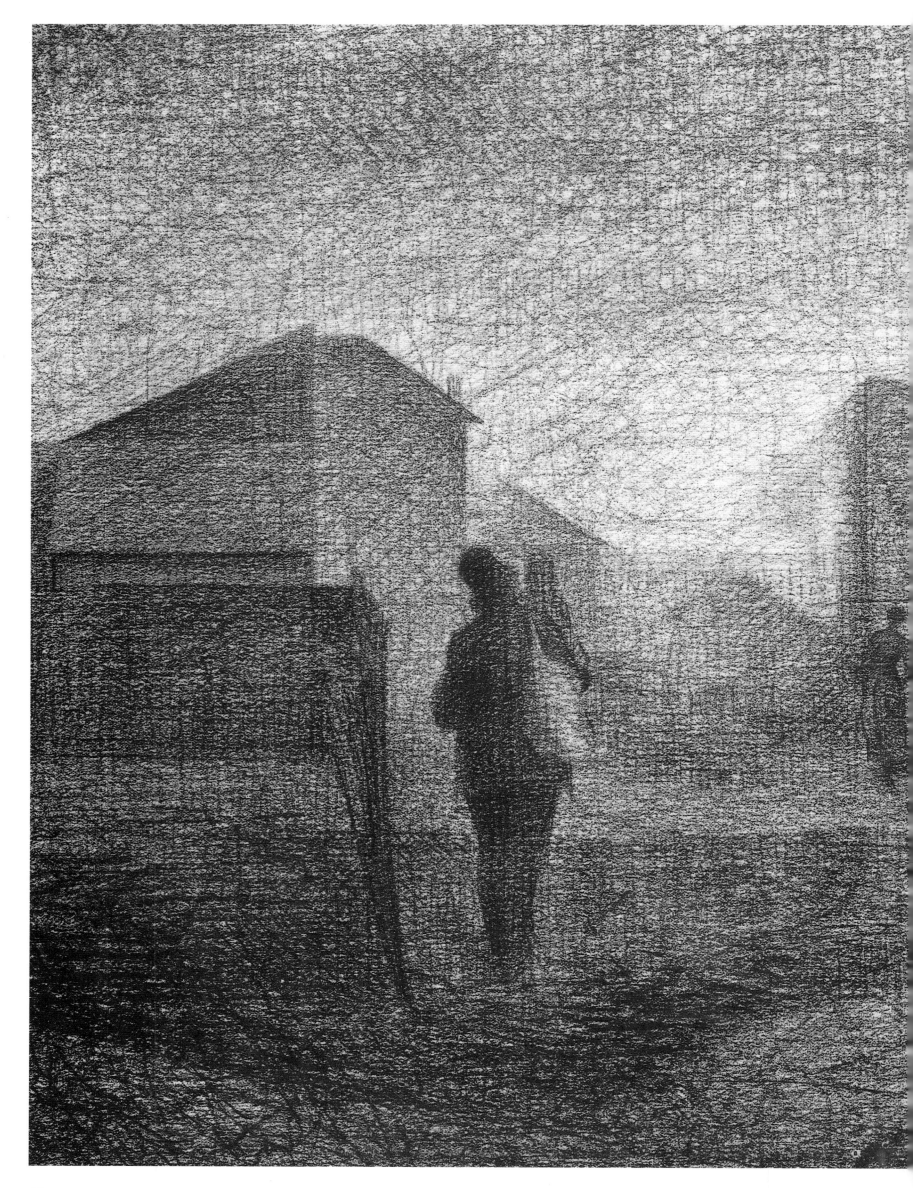

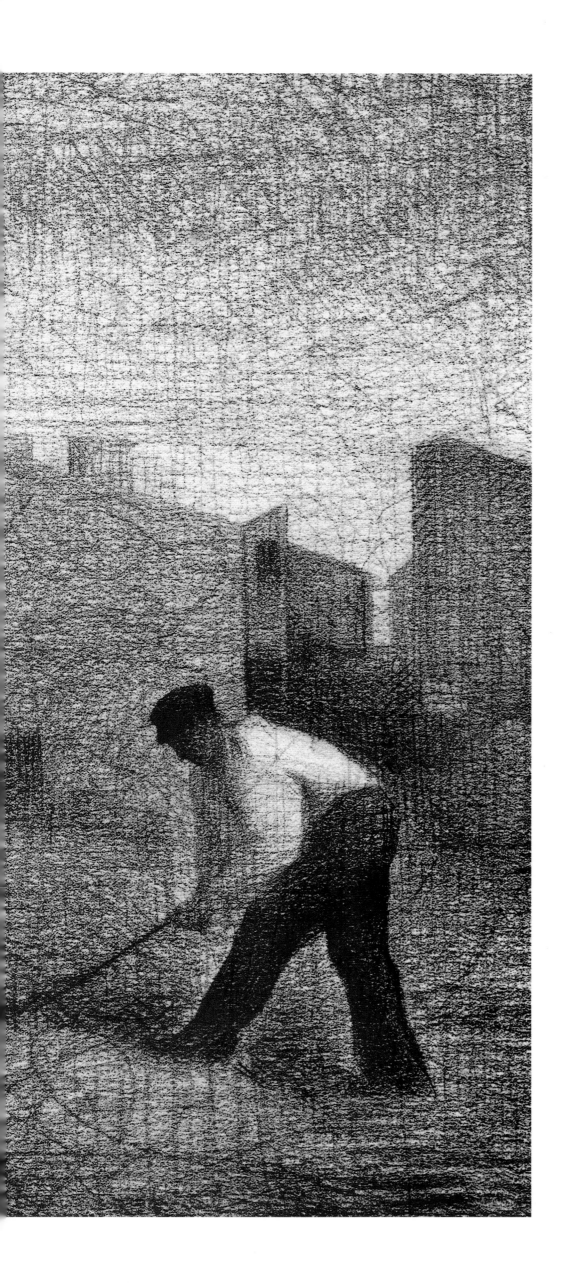

Stonebreaker and Other Figures, Le Raincy, c.1881

Conté crayon
12¼×15 inches (31×38cm)
Collection, The Museum of Modern Art,
New York, Lillie P Bliss Collection

Although this drawing does not appear to be a preparatory study for a painting, it is closely related to at least two works: *Stonebreakers, Le Raincy* (page 38) and *Suburb* (page 36), both of which were painted in 1881 or 1882. The newly built houses in the background are particularly close to the suburban image portrayed in *Suburb,* while the figures are related to other works Seurat completed in and around Le Raincy. Certainly this is an ambitious drawing and it is one of the many drawings in which Seurat explored urban and suburban themes during the early 1880s. Stylistically the drawing is typical of his work at this time. Seurat has rejected the strict and limited concerns of his student days in favor of a lighter and freer style. The architectural forms have been drawn in a series of angular shapes built up by a gentle cross-hatched technique. This hatching can be most clearly seen in the sky. Darker and heavier forms and tones have been achieved by increasing the pressure of the crayon marks on the paper, although the delicacy of the handling gives way to more awkwardly worked areas where Seurat's touch is heavier and less confident. Also the precise geometry of the forms, where the contours seem to have been drawn with the aid of a ruler, rests uneasily with the freer, flowing lines most apparent in the right foreground and on the wall of the building immediately behind the figure of the stonebreaker. As in other images of the suburban landscape by Seurat, this drawing is notable for the way in which the setting is sparsely populated and a feeling of emptiness permeates throughout. The figures appear to be isolated by the setting and dwarfed by the surrounding buildings.

Houses and Garden, c. 1882

Oil on canvas
11×18¼inches (28×46cm)
Private Collection

During the early 1880s Seurat painted several such views of houses in Ville d'Avray, a small village situated on the western edge of Paris and bordered by the rich suburbs of St Cloud and Sèvres. In the 1850s it had been the village that Camille Corot painted with great regularity, producing there some of the most beautiful paintings of his long career. Seurat's enthusiasm for him was recorded while he was still a student at the Ecole des Beaux-Arts. Later, in a letter to Félix Fénéon, Seurat described how he had familiarized himself with Corot's ideas on tone which had been published in 1869. He copied from the manuscript Corot's concern for the ensemble, for the overall harmony of a painting. Corot stated: 'What there is to be seen in painting, or rather what I look for, is the form, the ensemble, the value of the tones; color for me comes after.' Although these early sketches by Seurat reveal his exploration of color theory, he was also interested in the harmony of tone, an interest particularly evident in the development of his drawings. Just as he made use of the roughish texture of paper to create a strong tonal effect in the drawings so, too, he used the weave of the canvas combined with the balayé technique of brushwork to create a similar effect in his paintings. Corot went on to state: 'We do not attach enough importance to chiaroscuro in our canvases; enthusiastic as we are for color, we forget the tone. Without that science of black and white, without that composition of chiaroscuro, the picture seems incomplete.' In stressing the importance of tone, Corot emphasized the need for a single luminous spot in a painting. It is this last point that seems to have had a particular influence on Seurat's ideas.

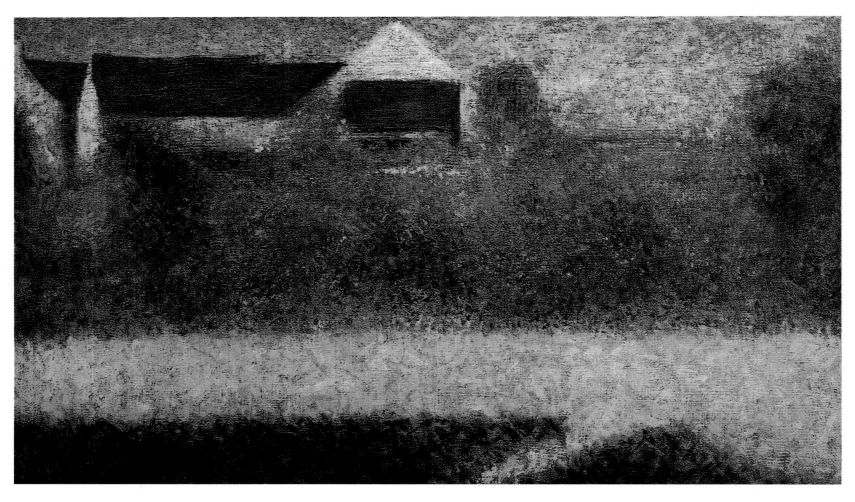

Place de la Concorde, Winter,

c. 1883
Conté crayon
9×12¼ inches 23×31cm
Solomon R Guggenheim Museum, New York

As with his painting of the ruins of the Tuileries Palace (page 58), Seurat has chosen to depict a specific Parisian location in this drawing. In this case it was the Place de la Concorde which is situated at the opposite end of the Tuileries gardens to the ruined palace, and, on its western side, led into the fashionable Champs Elysées. Just as the Tuileries Palace had a long history and was the symbol of French authority throughout the nineteenth century, so too the Place de la Concorde had a significant place in the history of Paris. The square, originally known as the Place Louis XV, had been laid out in the early 1760s and marked one the most important embellishments of Paris sponsored by Louis XV himself. A vast open square, it was laid out in a symmetrical arrangement, although the symmetry of the setting was not completed until the early nineteenth century with the building of the Madeleine

church to the north and the National Assembly on the southern side of the square. During the French Revolution the square was renamed and it was the site of the guillotine, and it was there that both Louis XVI and Marie Antoinette were executed. Even with this violent interlude the Place de la Concorde and the surrounding areas, particularly around the Champs Elysées, remained the most aristocratic part of Paris throughout the nineteenth century. The symmetry of the square is apparent in Seurat's drawing. Centrally positioned is a lamppost which is flanked on one side by one of the fountains and on the other by a carriage passing through the square. In this wintry scene he has captured in a bold and confident manner the snow juxtaposed with the shadowy forms and the darkness of the upper half of the drawing. The wide, open spaces of the square present a very bleak image of a winter's evening.

The Mower, c. 1882

Oil on panel
6¾×9⅞ inches (17×25 cm)
The Metropolitan Museum of Art, New York, Robeit Lehman Collection

Of all Seurat's small panels, this example is one of the most dramatic with its simplified compositional arrangement. Three parallel bands stretching across the panel provide a most schematized backdrop to the figure of the mower. Some critics have compared this panel to the paintings of Camille Corot but the relationship of the figure to the setting is without precedent, as is the extreme geometry of the composition. A connexion with Corot may derive from Seurat's use of the wood panel to establish a rich harmony of colors, but in all other respects we can see in this panel Seurat striving to establish his own identity and to develop his individual technique. The application of the paint has been handled in a bold and confidant manner, with firm, positive brushmarks used to define different areas. In the foreground it is possible to see the emergence of the balayé brushwork, the use of criss-cross brushstrokes to build up a solid effect, so characteristic of his paintings and sketches of the period 1882-83 onwards. The corn is painted in a series of firmly applied vertical brushmarks, while the green foliage in the background is similarly treated as the foreground. Spatial recession is denied, both by the compositional arrangement of three parallel bands and by the unifying effect of the brushstrokes. Silhouetted against the background is the figure of the mower energetically going about his work. The flesh tones are largely determined by the underlying color of the wood panel and are picked up throughout where parts of the panel slow through the paint surface. The contrast in the mower's dark trousers which relate to the color of his hair, separated by the white shirt, echoes the tripartite arrangement of the composition.

The Stonebreaker, c. 1882
Oil on panel
6¼×9⅞ inches
(16×25 cm)
Phillips Collection, Washington, DC

The motif of the stonebreaker features regularly in Seurat's work in 1882 and 1883. Usually it combined with his interest in the expanding suburbs of Paris, but this particular example depicts a lone stonebreaker set in a generalized landscape. Many artists had painted such images, most notably Gustave Courbet in 1849, and often drew attention to the monotony and arduousness of the work. Seurat, here, does not personalize the figure of the stone-breaker; instead, he is loosely sketched in, as are the pile of stones that are being smashed. Although comparisons are normally made between these small panels and the work of artists such as Jean-François Millet, Seurat appears to have been less interested in the plight of the worker than in experimenting with different color harmonies and in developing his painting technique. Millet may have provided the inspiration for the choice of

subject, but it was Eugène Delacroix who most influenced Seurat in his stylistic development at this stage. In his concern to experiment with contrasting complementary colors the example of Delacroix's art proved essential. Note how the blue headband and sash are juxtaposed against the orange of the worker's hair and trousers. The vibrant red signature is partly offset against the green foliage. Such contrasts Seurat had seen in Delacroix's paintings. In 1881 he made a series of notes on the color harmonies he had studied in Delacroix's work. For example, in Delacroix's *The Fanatics of Tangier*, Seurat commented on the contrasting complementaries. He noted: 'On another part of the roof hangs a blue drapery, grayed by the distance, harmonizing with the orange-white of the walls'; and in comparison to his signature he described how the red garment of one of the fanatics was 'exalted' by its green edge.

Farm Women at Work, c. 1882

Oil on canvas
15⅜×18⅛ inches (39×46 cm)
Solomon R Guggenheim Museum, New York

This small canvas remained in the collection of the Seurat family for many years after Seurat's death. In the late 1930s it entered the collection of Félix Fénéon who sold it to the Solomon R Guggenheim Museum in 1941. A transitional painting, it shows Seurat exploring the color theories of Ogden Rood while, at the same time, still revealing his debt to the example of the Barbizon artists. Two farm women are bent forward as they perform their work, their pose derived from Jean-François Millet's *The Gleaners* of 1857 (page 10, below), where the two women gleaning are similarly treated. Millet's peasant subjects were much admired by Seurat in the early 1880s and with Camille Pissarro painting a series of peasant figures at the same time there was a considerable revival of interest in Millet's work. In transitional works such as this, Seurat was slowly abandoning the earth colors associated with Millet and the Barbizon painters and replacing them with brighter colors. Throughout the canvas the paint has been applied in a series of crisscross brushstrokes which creates a harmonious effect, one enhanced by the rhythmical patterns formed by the successive areas of light and shade. Rood's theory of the division of colors, the juxtaposition of contrasts to heighten their effect, can be seen in the treatment of the women's hats. Here, the orange of the hats has been flecked with touches of blue, the complementary of orange, to create a brighter, more vibrant effect. The areas of foliage caught by the sunlight are similarly flecked with touches of yellow and orange over a light-green ground to suggest reflected and partially absorbed sunlight. Optical fusion was not Seurat's aim at this stage as the individual brushmarks are still clearly evident. Instead, he was interested in creating a dynamic surface effect.

Standing Female Nude, 1881-82

Black chalk
19¼×13⅜ inches (49×34cm)
Courtauld Institute Galleries, London
Courtauld Collection

Although this drawing is now widely believed to have been drawn by Seurat, there is still some doubt concerning its date. The nude figure emerging from the shadow is characteristic of his drawing style as it developed in 1882 and 1883, while the rather academic pose, with the chair on which the model is leaning obliterated by the surrounding darkness, is more characteristic of his work of 1881. Certainly there seems to be a difference in the way the figure has been drawn compared to the area of shadow that surrounds the model. All reference to the setting has been excluded and the light only falls across the side of the model. Such an effect may have resulted from the use of one specific light source. Seurat's close friend, Ernest Laurent, recalled him working by lamplight to create the effect so marvelously illustrated here. Seurat's interest in the effects of chiaroscuro and luminosity

may have been derived in part from his interest in the work of Rembrandt. As a student he had clearly displayed his interest in classical sources in his many drawings of the late 1870s, but an interest in Rembrandt could have been stimulated by the many publications devoted to the Dutch master in France in the 1870s and 1880s. In April 1882 reproductions of 13 Rembrandt etchings were published in the French newspaper *Le Figaro* which Seurat cut out and kept. Another publication referred to the transparent and luminous qualities Rembrandt achieved in his shadows and his manner of only lighting the essential elements of the composition. These are the very effects achieved by Seurat in this drawing. Indeed, the photomechanical method used to reproduce the Rembrandt etchings in *Le Figaro* would have distorted their original qualities and enhanced their blurred and shadowy effect.

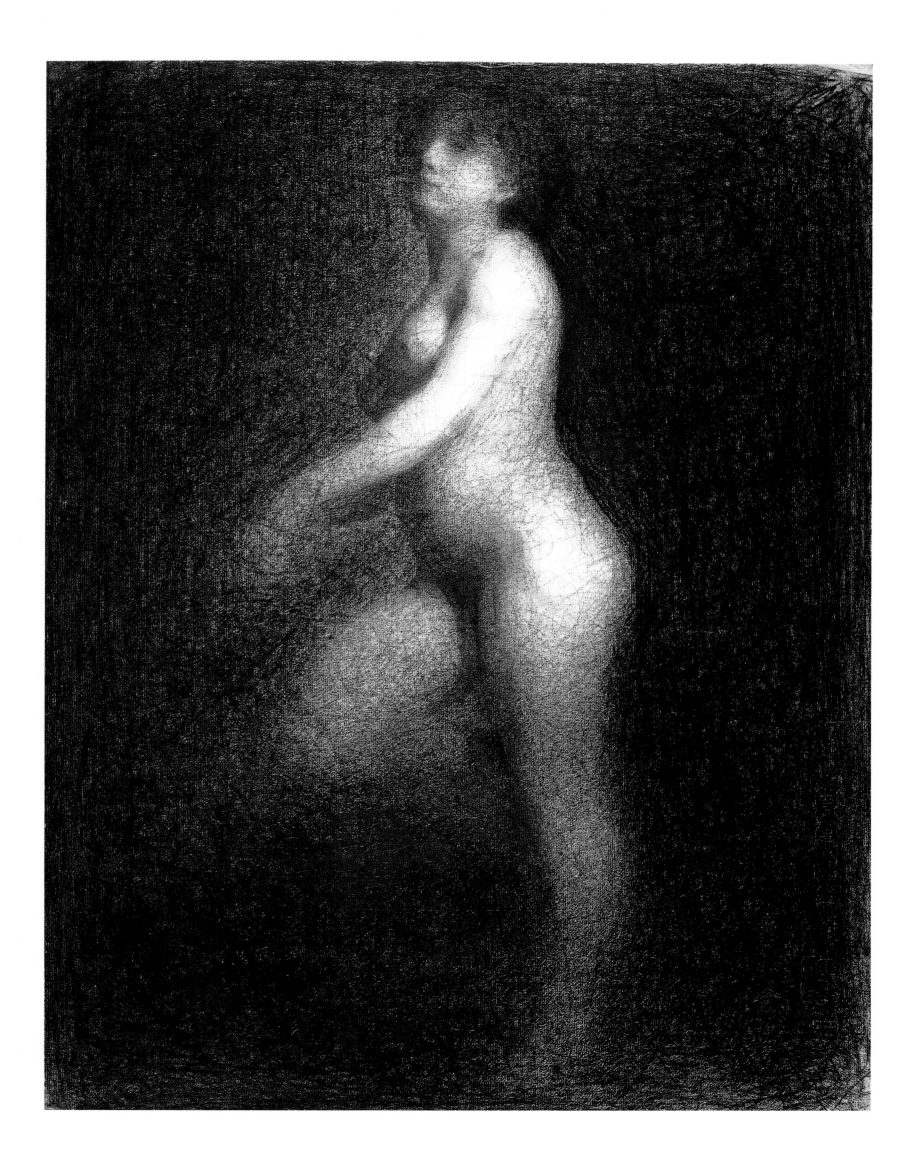

Boy Seated on the Grass, c. 1883

Oil on canvas
24⅞×31½inches (63×80cm)
Glasgow Art Gallery and Museum

Although not directly related to *Une Baignade* (page 72), this painting, Seurat's largest to date, has obvious similarities in the subject of a single figure relaxing on a grassy bank. Work was certainly proceeding on the studies for *Une Baignade* when this picture was completed. In a largely ill-defined setting – the grass bank dominates virtually all the pictorial space with only a hint of some foliage at the top of the canvas – a single boy sits with no sign of activity. This painting is related to a smaller painting, now in the Solomon R Guggenheim Museum, depicting a seated female peasant figure leaning forward in an equally ill-defined landscape (page 52). Both these paintings have been compared to Camille Pissarro's peasant paintings of the early 1880s when the figure assumed a new importance in his art and when Pissarro explored in detail peasant figures in relation to particular settings. Whatever the subject, *Boy Seated on the Grass* shows very clearly the development of Seurat's painting technique by 1883. Earth colors have disappeared from his palette and have been replaced by a range of yellows, soft blues and some oranges. In terms of color we can see that Seurat has moved from a palette derived from the Barbizon painters such as Millet and, here, has started to experiment with an Impressionist one. The texture of the brushstrokes marks a new development. The paint surface is built up in a number of layers, with a smooth initial underpainting which Seurat has overlaid with a criss-cross pattern of brushstrokes. This results in a dense surface effect, known as balayé. In contrast, the figure of the boy is treated in a softer, more blended manner.

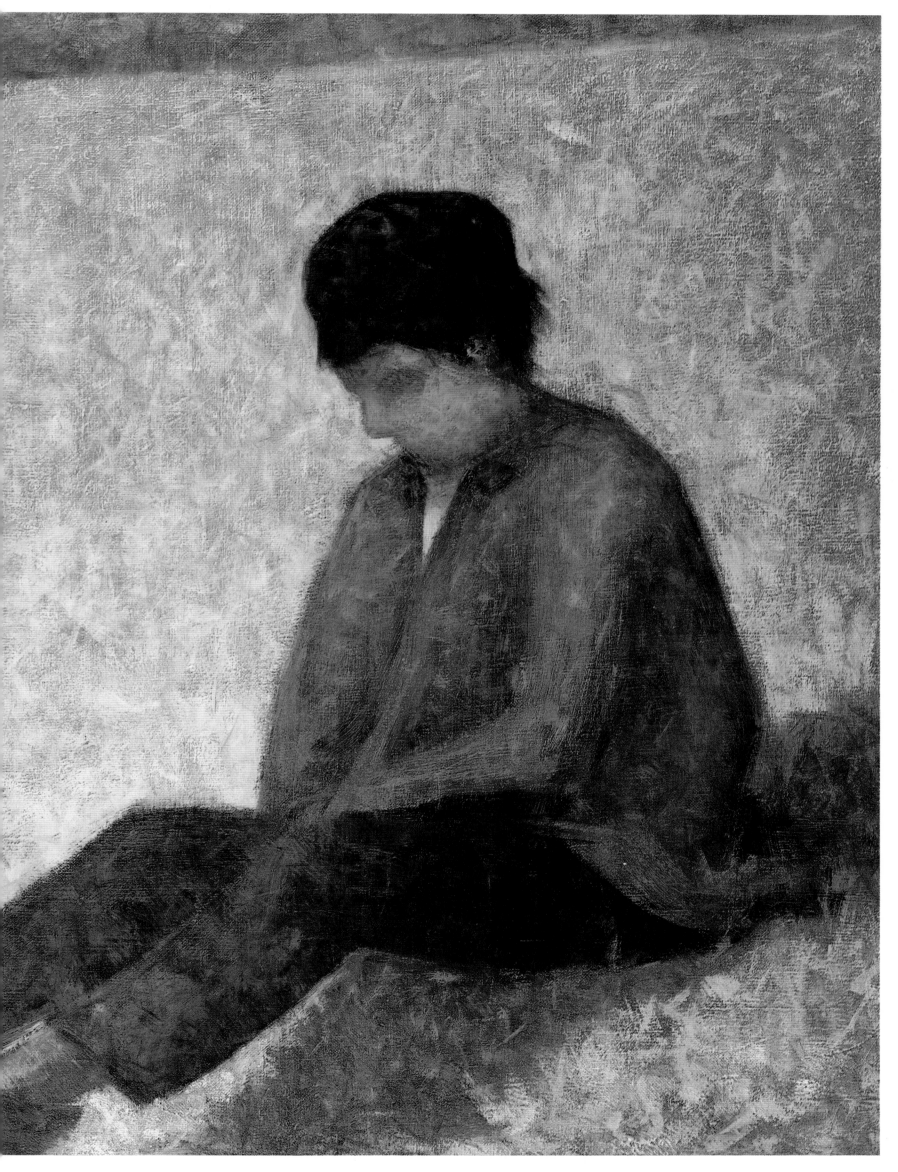

51

Woman Seated on the Grass,

1883
Oil on canvas
15×18⅛ inches (38×46 cm)
Solomon R Guggenheim Museum, New York

This painting is a companion piece to the larger *Boy Seated on the Grass* (page 50) in the Glasgow Art Gallery. Both depict single isolated figures placed in a simplified landscape setting. The composition of this example is more dramatic in the way the figure is set against a vast flat area of grass. Seurat's exclusion of the sky and any other landscape element results in a strong, two-dimensional effect, one enhanced by the side-on view of the seated girl. Never had the figure been given such a significant position in a painting by Seurat; normally any figures were fused into the landscape or were dominated by it. Here the figure assumes a new significance, and clearly foreshadows the first of his large paintings, *Une Baignade, Asnières* (page 72). In the relationship between figure and landscape, Seurat, in examples such as this, revealed his interest in the recent paintings of Camille Pissarro. Above all, however, Seurat was interested in painting a seated figure in full sunlight and this canvas marked an important stage in the development of his color explorations and in the desire to find a suitable technique to achieve the desired effects. As much of the scene is bathed in direct sunlight, the local color of the grass, in this case a rather scorched yellow ocher, has been covered by flecks of orange to represent sunlight reflected from the surface of the grass. In the shadowy area a range of blues and greens combine to represent the actions of colors in partial light. Again, some orange touches can be seen, both to suggest the continuing action of the sunlight and, as the complementary of blue, to heighten the effects created by the contrast of complementary colors. Throughout, the brushmarks have been evenly applied in the balayé manner.

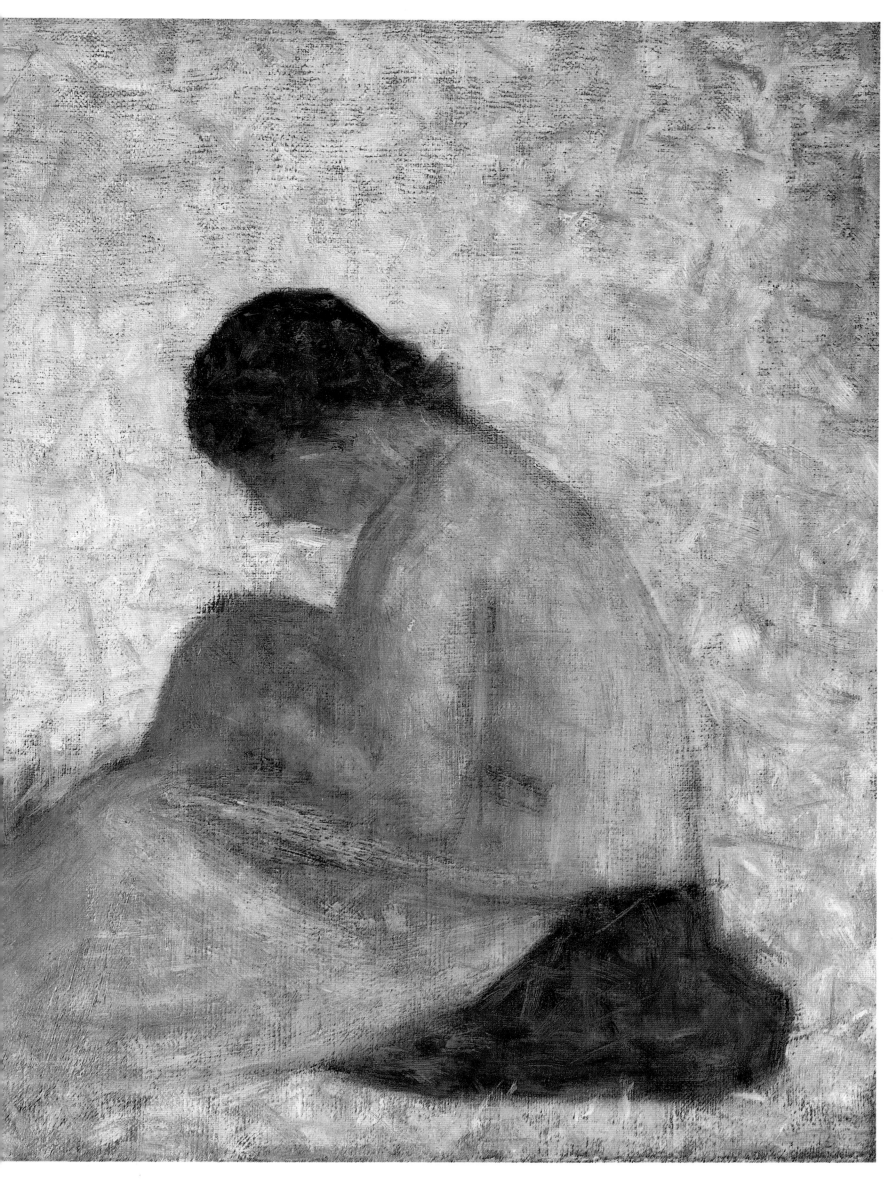

Houses among Trees, c. 1883

Oil on panel
6¼×9⅞ inches (16×25 cm)
Glasgow Art Gallery and Museum

This is one of the freshest and most lively of Seurat's small panels. In it the paint has been applied consistently in the balayé manner and the range of his palette has increased. This use of a wider range of colors was partly derived from the theoretical sources he had read. One of the most important of these sources were the theories of Eugène Chevreul. Chevreul had discovered that the intensity of colors was affected by the surrounding hues while working in the tapestry department of the Gobelins workshop in the 1820s and 1830s. His researches into these effects led him to formulate a law which he elucidated further in the publication of his ideas in 1839, in *De la loi du contraste simultané des couleurs*. He explained the law thus:

In the case where the eye sees at the same time two contiguous colors, they will appear as dissimilar as possible, both in their optical com-

position and in the height of their tone. We have, then, simultaneous contrast of color properly so called, and contrast of tone.

As an example Chevreul cited the effects of an area of red being placed next to an area of blue, where the effect of simultaneous contrast would result in the illusion of changes of color along their border. The edge of the blue area would appear to be tinged with green, the complementary of red, while the red would appear with an orange tinge, the complementary of blue. These effects are illusory. It would appear, therefore, that Seurat may have misunderstood Chevreul's ideas as he tried to emulate in paint the effects described by Chevreul. In his studies of 1882-83 Seurat was beginning to experiment with small, separate touches of color and he certainly added green to his blues and orange to his reds to enhance the effects of such contrasts.

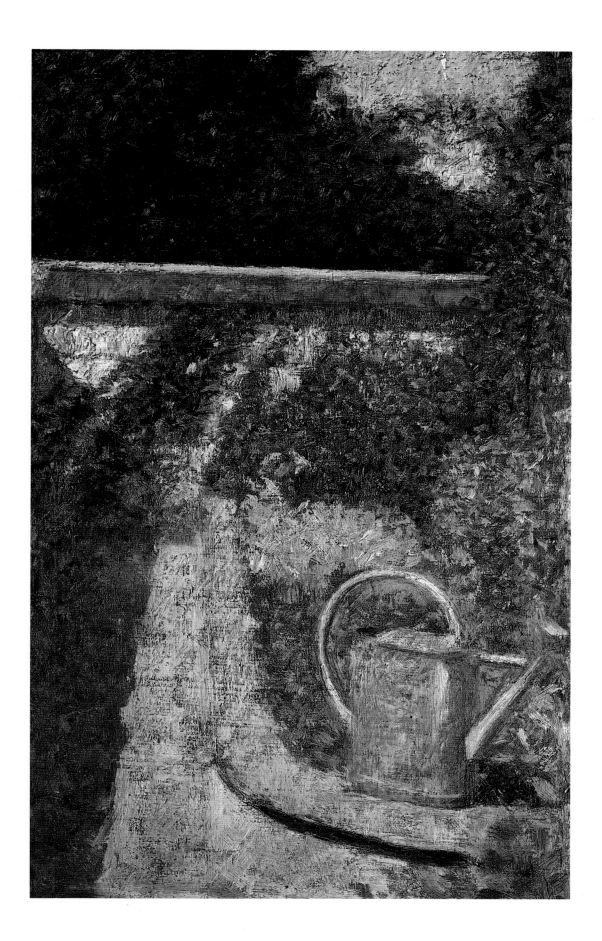

Watering Can in the Garden at Le Raincy, c.1882

Oil on panel
9⅜×5⅞inches (25×15cm)
Private Collection

Painted in Seurat's father's garden at Le Raincy, this small panel remained in the possession of his family until the 1950s. It is an experimental work, one in which Seurat not only continued his researches into a lighter palette but also explored the possibilities of a very formalized composition. Unlike in other paintings on which he worked at Le Raincy, Seurat has turned away from scenes of new suburban developments and people working and instead found inspiration in the quiet solitude of this garden. A short pathway, bordered on both sides by greenery, leads up to the garden wall with its distinctive red parapet. This wall cuts across the panel at a slight angle and beyond the foliage of a group of trees fills the upper part of the panel. Far from being a panel quickly painted in the corner of the garden the composition has been carefully contrived even if it does appear a little awkward. In the foreground Seurat has explored the harmony and rhythms of the curves of the handle of the watering can and the sweep of the garden path, our attention being attracted by the strong shadow which emphasizes the curve of the raised border. Much of Seurat's interest focused on the relationship between surface pattern and spatial recession, an interest which remained central to his paintings throughout his life. Note how the path and border meet the wall in an unconvincing manner; the line separating them becomes a vertical feature remaining close to the panel's surface and devoid of any descriptive role whatsoever. The watering can, so dominant in the foreground, rests uneasily against the background of plants, its flatness emphasized by its apparently over-large size. Finally the paint has been applied in a number of ways and these varied brushmarks draw attention of the physical nature of the paint surface.

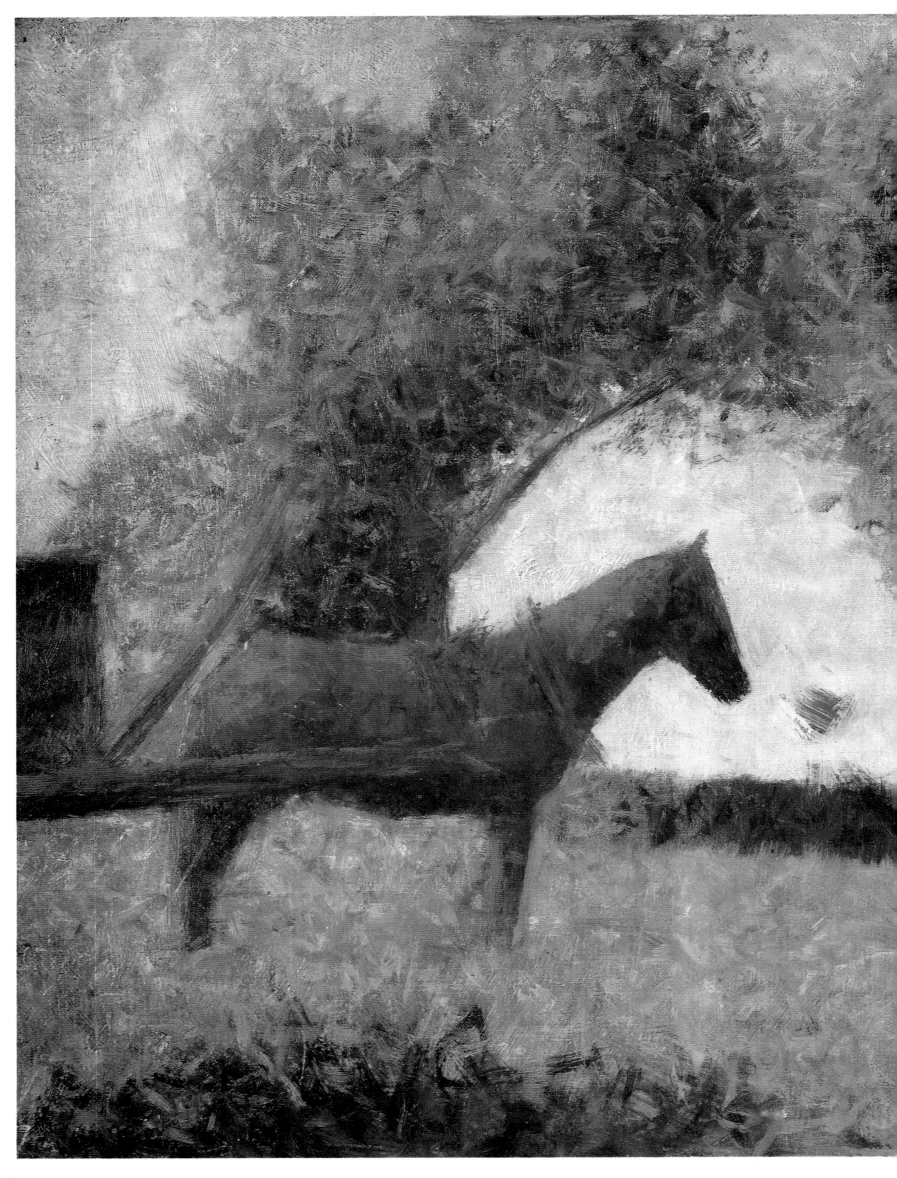

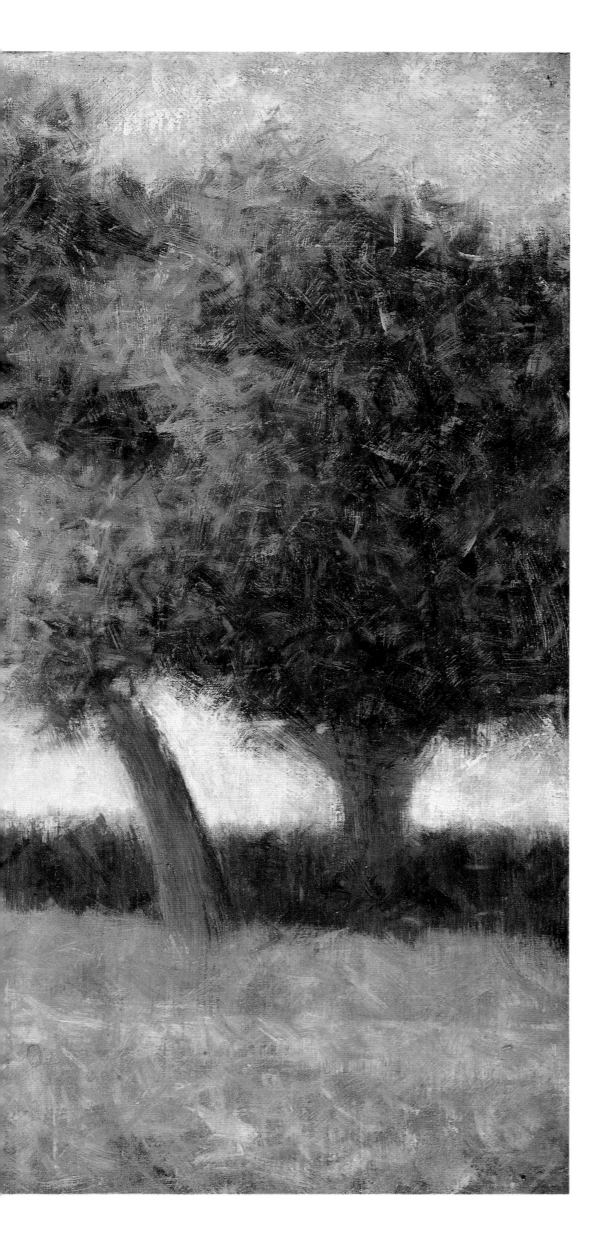

Horse and Cart, c. 1883

Oil on canvas
13×16⅛ inches (33×41 cm)
Solomon R Guggenheim Museum,
New York

In this small study the individual touches of color are easily identifiable. In the sunlit grassy areas touches of yellow and orange are laid over the light green local color, while blue is added to the darker green in the shadowy areas. In developing his color theory, one of the most significant sources Seurat consulted was Ogden Rood's *Modern Chromatics*, published in New York in 1879 and subsequently translated into French. In a letter written to Félix Fénéon in June 1890, Seurat stated that he became aware of Rood's ideas in an article published in *Le Figaro* in 1881. A scientist by training, Rood was also an amateur artist and his book was aimed at an artistic audience. In it he examined the nature of colors and their effects on each other. Central to Rood's ideas was the difference between the greater luminosity achieved by the mixing of colored lights when compared to that resulting from the mixture of pigments. Rood illustrated the fact that when two pigments were mixed together on an artist's palette the resultant effect would be duller than the luminosity of the individual pigments. In contrast, experiments involving projecting colored lights on to rotating disks resulted in an increased luminosity when mixed together. These two processes were known respectively as subtractive and additive mixture. To achieve the effects of additive mixture in painting, Rood advocated 'the placing [of] a quantity of small dots of two colors very near each other, and allowing them to be blended by the eye placed at the proper distance.' It is precisely this idea that Seurat adopted in his fully developed 'pointillist' paintings and can be seen at a nascent stage in this study. Seurat's understanding of Rood was flawed, however, because he failed to understand fully the precise details of Rood's experiments.

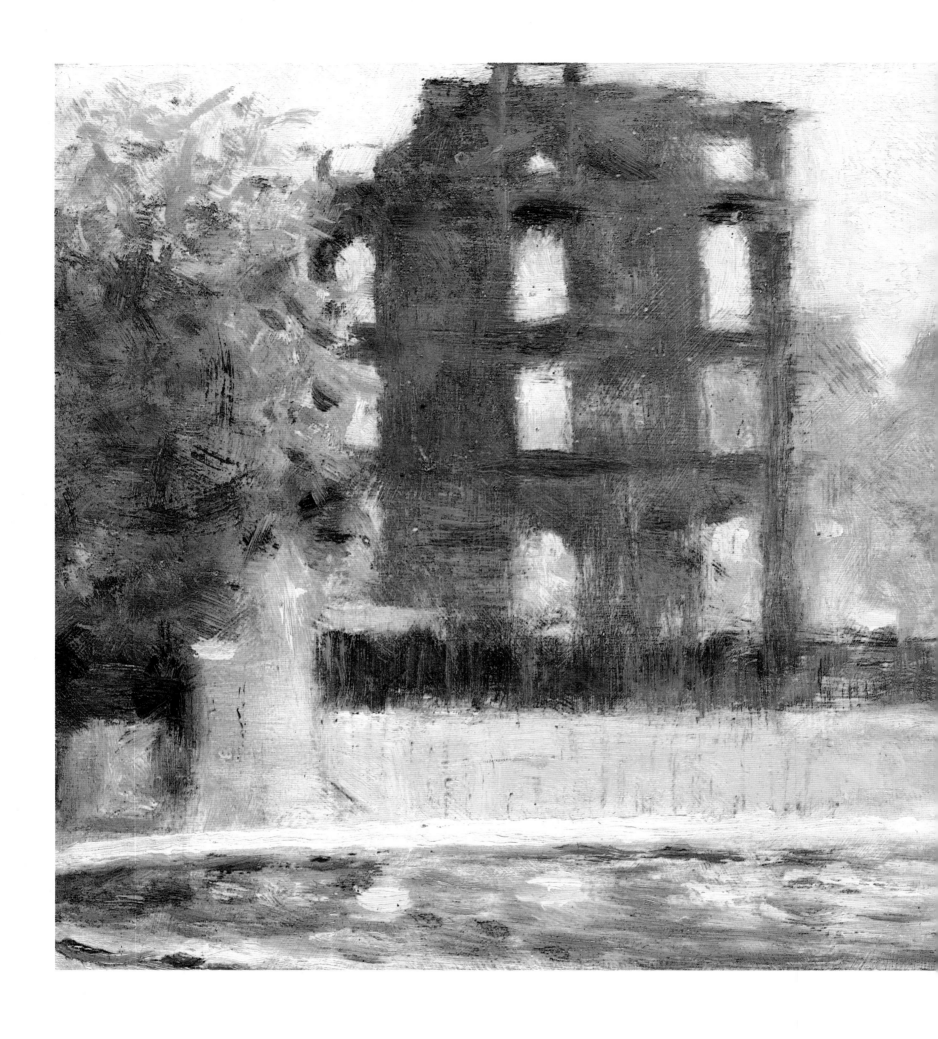

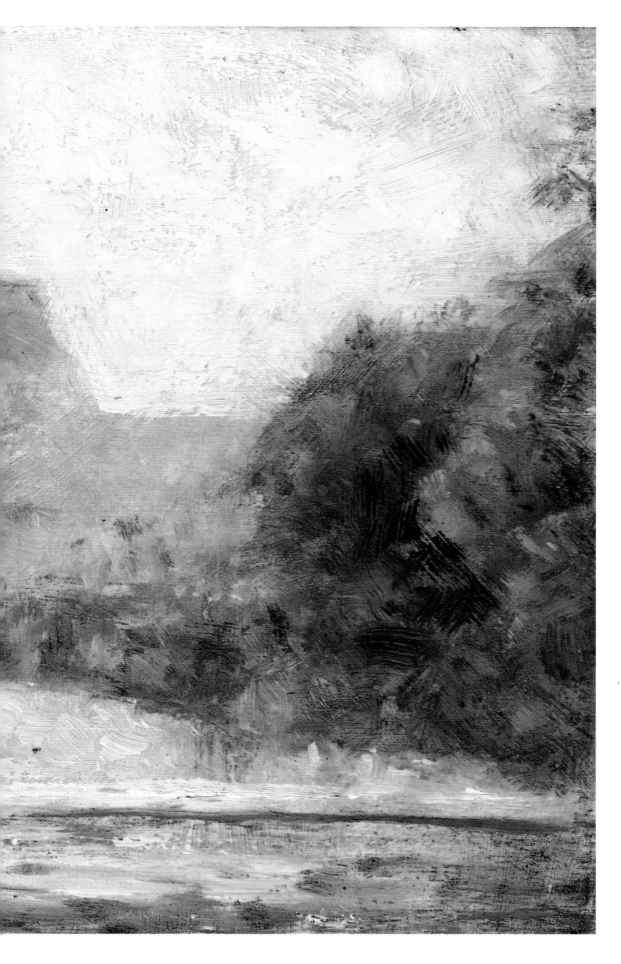

The Ruins of the Tuileries Palace, c. 1882

Oil on panel
6¼×9⅞ inches (16×25cm)
(Reproduced larger than actual size)
Formerly Galerie Jan Krugier, Geneva

This panel must have been painted before the fall of 1883 as the ruins of the Tuileries Palace were finally demolished at that time. Perhaps it was the imminent demolition of the remains of the building which encouraged Seurat to select this subject. The Tuileries Palace had been started by Catherine de Médicis, the widow of Henri II, in 1564 and it was located between the Tuileries gardens and the Louvre. Seurat has painted the ruins from the gardens and the outline of two of the Louvre's pavilions can be seen in the distance. In 1800 Napoleon I made the palace his Parisian residence and throughout the nineteenth century, with its successive political régimes, the Tuileries remained the official residence of the rulers of France. Between 1852 and 1870 the Emperor Napoleon III resided in the palace but left when the Franco-Prussian war broke out. The following year, 1871, Paris witnessed a popular uprising, the Paris Commune, and on the 20 May the Communards, fearing an assault from troops loyal to the Emperor, attacked the Tuileries by setting it on fire. The palace was all but destroyed although the remains were not finally demolished for another twelve years. Whether or not the symbol of the ruins of the residence of the rulers of France held any significance for Seurat, the panel has been painted in rather somber colors. The dominant browns and ochers, with the rather threatening form of the free-standing façade, create a very different effect from the many paintings of the gardens of the Tuileries, such as Manet's *Musique aux Tuileries,* 1861, which show scenes of leisure and enjoyment. On a more personal level, Seurat's *Une Baignade, Asnières,* was exhibited in 1884 in an adjacent building.

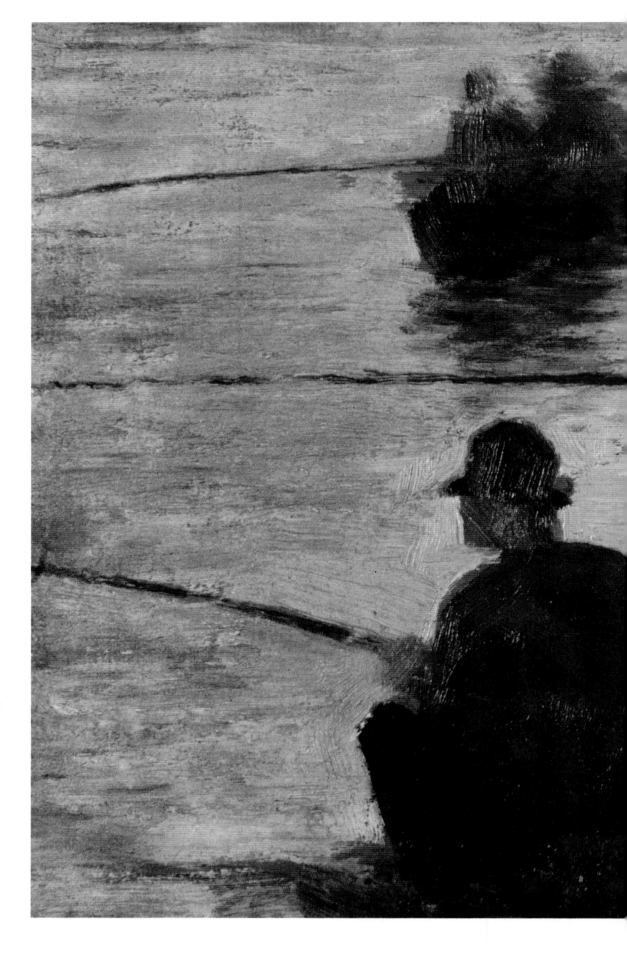

The Anglers, 1883

Oil on panel
6¼×9⅞inches (16×25cm)
(Reproduced larger than actual size)
Musée d'Art Moderne, Troyes

Seurat must have been sufficiently pleased with this panel as it was lent to the eighth Impressionist exhibition by its owner, Léon Appert. Appert was married to Seurat's elder sister, and had won a gold medal at the 1878 Universal Exhibition for his work in glass. He specialized in the manufacture of 'optical and colored glass' at which he seems to have been very successful throughout the 1880s. In this panel it is possible to see how Seurat experimented with different types of brushwork to define the motifs represented. The figures of the men fishing have been sketched in by a series of bold touches of blue pigment set off by hints of the rich orange color of the underlying panel. The contrast of these complementaries creates a particularly vivid effect. The surface of the river has been painted in a luscious manner, with slab-like brushstrokes clearly apparent such as the two touches of white to the right of the foreground figure. Such modeling in paint is more akin to the work of artists such as Cézanne rather then the more delicate approach normally associated with Seurat. Certainly the softness of his drawing style as it was developing at this time is in marked contrast to the bravura of the handling in this example. As in other panels, there is a curious treatment of spatial recession and the placing of the figures in the sketch. The space is defined by the receding line of the riverbank from bottom left to top right. However, the hint of a figure in the top right corner defies the spatial recession as it is similar in scale to those figures closer to the front plane of the panel. Such liberties of scale were to become characteristic of, and more fully exploited for pictorial reasons, in many of Seurat's mature paintings.

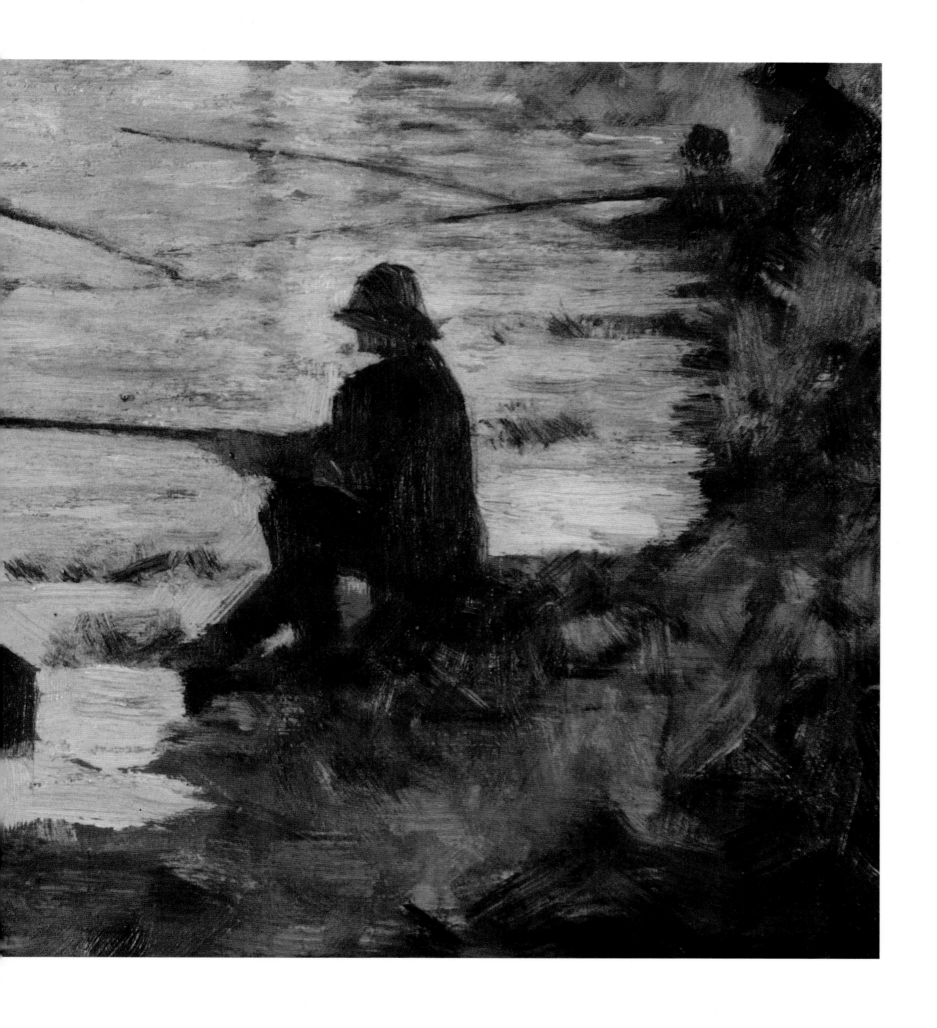

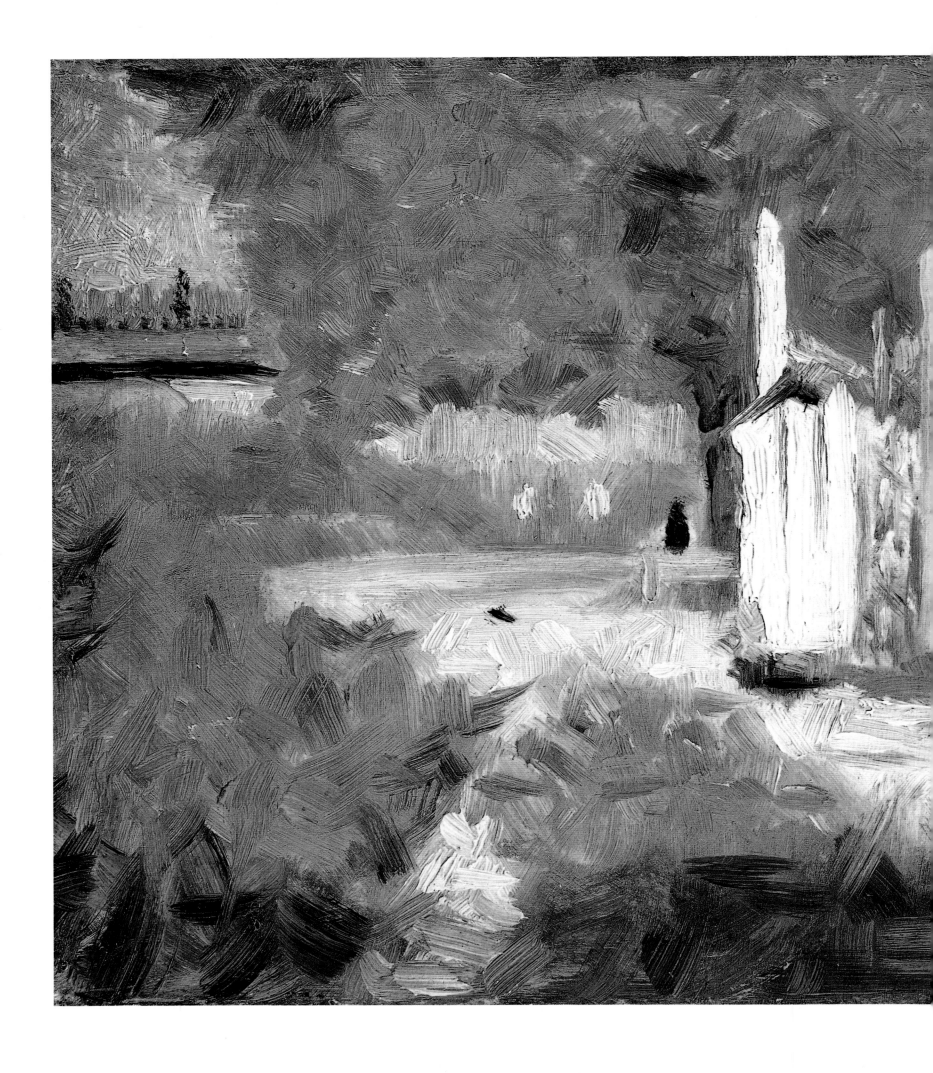

Man Painting his Boat, c. 1882-83

Oil on panel
6¼×9⅞ inches (16×25 cm)
(Reproduced larger than actual size)
Courtauld Institute Galleries, London
Courtauld Collection

A most freely painted and rather exceptional panel. In the choice of subject it is unrelated to the majority of panels and drawings that Seurat worked on in the early 1880s, and the paint is more vigorously handled than in other contemporary work. It would appear to be something of a maverick. Certainly the balayé brushwork – the criss-cross patterning – is characteristic of Seurat's paintings at this time, but those areas where the paint has been more thickly applied are less typical, particularly the bold area of white in the center of the panel. Here the paint has been molded into some type of structure, each brushmark suggesting an individual element of that structure. In the foreground the man painting his boat blue has been equally strongly handled. The combination of the central white area, possibly a response to Corot's dictum of having one single luminous spot in a painting, surrounded by the light green of the foliage creates a light, airy, and fresh effect. Such freedom of handling recalls certain paintings by Monet from the late 1860s and early 1870s when he was experimenting with working out-of-doors and thus having to paint quickly in order to capture changing light effects. Compositionally this panel also reveals an affinity with some of Monet's river views. The evenness of the coloring of the foliage makes it difficult to identify clearly all the landscape features. The foreground grass, for instance, merges with a bush on the left which almost reaches up to the overhanging foliage of the trees. The bush and trees are not on the same spatial plane, the trees being set back some distance, and the way the bush provides a strong foreground element through which only a slight hint of the background is given are all compositional devices much used by Monet.

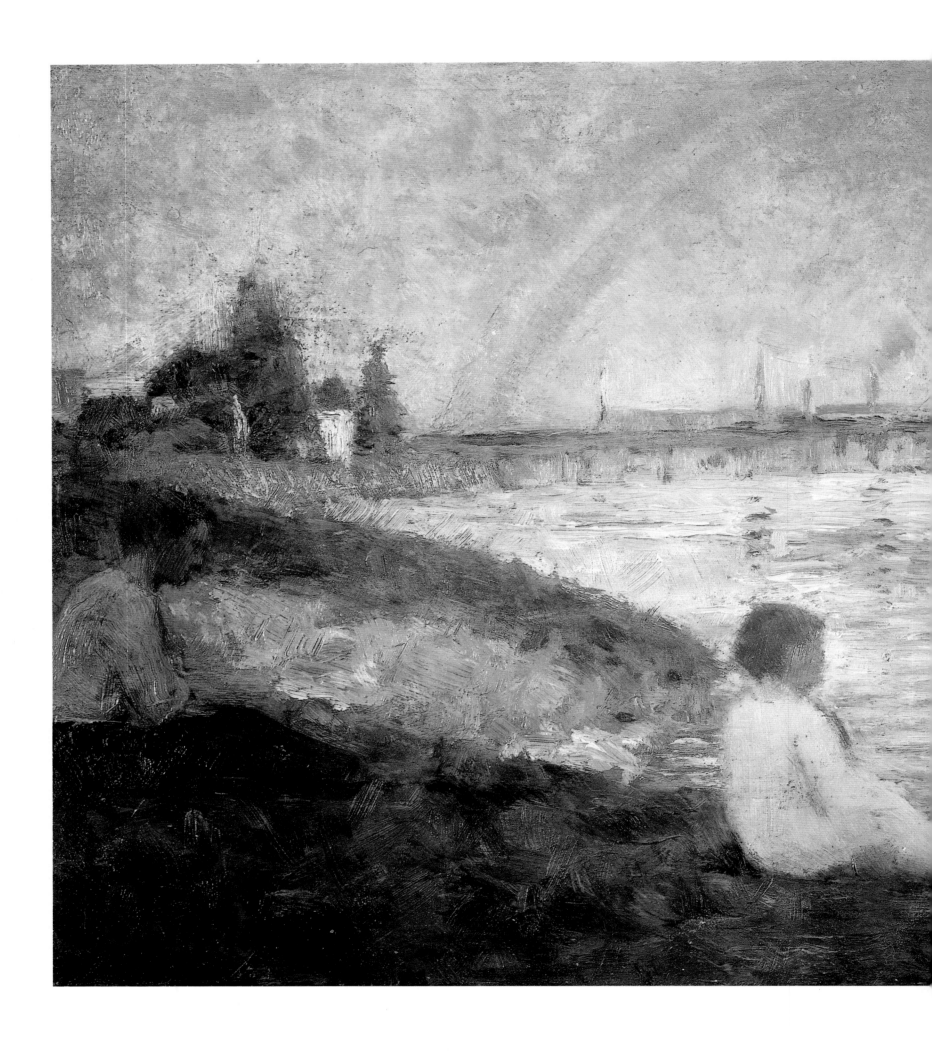

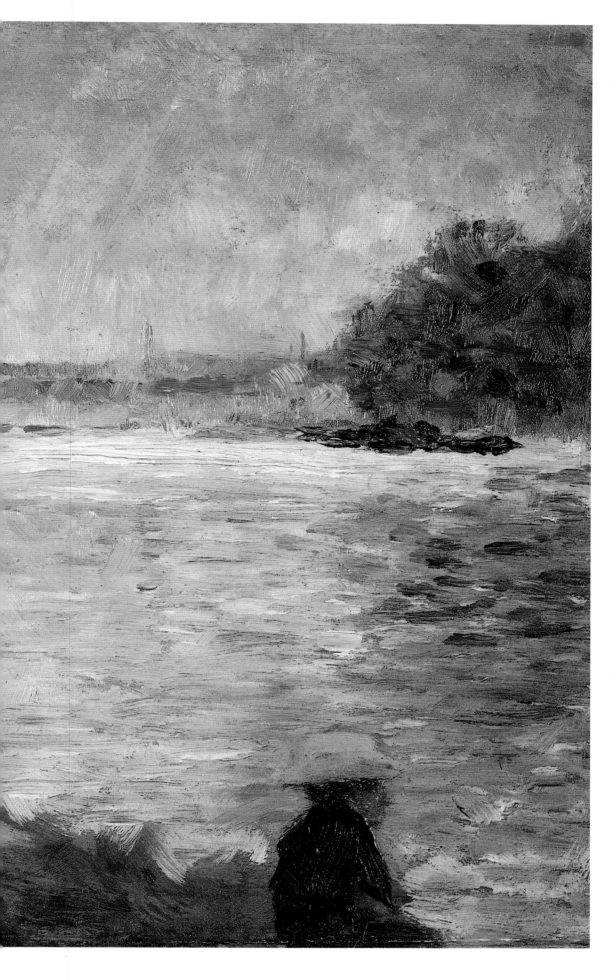

Study for 'Une Baignade, Asnières', 1883-84

Oil on wood
6¼×9⅜ inches (16×25cm)
(Reproduced larger than actual size)
Berggruen Collection, on loan to the
National Gallery, London

This small panel is one of the most exquisite of the preparatory studies for *Une Baignade, Asnières*. A calm, relaxed mood characterizes the scene, one often associated with the aftermath of stormy weather and the dramatic rainbow that sweeps across the distant sky is evidence of a summer's storm. The foreground grass and background vegetation is particularly lush and the surface of the river appears choppy, gradually subsiding after the storm. Probably the panel was painted in the summer of 1883. The paint has been applied in quite a free way with certain areas revealing that Seurat was experimenting with modelling with the pigment. The river, for example, has been vigorously treated and where it adjoins the far bank and the factories in the distance Seurat has defined it by one sweeping brushstroke. Similarly, the factories and other buildings are made up of single brushstrokes of red-orange. The treatment of the near bank, with the three male figures sitting in hunched profile, is made up of a series of dark green brushmarks to establish the local color of the grass with touches of black to define those areas in shadow. There is little evidence in this panel of the use of color that characterizes later panels; no use of yellow and orange to highlight sunlit areas, very limited use of blue in the shadows. Thus both the technique used and the fairly limited range of colors employed show that Seurat was still at an early stage in the lead up to working on the definitive version of *Une Baignade*. Compositionally, however, this panel provides evidence that Seurat had settled this aspect of the painting at a relatively early stage. Apart from giving greater prominence to the grass bank in the foreground, little else was changed.

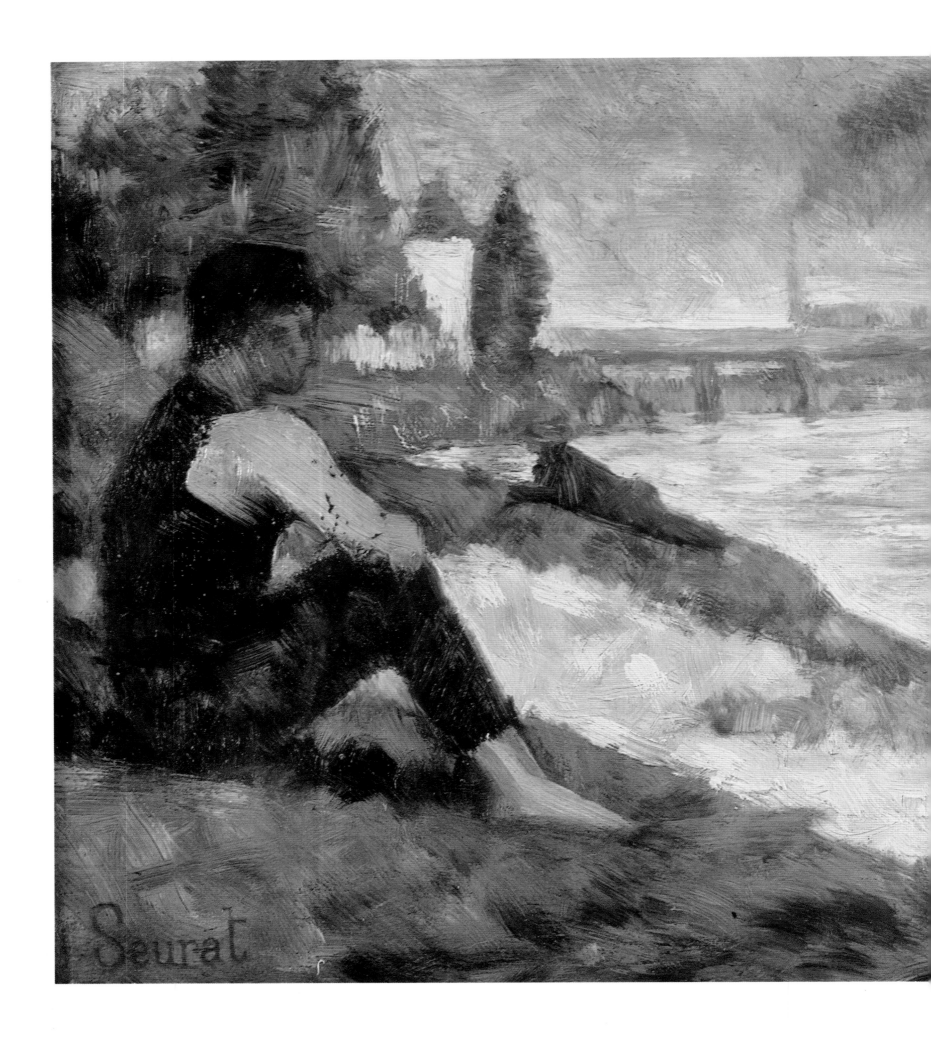

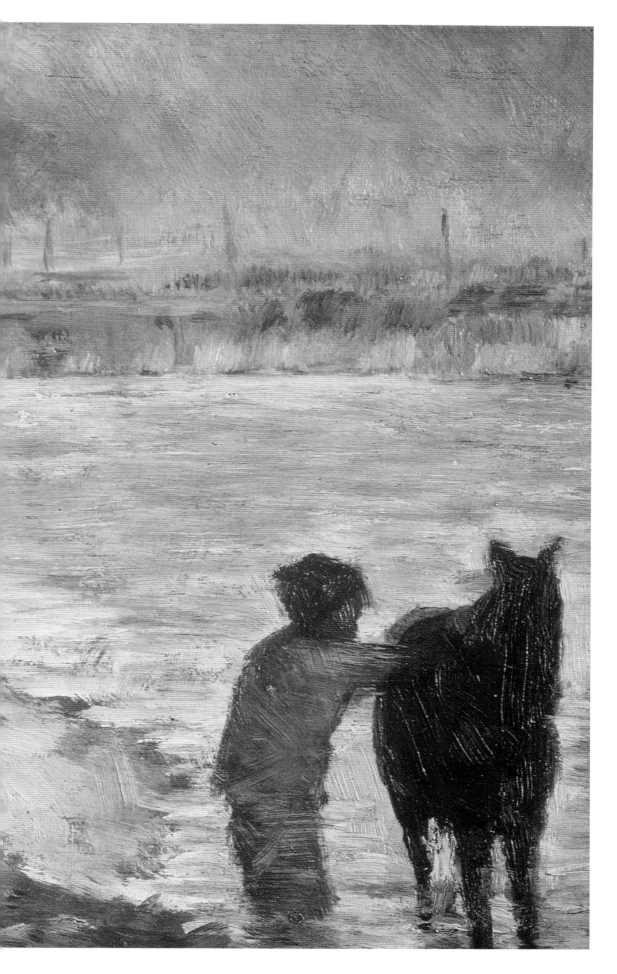

Study for 'Une Baignade': Seated and Reclining Figures, Black Horse, 1883-84

Oil on panel
6¼×9⅞inches (16×25cm)
(Reproduced larger than actual size)
National Gallery of Scotland, Edinburgh

In this vigorously worked study Seurat depicts three figures and a horse along the river bank. The seated figure in the left foreground and the reclining figure, appearing in a study for the first time, assume more or less their positions for the final composition. In the right foreground a blue-shirted boy brushes down a horse. Horses appear in a number of these preparatory sketches although Seurat excluded them in later studies. In one such study two horses are included, one being ridden by a bare-chested rider which, when combined with the depiction of yachts, gives the impression of a sunny afternoon with people engaged in various forms of relaxation. Such a representation of leisurely activity is less apparent in this version. More emphasis is placed upon the factories belching smoke in the background; there is no reference to the river as a source of entertainment and the figures are all dressed in dark clothes which may indicate a group of workers at rest. The inclusion of the horse has, it has been suggested, identified the collection of figures as workers engaged in delivery or transportation and what is represented here is the workers relaxing at the end of their day. Two are resting on the river bank while the third washes and brushes down his horse before returning to the depot. That the washing of the horse was a regular event, presumably daily, is suggested by the well-worn path leading into the river. Here the grassy bank has been eroded to a muddy bridleway as a result of the constant watering of the horses. Seurat must have felt unhappy about such a clear reference to the working day as he excluded horses in the completed painting.

Study for 'Une Baignade': Seated Youth, 1883-84

Conté crayon
12½×9½inches (32×24cm)
National Gallery of Scotland, Edinburgh

This study of a seated boy is one of the preparatory drawings for *Une Baignade*. In these works Seurat concentrated on the modeling and establishing the basic features of the main figures – ten such studies exist. Seurat's preferred drawing material was conté crayon, an artificial chalk which, when applied to a particularly grainy paper in movements of varying pressure, would result in the dramatic tonal values which can be seen so clearly in this example. This technique of allowing the texture of the paper to create a surface tension is paralleled by his method of dragging the paintbrush across the tiny surface undulations caused by the weave of the canvas, a technique much used by the Impressionist painters. By rubbing the chalk across the paper surface the ridges would become darker while the hollows would remain white. Increased pressure would produce even darker tones. By building up

forms in this way Seurat totally renounced the use of line and relied instead on the contrasting tones to define form. In fact, Seurat artificially exaggerated the tonal contrasts in order to define form and here to separate the seated boy from the background of the grass bank. This can be seen most clearly where the boy's back meets the grass bank; the crayon marks are more heavily applied to the boy's back thus darkening the tone while there is only the slightest hint of conté crayon to suggest the grass. Thus the tones have been respectively darkened and lightened to increase the contrast. Likewise the front of the leg appears very bright in contrast to the darkened ground. Through drawings such as this Seurat was able to establish the main tonal divisions of his major paintings; in fact, the drawings were pinned to the canvas so that Seurat could directly recreate the tonal values of the drawing in paint.

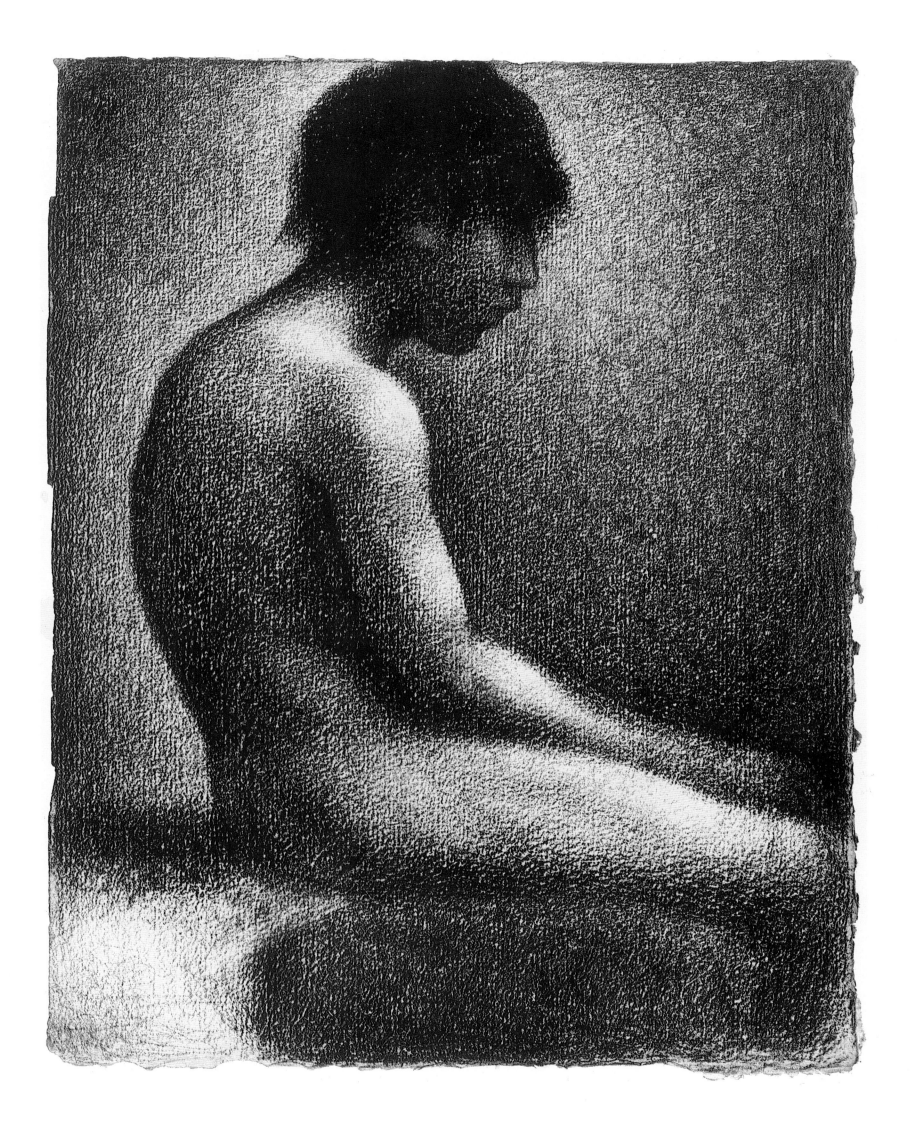

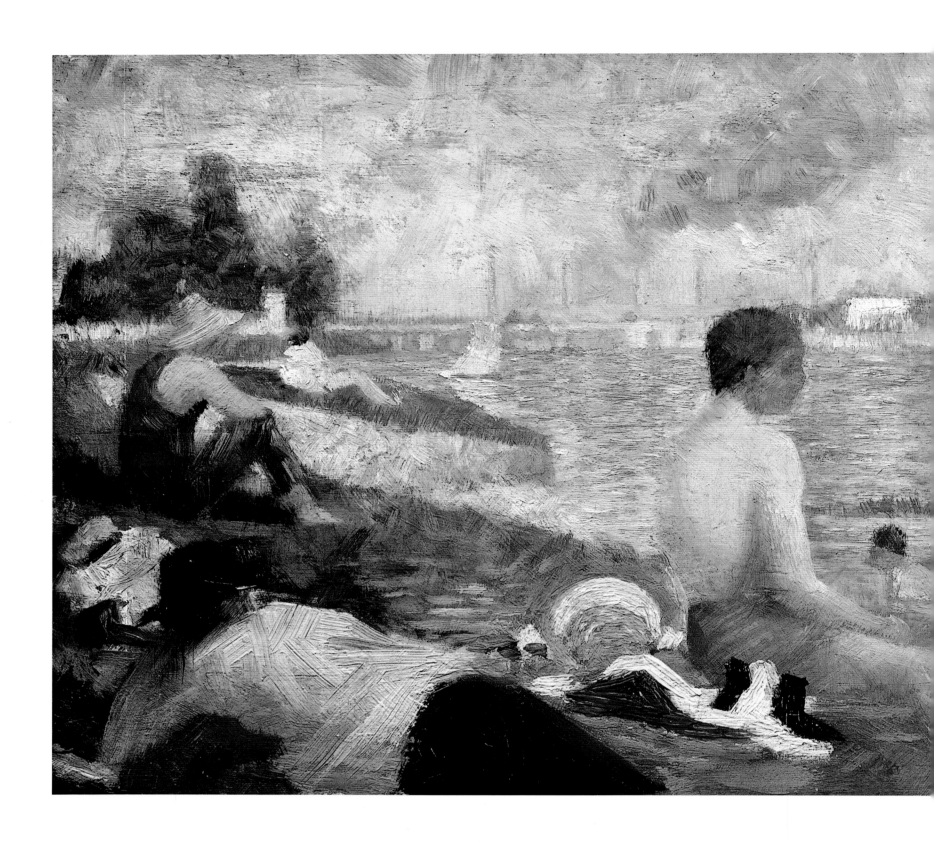

Study for 'Une Baignade': Final Compositional Study, 1883-84

Oil on wood
6¼×9⅞ inches (15.8×25.1cm)
Art Institute of Chicago
Adele R Levy Fund, 1962.578

This panel is the final compositional study for *Une Baignade* in which Seurat has settled on the main features and sketched in the main color accents. The positions of the figures are clearly established, although there are still significant differences from the final painting. The boy swimming on the extreme right is excluded while the headgear and the curve of the posture of the boy with his hands cupped across his mouth are more exaggerated in the final version. Other, smaller, changes have been made but Seurat has painted in the main elements. He has also established the color harmony by boldly sketching the main color accents – the orange-red dog and the red hat of the seated figure in the distance, for example.

The image of bathing suggests a scene of great enjoyment, but opposite the bathers and a little further along the river was the main sewer outlet for Paris. Contemporary descriptions commented on the effects of a hot summer's day, combined with the outpourings of effluent, on the river Seine at Asnières. One such account described how 'more than 120,000 cubic meters of solids have accumulated at the collector's mouth; several hundred square meters are covered with a bizarre vegetation, which gives off a disgusting smell. In the current heatwave, the town of Clichy possesses a veritable Pontine Marshes of its own.' Thus the scenes of leisure that Seurat has depicted here must be placed against the background of the vast amount of sewage flowing into the river at this point, and the generally unhealthy conditions which prevailed, particularly in the hot summer months. Although there is no explicit reference to the 'great collector,' as the main Parisian sewer was known, it is impossible that Seurat was unaware of its effects.

Une Baignade, Asnières, 1884

Oil on canvas
78¾×118⅛inches (200×300cm)
Courtesy of the Trustees of the National
Gallery, London

Rejected by the Salon jury in 1884, *Une Baignade, Asnières* was exhibited at the salon of the newly created Societé des Artistes Indépendants in May 1884. By far the largest and most ambitious project that Seurat had undertaken up to this time, it amounted to a challenge to the Parisian art world of the 1880s and as an announcement of the arrival of a new and original talent. Both in its treatment and in its subject *Une Baignade* shows Seurat responding to a long tradition of French art; it also reveals an acute awareness of modern Paris and contemporary developments in French artistic practice. The hieratic depiction of the resting and bathing figures, almost all seen in profile, was likened at the time to the work of Puvis de Chavannes, a classicizing artist renowned for working on a large scale. Puvis' painting such as *Doux Pays* (page 9) are characterized by their calmness and stillness, a mood much evident in *Une Baignade*. The critic Paul Alexis chastised Seurat for painting 'a fake Puvis.' Whatever classicizing tendencies may appear in the structure and composition of this painting, the subject is decidedly modern. The scene is the left bank of the Seine looking towards Asnières, identified by its railway bridge in the background, and in the far distance are located the factories of Clichy. We are, therefore, looking at a suburban and industrial scene. Many interpretations have been put forward as explanations of Seurat's choice of subject but any precise understanding remains as elusive today as it did to his contemporaries. This elusiveness of subject does not detract, however, from the monumental beauty Seurat gives to an everyday Parisian occurance.

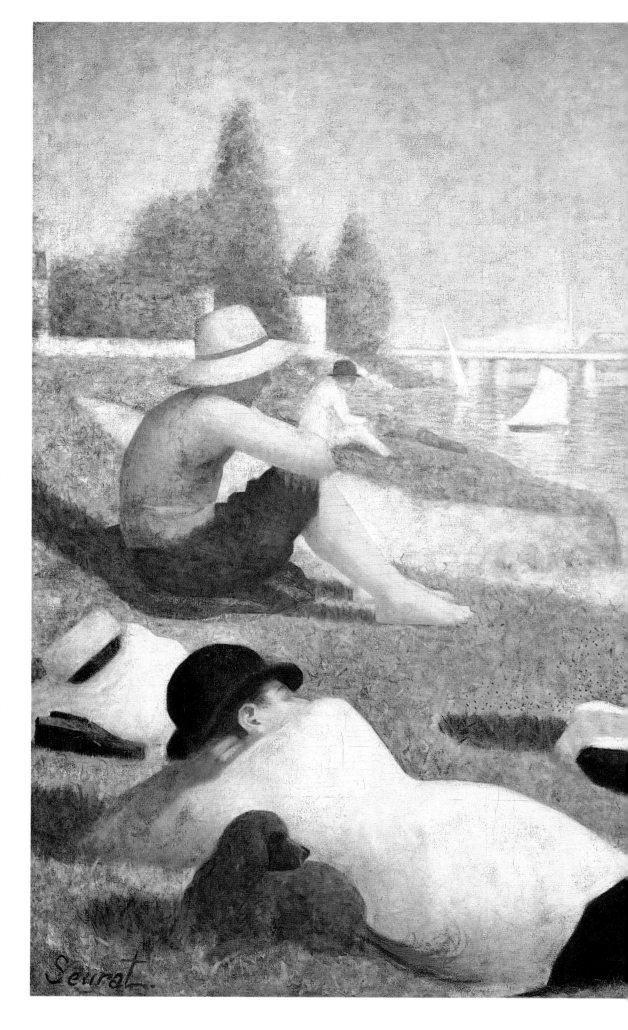

72

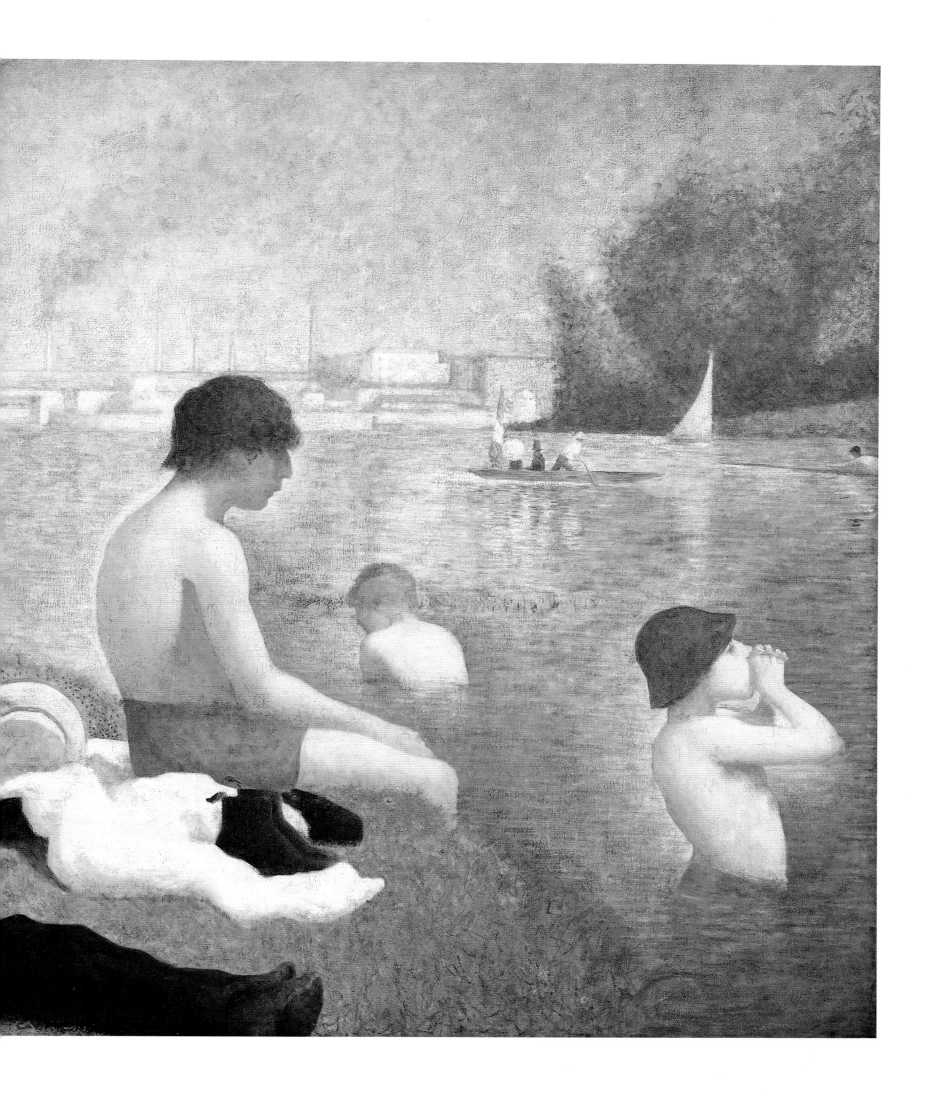

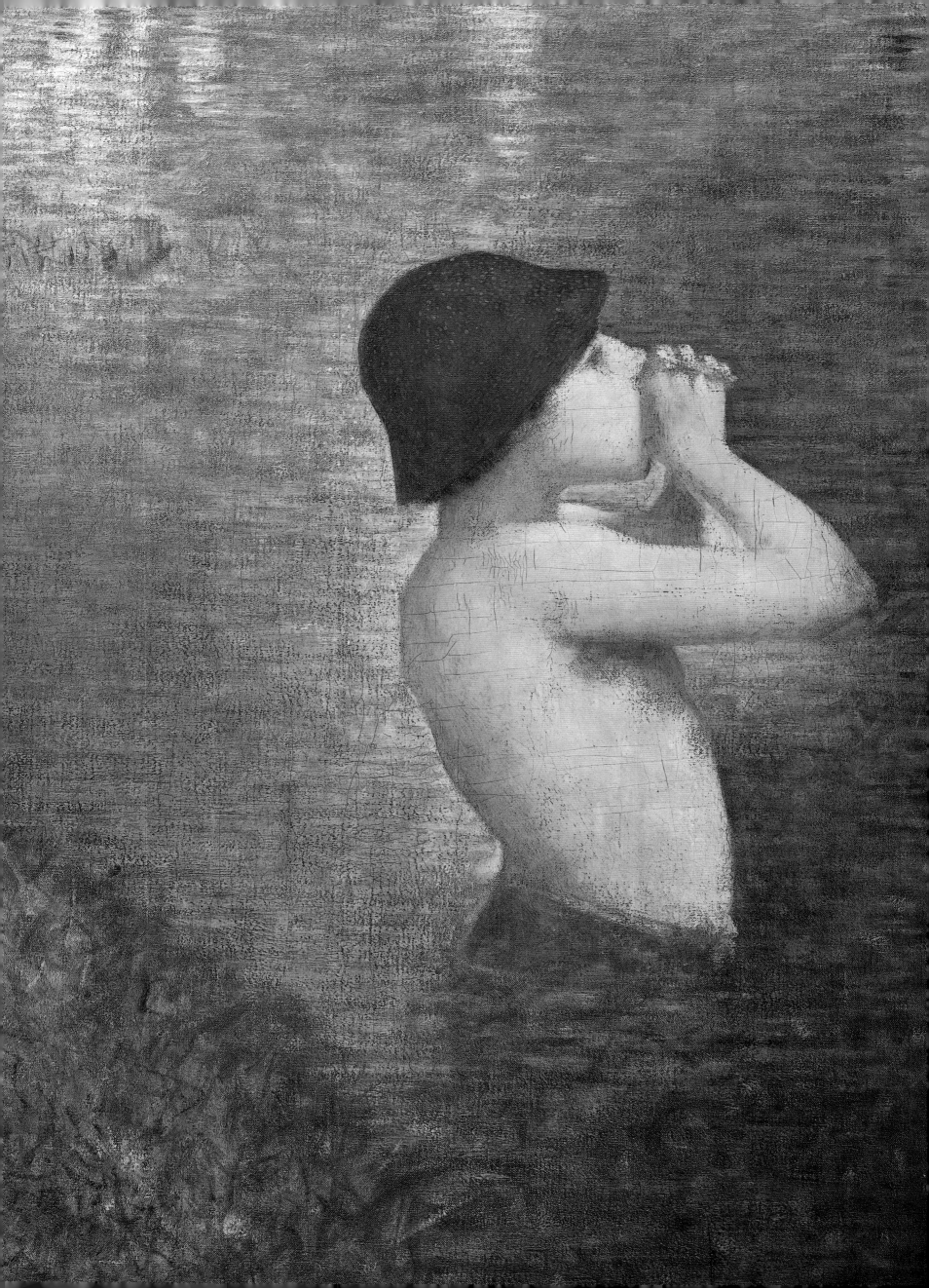

Une Baignade, Asnières, 1884
Detail
Oil on canvas
Courtesy of the Trustees of the National
Gallery, London

In his letter to Félix Fénéon written in June 1890 outlining the development of his style, Seurat referred to 'being impressed by the intuition of Monet and Pissarro.' The relationship between Seurat's art and that of the Impressionist painters has remained a vexed problem, but there can be little doubt that he became interested in Impressionist practice in 1883 and 1884. Nowhere can that be more clearly seen than in his treatment of painting water. Reproductions of *Une Baignade, Asnières*, because of its scale, always give the impression that the paint surface is covered by a series of uniformly sized brushmarks. Detailed inspection of the paint surface, however, reveals that this is not the case. In his treatment of the river Seine Seurat has used a thin layer of pigment that has been dragged across the surface of the canvas, allowing areas of canvas to show through and which, when combined with the weave of the canvas, creates an uneven surface effect. Far from using small, dotted brushmarks the river is made up of broad brushstrokes dragged across the canvas. Such a method of depicting water derives from Impressionist practice, particularly the work of Monet and his many paintings of river scenes from the late 1860s onwards. In contrast, the torso of the boy has been built up from small, densely worked brushmarks. However, Seurat has abandoned any concerns for naturalism in his treatment of the tones where the outline of the boy has been defined by the dramatic contrast in tone. His back, in shadow, has been darkened in tone and the river surface lightened, and the reverse effect can be seen where he is caught in sunlight. This effect is known as irradiation, which 'is a phenomenon of light which makes objects stand out one from the other, setting them in sharp relief.'

**The Rue Saint-Vincent,
Montmartre: Spring,** c. 1884

Oil on panel
9⅞×6¼ inches (25×16cm)
(Reproduced larger than actual size)
Fitzwilliam Museum, Cambridge

The rue Saint-Vincent was described by a friend of Seurat, Rodolphe Darzens, as being 'adored by painters, so picturesque and so sad.' The road was situated near the park of the Buttes Chaumont, located in Belleville, one of the poorest parts of Paris. The Buttes Chaumont was one of three municipal parks created by Baron Haussmann in his huge modernizing scheme for the development of Paris between 1853 and 1870. The site on which the park was developed had a particularly gruesome history. Originally it was made up of a series of quarries and it had been the site of the gibbet of Montfaucon which, for centuries, had been where public executions were carried out. The gallows had been moved in 1761 but the place remained a notorious haunt for criminals; up until 1849 it had become the dumping place for the sewage of Paris. For sanitary reasons, and to improve the quality of life in this area, it was agreed in the 1860s to transform the site into a park. The Baedeker guide to Paris in 1888 described the transformation: 'The quarries . . . have been transformed into a rocky wilderness surrounded by a small lake, while the adjacent rugged surface is now covered with gardens and walks shaded by trees. A cascade falling from a considerable height into an artificial stalactite grotto is intended to enhance the attractions of the scene. The park with its romantic scenery presents a curious contrast to the densely-peopled city which surrounds it.' This account of the park alludes to the picturesque as does Darzens description of the rue Saint-Vincent. As with the park, Seurat has ignored the social and industrial nature of the area and instead has painted a scene of a fine spring day. The social concerns treated in contemporary works are here totally absent.

The Painter at Work, c. 1884

Conté crayon
11⅞×9 inches (31×23cm)
The Philadelphia Museum of Art
A E Gallatin Collection

It has been suggested that this drawing of an artist seen from behind is a self-portrait, although there is no evidence to support this view. A painter is depicted standing on a step-ladder, palette in left hand and brush in right, painting a large canvas. The dimensions of the canvas are unclear, though it is considerably larger than the artist himself, and it is impossible to decipher the subject being painted. The style of the drawing is typical of Seurat's drawings of 1883-84 and if this is a self-portrait then it is likely that the painting is his first large-scale project, *Une Baignade, Asnières*, which he would have been busy completing at this time. Later Seurat referred to the importance of painting monumental works if the artist wanted to establish a school of followers. Certainly those artists much admired by Seurat at this time, such as Puvis de Chavannes, had established their reputations through their large decorative schemes. Such interests existed amongst Seurat's closest friends and former colleagues at the Ecole des Beaux-Arts who were hoping to develop their careers by obtaining both decorative commissions and by attracting attention by exhibiting large canvases at the annual Salon. Ernest Laurent, whose own portrait of Seurat (page 6) was drawn in 1883, for example, attempted to gain the commission for a series of decorations for the town hall at Courbevoie in 1884. In this drawing the tonal gradation is not handled as subtlely by Seurat when compared to some of the preparatory drawings for *Une Baignade* and other contemporary works. The figure of the artist has been solidly drawn, but the studio background is not clearly defined. The face has been tantalisingly drawn in the sketchiest of ways, leaving the viewer to guess at the artist's identity. Is this Seurat, or is it not?

Study for the 'Grande Jatte', 1884

Oil on canvas
$25\frac{5}{8} \times 31\frac{7}{8}$ inches (65×81 cm)
Courtesy of Mrs John Hay Whitney, New York

With this relatively large landscape study Seurat established the main compositional framework for the *Grande Jatte* (page 90). It was exhibited in Paris in December 1884 and marked the culmination of outdoor studies that had been painted throughout the preceding summer months. In it, the features of the landscape have been largely finalized, as have the areas of sunlight and shadow. To achieve the necessary spatial recession Seurat has made use of the diagonal of the river bank, moving backwards from the left foreground until it disappears in the trees near the horizon. The foreground has been opened up by excluding the tree on the right edge, now only suggested by the vast shadow that sweeps across the foreground. Spatial recession is achieved by the juxtaposition of bands of light and shade which take on the form of vast arabesques unrelated to naturalistic effects. On the right side of the painting, alternate areas of light and shade re-enforce the recession of the river bank. The shadow cast by the tree on the left falls parallel to the bank to suggest a general curve from the left corner of the canvas, sweeping into the center and echoing the shape of the foreground shadow. Close observation of the picture surface reveals how Seurat repositioned this tree from its original setting slightly further to the left. Therefore he felt sufficiently happy to manipulate nature to suit his pictorial needs, as both cast shadows remain a feature of the landscape, as they do in the final version of the *Grande Jatte*. The benefits of his summer visit to Grandcamp can be seen in the uniformity of the 'pointillist' brushmarks, but the more freely painted river surface still reveals a debt to Impressionist technique.

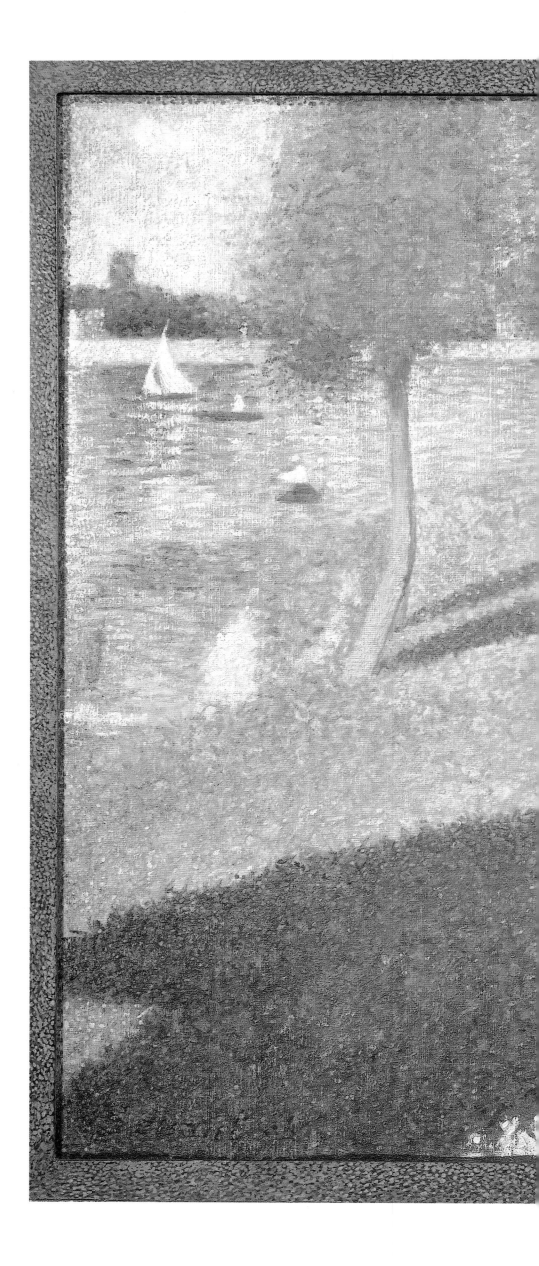

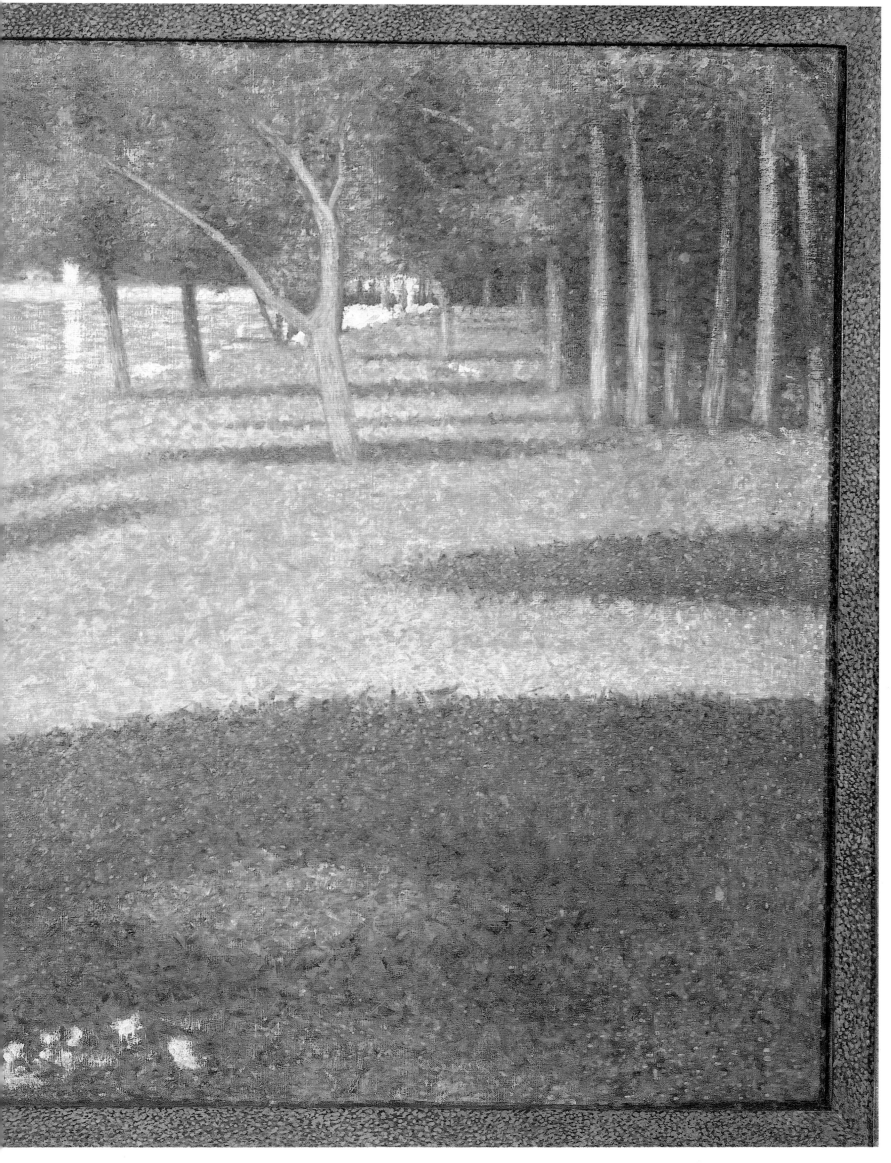

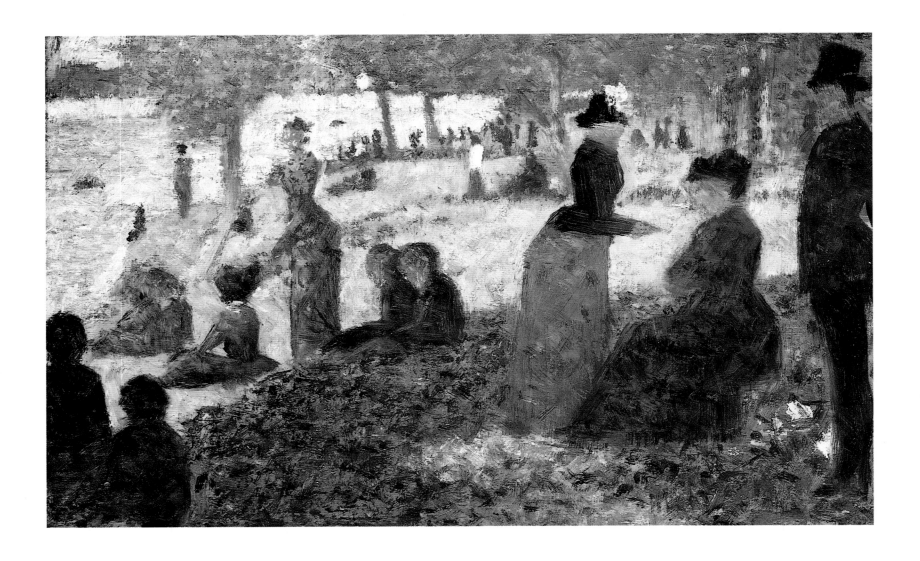

Study for the 'Grande Jatte', 1884

Oil on panel
6⅛×9⅞ inches (15.5×25.1 cm)
Art Institute of Chicago
Gift of Mary and Leigh Block

Having concentrated initially on establishing the main features of the landscape, Seurat has, in this study, begun to explore the positioning of the figures and their role within the *Grande Jatte*. Similarities and differences clearly exist between this panel and the completed painting. It is the foreground figures that were the focus of Seurat's attention, those in the distance are hinted at only by a single brushmark. Already, at this early stage, Seurat has decided that these figures should be seen in profile and he has grouped them in different combinations in a series of planes parallel to the picture surface. The man at the right edge performs the same pictorial function as do the walking couple in the completed painting. Likewise, the two seated figures in the center remain, although in a changed form. A general format has been established, but significant changes were made. At the bottom left, the two silhouetted figures never reappear. To the right, the seated woman and her companion were excluded from later studies. This pair provide an interesting insight into Seurat's exploration of the subject. They appear to be older, as do others in this panel, than the figures in the *Grande Jatte*; the whole mood appears to be much more weary. Heads are bowed, no children are playing and the spirit of youthfulness so evident in the *Grande Jatte* is notably absent here. The somber colors of the clothes add to the downcast feeling. Why, then, did Seurat make such major changes? That is not an easy question to answer. Descriptions of those who went to relax on the island of the Grande Jatte vary greatly. Here, Seurat has only just begun to explore the nature of that population and this panel reveals how dramatically his ideas were refined during the winter of 1884-85.

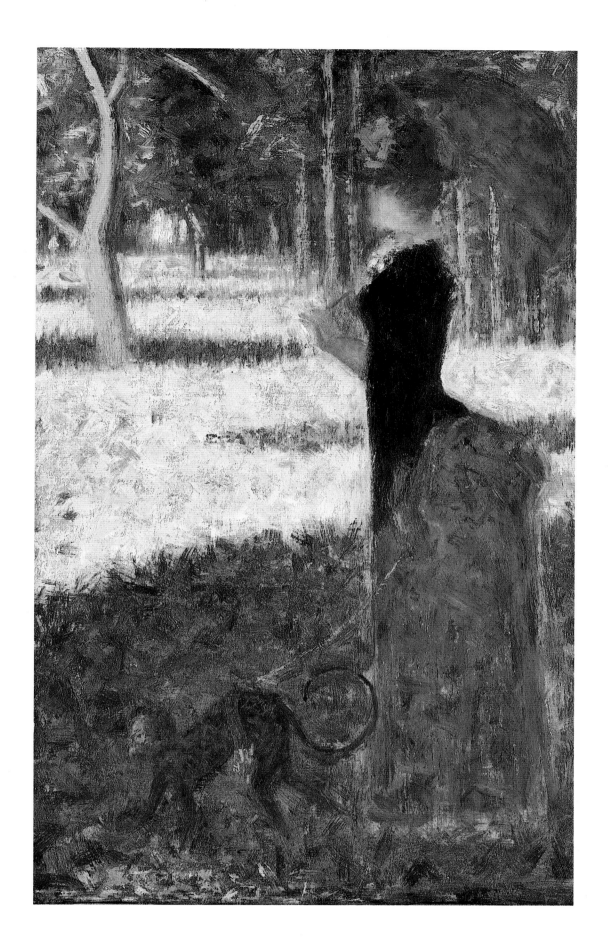

Woman with a Monkey, c. 1884-85

Oil on panel
9¾×6¼ inches (24.8×15.9 cm)
Smith College Museum of Art,
Northampton, Massachusetts
Purchased, Tryon Fund, 1934

This sketch of the woman and monkey placed at the extreme right edge of the *Grande Jatte* is related to a similar study in the Fitzwilliam Museum, Cambridge (page 87). In both studies Seurat was keen to establish the relationship between the figures in that part of the canvas and to sketch in the main color harmonies. The Cambridge panel is more closely related to the completed painting in that the main groups of figures have been finalized, whereas in this example Seurat has only concentrated on the figure of the woman walking with her pet monkey. Many sheets

of preparatory drawings were completed indicating how determined Seurat was to perfect this figure. The sequence of drawings show that Seurat started with some detailed and more naturalistic representations of a fashionably dressed woman. As his studies progressed the figure has become increasingly stylized, her profile flattened, the outline of her dress more exaggerated and hints of her personality eradicated. This development is well illustrated in this example where details of the woman's face have been neglected, and her posture is marked by the rigidity of the

contour defining the front of her dress in contrast to the wonderful curve of her bustle. Many critics commented on the stilted effect of the figures in the completed painting; it is as if Seurat had carved this figure out of wood, so static and rigid is the pose. Unlike many of the other studies the monkey is included in this sketch. Quick to point out the association of the monkey with the world of the prostitute, critics also noted the absurdity of walking with such a pet on a leash in public and how this association contributed to the overall artificiality of the scene.

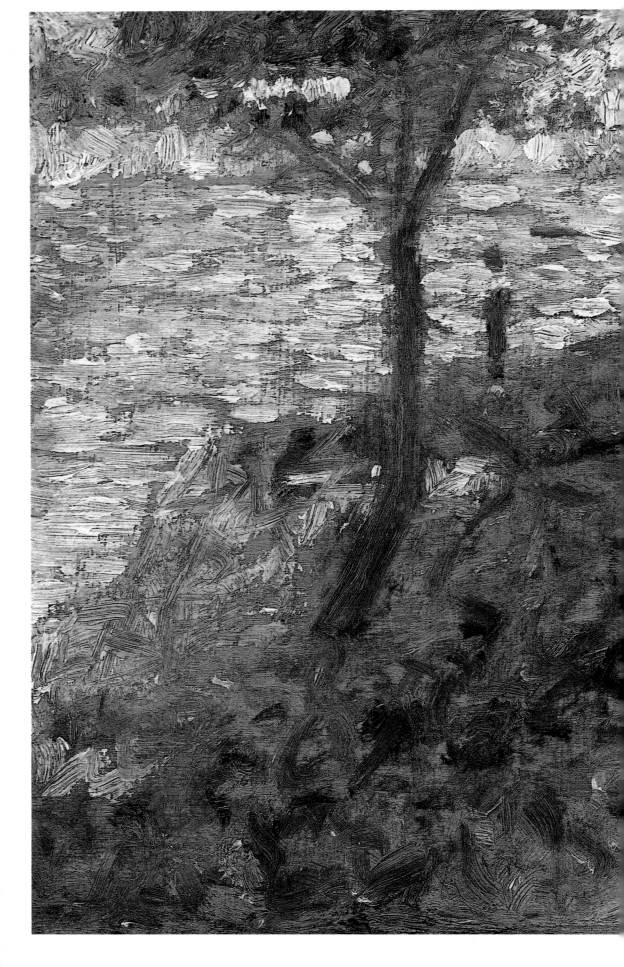

Study for the 'Grande Jatte', Middle Distance, Left, 1884-85

Oil on panel
6¼×9⅞ inches (16×25cm)
(Reproduced larger than actual size)
Berggruen Collection, on loan to the
National Gallery, London

A most rapidly painted panel in which Seurat has sketched in the main landscape features of the island of the Grande Jatte. From the empty foreground the island stretches back towards the top right-hand corner of the panel and dominates virtually all the pictorial space. Only a triangular slither of river and far bank are included in the upper part of the panel. The relative proportions of these landscape elements sketched here are much the same as those in the completed painting. From the positioning of the trees it is possible to deduce that Seurat later added a further section to the right edge in order to give himself more space in which to place the varied population of promenaders. That this panel was quickly painted is suggested by the boldness and freedom of the brushmarks, and the many areas in which the underlying color of the panel is allowed to show through. This is particularly noticeable in the way the river surface has been painted. In this sketch the island is sparsely populated, just a few isolated figures. For much of the week the island would have been empty, it was only on Sundays that it became a fashionable place to walk or just relax. Some contemporary descriptions refer to the island as a 'garden of Eden' suggesting that the island possessed idyllic qualities. In fact, the island had been a popular center for boating but by the mid-1880s it had become rather run down. On Sundays, however, it became a center of vibrant activity as one description written in 1886 indicates: 'On holidays and Sundays a dance-hall . . . reverberates with an endless racket; people lay out meals on the bare earth as if they were picnicking on grass, and swings and skittle-alleys flourish where trees used to be.' This sketch, and the finished canvas, reveal the contrasting faces of the island.

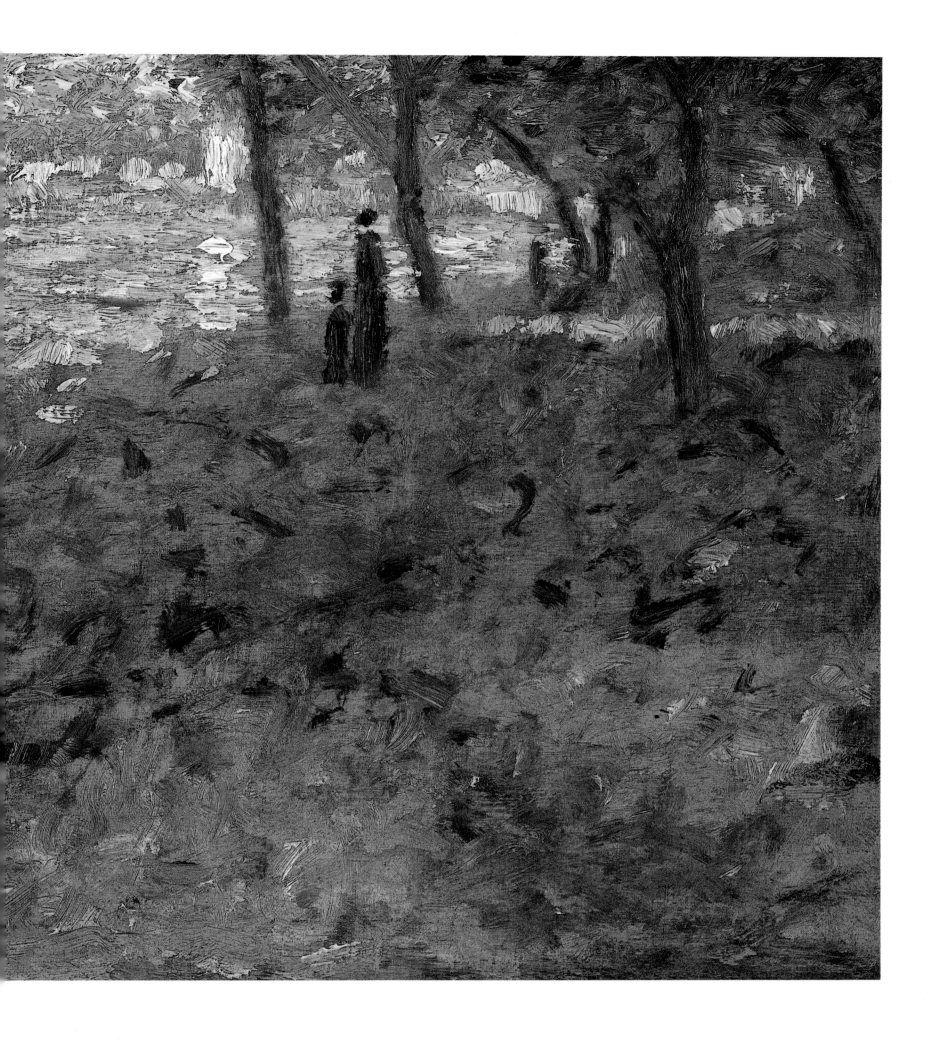

Study for the 'Grande Jatte',

1884-85

Oil on canvas
31⅞×25⅝ inches (81×65 cm)
Fitzwilliam Museum, Cambridge

One of the largest of the preparatory studies, this canvas provides an important source for establishing the development of the Neo-Impressionist technique. Not only has Seurat sketched in the major color harmonies, he has also finalized the grouping of the figures on the right side of the *Grande Jatte*. The canvas is covered throughout with a series of broad brush-strokes, painted in a criss-cross pattern, and a range of colors made up of the three primaries and their complementaries. In the foreground, the local color of the grass is painted in dark green touches to establish the shaded area so prominent in the completed canvas. To suggest areas of sunlight a lighter green is used which has been further highlighted by the addition of touches of yellow throughout. Blue has been added to areas of grass to emphasize the shaded areas, while orange touches have been added in the foreground to sug-

gest sunlight flickering through the trees. The walking couple are painted in predominantly red, blue and violet, the red of the woman's dress contrasting with the green of the surrounding grass. Seurat was keen to harness the effects of simultaneous contrast where the juxtaposition of two contrasting colors heightens their respective values. Both appear brighter and more vibrant. Seurat had discovered the law of simultaneous contrast by reading the writings of Eugène Chevreul, who had first published his ideas in 1839. Chevreul had worked in the dyeing department of the Gobelins tapestry workshop and it was there that his researches into color theory developed. He explained the law of simultaneous contrast: 'In the case where the eye sees at the same time two contiguous colors, they will appear as dissimilar as possible, both in their optical composition and in the height of their tone.'

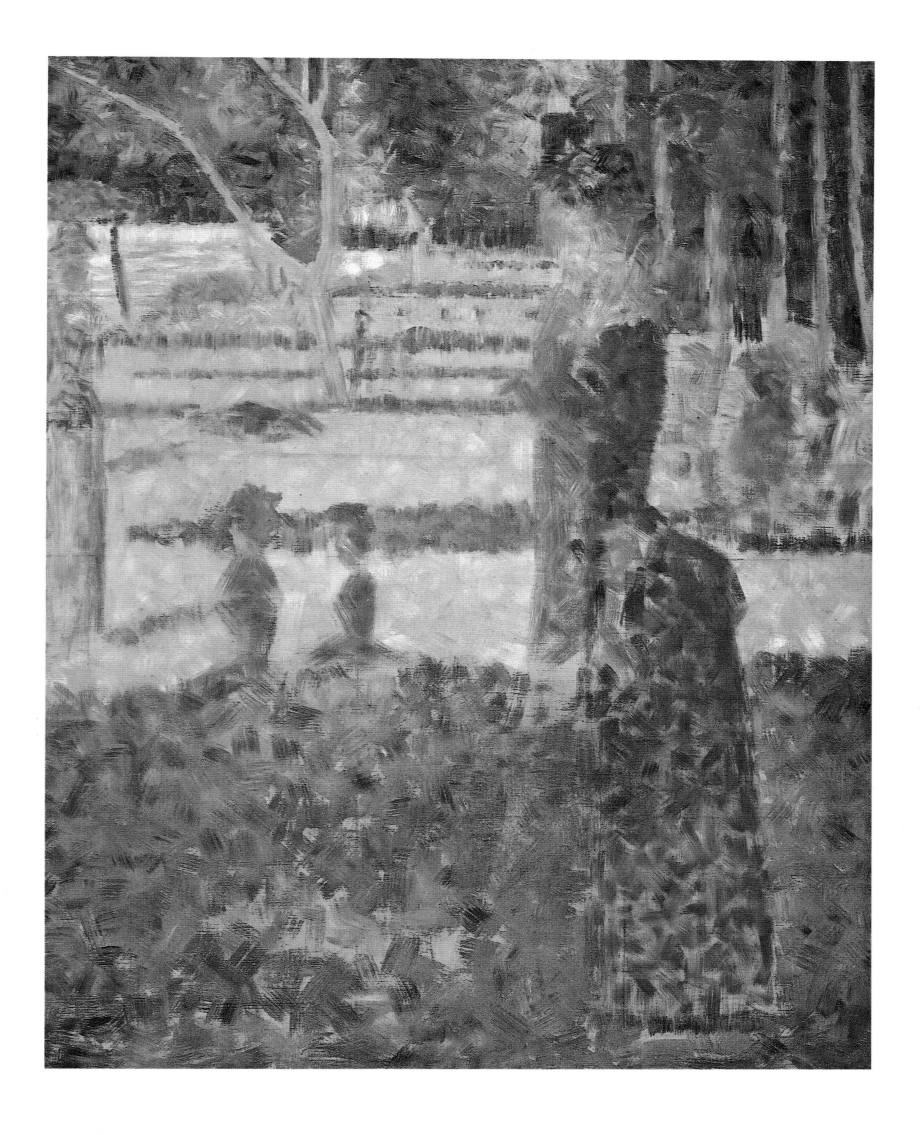

Final Study for the 'Grande Jatte', 1884-85

Oil on canvas
26¾×41 inches (68×104 cm)
The Metropolitan Museum of Art, New York
Bequest of Sam A Lewisohn, 1951

Although this is the final study for the *Grande Jatte*, there are still significant differences between it and the completed painting which suggests that Seurat kept on developing and amending the composition until the very last moment. For example, the pug dog has not been included in the foreground in this study although its presence is crucial in the painting. Likewise, the two reclining women located between the trombone player and the two soldiers are missing. The monkey has been moved closer to the woman standing at the right edge. Seurat has also made changes to her dress by exaggerating further the curve of her bustle; in fact, a close examination of this part of the study reveals a considerable amount of reworking and repainting, evidence that Seurat felt that this area was not yet fully resolved. Elsewhere the brushwork is evenly applied, although a series of much smaller 'dots' can be seen around the edges of the sketch. The connexion between the animals and the figures provides insights to possible readings of the painting. Dogs featured widely in nineteenth-century art and carried a variety of meanings. Pedigree dogs clearly were synonymous with people of high class, while mongrels were identified with the lowest classes. One newspaper critic wrote in 1887 that prostitutes visiting Asnières could be identified by their dogs, the pug being a particular favorite. Adding the pug in the final painting does not necessarily mean that Seurat used this device to identify the woman as a prostitute, but the rather lumpy shape of the dog and the silly bow around its neck relate to her pronounced bustle and her flowered hat. Both are dressed to camouflage their true identity.

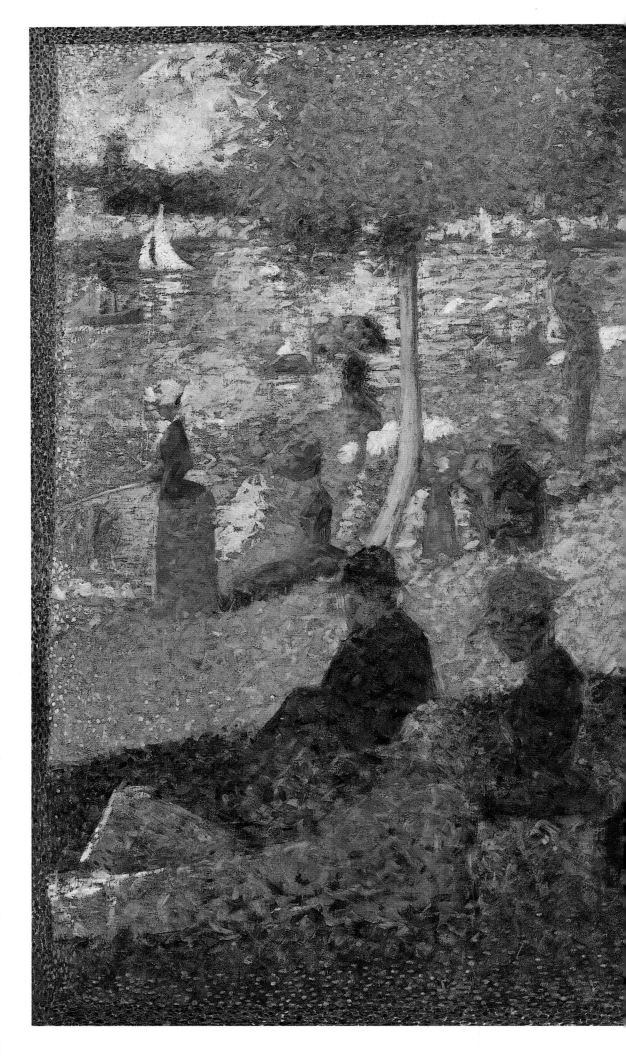

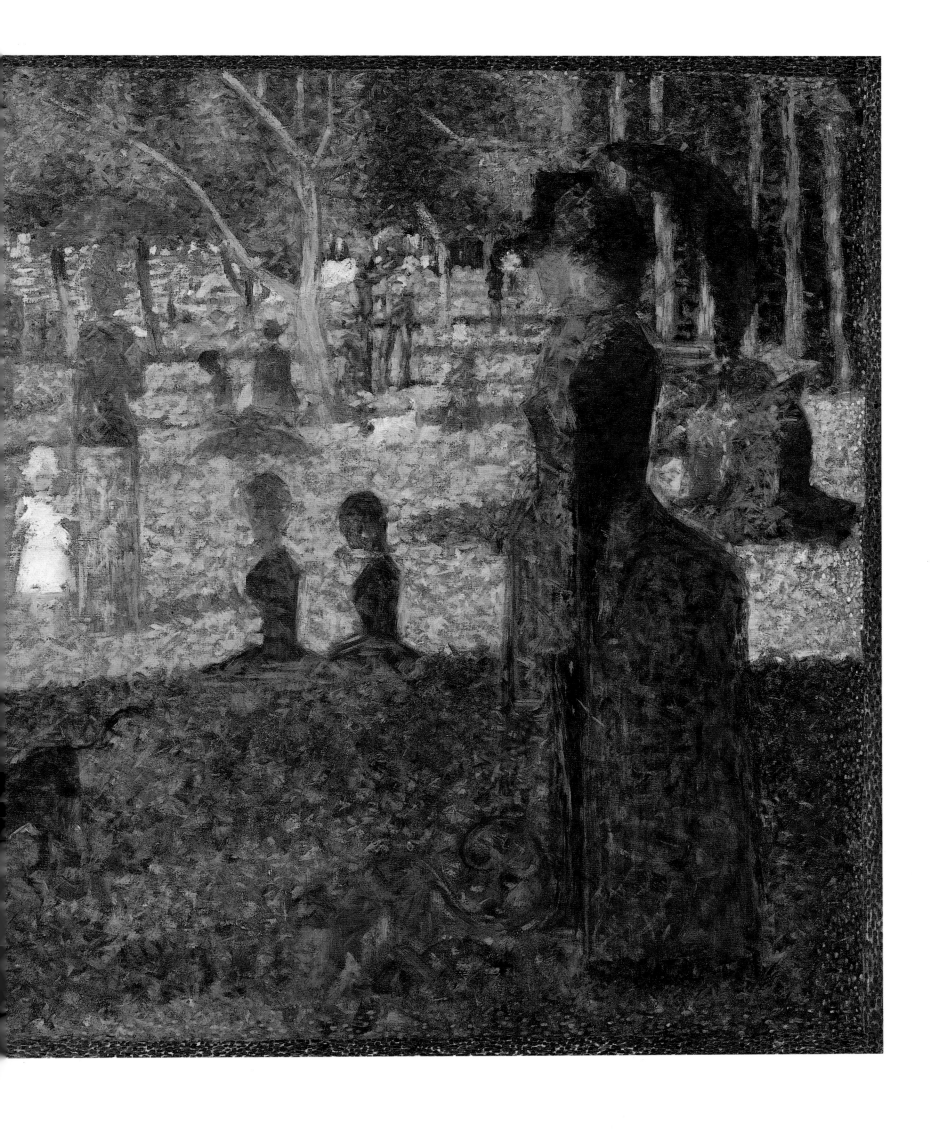

Un Dimanche à la Grande Jatte (1884), 1884-86

Oil on canvas
81¾×121¼ inches (207.6×308 cm)
Art Institute of Chicago
Helen Birch Bartlett Memorial Collection,
1926.224

Described as Seurat's 'manifesto painting,' the *Grande Jatte* was his most ambitious painting to date and it remains one of the most perplexing of his whole career. Although it is more or less the same size as *Une Baignade* which preceded it, the *Grande Jatte* is far more complex and has been the focus of most of the studies of Seurat's art. Also, it was the first painting to be painted completely in the new 'pointillist' technique. Some fifty people, mostly women, are represented strolling, resting, and relaxing on a summer's day on an island located in the river Seine near Asnières. Much iconographical analysis has been devoted to unravelling the precise nature of the subject and historians remain as divided today in their interpretations as were the critics who reviewed the painting when it was first exhibited. Seurat begun work on the canvas in 1884, a starting date to which he was keen to draw attention by including it in the title of the painting. His approach was more elaborate than in any other painting: some 30 panels, 25 drawings, and three major studies were used as preparatory material in its evolution. Studies of the landscape setting, of individual figures and groups of figures provide a detailed source of information on how Seurat's ideas developed during the period of the painting's development. Obviously he felt pleased with the completed painting as it was exhibited twice in 1886, firstly at the salon of the Société des Indépendants and then at the Eighth Impressionist exhibition. At both, the *Grande Jatte* received much critical attention, some supportive, some critical, and some distinctly hostile. Certainly the new technique confounded many but was explained in a review by Fénéon, while many strove to unravel the subject. Whatever the individual response, Seurat's significance was firmly established.

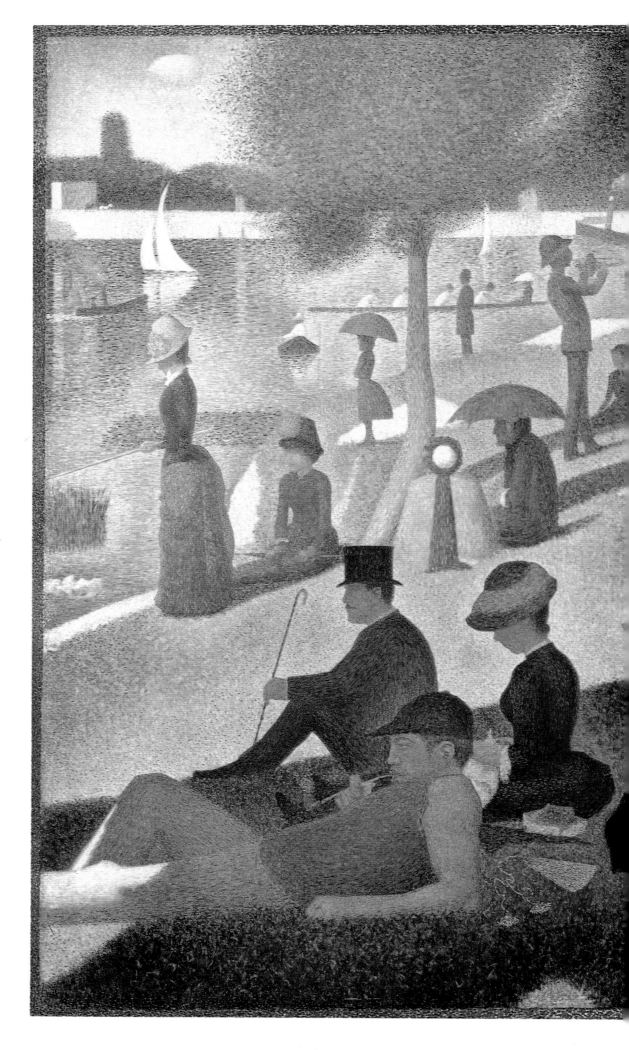

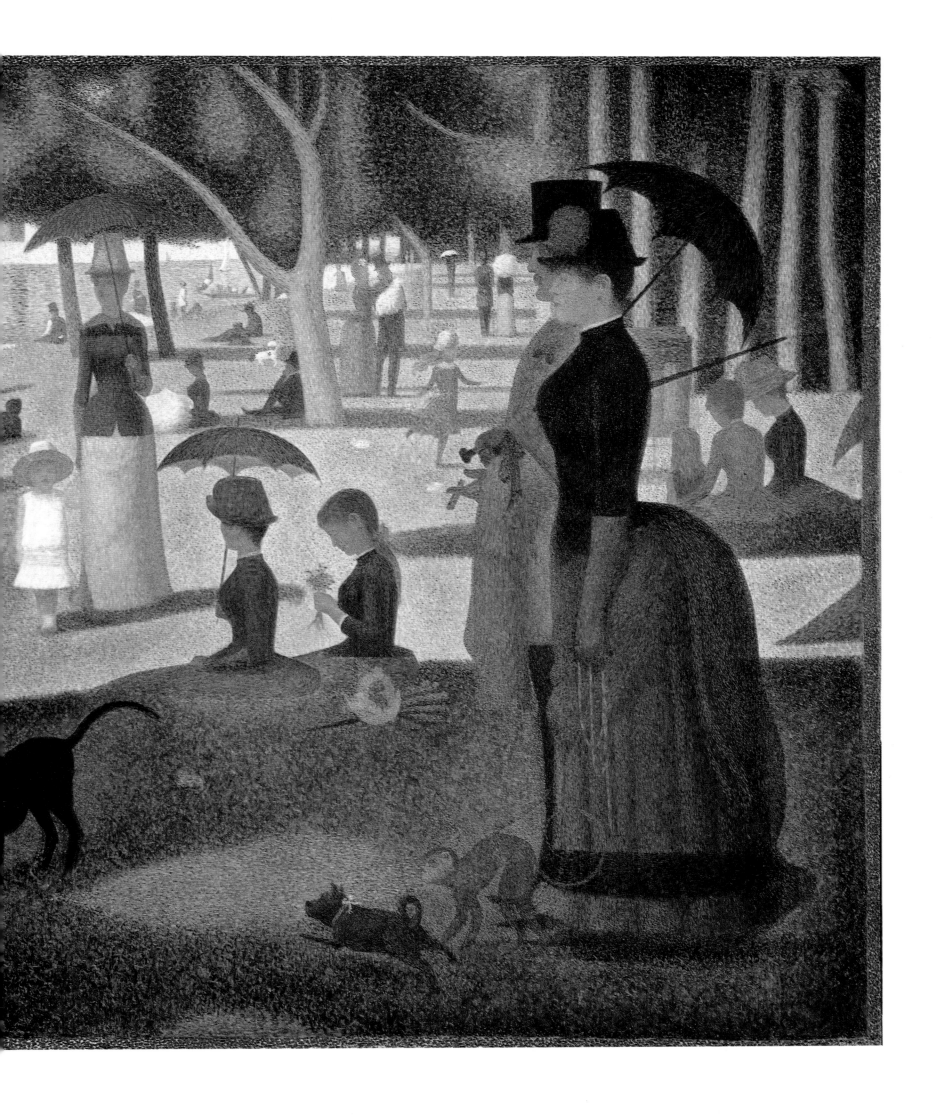

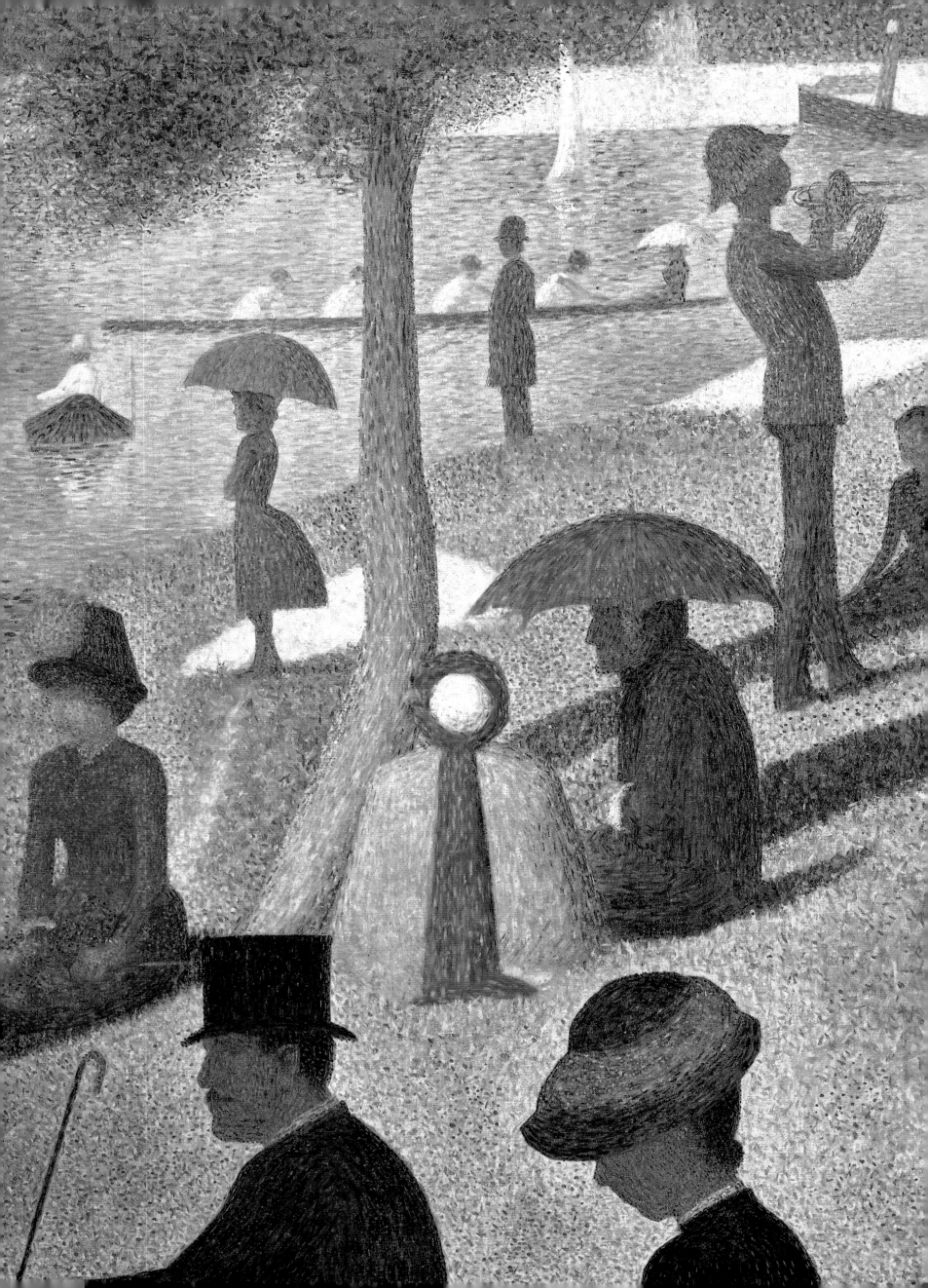

Un Dimanche à la Grande Jatte (1884), 1884-86

Detail
Oil on canvas
Art Institute of Chicago
Helen Birch Bartlett Memorial Collection

This detail shows the group of figures located slightly left of center in the *Grande Jatte*. In the distance two soldiers (see pages 90-91) walk side by side, their backs turned to the viewer; immediately in front of them two women are lounging on the grass while a man playing a horn strolls by. By the edge of the river a lone girl looks across to the opposite bank protected by her parasol from the piercing sunlight. In the foreground, behind the heads of the two fashionably dressed figures, three women can be seen sitting around the trunk of a tree. In a review discussing this painting, Seurat's friend Paul Adam referred to the stiffness of all the figures. He likened their treatment to the people seen in paintings by the fifteenth-century Flemish painter Hans Memlinc and praised their primitive qualities. The way in which many of the figures have been depicted in profile or directly from the front or back certainly adds to the stiffness referred to by

Paul Adam. Even though the subject is the leisured enjoyment of a Sunday there is everywhere a somber mood derived in part from the formality of the treatment of the figures. Each figure, or group of figures, is notable for its isolation. No-one calls out or gestures to anyone else, no-one appears to be engaged in conversation. This can be clearly seen by examining the group of three women seated around the tree. To the left a woman looks across the river, her back turned on the other two. To the right an older woman sits hunched under her parasol while the figure seen from behind is almost unidentifiable because of the abstract way in which Seurat painted her. Her round hat, red scarf and cape reduce her to a series of abstract forms and the simplified treatment is at its most extreme here. She is, in fact, a wet-nurse but she has been reduced to a mere type, a faceless, anonymous member of the Sunday crowd on the Grande Jatte.

93

Un Dimanche à la Grande Jatte (1884), 1884-86

Detail
Oil on canvas
Art Institute of Chicago
Helen Birch Bartlett Memorial Collection

Seurat must have agonized over the figures of the fashionably dressed man and woman who dominate the whole painting. Numerous studies were drawn and painted as Seurat worried over their poses, their gestures, and their appearance. In particular, Seurat repeatedly worked on the figure of the woman by gradually adding to the exaggerated curves that characterize her in the completed painting. When the *Grande Jatte* was exhibited in 1886 the figure of the woman was immediately identified as a cocotte. Later, in 1890, Jules Christophe described these two figures as the 'hieratic and scandalous couple; the elegant young man giving his arm to his pretentious companion with a monkey on a leash.' Ever since, commentators have identified the woman as a prostitute who openly flaunts herself with her male companion by her side. Although this interpretation has become widely accepted since Christophe's description, many reviewers who wrote about the painting in 1886 referred to the seriousness of the subject rather than its vulgar aspects. More recently attention has been drawn to the dominance of the number of women within the painting and it has been suggested that one of Seurat's concerns was the status of the family. Surrounding these two figures are groups of women and children. To their right are seated two women and a small girl, to their left and further into the distance a young girl dances and behind her a woman rearranges a blanket of a baby held by the father. This little group is the only example of a unified family and their juxtaposition with the faces of the walking couple in the foreground forces the contrast between them and the loose morality of the prostitute and her admirer. The prostitute rejects the motherly and family concerns of the groups of women who surround her.

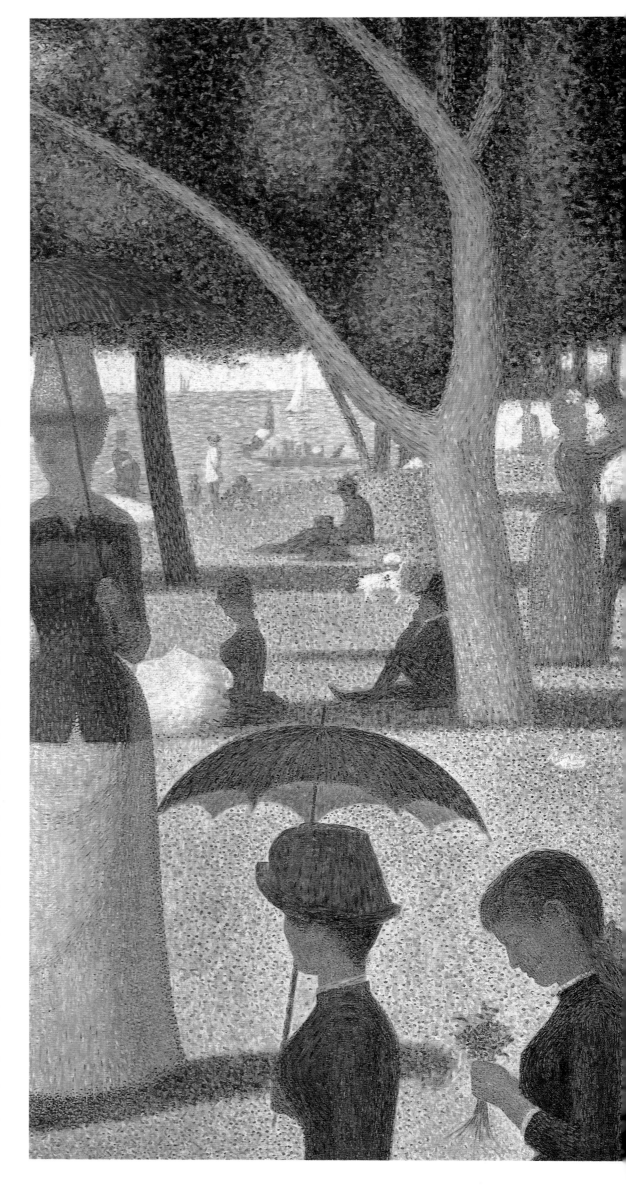

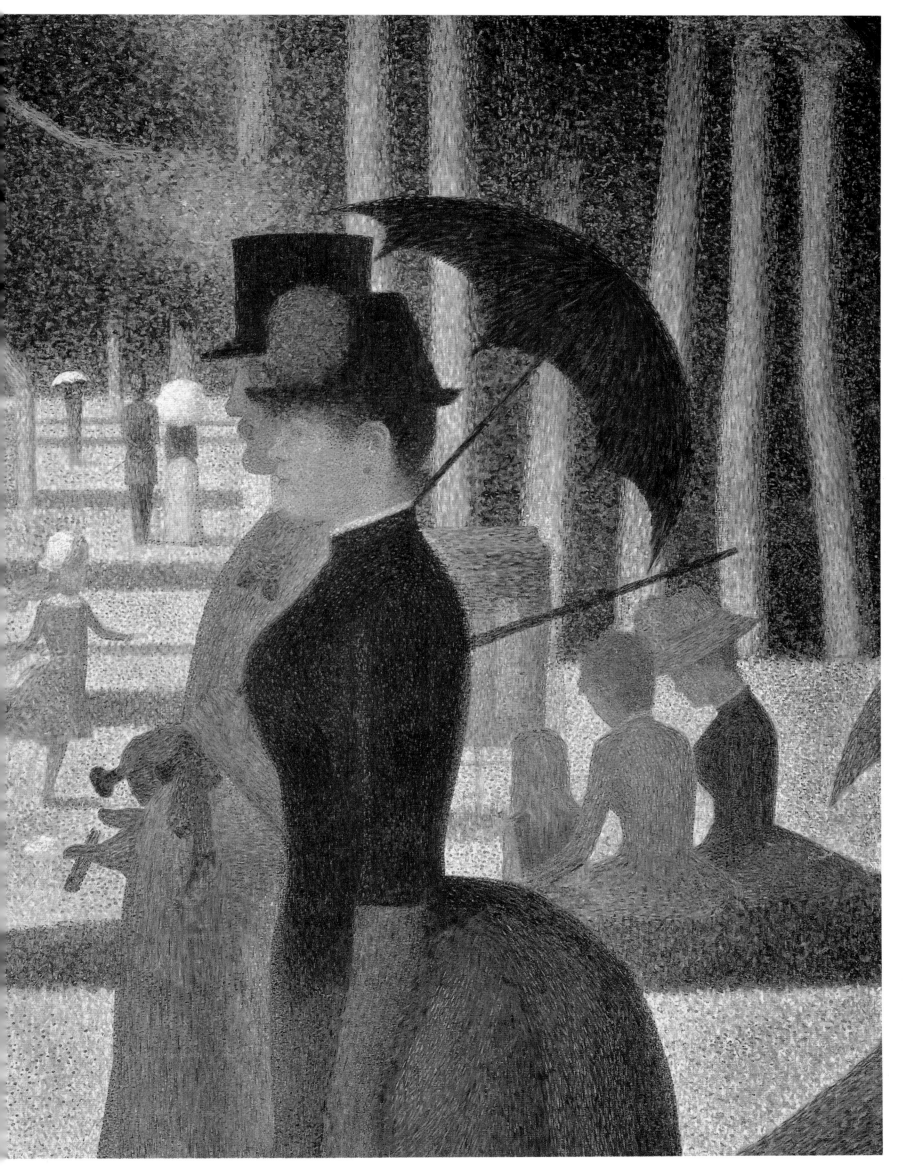

95

Un Dimanche à La Grande Jatte (1884), 1884-86

Detail
Oil on canvas
Art Institute of Chicago
Helen Birch Bartlett Memorial Collection

In the lower left corner of the painting Seurat painted this group of three figures. Pictorially they form a dominant and important part of the overall composition of the canvas. Located in the same spatial plane as the two standing figures at the extreme right of the painting, they define the foreground space and the triangular axis between these two groups, and completed by the woman and child in the center of the canvas, provides the main structural feature of the *Grande Jatte*. Silhouetted against the surface of the painting this group enhances the flatness of the painting but, at the same time, their poses lead the eye into the painting and establish a series of rhythms which are repeated throughout the canvas. For example, the diagonal of the bent leg of the reclining man is echoed by the angle of the walking stick of the top-hatted figure and, behind him, the diagonal is continued by the tree trunk further in the distance. Thus their profiles and postures both enhance the flatness of the painting and contribute to its depth. Although they occupy the same shaded area of grass it is not clear what the connexion between them is. They ignore each other; the two men with their blank, expressionless faces stare into an empty space while the woman passes her time reading and sewing. Their costumes draw attention to their differences. The formally dressed man and the fashionable clothes of the woman contrast with the casualness of the reclining, pipe-smoking man. But are they related to each other? It would appear not. They do not acknowledge each other's presence and they are not engaged in conversation. They are part of the vast anonymous population attracted to the island for the same reasons. It is leisure which unites the otherwise fragmented Parisian population.

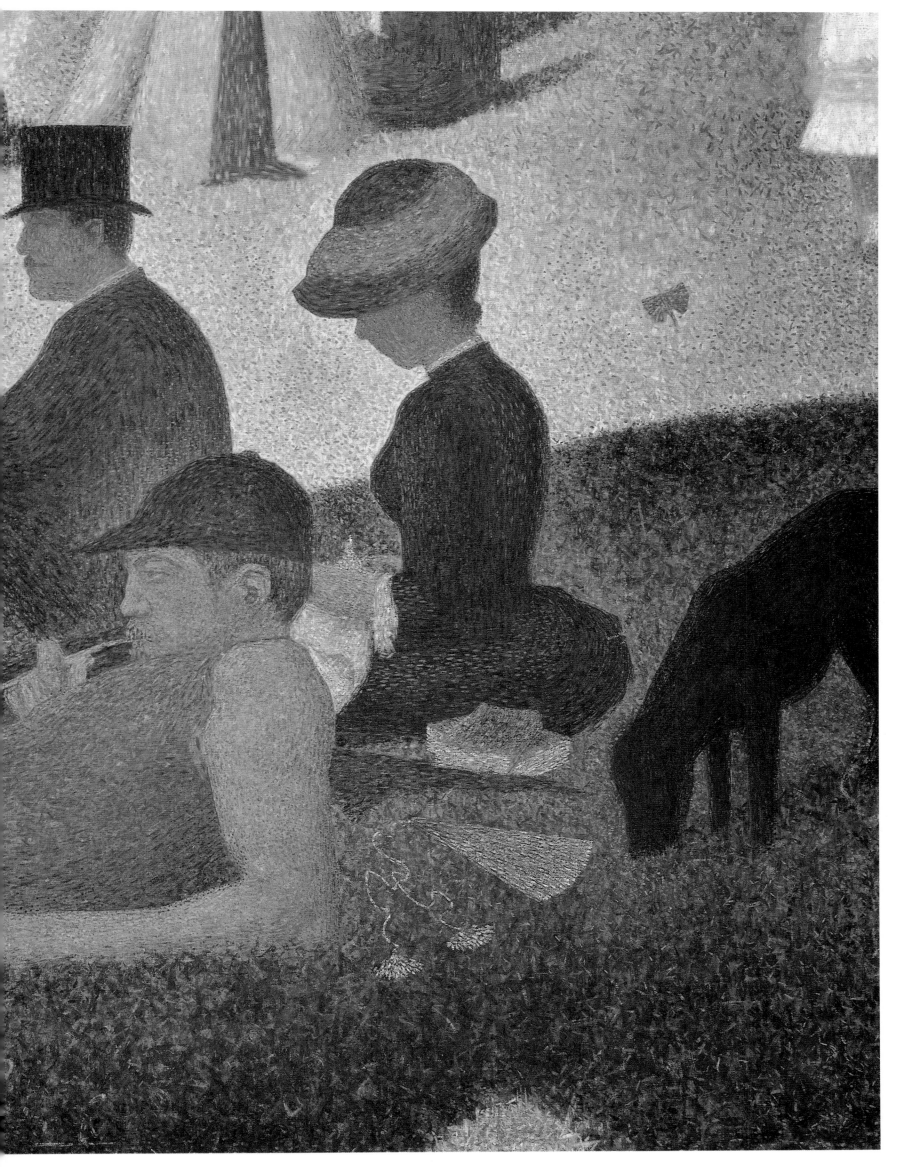

Family Group (Condolences),

c. 1886

Conté crayon on paper
9½×12⅝ inches (24×32cm)
Berggruen Collection, on loan to the
National Gallery, London

Exhibited in Paris in 1886, this drawing is one of the rare group portraits produced by Seurat. It was lent to the last Impressionist exhibition by its owner, the art critic and Symbolist writer Joris Karl Huysmans. Considerable disagreement exists as to the date of this drawing, some proposing that on stylistic ground it must have been drawn in 1883-84 while others date it to 1886. The latter date has been put forward because the subject, it has been suggested, represents the funeral of Seurat's maternal grandmother, even though the precise date of her death remains unknown. In it, a group of four people are located in an interior which lacks much detail and the setting is difficult to identify. One figure is shown from behind, one slightly turned at an angle, one in profile and the fourth, a bearded man, faces outwards, although his head is bent to one side and he appears to be engaged in conversation with the older

woman on the right. Is this man Seurat? His slim appearance and pointed beard are features shared by Seurat and it is tempting to consider that this drawing contains a rare self-portrait of the artist. The shadowy forms of the figures lack definition, their bodies merging into the interior setting. All would appear to be standing and it is possible that even though Seurat gave the drawing to a friend, it is not fully resolved. Some sense of an architectural background is given but the foreground area remains elusive. Seurat has also varied his drawing technique. The darkened forms of the figures are characteristic of other conté drawings where the crayon has been dragged across the surface of the paper and the degree of pressure has determined the tone. In contrast, and less commonly in his work, in the foreground there can be seen a series of more aggressive and slash-like crayon marks.

Fishing Boats, Low Tide, 1885

Oil on canvas
25½×32¼ inches (65×82 cm)
Reid and Lefevre Ltd, London

With the cancellation of the Indépendants exhibition arranged for 1885, Seurat halted his work on his painting of the *Grande Jatte* and left Paris for the Normandy coast. His summer trip to Grandcamp marked the beginning of a series of summer excursions to different parts of the Normandy coastline during the following five years. In establishing a pattern of working in Paris throughout the fall, winter, and spring combined with a summer spent painting at the coast, Seurat was following a tradition already popular among artists in the nineteenth century, such as Johann Barthold Jongkind and Claude Monet. This first excursion resulted in five paintings of scenes of the Grandcamp coastline and its immediate environs. Apart from their significance as Seurat's first important seascape canvases, these paintings were crucial in the development of a fully Neo-Impres-

sionist style, which was not apparent in his paintings of early 1885, but was firmly established by the end of that year.

In this example the setting of early evening with the boats leaning at different angles because of the low tide combined with the calmness of the weather evokes a feeling of quietude and stillness. Such feelings were noted by critics of the time. Félix Fénéon, Seurat's most ardent supporter, wrote of the melancholic quality of the Grandcamp seascapes: '*Boats off Grandcamp*, a slow procession of triangular sails and another view of the sea where a column of sun is quivering – it makes us stop and wonder, anxious at such infinity.' Noting such a melancholic mood another critic, Jules Vidal, commented that Seurat's 'seascapes are done with an expert technique, resonant with the open air, and with an enchanting impression of sadness.'

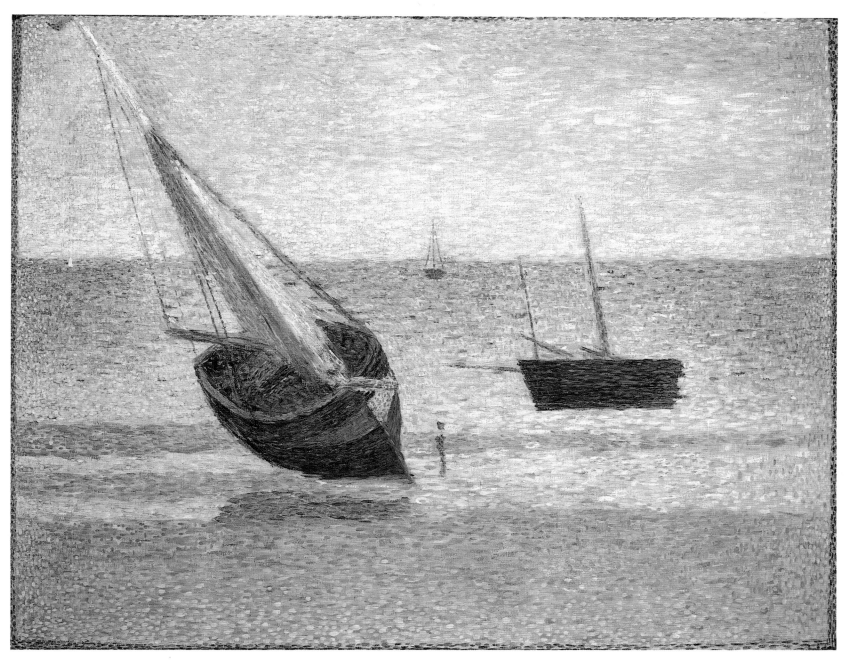

Bec du Hoc, Grandcamp, 1885

Oil on canvas
25½×32¼ inches (65×82 cm)
Tate Gallery, London

This painting is the most dramatic that
Seurat painted during his visit to Grand-
camp. The sandstone outcrop dominates
the painting and the way it is juxtaposed
against the background of sea and sky
make this one of Seurat's most important
seascapes. Obviously Seurat felt so as he
exhibited the painting five times between
1886 and 1888; in 1886 it was exhibited
twice, like the *Grande Jatte,* which it
flanked both at the last Impressionist ex-
hibition and then at the second Salon des
Artistes Indépendants. Both the composi-
tion and, to a much lesser extent, the hand-
ling of paint reveal a debt to the work of
Claude Monet. Monet had made repeated
trips to the Normandy coast throughout
the 1880s during which he painted many
cliff scenes. These paintings are charac-
terized by their dramatic compositions,
partly derived from Japanese prints, where
the forms of cliff, sea, and sky are treated as
a series of interlocking planes and tradi-
tional perspective is rejected. Sudden leaps
in space are complemented by a varied
treatment of the paint surface in order to
capture the particular qualities of sea, of
cliffs, and of the sky.

Seurat, here, has clearly adopted
Monet's compositional device in the way
that the relationship between the viewer
and the foreground is unclear, and in the
jumps in space from the clifftop to the out-
crop of the Bec du Hoc itself and, beyond,
to the sea and sky. The exuberance of
Monet's brushwork is rejected for a more
systematic and even application of paint,
although in this painting Seurat still varied
his brushmarks in different areas of the
canvas. The surface of the cliff is painted in
a series of criss-cross strokes which build
up to a dense surface effect, while the sea is
painted in a pattern of short, parallel
brushstrokes. The sky is painted in a loose
manner, much more akin to the approach
of Monet.

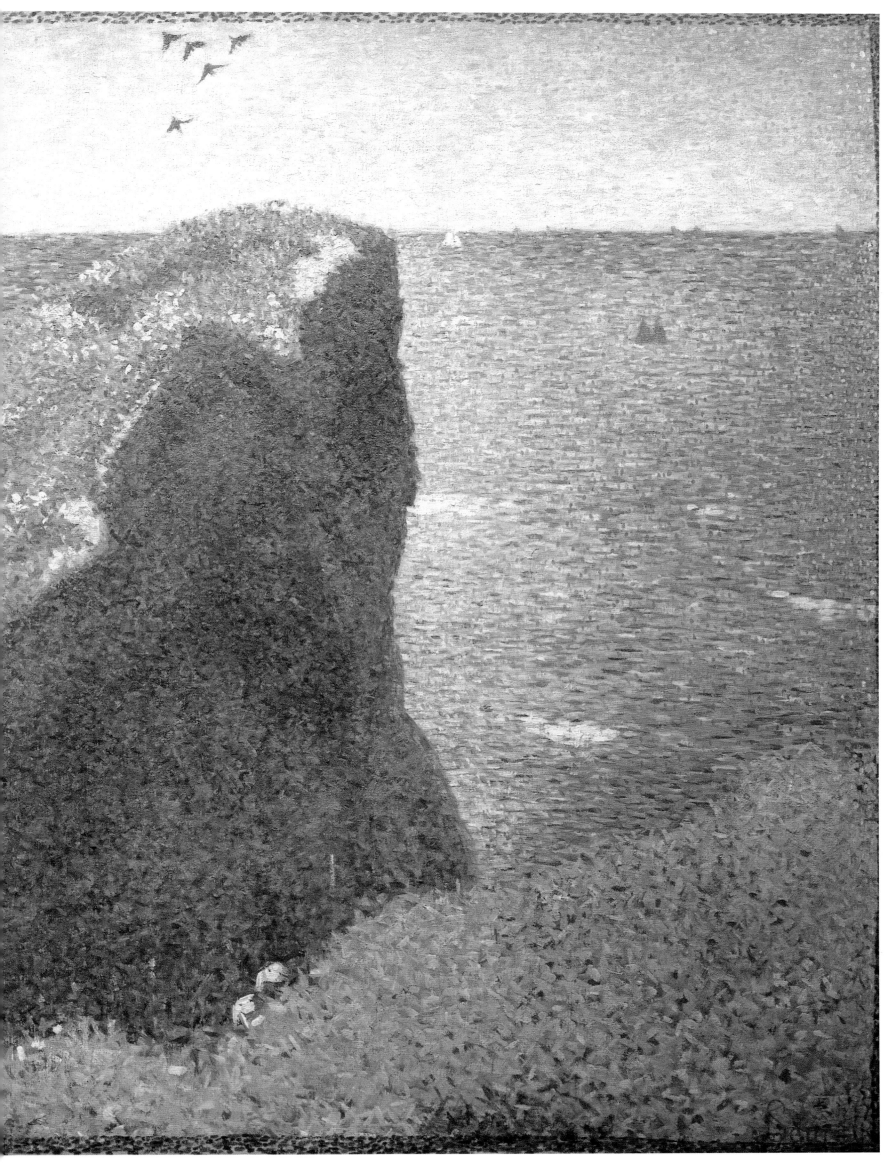

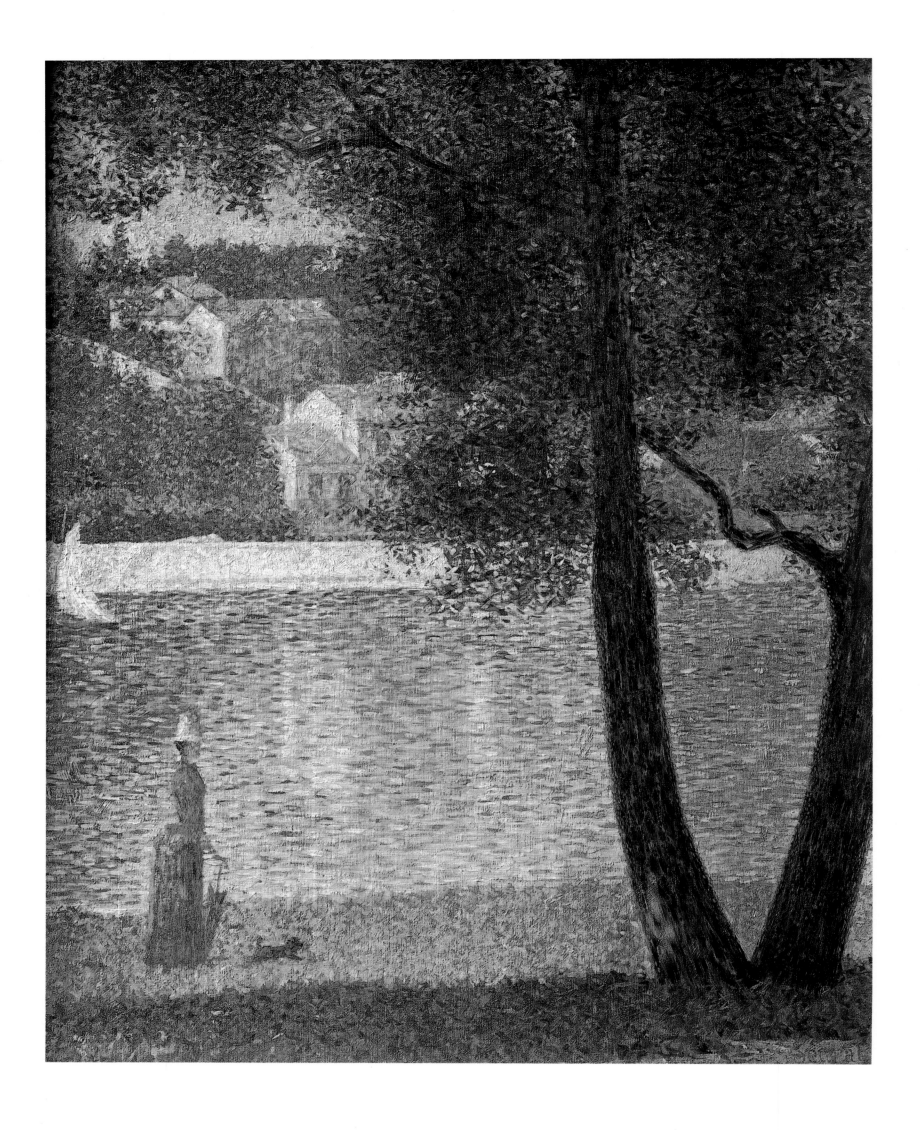

The Seine at Courbevoie, 1885

Oil on canvas
31⅜×25⅝inches (65×82cm)
Private Collection

Much of Seurat's work during 1885 was concentrated on the continuing development of the second of his large paintings, the *Grande Jatte* (page 90), which was exhibited at the last Impressionist show the following year. This exquisite painting was also exhibited at the same time and, in certain ways, it has similarities with the *Grande Jatte* while, in other important ways, it is significantly different. The location of the subject is the island of the Grande Jatte, seen in the foreground; the houses depicted on the opposite bank are the suburban villas which were being built in the expanding suburb of Courbevoie. References to the increasing industrialization along the banks of the River Seine have been excluded here. The factories in the background of *Une Baignade* (page 72) would have seemed an unacceptable intrusion to the peaceful setting of the bourgeois homes nestling on the riverbank. The

varieties of Parisian population that throng the island in the *Grande Jatte* are here represented by the solitary figure of a woman walking her pet dog. Even if it is the same dog that makes such a telling appearance in the foreground of the *Grande Jatte* the mood of this painting could not be more unlike that of the larger painting. The darker side of the landscape is rejected. Instead Seurat has painted a canvas that is full of the life of a summer's day. Sunlight animates the far bank and the surface of the river; a single boat signifies the pleasure of sailing and the solitary woman with her parasol relaxes in the heat of the afternoon. The evenness of the brushmarks suggest that this painting may have been painted on Seurat's return to Paris from Grandcamp. Although this painting was not a study for the *Grande Jatte*, it presents a contrasting image of the island as seen in *Un Dimanche à la Grande Jatte (1884)*.

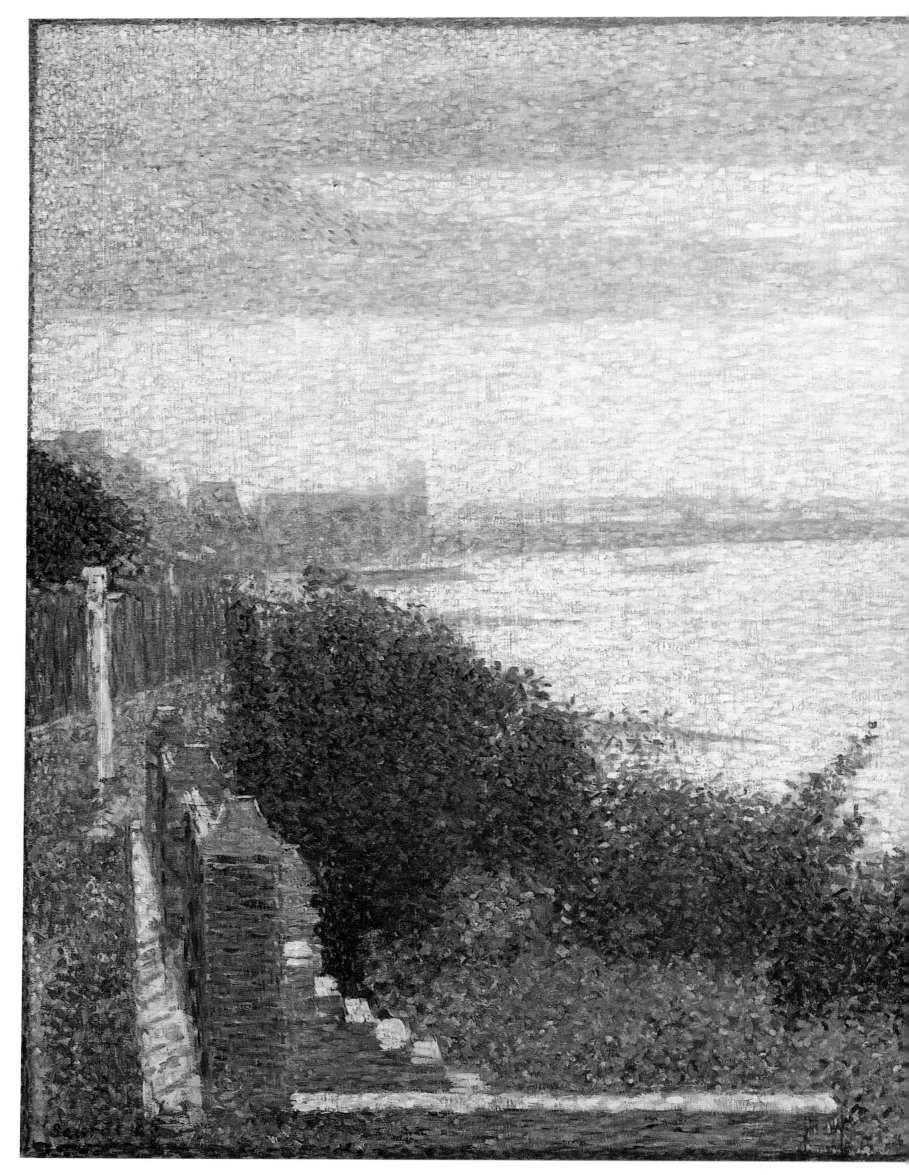

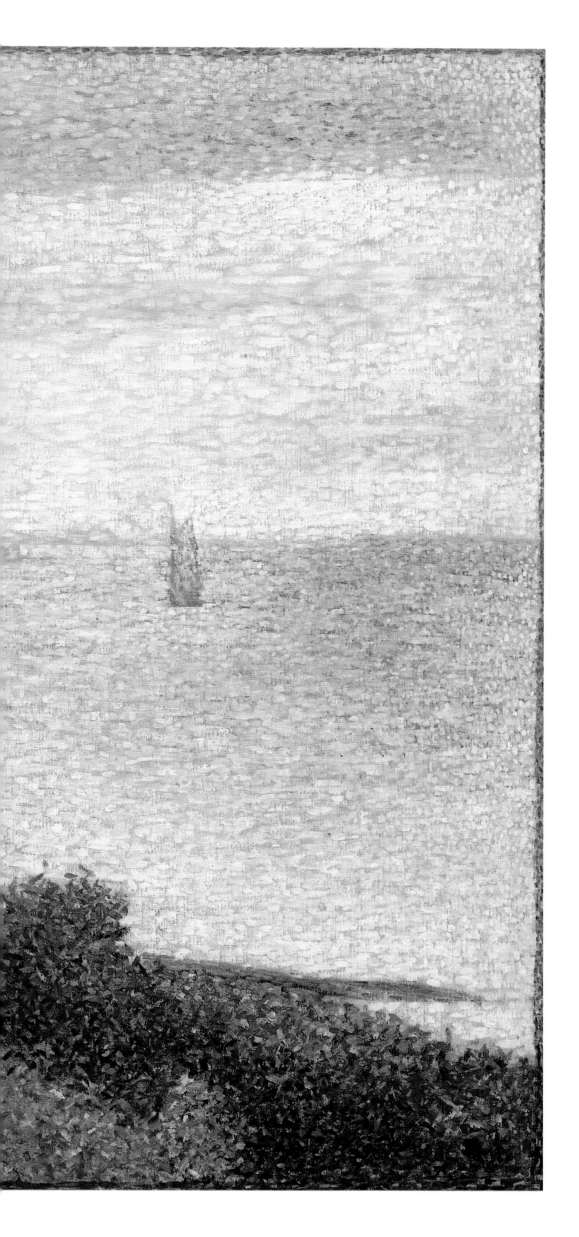

Grandcamp, Evening, 1885

Oil on canvas
26×32½inches (65×82cm)
Collection, The Museum of Modern Art,
New York
Estate of John Hay Whitney

Exhibited at the second salon of the Societé des Artistes Indépendants and the Eighth Impressionist exhibition in 1886, this painting is often titled *The English Channel at Grandcamp.* In an ambivalent review Emile Hennequin praised the delicacy of Seurat's seascapes but he felt that the views were unsatisfactory and that the new technique was beyond comment. He described how: 'Seurat has surprised the unpleasant views with a new approach on which we are not competent to comment. But judging the general effect of the canvases, we find extremely delicate tints in his series, notably in the seascapes at Giraud Camp (sic). In them the sea has the right color, that blue-gray spangled with green that makes the northern archipelagoes so charming.' In the compositional arrangement Seurat has established a format he returned to in many of his other Marines. In the foreground a strong diagonal divides the image between a clearly defined area of foliage and the more expansive areas of sea and sky. The use of such a diagonal division is offset by the many vertical and horizontal forms of the various architectural elements, the steps in the foreground, and the buildings and harbor wall in the distance. In common with the other Grandcamp paintings Seurat's technique is varied in this painting. The foliage is densely painted in a series of criss-cross brushmarks, while the sea and sky are painted in small parallel brushstrokes stretching across the canvas. Throughout, as Hennequin noted, there is a blue-gray tonality with just the hint of the sun shining through an overcast sky in the play of light on the surface of the sea. The darker clouds in the sky continue the predominantly horizontal rhythms throughout the painting.

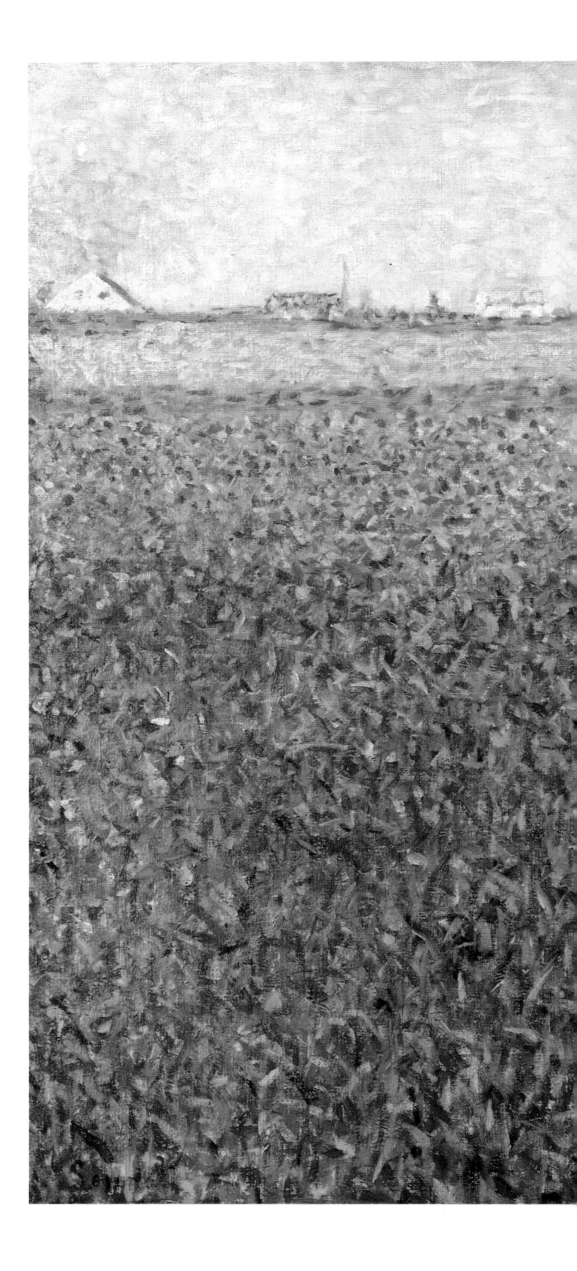

Lucerne at Saint-Denis, 1885

Oil on canvas
25½×31⅞ inches (65×81 cm)
National Gallery of Scotland, Edinburgh

Notable for its open foreground and the high horizon, this painting is a transitional work in the development of the Neo-Impressionist style. Saint-Denis was a northern suburb of Paris, an area characterized by its market gardens. On the edge of Paris, Saint-Denis was part country and part city. Small-scale agriculture was expanding in order to meet the demands of a rapidly growing city, but, at the same time, that very expansion threatened to swallow separate communities such as that of Saint-Denis. Here, a field of lucerne, grown for fodder to feed the vast population of horses necessary for the functioning of Paris, is nearing harvest. The field dominates the foreground while, near the top of the canvas, a wall separates the buildings of Saint-Denis. Seurat has applied the paint in a series of dash-like brushstrokes, the local color being overlaid with touches of other colors. For example, the area of shadow in the foreground has been painted in green with flecks of blue to enhance the shadowy effect, while those areas in sunlight have been overlaid with touches of yellow ocher. Flecks of red paint identify the crop's readiness for harvesting. In the background the wall is painted in a much freer way, made up of a series of broader and longer dash-like brushstrokes. The sky, too, is quite loosely painted. This technique and compositional form can be seen in the paintings of Paul Signac at this time. He had made Parisian suburban subjects something of a speciality and shared a similar interest in the encroachment of the city on the surrounding countryside. Also, this type of composition with its high horizon was particularly influential on Seurat's friends, notably Charles Angrand and Vincent van Gogh, who made much use of this arrangement in his early paintings of Arles in 1888.

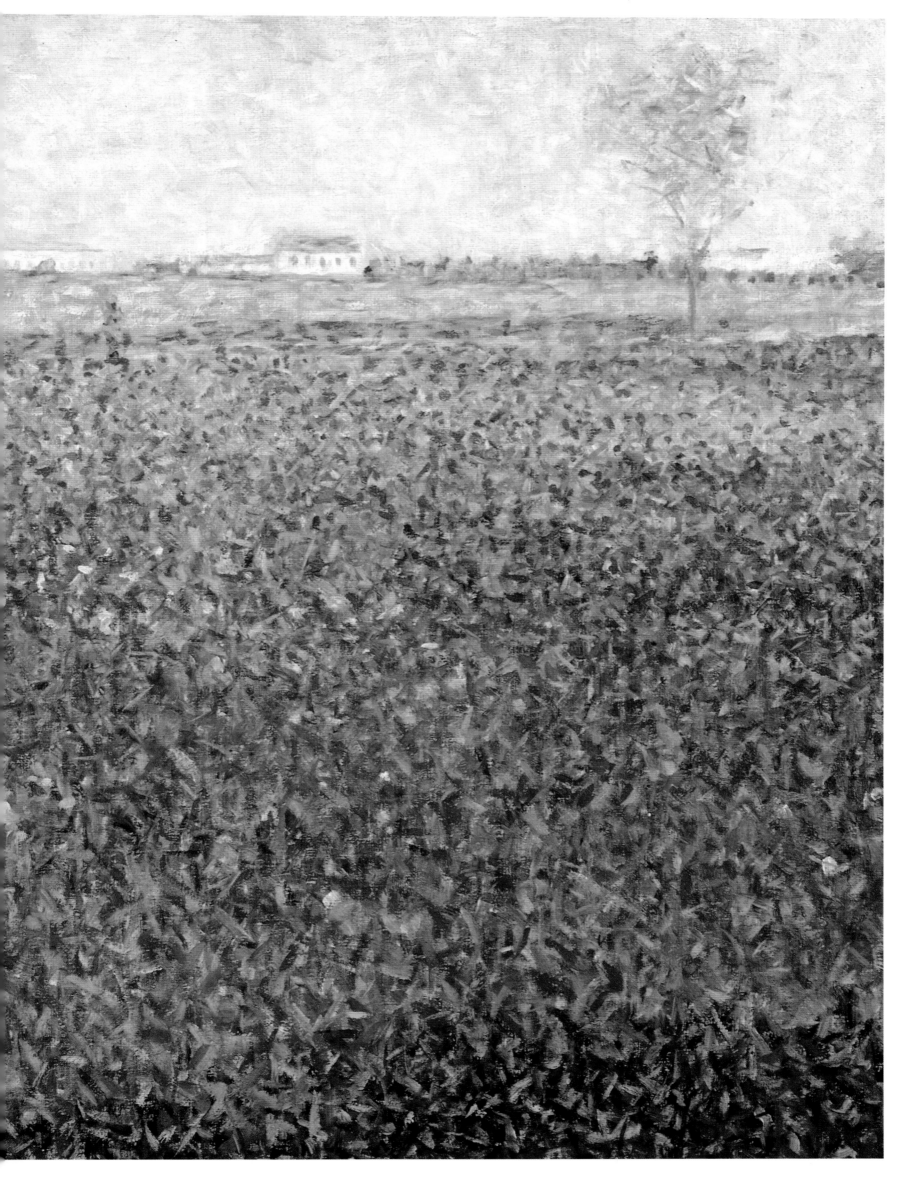

107

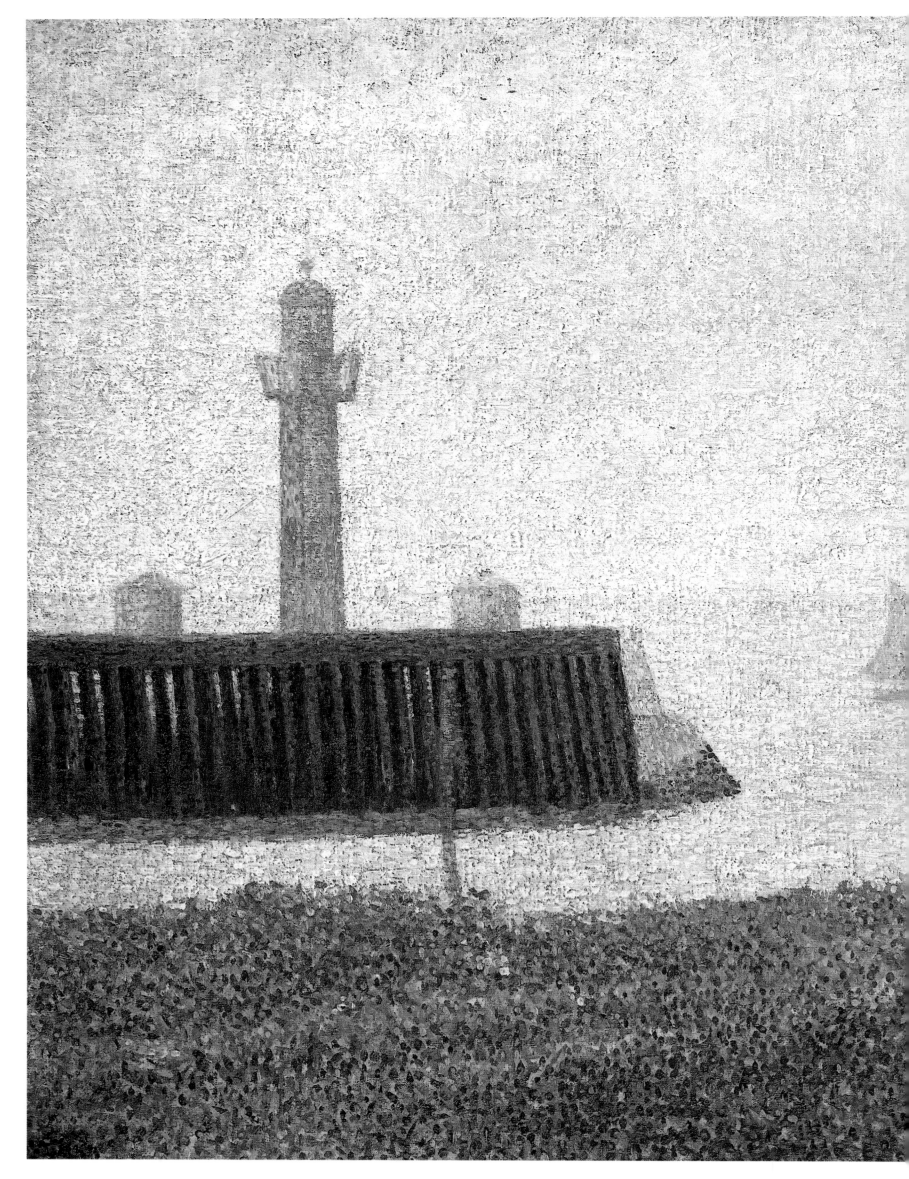

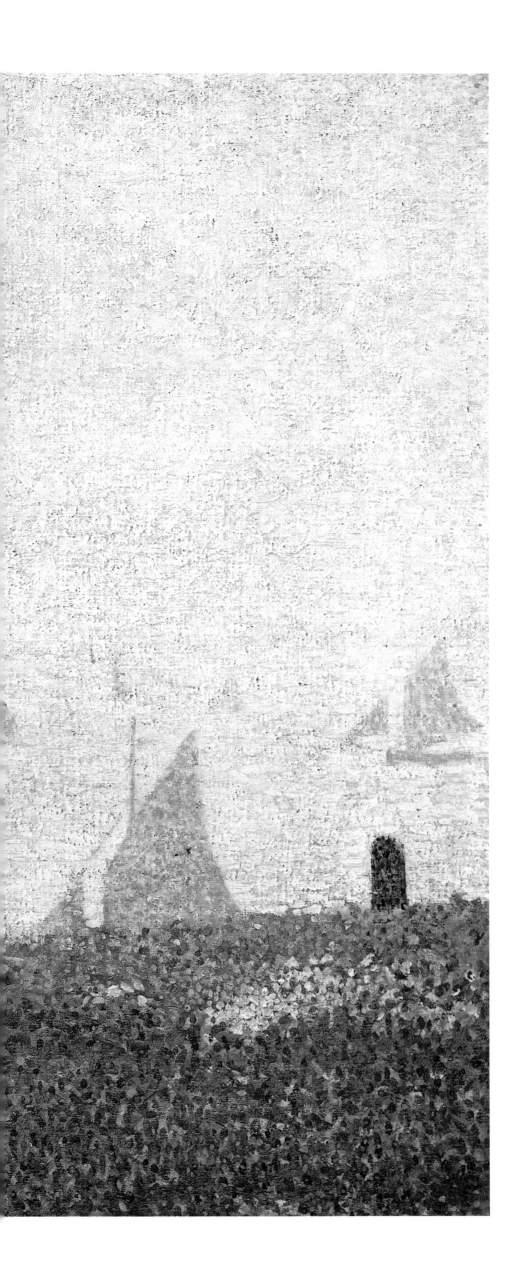

End of a Jetty, Honfleur, 1886

Oil on canvas
18⅛×21⅝ inches (46×55 cm)
Kröller-Müller Museum, Otterlo

As with other paintings which date from Seurat's visit to Honfleur, this canvas was probably completed in Paris during the fall of 1886 and it was ready for exhibition at the March 1887 salon of the Société des Indépendants. There it was purchased by Paul Adam, a young writer and critic whom Seurat might have met through Paul Signac, although he was also a close friend of Albert Dubois-Pillet, that stalwart of the Société. Adam was involved with the emerging Symbolist movement, he knew Félix Fénéon and collaborated with him on publishing various periodicals associated with the new movement. He also engaged in art criticism. In a review of the marines Seurat exhibited in Paris in 1886, where he showed canvases painted the previous summer at Grandcamp, Adam was critical. He felt that the paintings owed too much to Impressionist, and therefore naturalist, practice and that they lacked a suggestive mood. For Symbolist writers such as Adam, the Impressionist artists had tried to capture the fleeting moment, and in their canvases nature was 'in permanent convulsion.' However, he was much more impressed by the Honfleur marines. In contrast to Impressionist paintings, and Seurat's Grandcamp marines, these canvases contained a more enduring quality. Such sentiments were shared by Gustave Kahn in his review of the same exhibition. In this example a calm summer's day is represented with many boats sailing in and out of the harbor entrance where it meets the estuary of the river Seine. Seurat's Honfleur paintings fall into two compositional types; those that feature a strong diagonal arrangement and those where the emphasis is on the horizontal. Clearly this painting is one of the latter, with its bands of foreground, sea, jetty, and sky which, for Fénéon, gave the painting its 'serene character.'

The Beach of Bas-Butin, Honfleur, 1886

Oil on canvas
26⅜×30¾ inches (67×78 cm)
Musée des Beaux-Arts, Tournai

Seurat's paintings of Honfleur have long
been recognized as evidence of his skills as
a landscape- and seascape-artist of major
importance. Favorably received by a small
group of young critics, those of the newly
emerging Symbolist movement, Seurat's
paintings were noted for the calmness of
their mood, for their accurate observations
of natural forms, and for the delicacy of the
light. Nowhere are these observations
better illustrated than in this example. The
commercial workings of the port of Hon-
fleur are here neglected in favor of the cliffs
and beach which overlook the Seine estu-
ary. The only suggestion of a commercial
port is the packet-boat edging its way
towards the coastline. This painting may
have been one of the first undertaken by
Seurat on his arrival in June 1886 as it was
ready for exhibition in Nantes in October
1886, along with *The Lighthouse* (page
114). Sweeping up diagonally from the left
foreground is the sandy beach which
merges imperceptibly with the cliffs; the
calmness of the sea and the virtually cloud-
less sky combine to suggest the balmy
mood of a fine summer's day. Composi-
tionally the painting reveals a debt to
Claude Monet's cliff scenes of the early
1880s, particularly in the way the space is
organized into a number of clearly defined
sections – the foliage in the foreground, the
sandy forms of beach and cliff, the sea, and
then the sky. Unlike Monet, Seurat has re-
jected the extremes of weather conditions
and instead of capturing the dramatic he
has selected the almost ordinariness of a
hot summer's day. Nothing is happening,
nothing moving and, unlike Monet's pre-
ference for juxtaposing human beings
against the forces of nature, Seurat ex-
cludes any human element. The interlock-
ing of the forms may owe something to the
influence of Japanese prints.

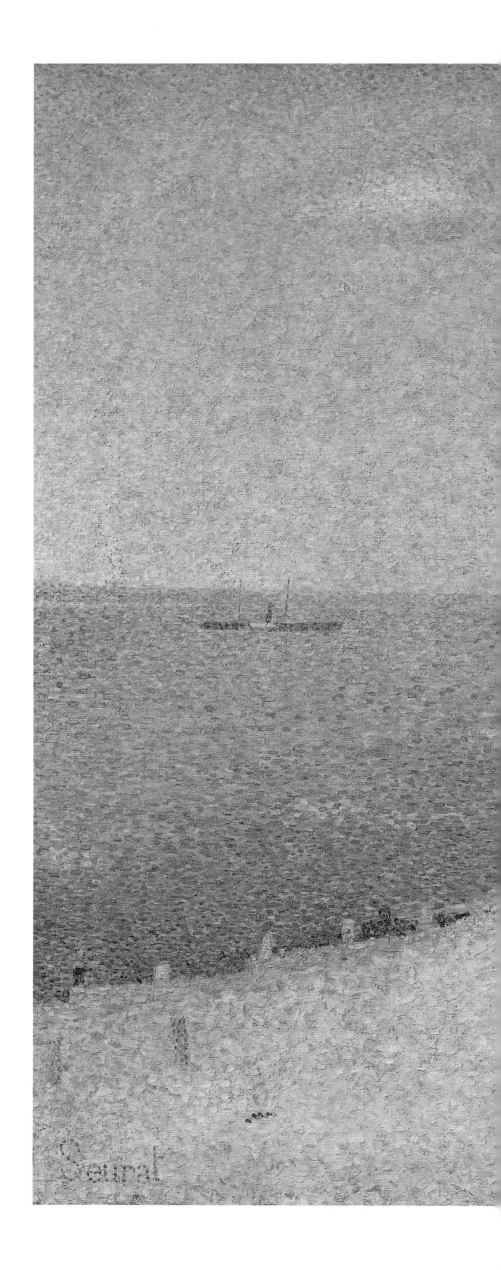

110

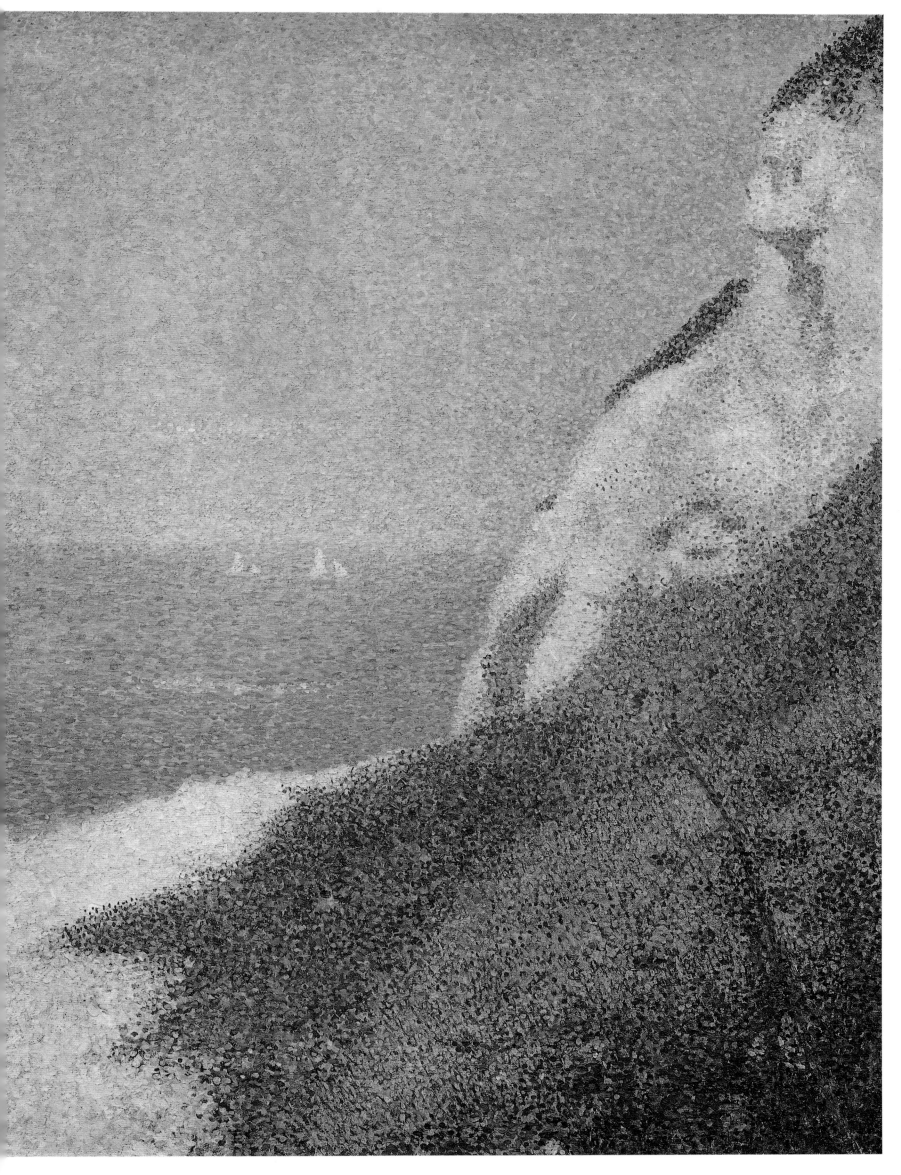

111

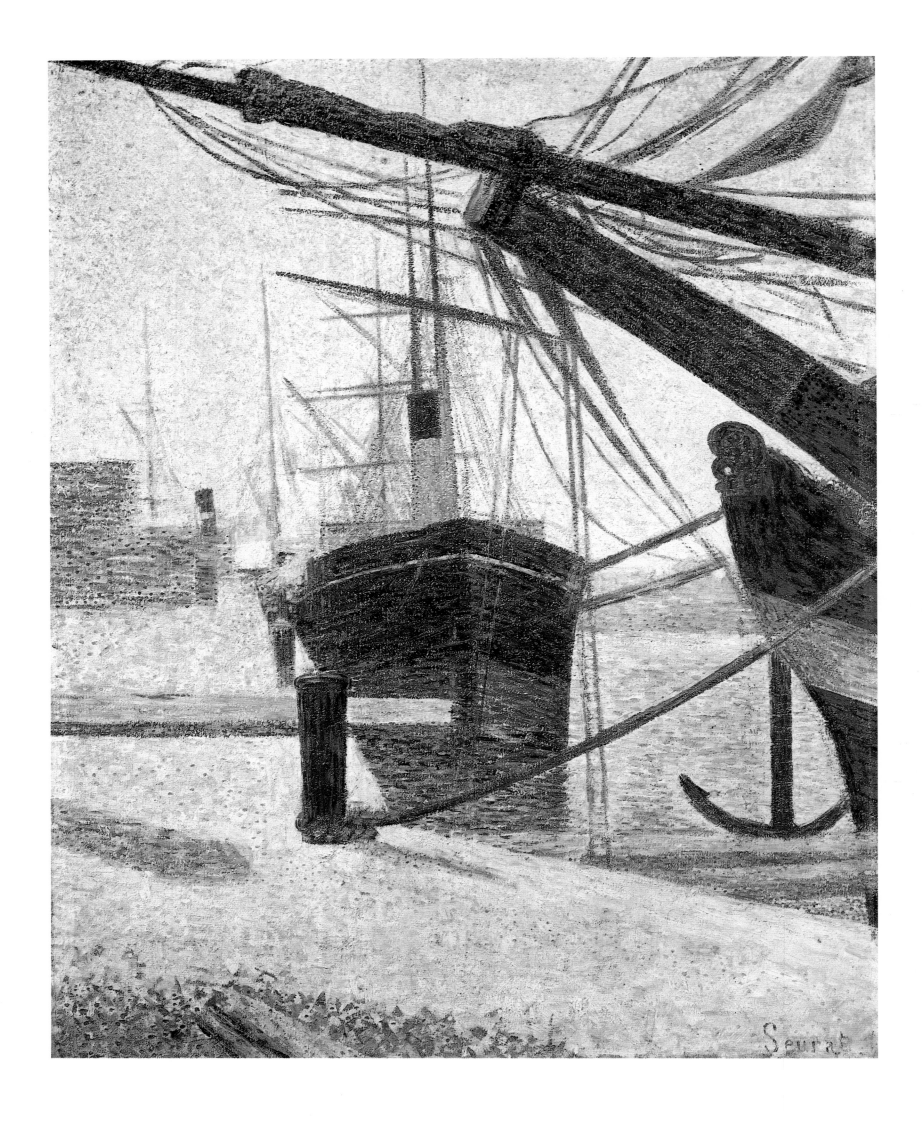

Corner of a Dock, Honfleur, 1886
Oil on canvas
31⅞×25⅝ inches (81×65 cm)
Kröller-Müller Museum, Otterlo

This painting is directly related to the *'The Maria' Honfleur* (page 116) in the similarity of the subject – boats tied to the jetty side – and in the compositional arrangement, with its pronounced vertical axis. This is, however, a less finished work and as such is the exception to the rest of the Honfleur series. Its status as a sketch was acknowledged by Seurat when he wrote to his friend Paul Signac in August 1886, noting that this picture was completed as a large-scale sketch, 'the motif having long since dispersed.' Seurat's determination to be faithful to the motif, to capture accurately the scene in front of him, can be measured by his comment that the disappearance, presumably of one or both of the boats, meant that he could not complete the painting. He must have been satisfied with it, however, as the painting was exhibited immediately on his return to Paris at the

second salon of the Société des Artistes Indépendants which opened on the 21 August; it was exhibited as a 'a large oil sketch.' In February 1887 the painting was displayed in Brussels. Subsequently it was given by Seurat to Emile Verhaeren and in a letter Seurat explained that it was a sketch, 'only a week's work.' As such it provides an invaluable insight into Seurat's working method as it had evolved by the summer of 1886. The main elements have been sketched in and defined by a variety of brushmarks, horizontal dash-like strokes defining the surface of the water in the harbor, vertical strokes for the bollard. The foreground is treated in quite a free way and any dotting of the picture surface is quite random at this stage. The position of the shadows suggests that Seurat painted this in the evening, at a slightly later time than he painted the *'Maria'*.

The Hospice and the Lighthouse, Honfleur, 1886

Oil on canvas
26¼×32¼ inches (66.7×81.9 cm)
National Gallery of Art, Washington
Collection of Mr and Mrs Paul Mellon

The seascapes he exhibits this year, his views of Honfleur, especially his *Lighthouse*, affirm the very real talent of which he has already furnished indisputable proof. These pictures still depend upon the sensation they express of nature more dormant than melancholy, a nature calmly at ease beneath wrathless skies, sheltered from the wind I find in them a repose for the quiet soul, a distinction of pallid indolence, a caressing sea that lulls all weariness and disperses it.

So wrote the critic J K Huysmans in April 1887 when he saw Seurat's paintings of Honfleur for the first time. The qualities of calmness and permanence were much praised by a younger generation of Symbolist critics and it was those characteristics which separated Seurat's seascapes from those of the Impressionist artists. Reviewing the same exhibition, Gustave Kahn drew attention to Seurat's 'anti-Impressionism.' Kahn described how:

Seurat gave nature a calmer aspect through a new process (juxtaposed dots), enabling [him] to conform more faithfully to the tenuity of light and its effects. [He] chose calm landscapes, less troubled waters, and tried to convey a more permanent image of a landscape rather than its momentary appearance.

In a letter to Signac, Seurat informed him that this picture was merely sketched in when he left Honfleur for Paris. It was worked on through late summer in his studio and was exhibited in Nantes in October 1886, and again at Les Vingt in Brussels in February 1887. There it was purchased by Emile Verhaeren who was informed by Seurat that the painting was the result of two and a half months' work. The view looks upstream, back towards Honfleur, the hospice on the right and the lighthouse centrally located; throughout there is a careful balancing of vertical and horizontal forms.

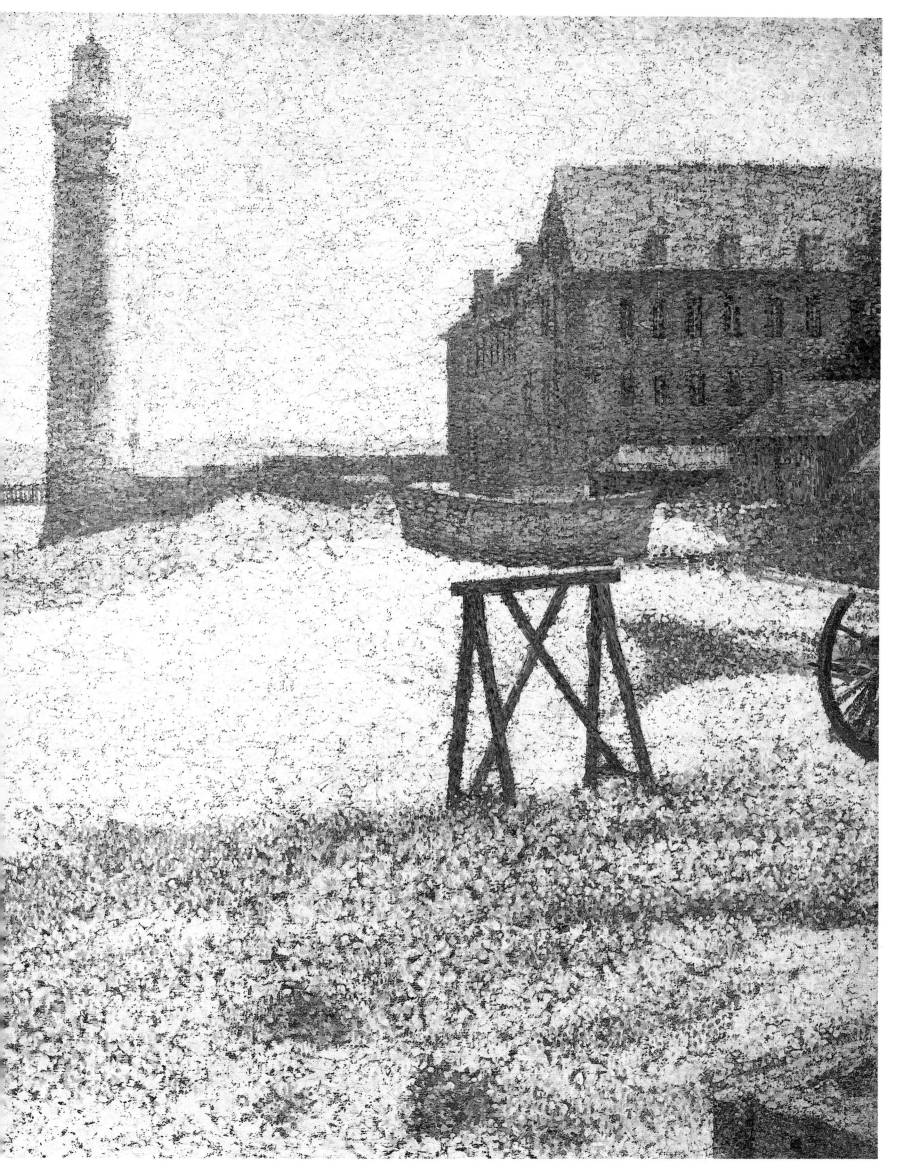

115

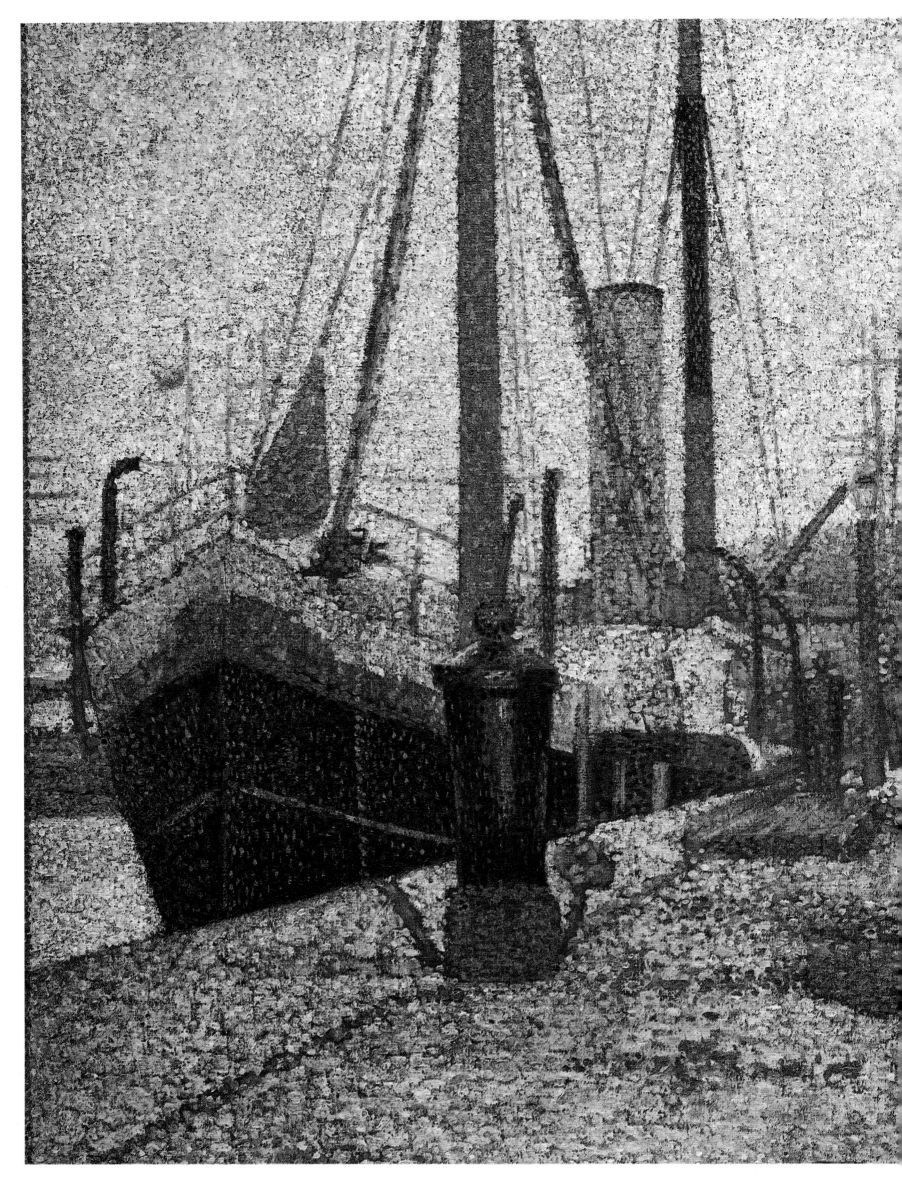

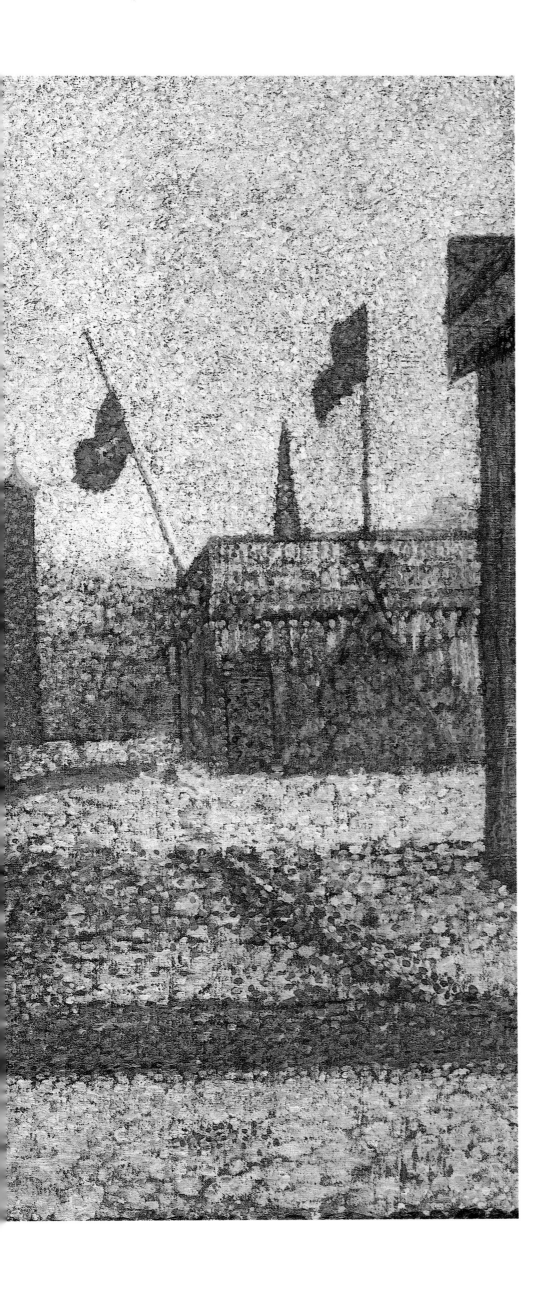

The 'Maria,' Honfleur, 1886

Oil on canvas
21⅝×25⅝inches (55×65 cm)
Museum of Modern Art, Prague

In contrast to his summer visit to the relatively remote Grandcamp the previous year, Seurat visited the much busier port of Honfleur in 1886. Honfleur is situated at the mouth of the river Seine, opposite the larger and more commercial port of Le Havre; it had a long history as a port, and was first sanctioned as such by Louis XIV's minister Colbert in 1683. This old port forms the focus of the town and is noted more for the picturesque qualities of the setting and the surrounding buildings. It functions more as a tourist attraction than as a commercial port. This was also the case in the nineteenth century when these picturesque qualities began to attract artists to Honfleur – Jongkind had painted there in 1866, while others such as Cals and Raffaëlli painted groups of pictures of the port in 1879 and 1884 respectively. Thus a strong tradition had developed of Honfleur being an important attraction for landscape artists from the middle of the nineteenth century. It may well have been the examples of these other artists that encouraged Seurat to go there. He arrived in Honfleur in late June 1886 and remained there until mid-August when he returned to Paris, a stay of between seven and eight weeks. The 'Maria' depicts a packet-boat which sailed regularly between Honfleur and Southampton as part of the route connecting Paris and London, a journey undertaken three times a week throughout the summer season. The 'Maria' would have been a regular sight in the port as captured here by Seurat, and according to the position of the shadows the scene would appear to be one of early evening. Many of the details can still be seen today, such as the bollards and the railway track, illustrating how faithful Seurat remained to the scene in front of him.

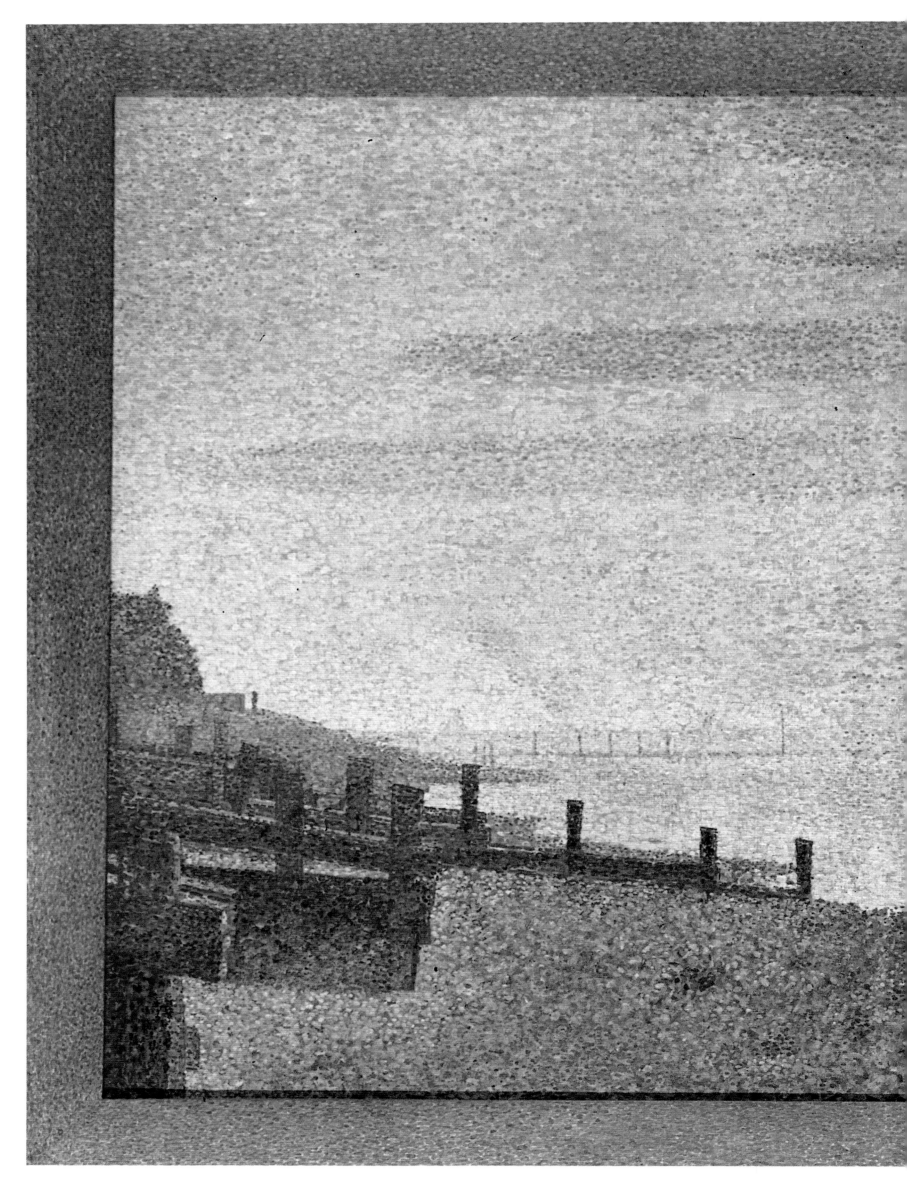

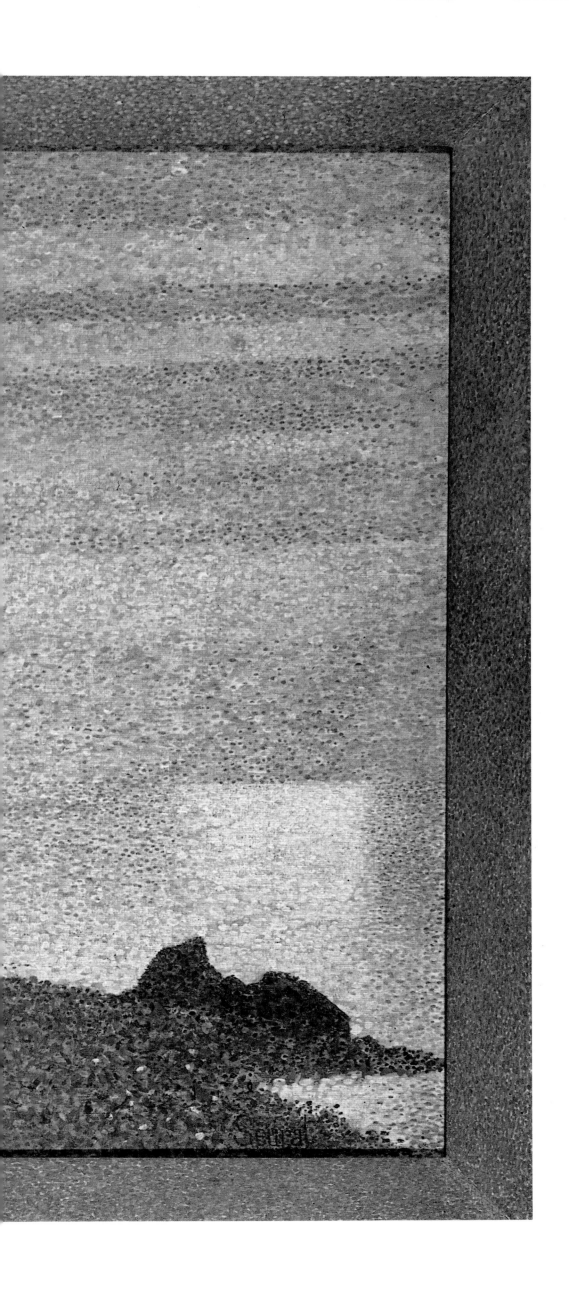

The Seine Estuary, Honfleur, Evening, 1886

Oil on canvas
25¾×32 inches (65.4×81.3 cm)
Collection, The Museum of Modern Art, New York
Gift of Mrs David M Levy

First purchased by Gustave Kahn, as *Soleil Couchant*, this painting is the first of only two seascapes which were painted at the end of the day to capture the changing lighting effects of the setting sun, to paint, in effect, a nocturne. The second was painted on his last visit to the coast in 1890. The changing lighting conditions of the coast greatly excited Seurat and in a letter complaining that rainy weather was preventing him from working he looked forward to the return of better days, so that he could 'go and get drunk on light again.' Characteristically in the Honfleur paintings, Seurat made use of the strong diagonal element of the beach disappearing into the distance to counter the otherwise horizontal structure of this canvas. He had recently become interested in the ideas of Charles Henry, who believed that a strong horizontal composition would suggest a mood of calm. Such a mood is produced in this painting but, surely, it has as much to do with the effect of the setting sun on the surface of the sea, with the somber mood of the coloring, and the lack of any sign of movement – just the slight diffusion of smoke from a ship on the horizon – as with any theoretical concerns. Seurat's interest in painting a nocturne may be related to the paintings of James McNeill Whistler who had started to paint nocturnes in the 1860s. His art had become increasingly well known in Paris in the 1880s and was particularly popular in Symbolist circles. Although the Honfleur paintings were the first ones to be consistently painted in the pointillist technique, the dots in this example were added over a more freely painted surface. The dots are more pronounced in different parts of the painting and are used to heighten color contrasts and to create a more animated surface effect.

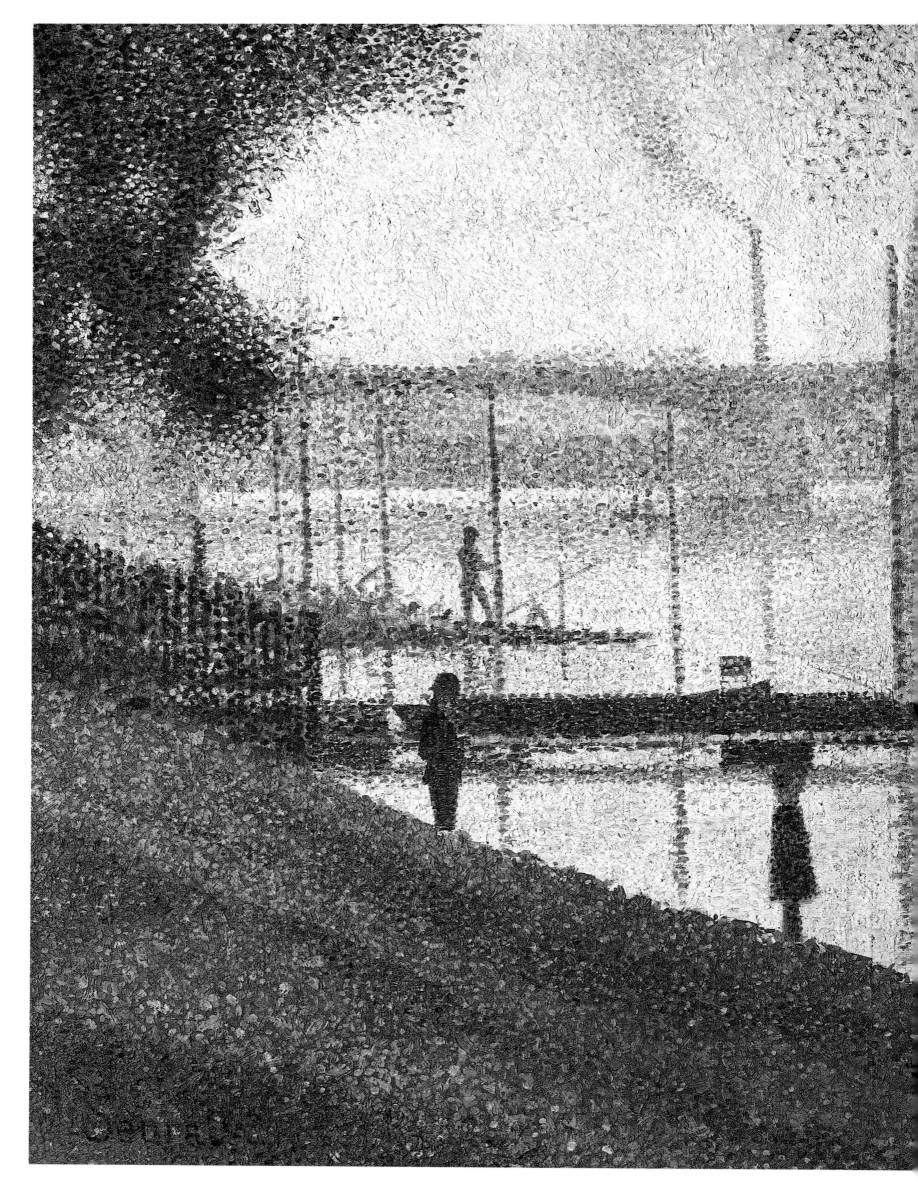

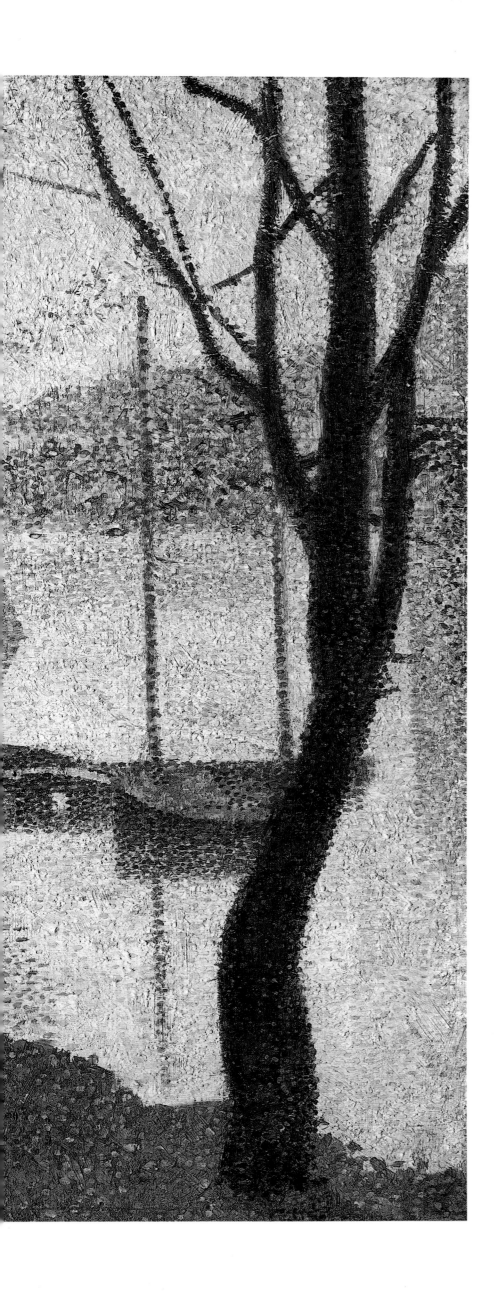

Le Pont de Courbevoie, 1886-87

Oil on canvas
18⅛×21⅝ inches (46×55 cm)
Courtauld Institute Galleries, London
Courtauld Collection

Like Asnières, Courbevoie was an expanding industrial suburb of Paris in the 1880s. As in *Une Baignade* Seurat has painted a view of the river Seine, looking downstream, at one of the newly constructed bridges connecting Paris with the outer suburbs. Compositionally the two paintings have much in common; the diagonal of the river as it flows from left to right, the area of bank in the foreground, the hint of the opposite bank and the use of the bridge to define the horizon. Unlike *Une Baignade*, however, this painting does not share the same complex subject matter. Only three isolated figures can be seen almost motionless, two on the river bank itself, while the third is fishing from the projecting promontory of land. In the distance two more figures can be seen in a small boat. The most remarkable feature of this painting is its formal structure and the very strict way in which Seurat has organized the composition. Throughout, the play of horizontal, vertical, and diagonal forms come together to create one of the most disciplined of Seurat's landscapes. The dominant diagonal of the foreground bank is offset by the rhythmical arrangement of the repeated verticals running across the picture surface. The boat masts and their reflexions, the factory chimney, the wicker fence, all contribute to the tautness of the painting. Note how these forms both accentuate the diagonal regression and yet enhance the flatness of the picture surface in the way they are regularly repeated across the painting surface, but become more closely spaced at the left edge to give the impression of spatial recession. The pattern formed by the bent tree in the foreground is wonderfully repeated by the single sail. Nature has been reorganized in a most structured and precise manner.

121

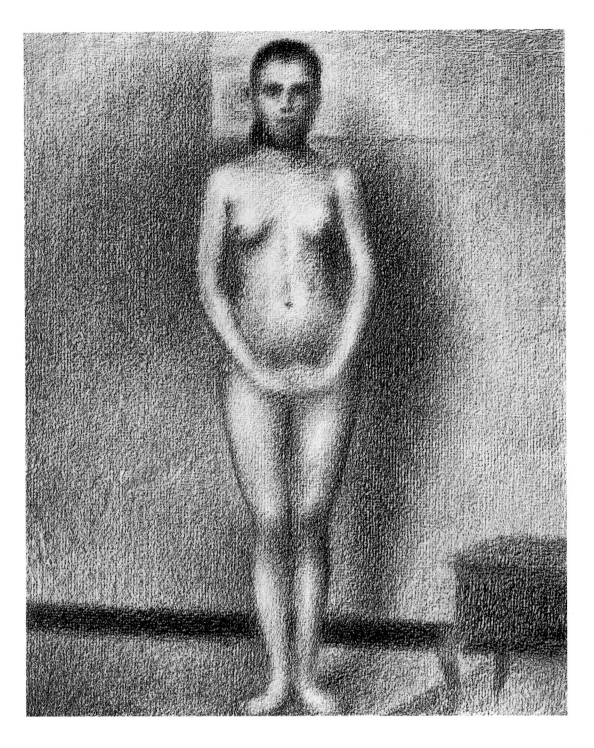

Study for 'Les Poseuses': Standing Model, c.1887

Conté crayon
11⅞×9inches (30×23cm)
The Metropolitan Museum of Art, New York
The Robert Lehman Collection

This rather tentative drawing was probably the first work in the series of drawings and paintings Seurat completed in his preparations for *Les Poseuses*. A single model is depicted in a rather awkward pose as she stands in front of the wall of Seurat's studio. Stiffened by her erect pose, the model clasps her hands together in front of her. Although she does not attempt to hide her nudity there is, in the formality of the pose, a tension which is not apparent in later studies. In fact, a comparison of this example with the painted version in the Musée d'Orsay (page 123) draws attention to the relaxed and informal effect Seurat has achieved in the painting. The frontality of the pose is derived from the figures painted in the *Grande Jatte* and contrasts with the many more varied poses Seurat used in his early studio-studies, notably the studies of men and women working. Any hint of movement is denied, even to the extent that little in the way of furnishings clutter the studio. Unlike the completed painting there are no discarded clothes, no references to the fashionable accessories of the model, and the studio is sparsely furnished with a single picture on the wall behind the model's head and a stool on the floor to her left. This emptiness combined with the effects of the lighting create a slightly manacing quality. The source of the light comes from the foreground left and directly lights most of the figure frontally with the only shadows being formed around the contours of the figure. Behind, projected on to the wall, is an area of shadow which lacks definition and it is this dark presence which creates such an eerie effect, one much used by the Norwegian painter Edvard Munch in many of his interior scenes in the 1890s.

Study for 'Les Poseuses': Model from the Front, c. 1887

Oil on panel
10¼×6¾ inches (26×17 cm)
Musée d'Orsay, Paris

This small panel is the preparatory study for the central figure in *Les Poseuses*. Unlike the studies for the other two figures, this sketch has been more fully worked on and Seurat felt sufficiently happy with it to exhibit it in the Spring of 1887 at the salon of the Société des Artistes Indépendants. The standing figure first appears in a conté drawing (page 122), now in the Metropolitan Museum, New York. Both in the drawing and in this panel the nude model is seen directly from the front but the pose of the figure, with the slightly extended right leg and head tilted to one side, is far more confidently handled in the panel, a contrast to the somewhat tentative treatment in the drawing. The nude is placed in front of the wall of Seurat's studio but in the final version of *Les Poseuses* she has been repositioned to the corner of the studio where she becomes the pivot around which the whole composition is constructed. She stands in front of the meeting point of one wall of the studio and the diagonal formed by the canvas of the *Grande Jatte* placed against a second wall. By being so positioned she flattens the pictorial space and denies the spatial recession formed by the two diagonals. In choosing to paint the nude, Seurat confronted the problem of how an artist concerned with contemporary life could find a suitable way of treating the most traditional and elevated of artistic themes. Comparisons were made to classical sources. Gustave Kahn likened the models to antique statues and described the painting as having 'the simplicity and the majesty of antique art'. Other comparisons were made with the work of Ingres, and the poses of the three models certainly suggest a close affinity with his nudes. Félix Fénéon felt that Seurat's nude models would glorify any museum or art gallery.

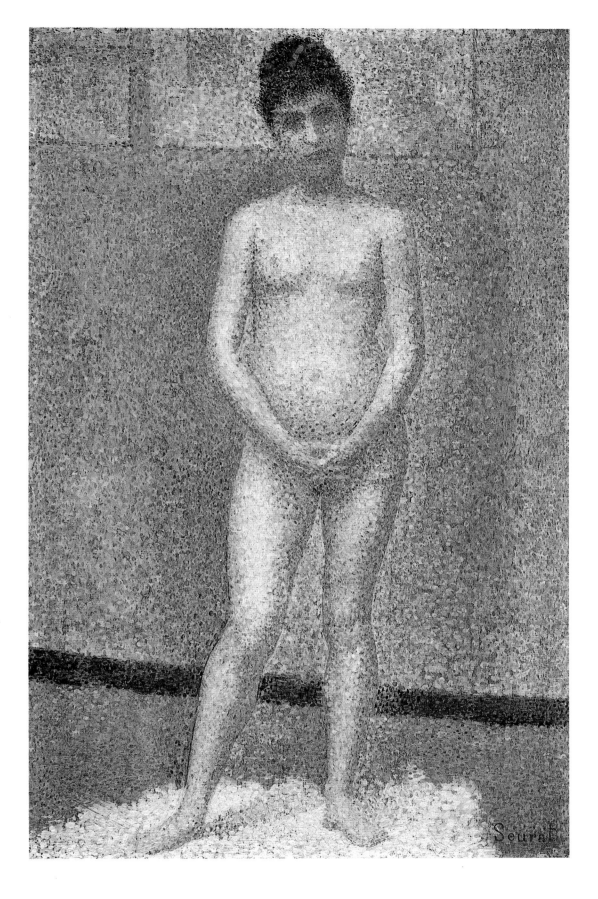

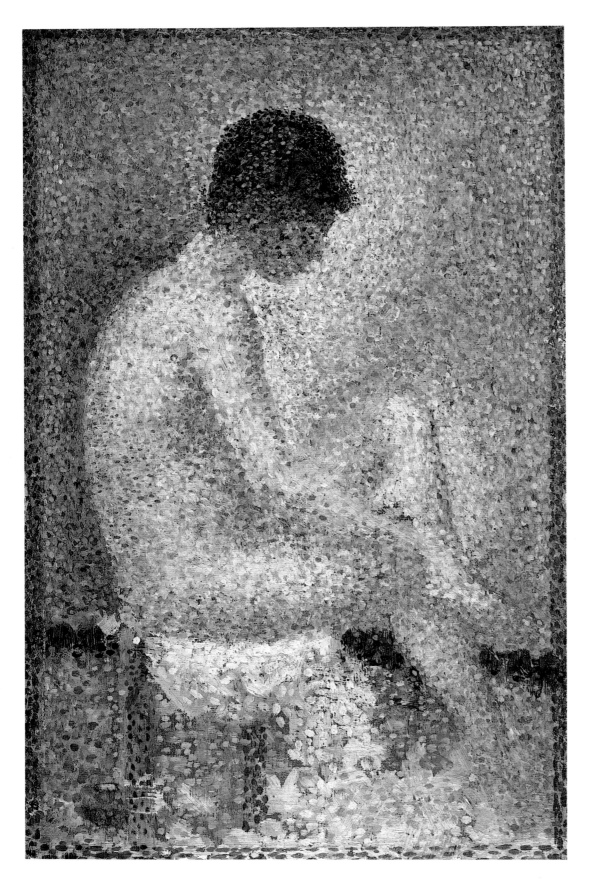

Study for 'Les Poseuses': Model in Profile, c. 1887-88

Oil on panel
9½×5⅞ inches (24×15 cm)
Musée d'Orsay, Paris

Apart from the absence of her green stockings, the model in this study for the right-hand figure in *Les Poseuses* is as she appears in the completed painting. Very minor changes were made to her pose; a slight exaggeration of the curve of her back and a stronger definition of her facial features. Much of the paint surface has been evenly painted in small 'dotted' brushstrokes, but it is possible to identify those areas that Seurat worried over. In particular, much reworking has taken place in order to define the outline of the figure. An almost continuous blue line defines the curve of her back set against the far wall of Seurat's studio. Tonal contrast has been exaggerated to help define form; for example, the blue of the wall has been darkened in contrast to the lightened flesh tones of the model's back. The upper part of her right arm has darker flesh tones offset by an area of white paint. Parts remain unresolved however, notably the left thigh which merges imperceptibly with the background. Seurat has added a certain directional force with the brushmarks in the light area around the model's head, creating a halo-like effect. Although variations in the paint surface can be seen, these studies, along with the completed version of *Les Poseuses* and its copy, of all Seurat's canvases are the most systematically worked according to the principles of Neo-Impressionist theory. However, when they were painted in early 1887 Seurat was experiencing considerable difficulties and frustrations. He had become increasingly secretive about his technique and isolated from his friends. In August 1887 he wrote to Signac complaining that he was finding work difficult and was no longer seeing anybody. His problems proved temporary as the two versions of *Les Poseuses* testify.

Study for 'Les Poseuses': Model from Behind, c. 1887-88

Oil on panel
9½×6¼ inches (24×16 cm)
Musée d'Orsay, Paris

This small panel is a study for the nude model seated at the left in the final version of *Les Poseuses*. As in the completed painting she is shown silhouetted against the canvas of the *Grande Jatte*, the painting's border and standing woman can be seen in the background. A number of changes were made by Seurat from this sketch and the large canvas. Although the nude is still shown from behind her head is turned slightly more to the right so that a little more of her face can be discerned. Her left arm is more clearly defined. In this sketch we can see that Seurat must have experienced certain difficulties in finalizing the contours of the figure, particularly those of her left side. It is difficult to make out the curve of her waistline and both her left leg and left arm are ill-defined. All seem to merge together to create a line almost perfectly parallel to the edge of the panel. The dotted surface blurs such lines even further. Absent are the accoutrements which surround the model in the finished painting. Here, she is completely nude, but in the painting she is still partially dressed with her chemise and dress rolled down to her hips, thus encouraging the view that she is still in the process of undressing. Most noticeable is the consistency of the application of paint, with the small 'dots' of pigment applied over a more freely worked area of underpainting. The pose recalls the nudes of Ingres, especially the *Valpinçon Bather* of 1808. Both nudes are bent forward giving them the appearance of being slightly round-shouldered and their heads are gently tilted to the right. In the completed painting the model's waist, no longer constrained by her undergarments, contrasts dramatically with the pinched waist of the standing woman in the *Grande Jatte*.

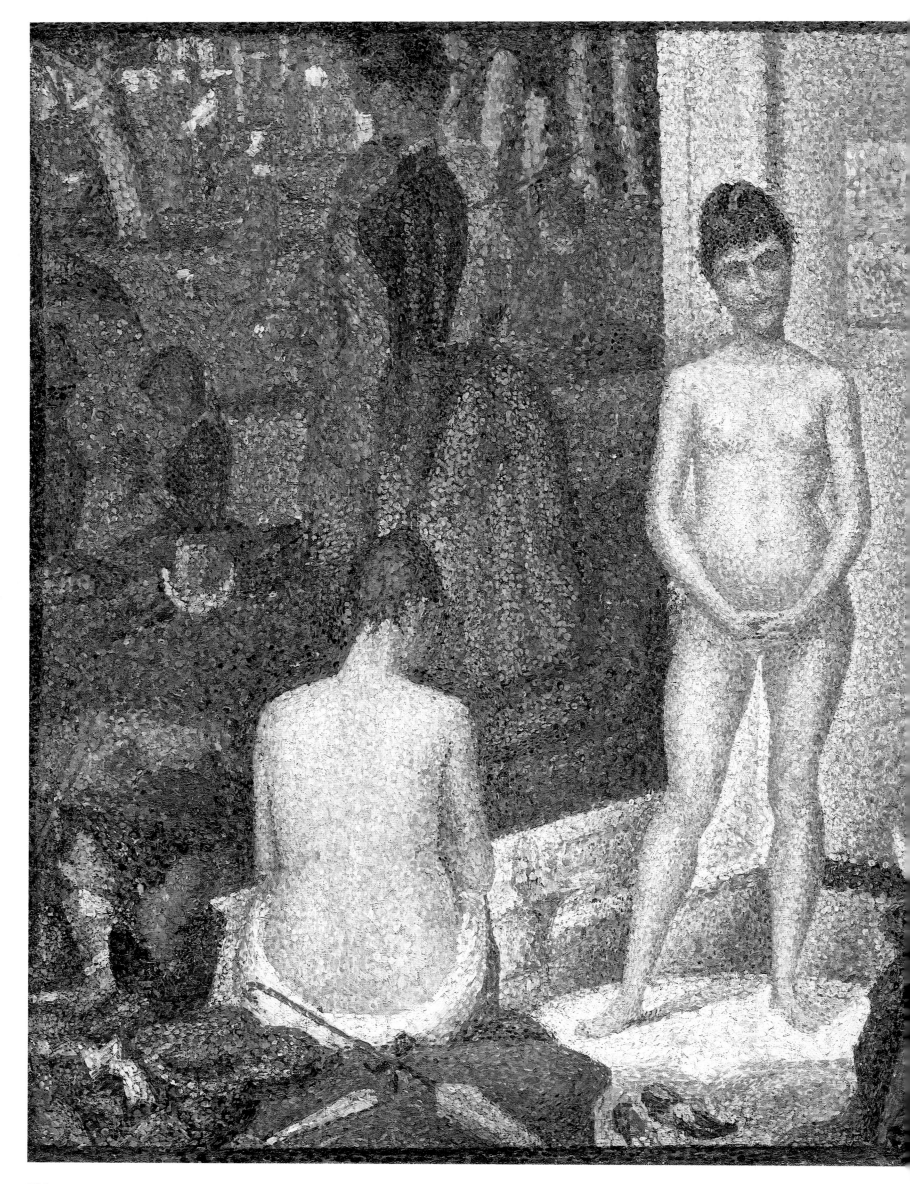

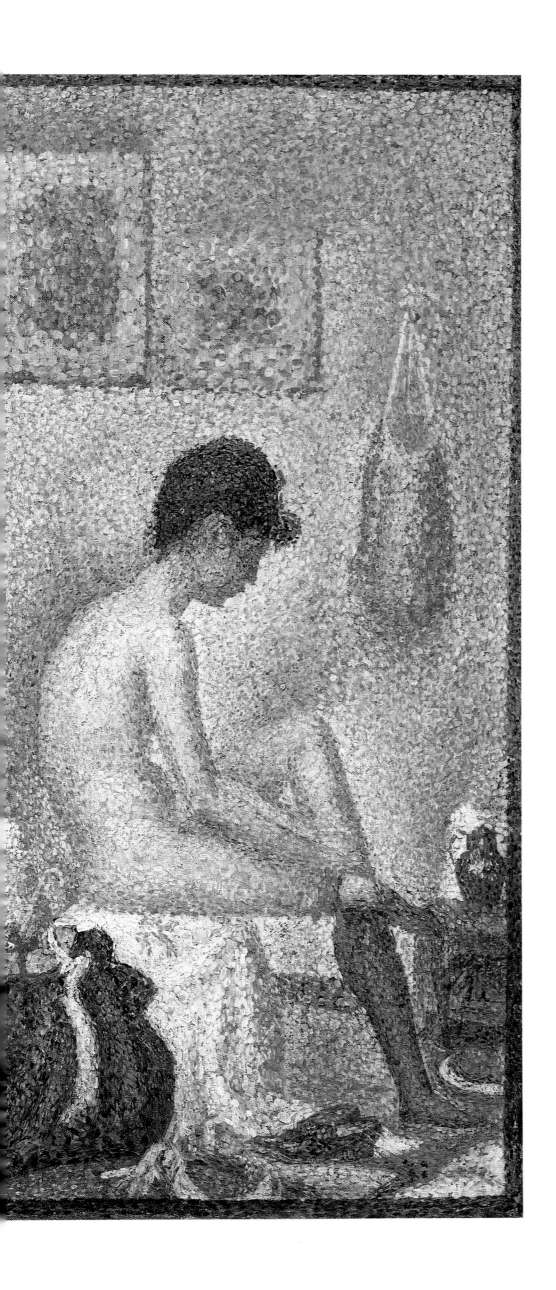

Les Poseuses (Small Version),

c. 1888
Oil on canvas
15⅜×19¼ inches (39×49 cm)
Berggruen Collection, on loan to the
National Gallery, London

This painting is an exact copy painted by
Seurat of a larger canvas he exhibited at the
salon of the Société des Artistes Indépen-
dants in 1888. The large version of *Les
Poseuses* belongs to the Barnes Founda-
tion, Merion Station, Pennsylvania, who
do not permit color reproduction of works
in their collection, so it is the smaller ver-
sion which is illustrated here. To make
such a faithful copy was an exceptional act
on Seurat's part; none of the other major
paintings was copied. The large version
was the first canvas to be painted fully in
the 'pointillist' style, and Seurat ex-
perienced difficulties in perfecting the
color harmonies which were already
beginning to change soon after the paint-
ing was completed. Signac blamed inferior
pigment as the cause of subsequent
changes. Seurat, therefore, made this copy
to remind him of the original color harmo-
nies. When exhibited, *Les Poseuses* was
much praised by friends, one describing it
as 'a masterpiece', while another referred
to it as 'perfection'. Three naked models
are shown in a variety of poses, or one
model in a sequence of three different posi-
tions, in Seurat's studio, one wall of which
is covered by his painting of the *Grand
Jatte*. The juxtaposition of the models with
part of the *Grande Jatte* is a curious one and
was commented on by some critics. Paul
Adam, a friend, contrasted the stiffness of
the figures in the *Grande Jatte* with the
simplicity of the nude models in the
studio. He described:

On the one hand we have figures in the
simplicity of nature, with an enigmatic femi-
nine smile on their lips, with their elegant
curves, neat, girlish breasts and soft pearly
skin. And on the other are figures in their best
clothes, stiff and starchy, solemn under the
warm summer foliage.

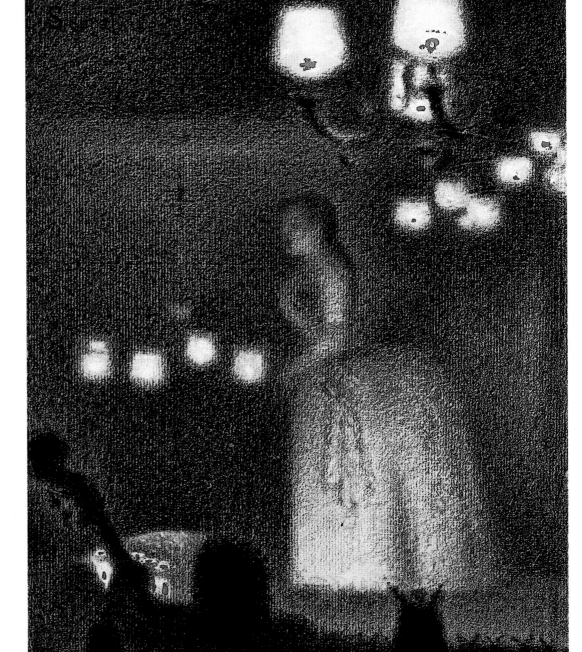

Eden Concert, 1887
Conté crayon, heightened with gouache
and colored inks
11⅞×9 inches (30×23 cm)
Vincent van Gogh Foundation
National Museum Vincent van Gogh,
Amsterdam

Exhibited at the salon of the Société des In-
dépendants in 1887, this drawing is related
in theme and composition to the painting
Le Chahut (page 157) of 1889-90. It once
belonged to Theo van Gogh. Although it is
a drawing, colors have been added, for
example, pink in the singer's sash with a
complementary halo of green dots. The
highlights have been accentuated by
touches of white. Because Seurat chose to
exhibit this drawing, it must be considered
as more than just a preparatory sketch for
Le Chahut, and should be regarded as an
autonomous work, even given their
obvious similarities. A single female chan-
teuse is seen from behind the orchestra and
this low viewpoint is emphasized by the
upward play of the lighting. Much of the
scene is bathed in shadow with the dark sil-
houette of the bass player looming in the
immediate foreground. Café-concert sub-
jects had become an increasingly popular
subject among artists in the second half of
the nineteenth century. Both Edgar Degas
and Edouard Manet had treated this sub-
ject. Degas, in the mid 1870s, produced a
number of café-concert pictures in a
variety of media, often, as Seurat has done
in this example, mixing them in one parti-
cular image. His *Aux Ambassadeurs: Mlle
Becat* (1877), one of five prints, shows the
singer bending forward with the front of
her dress and face dramatically lit by the
floor lights. Much of the rest of the scene is
doused in shadow. Manet's *Corner in a
Café-Concert* of 1878-79 (page 24) focuses
on the clientele, engaged in café banter,
awaiting their drinks. The inclusion of a
dancing figure in the background acknow-
ledges a debt to Degas. In this example
Seurat has acknowledged a similar regard
for Degas.

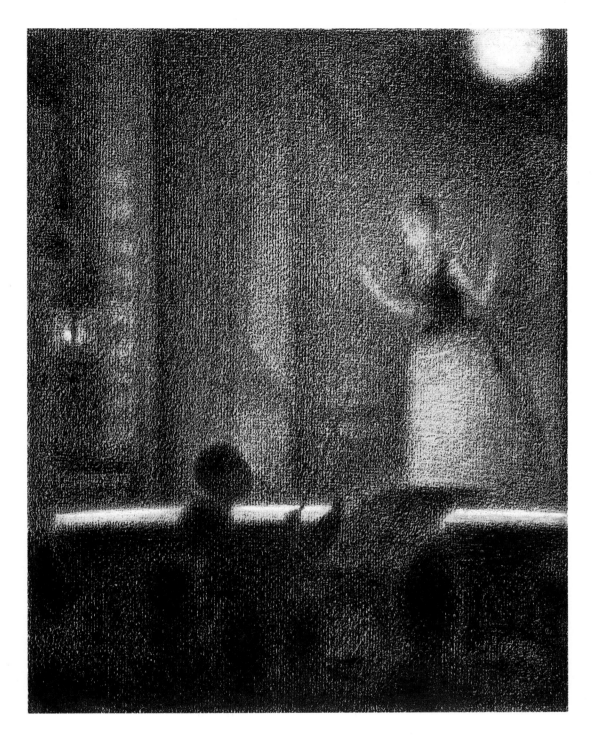

A la Gaîté-Rochechouart,

c. 1887-88

Conté crayon heightened with gouache
12¼×9inches (31×23cm)
Courtesy of the Fogg Art Museum,
Harvard University, Cambridge,
Massachusetts
Bequest of Grenville L Winthrop

At the salon of the Societé des Indépendants in 1888 Seurat exhibited eight drawings, four of which were of café-concert subjects. This particular example was shown again in Brussels in 1889 when it was purchased by Emile Verhaeren. Although the subject is similar to that of *Le Chahut* (page 157), painted some eighteen months after this drawing, this work was not conceived as a preparatory study. That Seurat was willing for it to be exhibited publicly on two occasions suggests that it was thought of as an autonomous work. Compositionally the drawing would appear to owe much to the work of Degas, such as his *Aux Ambassadeurs: Mlle Bécat* (page 23). The chanteuse is seen performing on stage from the vantage point of the audience who dominate the foreground. In between is placed the orchestra and conductor. Seurat's drawing is a masterly exercise in the delicate way he has manipulated the crayon to build up a series of tones from the brightly lit stage, the effect of the floor lights, to the darkened silhouettes of the audience, and the wonderfully dramatic contrast of the conductor's head set against the stage. The free exuberance of some of his earlier drawings has been developed into a more controlled style here, with every nuance of form delicately handled. Just as his drawing technique had become more refined and the touch more even, so too the composition of this drawing was the result of careful and precise preparation. An analysis of the composition has shown that Seurat adhered strictly to a precise geometric structure deriving from the Golden Section. Initially the paper was cut to size so that the dimensions, width to height, related to the Golden Section. Internal divisions repeat this formula, the line of the stage and the vertical formed by the singer's dress forming the dominant axes.

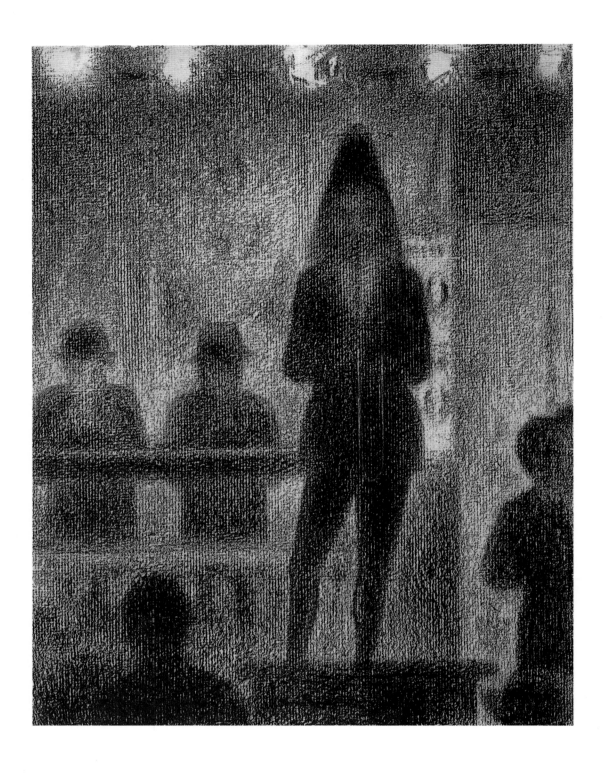

Study for La Parade: The Trombone Player, c.1887

Conté crayon
12¼×9inches (31×23cm)
Philadelphia Museum of Art
Henry P McIlhenny Collection, in
memory of Frances P McIlhenny

Although Seurat seems to have worked very quickly to complete *La Parade* (page 132) and used the small panel in the Bührle collection (page 131) to establish the main compositional arrangements, a number of detailed drawings were completed, of which this example concentrates on the central figure of the trombone player. In all Seurat completed three preparatory drawings dealing in turn with the three sections of the completed painting. For a preparatory study this drawing is remarkable for the degree to which Seurat has resolved matters of composition and of detail. Little has been changed in the translation from drawing to painting. The figures assume the positions they have in the painting, the most significant change being their more elongated form in the painting in place of the rather squat poses they have here. This has the effect of enhancing the vertical divisions of the composition and the hieratic forms of the musicians. The trombone player himself assumes a most elegant pose, the slender nature of his appearance evident in his slim, tapered legs. It is unlikely that this drawing was started in front of the Cirque Corvi, the source of *La Parade*. Certainly it was completed in the studio. The touch is sure and positive and the drawing does not give the impression of a sketch rapidly worked outside under difficult light conditions. The precise geometric background and the general disposition of the forms suggest that Seurat used this drawing as a way of finalizing the precise relationships and structures that are so evident in the completed painting. Unlike other drawings Seurat seems to have been less concerned with the atmospheric effects resulting from the artificial light of a night-time subject.

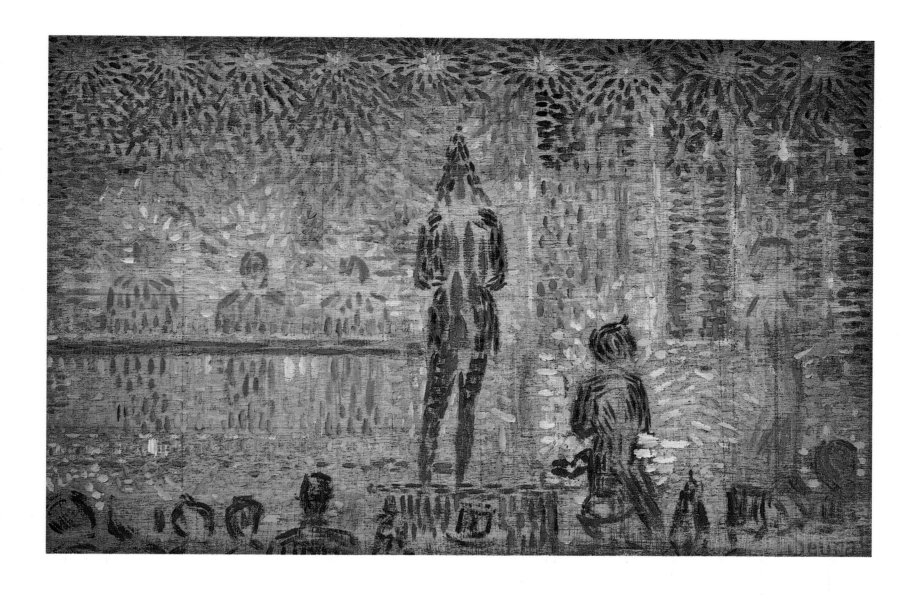

La Parade de Cirque, 1887-88
Oil on panel
6¼×10¼ inches (16×26 cm)
E G Bührle Collection, Zurich

Unlike the many studies that preceded *Une Baignade* (page 72) and the *Grande Jatte* (page 90), this painting resulted from only three drawings and one rapidly worked oil sketch, suggesting that Seurat had a clear idea of the form of the painting from a very early date. This sketch contrasts with studies for other paintings where the composition was constantly reworked until Seurat was satisfied. Here, because the scene was a night-time one, the sketch is the only painted one that Seurat completed and, as such, bears a striking resemblance to the finished painting. An underlying grid pattern can be clearly identified, the vertical axis divided into quarters and the horizontal axis into six segments. This rigid geometry is more pronounced in this painting than in any other by Seurat. The

background architecture is divided according to mathematical relationships elucidated in Charles Henry's *Scientific Aesthetic*, and Fénéon referred to Seurat's use of the golden section in order to create a more harmonious composition. The sketch suggests that Seurat had a clear idea of the final form of the painting; all the figures are sketched in and assume their definitive positions, and the architectural background is firmly established. Only the tree is absent. The main color accents are painted in with emphasis placed upon the light radiating outwards from the gas lights at the top of the painting. There is a uniformity of touch that reinforces the balance of the horizontal and vertical and establishes a series of tensions which make this the most precise of Seurat's paintings.

La Parade de Cirque, 1887-88

Oil on canvas
39⅜×59 inches (100×150 cm)
Metropolitan Museum of Art, New York
Bequest of Stephen C Clark, 1960

La Parade was painted throughout the winter of 1887-88 and was ready for exhibition in March 1888 when it was displayed at the Indépendants. The subject shows a single trombone player performing outside in front of a group of four musicians who are placed to the left side of the painting. To the right a conductor, seen in profile, is being harangued by another performer. In the foreground assemble various onlookers and members of the public forming a line to gain entry to the performance at the ticket booth at the extreme right edge of the painting. The trombone player performs his solitary act as an advertisement for the activities taking place inside. In this painting Seurat explored for the first time the nature of night-time Parisian entertainment, a subject he was to examine further in his paintings *Le Chahut* and *Le Cirque*. The subject was derived from the Cirque Corvi which was part of a travelling fair which performed annually in Paris in the spring at the Place de Nation on the eastern edge of Paris. This was a working-class district of Paris although the annual fair attracted an audience from much further afield. Seurat has drawn attention to this varied audience in the foreground of the painting by identifying different social groups by the nature of their headgear. Those in the left foreground wear simple hats while those on the right disport a variety of exotic headgear. The two groups are separated, with only those on the right able to afford the price of entry to the full performance. Gustave Kahn described the painting as 'wilfully pallid and sad' and in it Seurat has focused on class differences as they existed in terms of Parisian entertainment. The cheerless expressions on the faces of those unable to enter are reflected in the motionless bodies of the musicians.

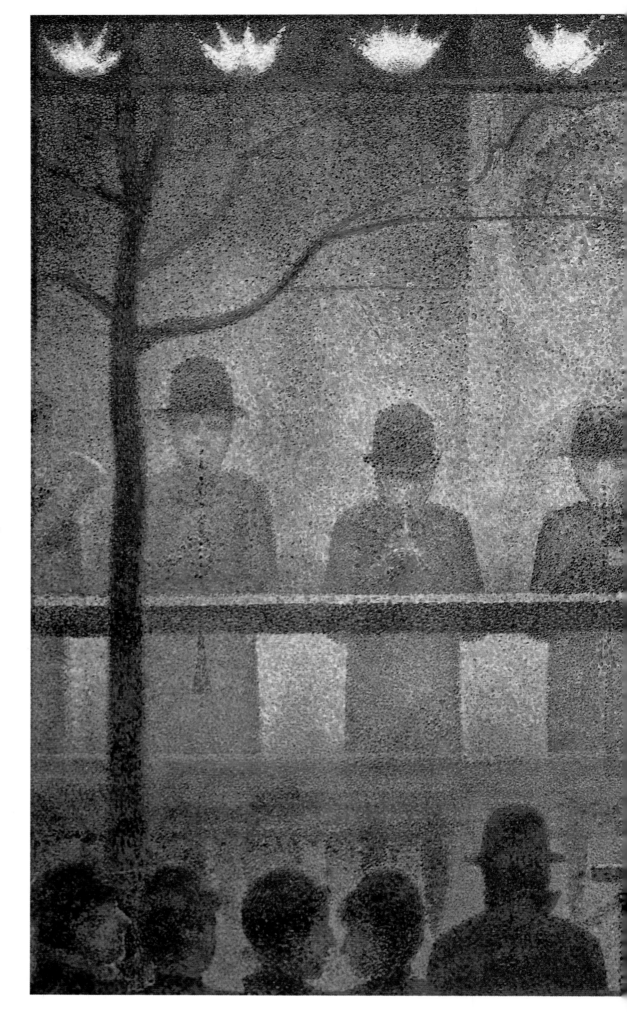

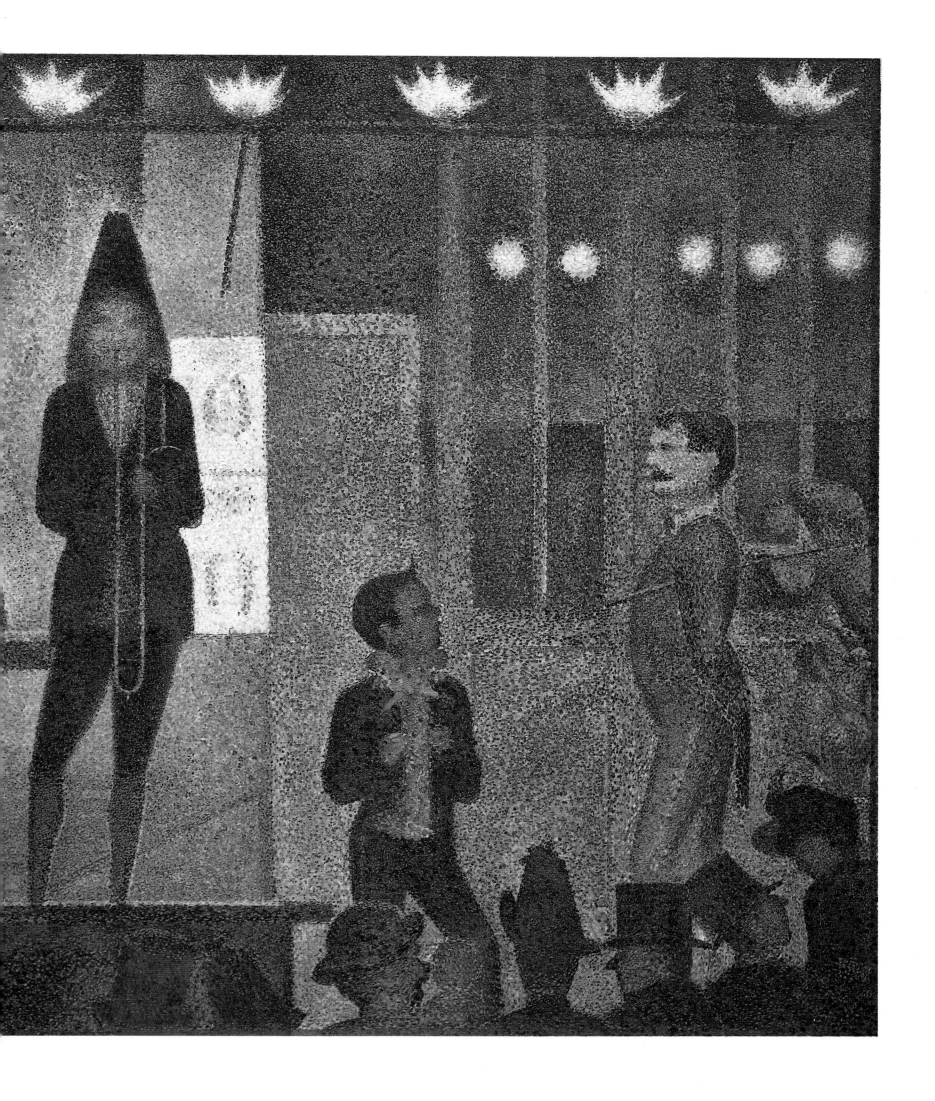

Banks of the Seine (Island of the Grande Jatte), 1888

Oil on canvas
25⅝×31⅞ inches (65×81 cm)
Musées Royaux des Beaux-Arts, Brussels

This painting was exhibited at Les Vingt in Brussels in 1889 alongside a second painting, *Dull Weather (Island of the Grande Jatte)* (page 146), and the two paintings should be seen as companion-pieces. Early in 1888 Seurat returned to the island of the Grande Jatte to paint these two pictures. Just as he had become interested in his Honfleur paintings of 1886 in depicting the lighting effects of different times of the day, in these paintings he has contrasted changing weather conditions. One shows a dull, rainy day while this example represents a fine spring day with people sailing and rowing. Seurat was accompanied on his return to the banks of the river Seine by his closest friend, the artist Charles Angrand. Possibly Seurat returned to this location to make up for the fact that he failed to get away from Paris to the coast during the summer of 1887. Whatever the reason, his view of the Parisian suburbs has changed dramatically from his earlier paintings, in particular *Une Baignade* (page 72) and *La Grande Jatte* (page 90). Represented here is a scene of leisurely activity set against a background of luxuriant verdant growth. Absent is the critical social observation so evident in his earlier paintings. Gone are the references to the seedier aspects of suburban life and leisure and, instead, they have been replaced by a view of the river as a source of innocent pleasure. The richness of the landscape and the lack of any reference to industrial activity is in marked contrast to his other representations of this part of the river Seine. It is as if Seurat had turned to other depictions of the Seine as a source of leisure without social commentary as represented by paintings such as Renoir's *Luncheon of the Boating Party* of 1881.

134

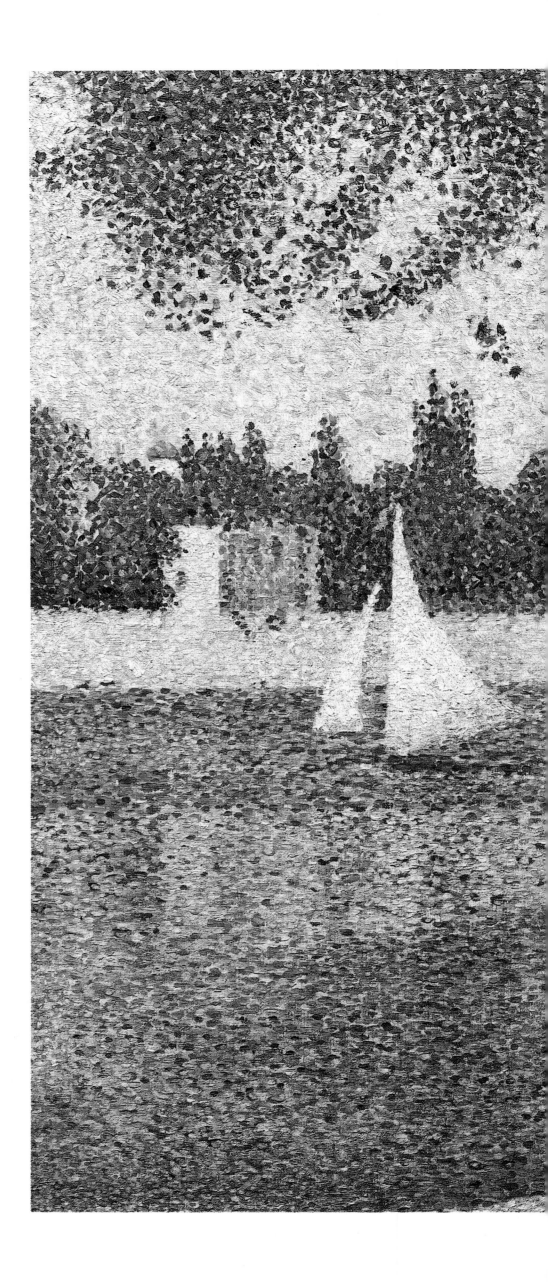

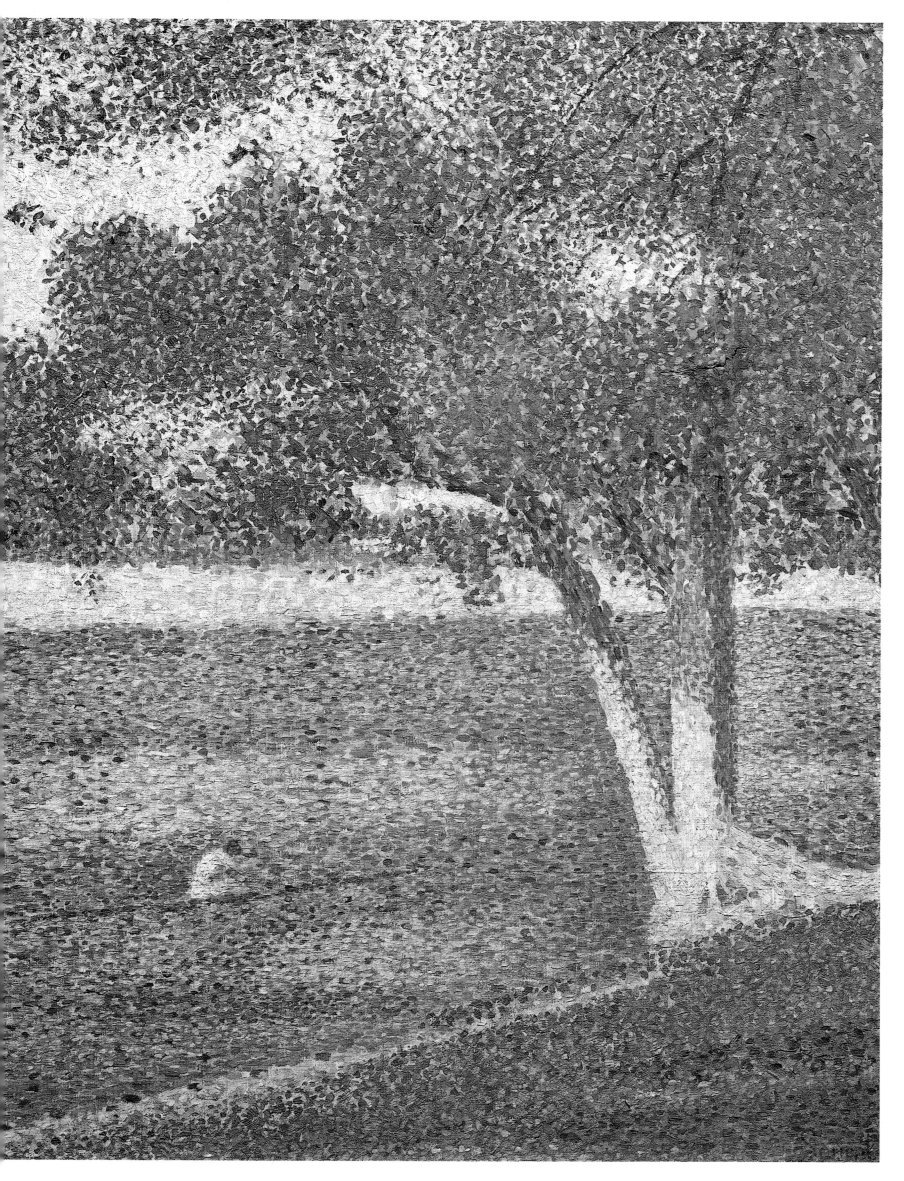

Port-en-Bessin, The Outer Harbor, Low Tide, 1888

Oil on canvas
21¼×26 inches (54×66 cm)
The Saint Louis Art Museum,
St Louis, Missouri
Museum Purchase

After the success of the exhibition of *Les Poseuses* at the salon of the Société des Indépendants in the early 1888, Seurat traveled to the Normandy coast once again in order to paint more marines. He chose to go to Port-en-Bessin which is located near Grandcamp, where he spent his first summer trip to the coast in 1885. Signac had persuaded Seurat to go to Grandcamp and it may well have been because of his encouragement again that Seurat returned to that part of the coast. His visit must have been about the longest of all his summer visits as he left Paris in August 1888 and did not return until mid-October, a stay of about two months. Six paintings resulted from his visit. Although close to Grandcamp, the paintings produced in Port-en-Bessin are completely unlike those painted on his first trip to the Normandy coast. The Grandcamp canvases were his first experiments in painting seascapes; they acknowledged a debt to artists such as Monet in their compositional arrangements; many were worked from small preliminary sketches. In contrast, the Port-en-Bessin paintings are some of the most sophisticated seascapes Seurat painted; no preliminary sketches survive and, in their composition, they continue his interest in surface pattern so evident in paintings such as *La Parade* finished the previous winter. This example is a view from the wall of the outer harbor looking back inland to the inner harbor and the buildings of Port-en-Bessin nestling around. Here, Seurat has explored the horizontal forms of the sky, the low, distant hill, the band of houses. This geometry is dramatic in the foreground where the viewer seems to be in a raised position, looking down on the solid, flattened forms of the harbor walls.

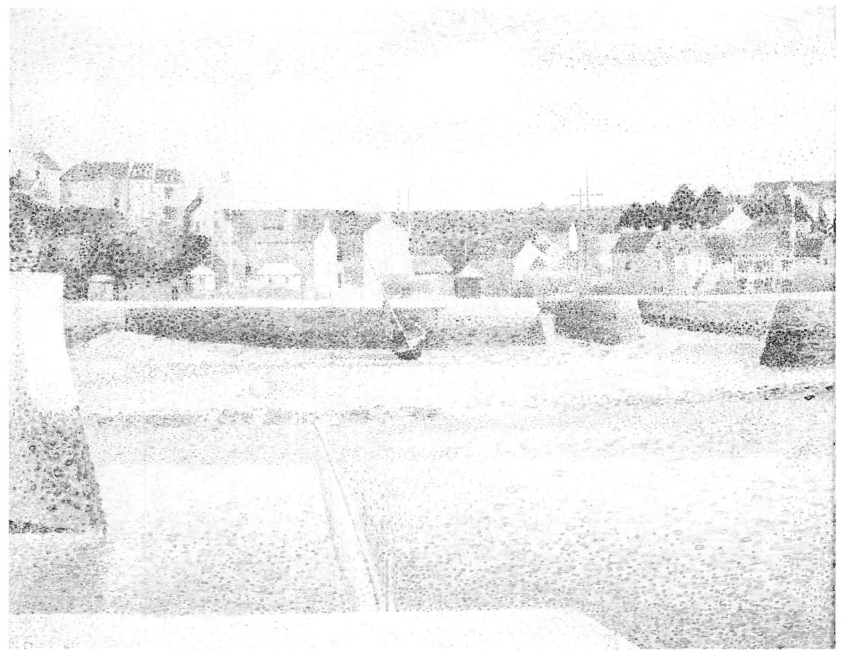

Les Grues et la Percée, Port-en-Bessin, 1888

Oil on canvas
25⅝×32¼ inches (65×82 cm)
National Gallery of Art, Washington

For this painting, Seurat climbed the Falaise de Huppain which is located to the west of Port-en-Bessin. The view is continued along the coast towards the Contentin peninsula which can just be made out on the horizon, a thin sliver of land separating sea from sky. This cliff scene recalls his *Bec du Hoc* painted at Grandcamp in 1885, just a few kilometres along the coast. That painting, with its rocky outcrop, recalled the example of Monet and his paintings of cliffs of the early 1880s. In it the outcrop was set off against the sea and sky and dominated much of the pictorial space. Even though the Bec du Hoc was an early example of the Neo-Impressionist technique, there were still discernible variations in the brushwork. In this example Seurat has divided the painting diagonally into two halves, the cliff in one, the sea and sky in the other. Although the paint has been applied in touches consistent in size, Seurat has used brushwork to create a dynamic effect. The contours of the cliff, the areas of light and shadow are not only defined by variations of color but also by the directional force of the brushstrokes. All the brushmarks appear to converge toward the lower right corner. This dynamic effect is enhanced by the wavy line at the lower edge of the canvas, an effect rhythmically repeated in the clouds above. In contrast to these swirling forms is the calmness of the sea and lower sky. A second rhythmical pattern can be seen here. The Contentin peninsula draws attention to the horizon; this horizontal is repeated in the line of the cliff and in the finger of land projecting from behind the cliff. The ship's mast just touches the horizon line. Nature has been transformed to create the most harmonious of paintings.

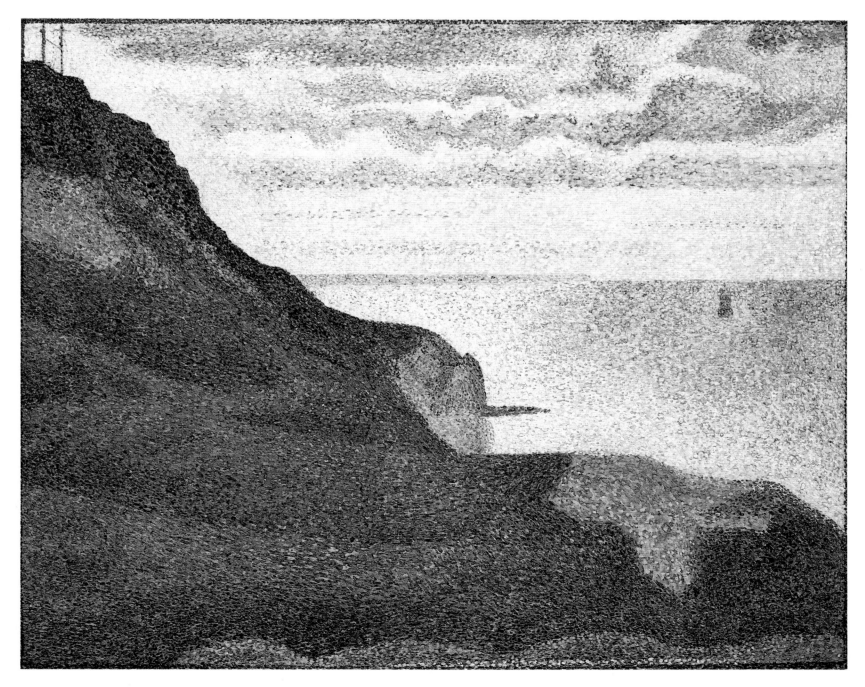

137

The Entrance to the Outer Harbor, Port-en-Bessin, 1888

Oil on canvas
21⅝×25⅝ inches(55×65 cm)
Collection, The Museum of Modern Art,
New York
Lillie P Bliss Collection

This painting was painted from the same
spot as *Les Grues et ia Percée* (page 137)
and *Port-en-Bessin, The Outer Harbor, High
Tide* (page 142). Here the view is directly
out to sea through the outer harbor en-
trance, while in the other two paintings the
view is to the west and to the east re-
spectively. Such precise recording of the
morphology of a town and its immediate
environs had not been a characteristic of
Seurat's art before. This is a most re-
markable painting and an outstanding
example of his interest in shaping the
forms of nature into a series of rhythmical
patterns that almost border on the abstract.
And yet, any visitor to Port-en-Bessin
today would see how faithful Seurat re-
mained to nature and how accurately these
paintings record the setting. Little has
changed since the 1880s. In this example a
number of devices have been used to create
a flat, two-dimensional space. The horizon
has been pushed up to the very top of the
canvas, while the cliff in the foreground
has been flattened, and where it meets the
sea there is no apparent jump in space. The
two arms of the harbor wall are brought
close to the picture surface. Such an effect
of foreshortening was quite common in
Seurat's marines. Most dramatic of all are
the darker oval patterns formed by the re-
flexion of the clouds on the surface of the
sea. Also, the sea is quite shallow in parts
and it is possible, from the vantage point of
the cliff, to observe variations in the color
of the sea because of changes in the under-
lying vegetation. In a most telling descrip-
tion of this painting, John Russell felt that
Seurat had reached 'an arguably quite un-
realistic submission of natural fact to a
constructive scheme.'

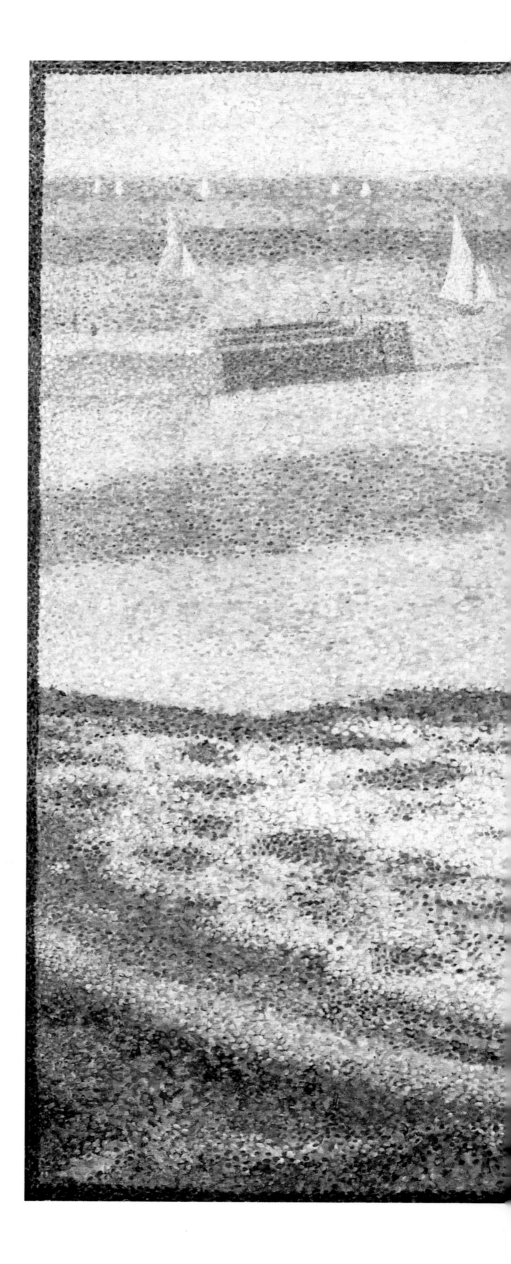

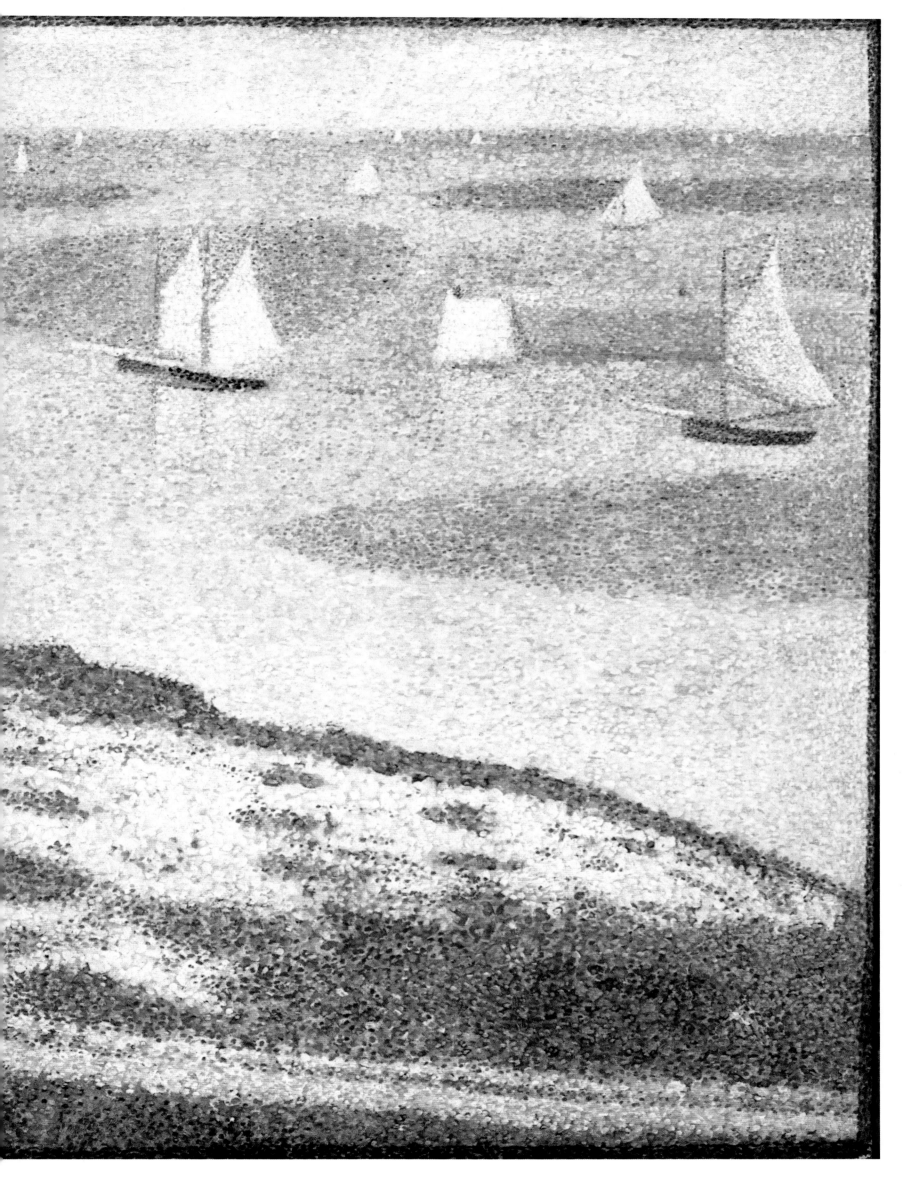

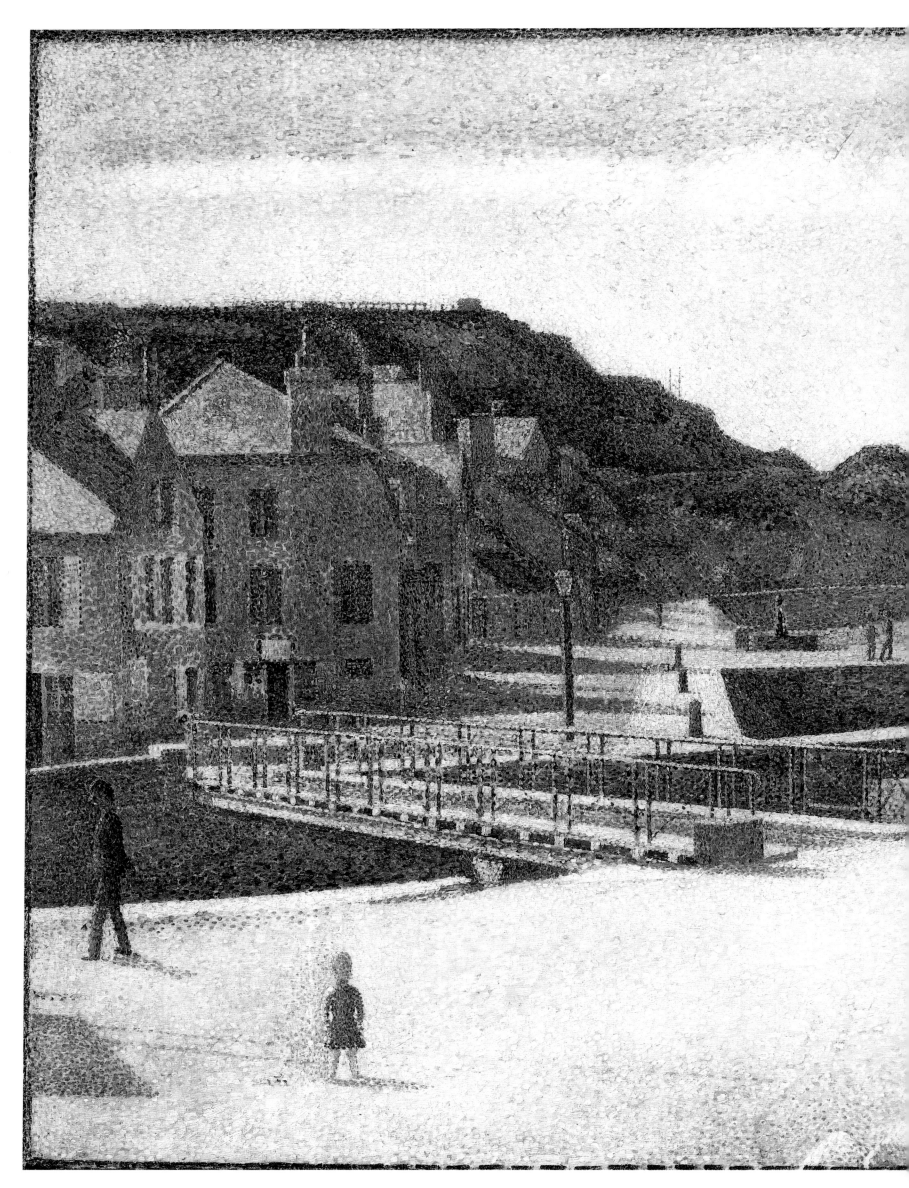

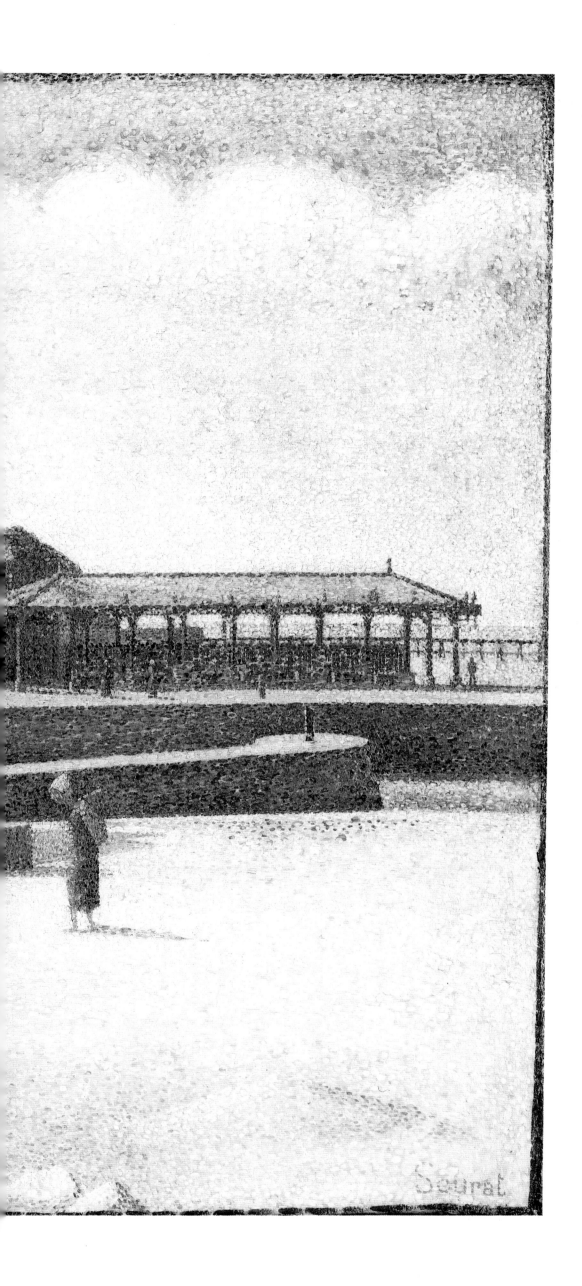

Seurat

The Bridge and the Quays, Port-en-Bessin, 1888

Oil on canvas
26⅜×35½ inches (67×85 cm)
The Minneapolis Institute of Arts

All the Port-en-Bessin paintings were exhibited together in Brussels early in 1889, suggesting that Seurat considered them as a definite group. This idea is supported by the way he approached the various subjects. Unlike Honfleur, where he painted in the summer of 1886, Port-en-Bessin was very much a fishing port with no tourist interest and no tradition as a center for artists. Even today the town still functions as a fishing port with the boats and the surrounding houses jostling for space. Little in the harbor area appears to have changed since Seurat's visit. The main street is bordered by shops on the one side and by fishing boats in the inner harbor on the other side. The town is compact and Seurat has, in these paintings, captured the very essence of the port. So methodical was his approach that the views in several paintings were observed from the same spot. All Seurat did was to change his angle of vision, to rotate around and paint what he saw in front of him. The paintings are, therefore, a faithful and accurate record of the port. Here we see the bridge which connects the inner and outer harbors, the houses on the left facing the sea and, in the background, the Falaise de Huppain. Set late in the day, with lengthening shadows, the painting has an eerie, dream-like quality. In the open foreground, the small girl looking directly at the viewer, the solider to the left and the stooping woman, all appear as if they have been transposed from the *Grande Jatte*. They possess the same stiff appearance, are oblivious of each other, and look out of place in a fishing port. Seurat's interest in pattern can be seen clearly in the precise forms of the harbor, while the puffy clouds echo the undulating forms of the cliff.

Port-en-Bessin, The Outer Harbor, High Tide 1888

Oil on canvas
26×31⅞ inches (66×81 cm)
Musée d'Orsay, Paris

In this painting, the third painted from the same spot on the Falaise de Huppain, Seurat turned his gaze in an easterly direction and depicted the outer harbor of Port-en-Bessin nestling between the surrounding cliffs, with the Falaise du Castel beyond. The undulating forms of the cliffs are set off against the more rigid, geometric forms of the quayside and the general architectural setting. All that has changed since this painting was completed is that the canopied shelter located in the center has been demolished. The consistency of the brushmarks, and the general color scheme, has encouraged some to compare these paintings to early color photographs. Certainly Seurat may have been interested in the technical aspects of color printing, and the frozen stillness of the scene represented here may share a superficial likeness to early photographs. Of greater significance, however, was Seurat's interest in Symbolist ideas. From the mid 1880s a growing number of writers and critics were responsible for the development of a Symbolist aesthetic. Central to this development were the journals, *La Revue Indépendante* and *La Vogue*; the former being published between May 1884 and May 1885 while the latter only had a brief existence in 1886. Both were edited by Félix Fénéon and attracted contributions from all those who were to form the nucleus of the Symbolist movement. Writers such as Paul Adam and Gustave Kahn not only contributed to these journals but were also keen supporters of Seurat's art. Their concerns for developing a literary style that was evocative of different moods and emotions, both through the use of certain words and through new compositional structures, parallel the attempts by Seurat to capture similar effects in his marines.

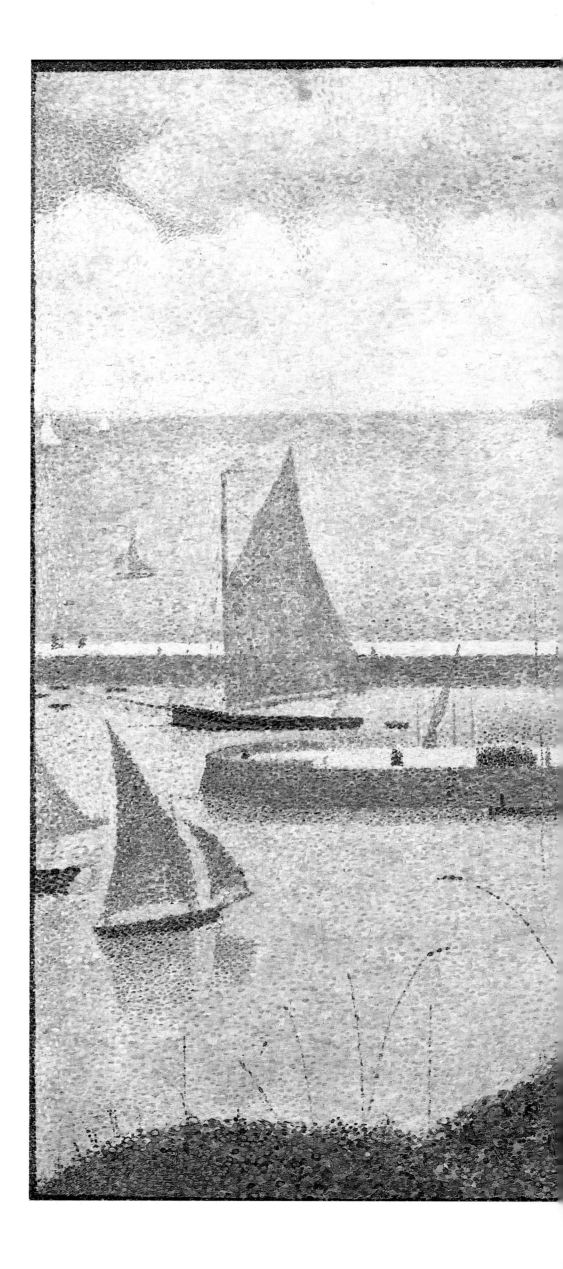

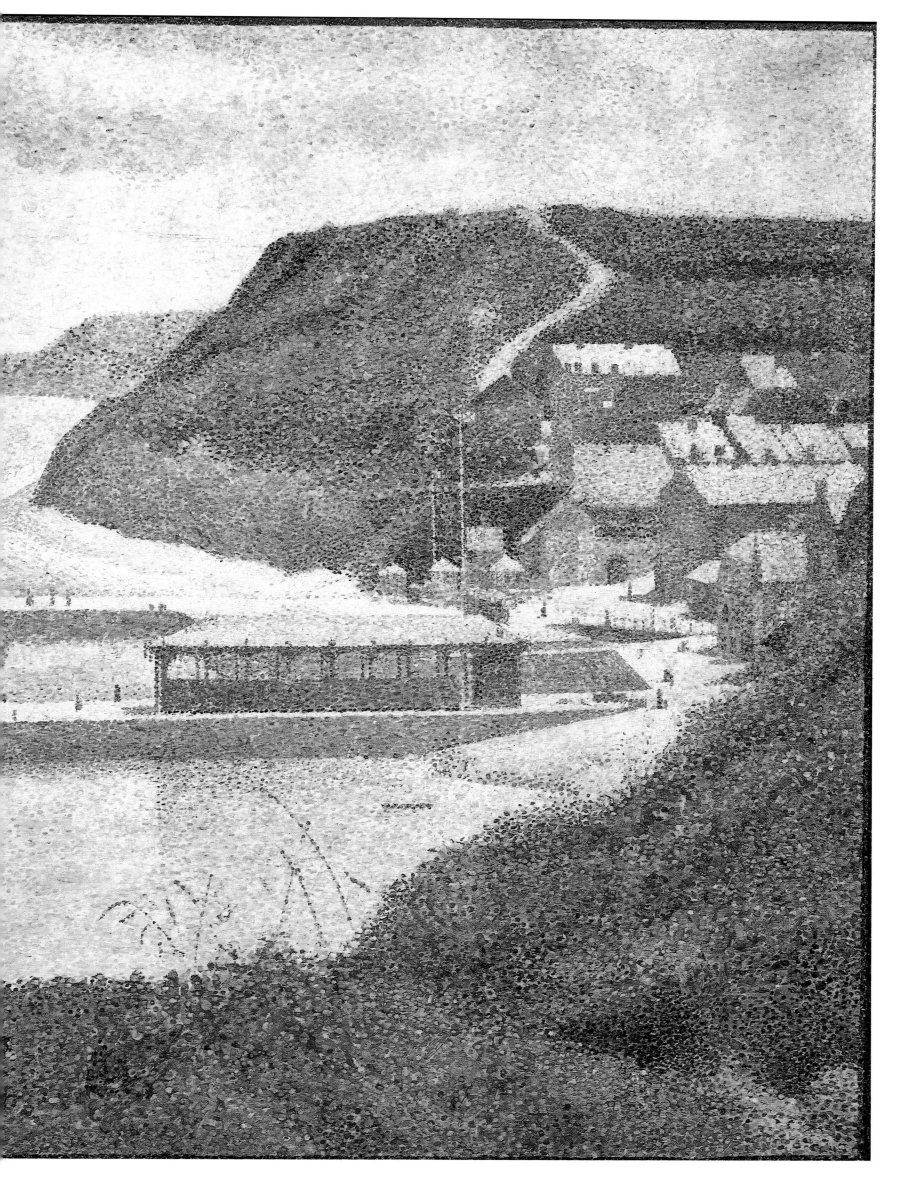

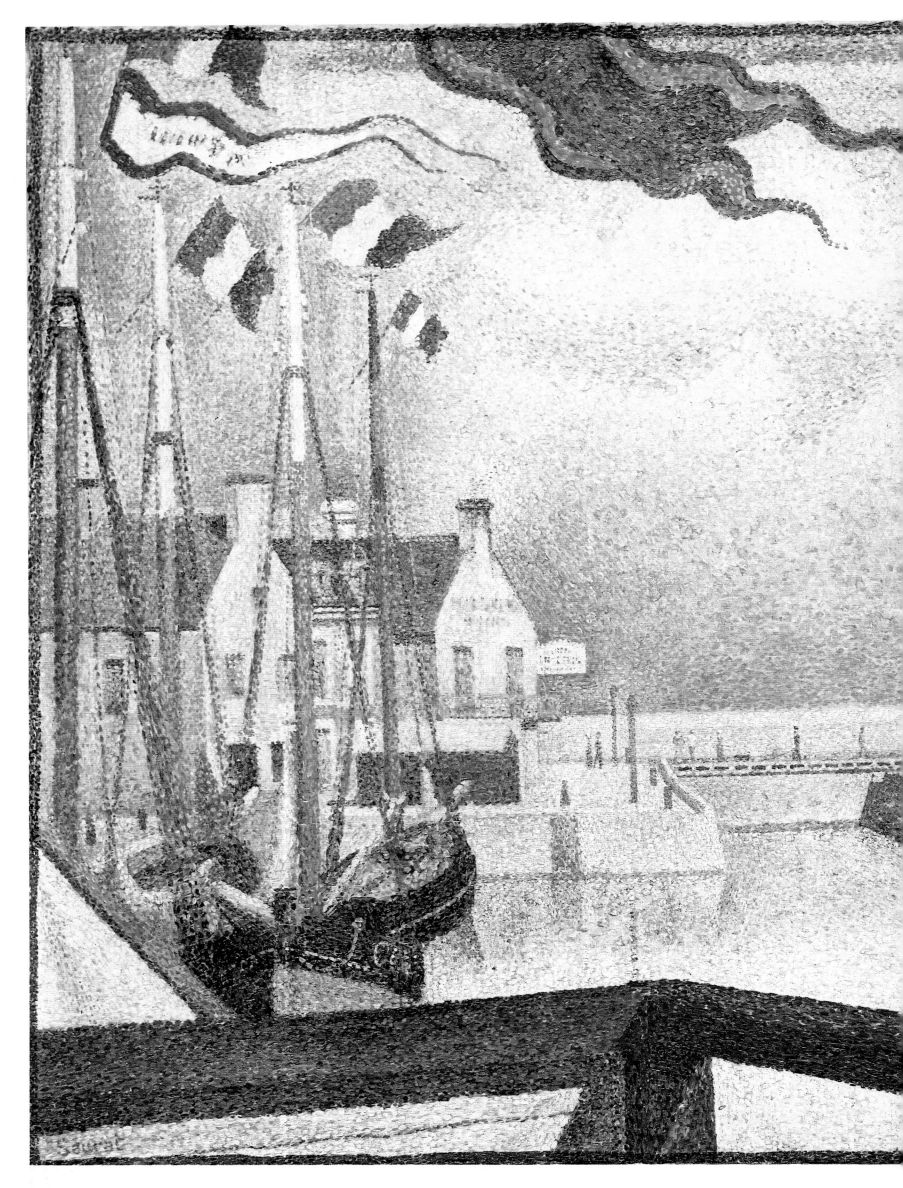

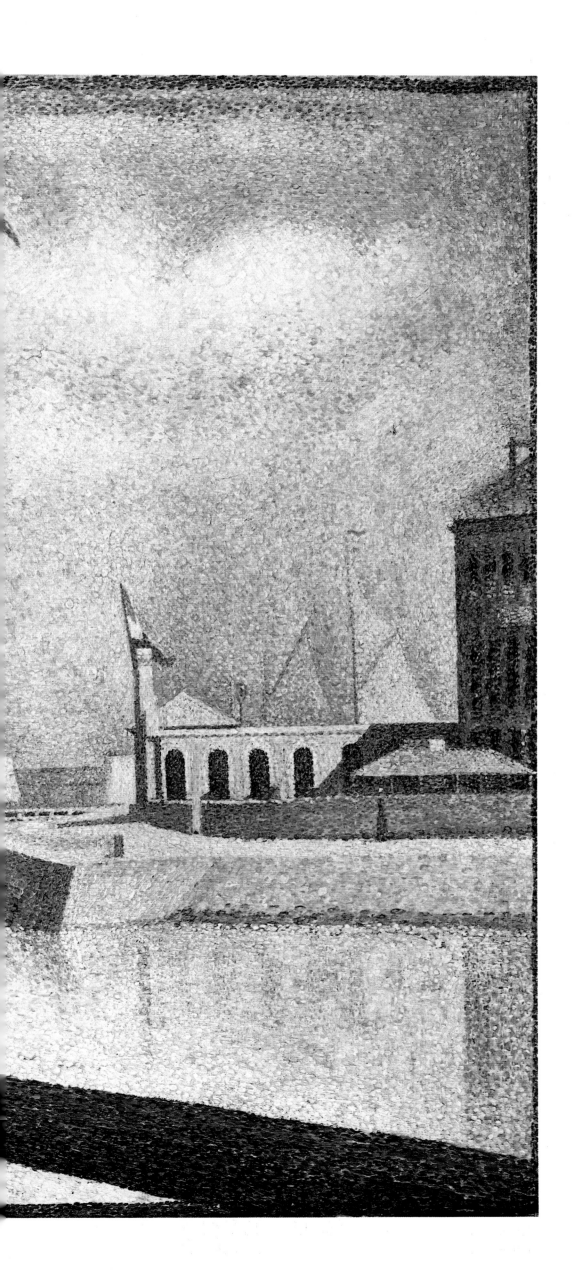

Port-en-Bessin, Sunday, 1888

Oil on canvas
25⅝×33⅞ inches (65×81 cm)
Kröller-Müller Museum, Otterlo

Just as the figures in *The Bridge and the Quays, Port-en-Bessin* (page 140) recalled Seurat's urban paintings, so too this painting prefigures examples such as *Le Cirque* (page 171). The balcony and railings provide a dramatic foreground device to lead the viewer's eye into the painting; it is as if the viewer were standing on the balcony observing the very same scene. Used in this way, the balcony performs a similar pictorial function as that of the clown in the foreground of *Le Cirque*. The agitated flags at the top of the boats' masts with their painted sails look forward to the coat-tails of the dancers in *Le Chahut* (page 157). Yet, for all its manipulation of form, this painting is still an accurate representation of the setting. The view looks outward from the town, with the inner harbor separated from the outer harbor by the narrow channel which can be seen in the center of the painting. Pedestrians are crossing the bridge which spans the channel and, beyond, the wall of the outer harbor acts as the line of horizon. It is a painting of both playful and calm moods. The freedom of the flags, almost Art Nouveau in their sinuous shapes, and the conchoid clouds contrast with the rigorous geometry of the masts and the architectural setting. The absence of any definite activity can be explained by the fact that the painting was done on a Sunday. It is known that the fishing fleet traditionally set sail on a Monday and returned to port the following Saturday. Thus Sunday was the only day that the whole community was together in Port-en-Bessin. And yet, one would expect some sign of activity. Certainly some figures are to be seen in the distance and the sails of boats of weekend sailors can be seen beyond the outer harbor wall, but no-one works at cleaning the fishing boats. Even the sea is at its most benign.

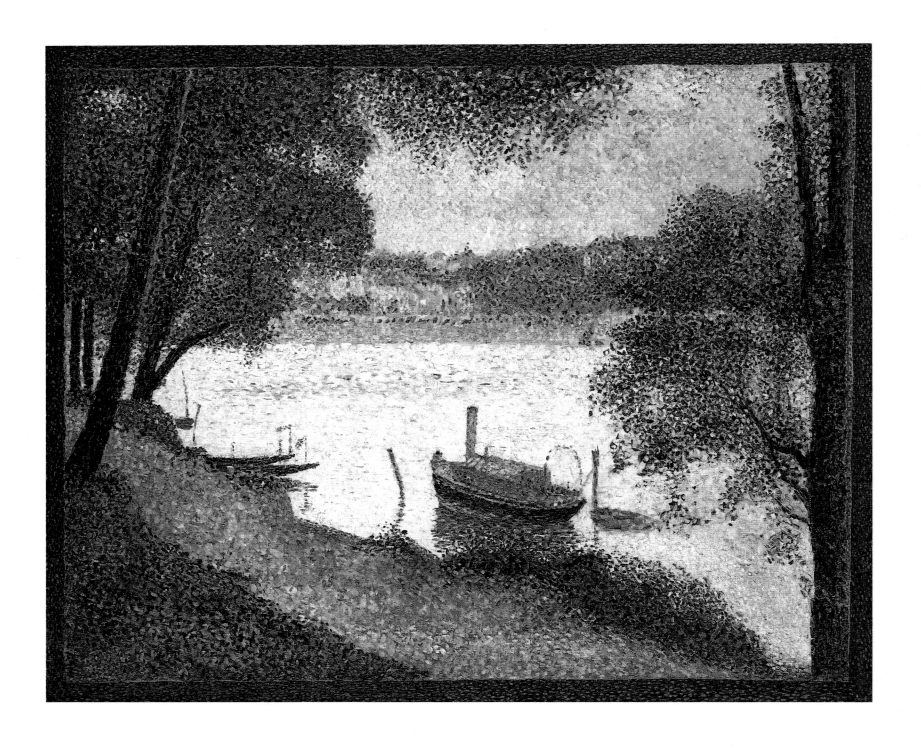

Temps Gris, La Grande Jatte,
1888

Oil on canvas
27½×33inches (70×84cm)
From the Private Collection of Mr and
Mrs Walter H Annenberg
Philadelphia Museum of Art

Similar in size this painting is the companion-piece to *Banks of the Seine (Island of the Grande Jatte)* which was painted in the Spring of 1888. In that painting Seurat depicted the enjoyment of a fine sunny day in contrast to the rather somber mood which characterizes this example. The dull weather of a rainy day permeates throughout, the darkness made more emphatic by the overhanging foliage framing the scene. The complex compositional arrangement framed by the trees on either side of the painting was commented on by Robert Goldwater in 1941. Goldwater described how the trees both contribute to the flatness of the frontal plane of the canvas while, at the same time, they continue the diagonal of the riverbank. He noted how:

the trees to right and left which serve to frame the picture and to establish the first, repoussoir plane, are themselves at different points upon a

spatial diagonal that recedes from right to left; this latter fact is obscured by a uniform intensity that brings them equally forward, and also by the repetition of this frontal plane in that of the shore in the distance.

The tension created between the illusion of spatial recession on the one hand and a concern to emphasize the flatness of the paint surface was a characteristic of many of Seurat's paintings from the mid-1880s onwards. A similar effect can be seen in *Le Pont de Courbevoie* of 1886-87 (page 120), in which Seurat has painted a similar view of the river Seine without the framing effect of the trees evident in this example. Also in contrast to that painting Seurat has painted here a much more rural image. Absent are the references to suburban factories and smoking chimneys; instead a solitary houseboat suggests a much quieter and more peaceful setting.

The Eiffel Tower, 1889

Oil on panel
9½×5⅞ inches (24×15 cm)
Fine Arts Museums of San Francisco
Museum Purchase, William H Noble
Bequest Fund

This small panel does not appear to have been painted as a preliminary study for a major painting. It shows the tower in an incomplete state, prior to the opening of the 1889 Exposition Universelle for which it was specifically built. In its original state the tower was painted in several shades of color, from copper red at its base to yellow at the top. In selecting this subject, Seurat acknowledged the potent symbol that the Eiffel Tower represented. As the most notable feature of the 1889 Exposition marking the centennial of the French Revolution, the tower stood as 'a bold statement of confidence: a confirmation of the consolidation of the Third Republic after its uncertain beginnings; a glorification of the Third Republic as the guardian and heir of the French Revolution; and an affirmation of the promises of liberal republicanism in the decades to come.' Claude Roger-Marx, first owner of this painting, had glorified the new iron architecture, applauding the exposed wrought-iron structure, and praised the airy, floating sensibility created by the interpenetration of light and air. This can be clearly seen in this panel where the tower emerges imperceptibly from the ground, the base treated in the same combination of orange-blue touches as is the surrounding ground. For artists working in Paris in 1889 the tower was an unavoidable image and it is likely that Seurat's response coincided with that Camille Pissarro. For Pissarro the tower, as depicted in the *Turpitudes Sociales* (page 25), represented progress. Father Time observes the rising of the tower as the sun rises to spread light and life to all. Here the rays spread outwards from the tower to form the word 'Anarchie.' Thus modernity, progress, and anarchism are clearly identified as the symbols of modern Paris.

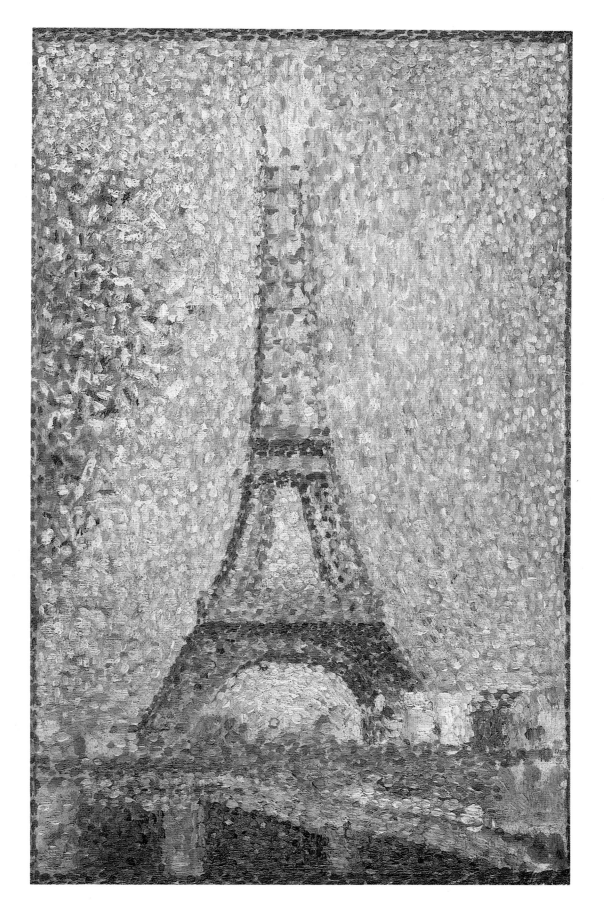

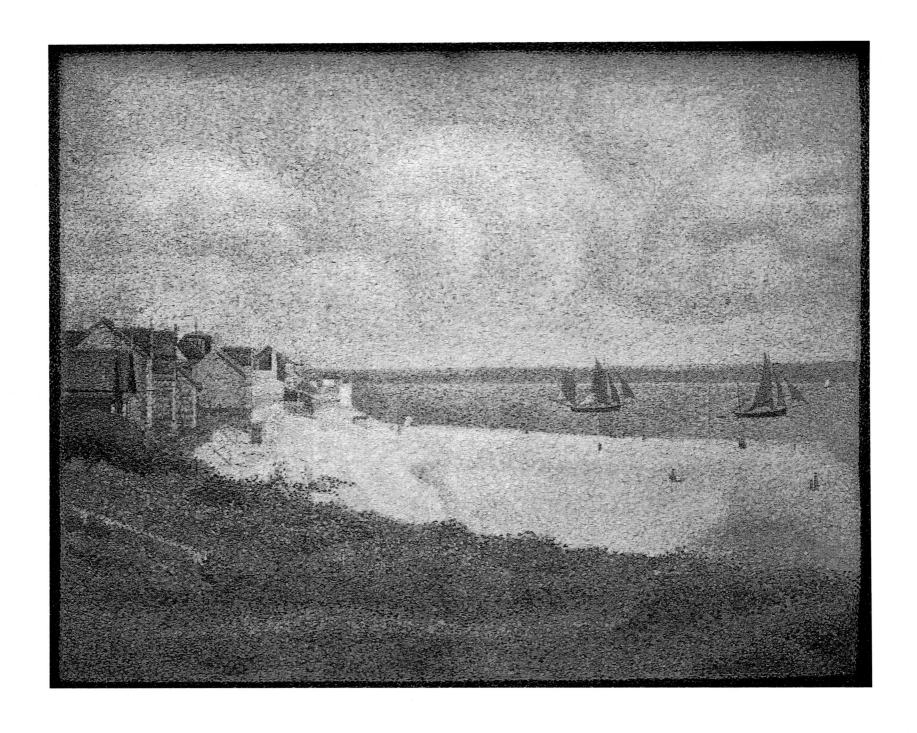

Le Crotoy, Downstream, 1889

Oil on canvas
27½×33⅞ inches (70×86 cm)
Stavros Niarchos Collection, London

For his summer visit to the coast in 1889, Seurat chose the small fishing port of Le Crotoy. Le Crotoy is located at the mouth of the Somme estuary, a landscape of marshland and rivulets, of unrestrained flatness where only the huddled buildings of Le Crotoy nestling on a small promontory break the line of the horizon. His choice may seem a curious one in that the town does not appear to have attracted other artists, nor did it have much of a reputation as a center of tourism. Only two paintings resulted from this visit as Seurat appears to have hurried back to Paris on receiving the news that his mistress, Madeleine Knobloch, was pregnant. Even the titles of the two paintings (pages 148 and 149) suggest they must have been conceived as a pair, one viewing the river upstream, the other downstream. They were exhibited together at the Indépendants show in Paris in September 1889 and, again as a pair, at the

1891 exhibition of Les Vingt in Brussels. The downstream view illustrated here reveals the wide sweep of the grassy foreground and sandy beach, the town pushed to the extreme edge of the canvas, billowing clouds in the sky, and two sailboats making their way out to sea. Although the application of the brushstrokes is much more uniform in this example, Seurat's treatment has become increasingly stylized. Accepting the openness of the landscape, Seurat has dramatically reduced the scale of the figures sitting and promenading on the beach to such an extent that they are dwarfed by everything around them. The treatment of the clouds caused Félix Fénéon a certain amount of consternation as his attachment to a more traditional form of realism conflicted with Seurat's increasingly schematized forms. Here, for Fénéon, the 'conchoid clouds' remained unconvincing.

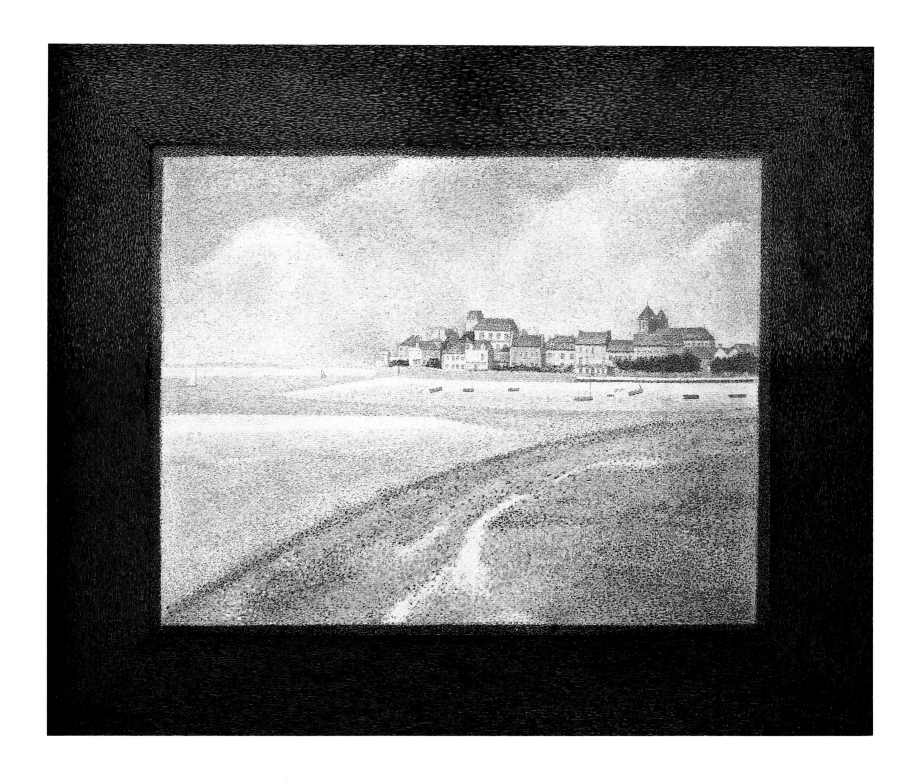

Le Crotoy, Upstream, 1889

Oil on canvas
27½×33⅞ inches (70×86 cm)
© The Detroit Institute of Arts
Bequest of Robert H Tannahill

Exhibited in 1889 with *Le Crotoy, Downstream*, this painting is remarkable as it is the only painting by Seurat to survive with its painted frame intact. Seurat later described his decision to surround his canvases with large painted frames in a letter to Maurice Beauborg in 1890. He wrote that the frames were painted 'in the harmony opposed to the tones, colors, and lines of the picture.' Writing in 1891 Emile Verhaeren elucidated in greater detail Seurat's interest in firstly painting the borders of his pictures in complementary contrasts and then by referring to Seurat's fascination with Wagnerian theatrical effects. He described Seurat's method:

At first, he colored the edges according to the law of complementaries. Where the edge of the work was blue, orange was indicated as a boundary; if red, then green would set it off,

and so on. It was only recently that he added complementary contrasts. He had imagined that at Bayreuth, the theater was darkened in order to present the illuminated scene as the unique center of attention. This contrast of great light amid shadow induced him to adopt dark frames, although retaining, as in the past, their complementary relationship to the image.

Having praised Seurat's seascapes in 1887-88, Fénéon was distinctly cool and disapproving of the Le Crotoy paintings. In this example he criticized the form of the clouds as resembling a 'mushroom or a jelly-fish,' and he believed that Seurat was suffering an unhealthy influence from the poster artist Jules Chéret. The seascapes, Fénéon believed, were becoming too stylized and the use of the right-angle, derived directly from Chéret's poster designs, stretched the plausibility of such scenes.

149

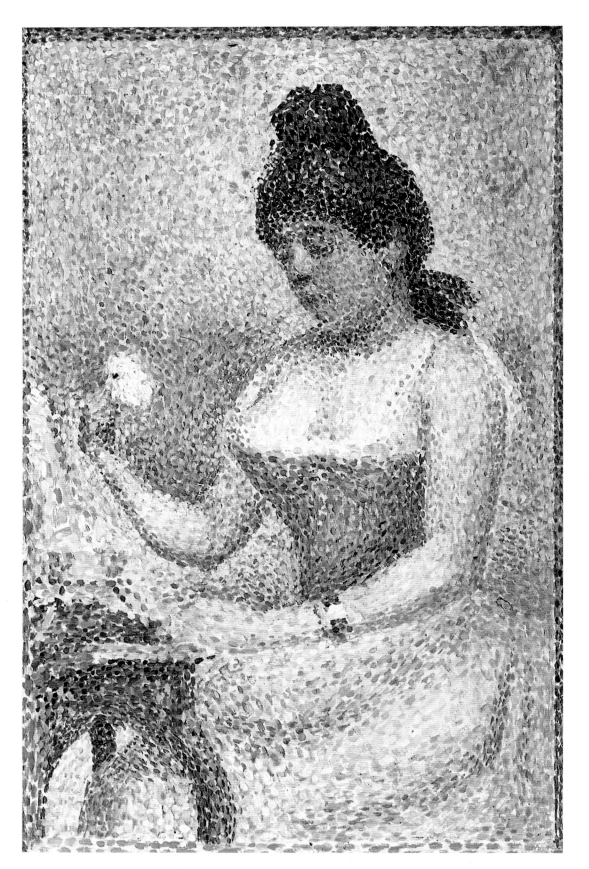

Jeune Femme se Poudrant,
1889-90

Oil on canvas
37×31½ inches (94×80 cm)
Courtauld Institute Galleries, London
Courtauld Collection

This painting was exhibited at the Sixth salon of the Société des Artistes Indépendants in March 1890 and is a portrait of Madeleine Knobloch, a young Belgian woman, who had become Seurat's mistress in late 1888 or early 1889. Signac later recorded that Seurat had begun work on the painting in 1888. The relationship was a curious one in that Seurat kept their liaison secret from all but two friends, Paul Signac and Charles Angrand, and when Seurat discovered that Knobloch was pregnant in the summer of 1889 he moved his studio to a secluded courtyard near the Place Pigalle to keep news of his impending fatherhood secret. As a portrait of his mistress, the painting does not flatter or depict her in a loving, tender way. Her rather ample appearance is contrasted with the absurdly small dressing table. The curving legs of the table draw attention to the generous curves of the young woman as she powders herself. Such curves are echoed in the way the paint is patterned on the rear wall, in the exotic plant forms and in the folds of her dress. The painting was exhibited alongside *La Parade de Cirque* (page 132) with the latter's rigid formalism and precise geometric structure. In contrast, *Jeune Femme se Poudrant* shows Seurat at his freest and most exuberant and the flowing forms prefigure the Art Nouveau movement of the 1890s. Fénéon, unaware of the identity of the sitter, disliked the painting. Roger Fry, writing in 1926, referred to the grotesque form of the woman, but he approved of the decorative flatness of the painting and praised its almost abstract beauty. Seurat may originally have included a self-portrait in the small frame at the top of the painting, but painted over his image with the vase of flowers on the advice of friends.

Jeune Femme se Poudrant,
1889-90

Oil on panel
10⅛×6⅝ inches (25.7×16.8 cm)
The Museum of Fine Arts, Houston
On extended loan from the John A and
Audrey Jones Beck Collection

The connexion between this painting and eighteenth-century toilette scenes has been suggested on several occasions. Although the subject was a private one for Seurat, to evoke the eighteenth century would have been a fashionable act in the late 1880s. For much of the nineteenth century there had been little interest in the art of the eighteenth century, but with the publication of Edmond and Jules de Goncourt's famous study in 1869 interest was revived. For them the eighteenth century was 'almost a century of grace, the century of woman and her caressing domination over manner and customs.' By the 1880s this revival had reached significant proportions as can be witnessed in the person of Roger-Marx, secretary to the Director of the Ecole des Beaux-Arts in the 1880s, and artistic director of the 1889 Paris exhibition, who encouraged official patronage of a revived rococo style. The 1889 exhibition also was the focus for debates concerning the role of women in society. Seurat's acquaintance, the novelist Victor Joze, for whom Seurat illustrated a book cover (page 154), became actively involved in this debate. Joze rejected the demands for greater rights for women as he believed women should only inhabit 'the private world of emotion and maternity.' As he bluntly explained, 'a woman exists only through her ovaries.' Although these views were expressed in the mid 1890s, they referred to issues already apparent by 1889. It is tempting, therefore, to wonder if Seurat shared similar views. The exaggerated rococo details draw attention to Madeleine Knobloch's appearance. She was pregnant when this painting was started and there is an undoubted erotic quality and voyeuristic aspect as we, and originally Seurat himself, gaze at this intimate subject.

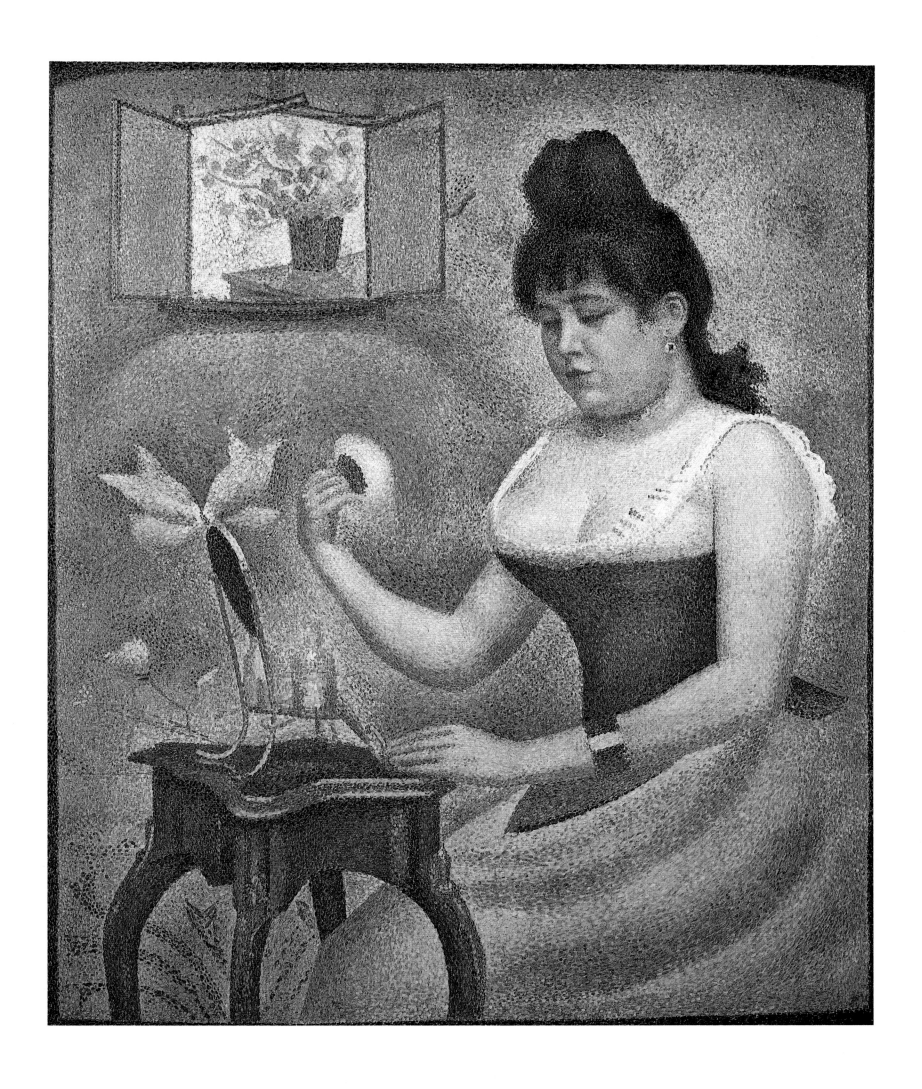

151

Jeune Femme se Poudrant,

1889-90
Detail
Oil on canvas
Courtauld Institute Galleries, London
Courtauld Collection

This detail reveals the interest Seurat displayed in the play of pattern and abstract forms in his late paintings. Writing in 1941 Robert Goldwater commented that there was a tension between 'the design of the painting and its subject,' and it was this contrast between the various patterns and the form of the woman which contributed a humorous element to the painting. Perhaps many of Seurat's friends felt awkward about this depiction of his mistress as few outwardly commented on it. A series of curving rhythms are repeated throughout the canvas. Illustrated by the rococo curves of the dressing table, the stencilled plant forms on the wall and the pattern of the inverted pink arrows, Seurat's use of color is at its most arbitrary. Blue and pinks dominate throughout and any concern for using color in a naturalistic way has been rejected in favor of pictorial effect and abstract patterning. This can be seen in the contrast between the lighter and darker blue areas on the wall. Parts of this effect follows Seurat's concern for defining contours by artificially heightening the tones of the colors along their mutual edge, such as around the powder puff and the girl's outstretched arm, but in other areas it is more arbitrarily handled. The plant forms and the patterns suggest a general upward movement and have therefore been explained in terms of Charles Henry's ideas concerning the emotional values associated with line and color. While the forms of the painting do appear to be suggestive of upwardly ascending lines, and therefore of happiness, the colors do not correspond to those thought by Henry to achieve the same effect.

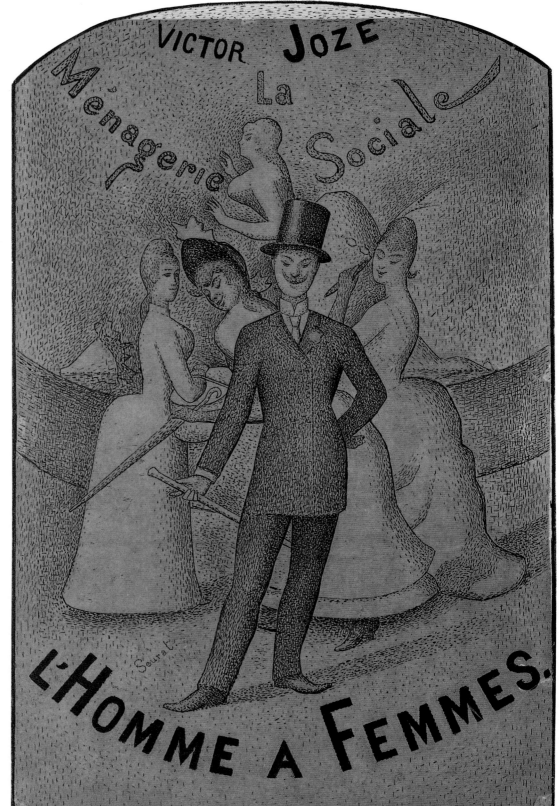

L'Homme à Femmes, 1890

Pen and ink
10¼×6¾ inches (26×17 cm)
Formerly Galerie Jan Krugier, Geneva

Given Seurat's strong interest in popular art, it is perhaps surprising that this illustration was his only foray into that realm. In 1890 he was commissioned to design this book cover for a friend, the writer Victor Joze. Joze had written on Neo-Impressionist art for a Polish periodical and the two must have met around 1887. In the novel, rather like Guy de Maupassant's *Bel Ami* written in 1885, Joze describes the numerous affairs of a naturalist writer, Charles de Montfort. It is de Montfort who appears in the center of the illustration, looking very much the dandy in his top hat and suit. Behind de Montfort are the various women he seduces and has affairs with. Like Georges Duroy, the hero of Maupassant's *Bel Ami*, de Montfort improves his social standing by gradually seducing wealthier and more influential women. Beginning with a liaison with a shop assistant, he variously takes up with a streetwalker, a café-concert singer and ends up having a long affair with the wife of a titled husband. Behind him the women cast admiring glances. For the cover Seurat has adopted a precise drawing style with the outlines of the figures clearly defined. A source of light coming from the left results in shadows being cast diagonally across the surface. The dotted effect is fashioned in a somewhat arbitrary manner, although Seurat has continued to exploit the theory of irradiation where tones are artificially heightened at their meeting point. Also, the ideas of Charles Henry are evident in the upturned effect of the man's moustache and eyes and in those of two of the women suggesting a scene of gaiety and happiness. Most curious of all is that one of the characters in the book, an artist named Georges Legrand, is clearly based upon Georges Seurat himself.

154

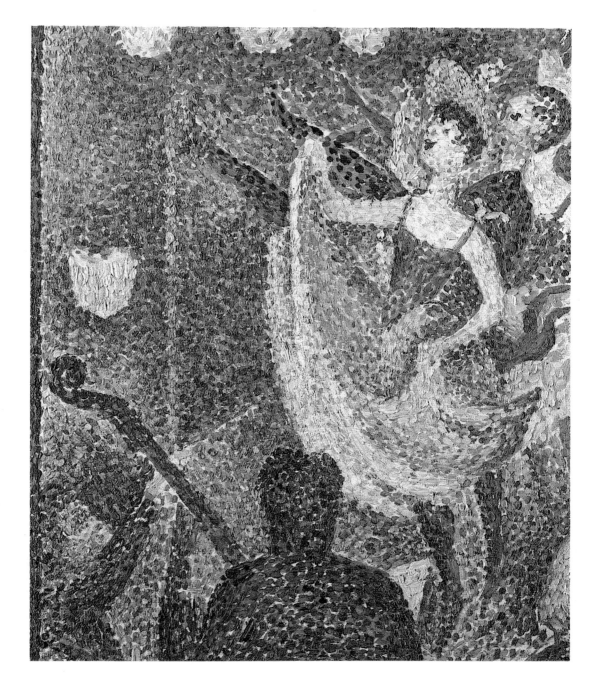

Study for 'Le Chahut', c.1889-90

Oil on panel
9⅝×6¼inches (22×16cm)
Courtauld Institute Galleries, London
Courtauld Collection

This panel was the first color study painted
by Seurat in his preparation for *Le Chahut*.
Compositionally it is related to a drawing
he made of a café-concert subject at the
Divan Japonais in 1887-88 and exhibited
early in 1888. Already in the drawing
Seurat had established the basic composi-
tion of *Le Chahut*, the foreground domi-
nated by the musician and the dancers in
the right half of the image. This panel
translated the forms of the drawing into
color so that Seurat could explore further
the harmonies and relationships of the
color accents. The darker areas have been
sketched in a series of blue and orange
dots, whereas the background has been
painted in a variety of green, ocher, and
blue touches. Neo-Impressionist color
theory has been less rigorously applied as
Seurat explored the possibilities of using
color in a freer way in order to portray the
nature of café-scenes. The juxtaposition of
light and dark areas has been firmly estab-
lished, in particular the dark haloes which
surround the gaslights. Just as Seurat was
abandoning the rigid application of color
theories that had characterized earlier
paintings, it is possible to see in this sketch
how he began to experiment more con-
fidently with the directional forces he
could achieve in the application of paint.
The dotted brushmarks follow, and en-
hance, the movements and rhythms of the
high-kicking dancers. The handling of the
definitive version is more restrained.
Although Seurat added a fourth dancer, in
the final study (page 155), the basic figure
groupings have been established here.
Some detail has been given to the faces of
the dancers but the sinister details of the
male figure in the lower right corner are as
yet undefined.

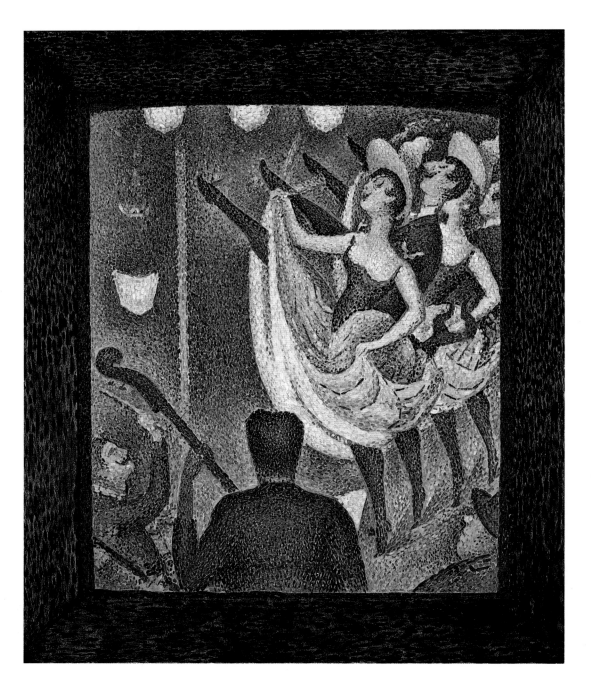

Study for 'Le Chahut', 1889-90

Oil on canvas
21⅞×18⅜ inches (55.6×46.7 cm)
Albright-Knox Art Gallery, Buffalo
General Purchase Funds, 1943

Several preparatory studies exist for *Le Chahut*, this painting being the largest and the one in which most of the features of the completed canvas are apparent. In the small color study in the Courtauld Institute Galleries, London, Seurat had established the basic compositional arrangement and had sketched in the color harmonies. This study reveals a further stage in the planning of the painting. A fourth dancer has been added at the right, while in the lower left the flautist has been placed between the conductor and the picture surface. To the right the head of the male spectator has been more clearly defined although he lacks the facial details that are so crucial in the finished painting. As yet Seurat had not resolved the

audience glimpsed through the dancers and orchestra. Most important, however, is the establishment of the color harmonies. The painting is dominated by colors ranging from red to yellow, with a yellow-orange effect evident throughout. The complementary contrasts of blue-violet not only exist in the shadows, as one would expect, but are rather arbitrarily placed throughout the painting. In his search for harmony Seurat was willing in these later paintings to reject naturalistic concerns in favor of achieving the right pictorial effects. To achieve the impression of a happy experience he has used predominantly warm colors, as well as employing Charles Henry's ideas of the emotional qualities of line. A sensation of gaiety has become Seurat's overriding concern and he has used different pictorial effects to achieve that aim. One friend described *Le Chahut* as his first successful realization of his theories, that everything was calculated with one aim and that the formal qualities enforce the 'dominant idea.'

Le Chahut, 1889-90

Oil on canvas
66½×54¾ inches (169×139 cm)
Kröller-Müller Museum, Otterlo

Exhibited at the salon of the Société des Indépendants in 1890, Seurat has captured here the essential features of a typical Parisian café-concert. This painting is certainly one of the most important works of his entire oeuvre. The scene shows a group of dancers performing a fashionable high-kicking dance, known as the Quadrille Naturaliste. Particularly popular in the late 1880s and early 1890s, this dance was characterized by the dramatic movements of the dancers and the erotic thrills experienced by the predominantly male audiences as they glimpsed the naked thighs of the female dancers performing the high-kicking routine. Seurat appears to have made much of Charles Henry's ideas concerning the connexions between psychological effects and movements of line and the values of color. Theo van Gogh found this painting 'curious' and wrote that he was aware that Seurat was attempting 'to express things by the means of the direction of lines.' Similarly Henri van de Velde stated Seurat's 'intention . . . to succeed in expressing gaiety by the consistent direction of lines.' Henry's ideas that upward-moving lines suggested gaiety seem to permeate throughout the painting. The rhythm of the dance, the gestures of the conductor, the gas jets all suggest upward movement and thus the jollity that the audience and the spectator should be sharing. Perhaps all is not what it appears, however. The viewer is shielded from the action by the bulky, silhouetted back of the bass player and the caricatured face of the male figure in foreground. The latter is depicted with a pig's snout – a device derived from contemporary caricature – as he leers at the dancers' thighs, which alludes to the seamier side of the evening's entertainment.

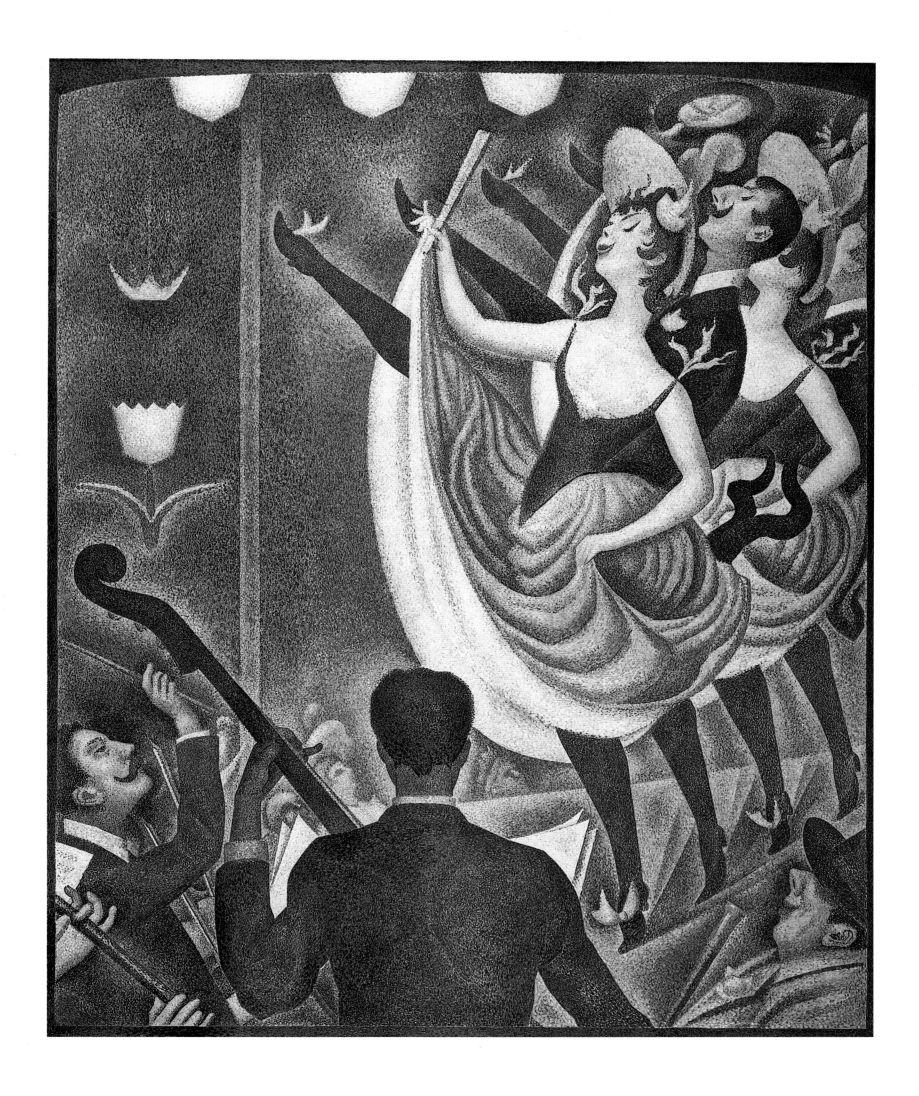

Le Chahut, 1889-90
Detail
Oil on canvas
Kröller-Müller Museum, Otterlo

Gustave Kahn, who soon purchased this painting, identified this detail of the male spectator as the 'synthetic image of the public.' He was an 'archetype of the fat reveller' and his 'pig's snout' reveals Seurat's interest in caricature as a source of his paintings. In fact, it was his increasing use of caricature that caused the displeasure of his supporter and friend, Félix Fénéon. Fénéon believed that caricature was not a suitable feature of a serious work of art. Seurat, however, was particularly interested in cartoons and popular broadsheets, a fascination inherited from his father. In adopting the forms of popular imagery Seurat could enhance the satirical content of paintings such as *Le Chahut.* Although comparisons have been made with the poster designs of Jules Chéret, for example the shared features between Chéret's *Les Girard* (page 26) and Seurat's paintings of urban entertainment, it is the reference to contemporary caricature that gives Seurat's paintings their unrivalled insights into the seamier side of Parisian nightlife. As the male figure vulgarly enjoys the display of the legs of the female dancers his identity would have been apparent to many observing Seurat's painting. To heighten the contrast between the leering male spectator and the dancers he so admires, Seurat has depicted them in a most formal, hieratic way that denies their own individuality. Kahn likened their representation to Egyptian art and described their performance as 'this solemn and cabalistic pantomime.' Even though they are engaged in the most energetic of dances their movements and gestures are frozen, static, and immobile. The regularity of their features is in marked contrast to the physiognomy of the male spectator.

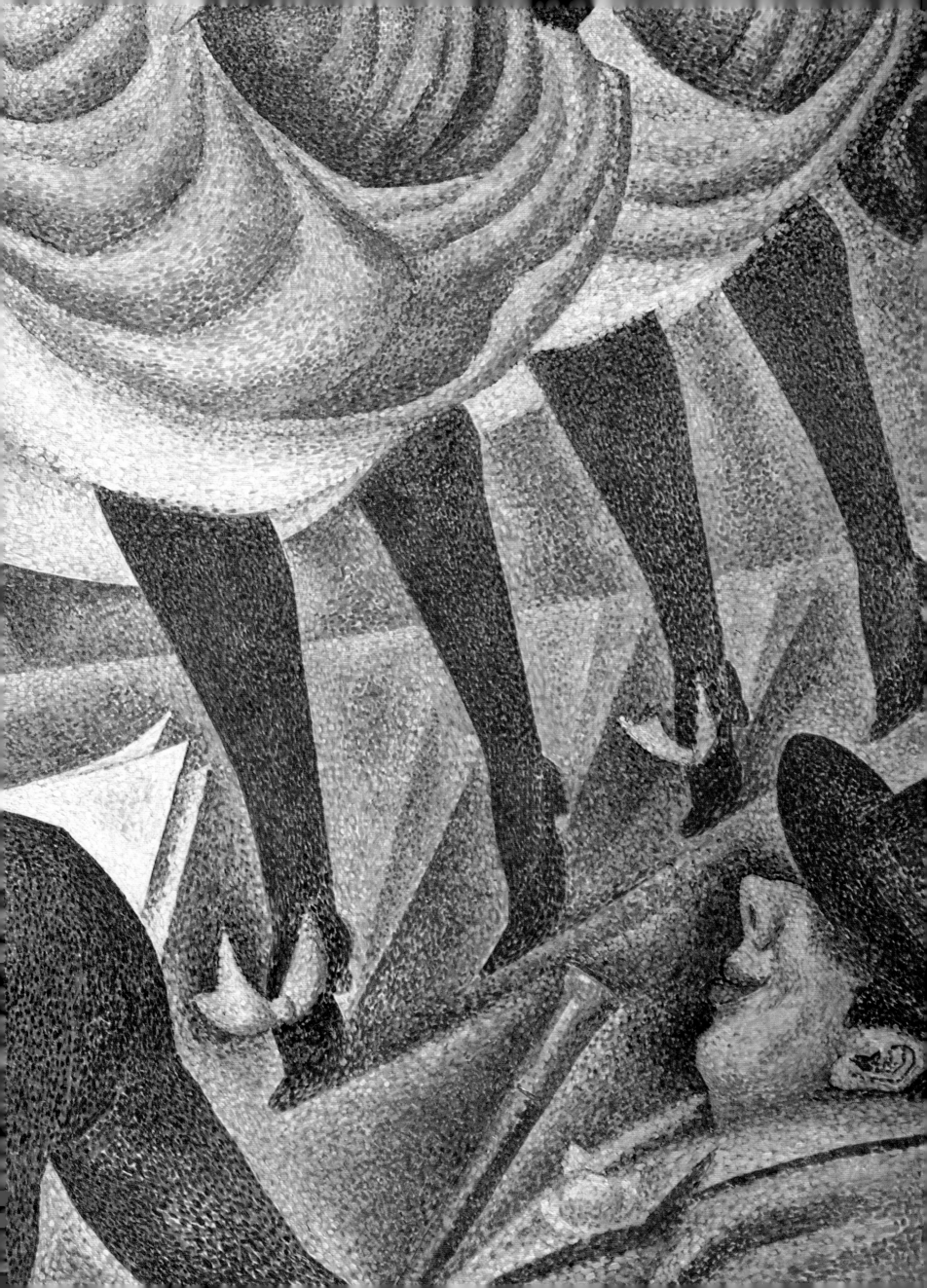

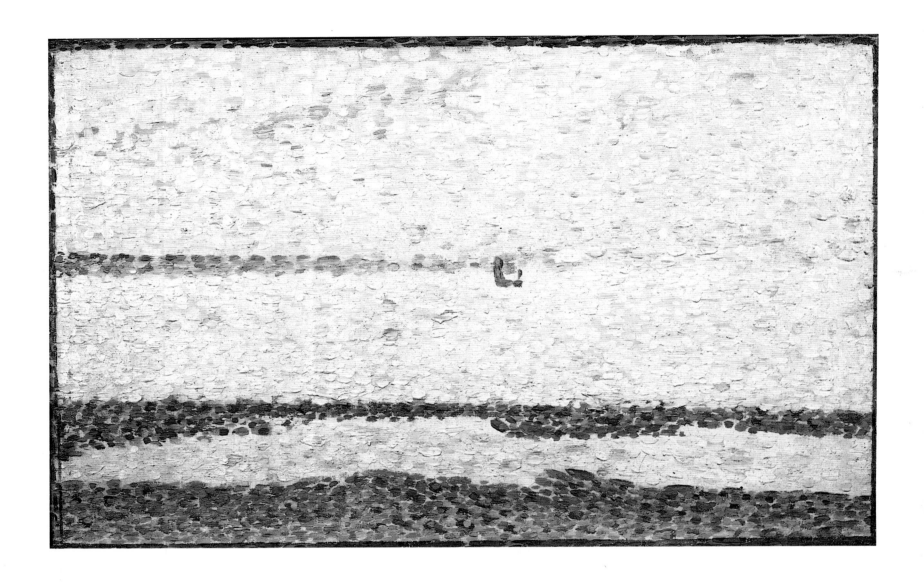

The Beach and a Boat, Gravelines, 1890

Oil on panel
6¼×9⅞inches (16×25cm)
Courtauld Institute Galleries, London
Courtauld Collection

Although this panel has a certain affinity with the *Study for the 'Channel at Gravelines'* it is not directly related to any of the four large paintings painted by Seurat in the summer of 1890. Sea and sky merge together and, apart from the solitary boat, this sketch reveals an almost abstract treatment of the scene. In the foreground an area of sand is indicated by a series of blue and orange touches, an effect that is repeated in a second spit of sand immediately above and then by the promontory of land which marks the horizon between the sea and sky, and which is abruptly ended by the vertical formed by the sail of the fishing boat. Even in such a small study Seurat's concern for a precise composition is apparent. The harmonious pattern is created by the repetition of the three horizontal bands of sand which are, in turn, set off against the single vertical accent of the boat. This motif is positioned slightly to the right of center in the panel, although the line formed by the bottom of the boat falls exactly at the halfway point on the vertical axis of the panel. The rest of the panel is painted in creamy ocher touches. Seurat has applied the paint in a more luscious manner, a characteristic feature of these late panels and a technique which foreshadowed developments in the technique of other Neo-Impressionist painters in the 1890s. Surrounding and framing the scene is a painted blue border with additional touches of orange to set off the colors of the painting. It is the prominence given to the individual brushmarks that attracted the interest of artists such as Robert Delaunay in his paintings of the Eiffel Tower in the years just before 1914.

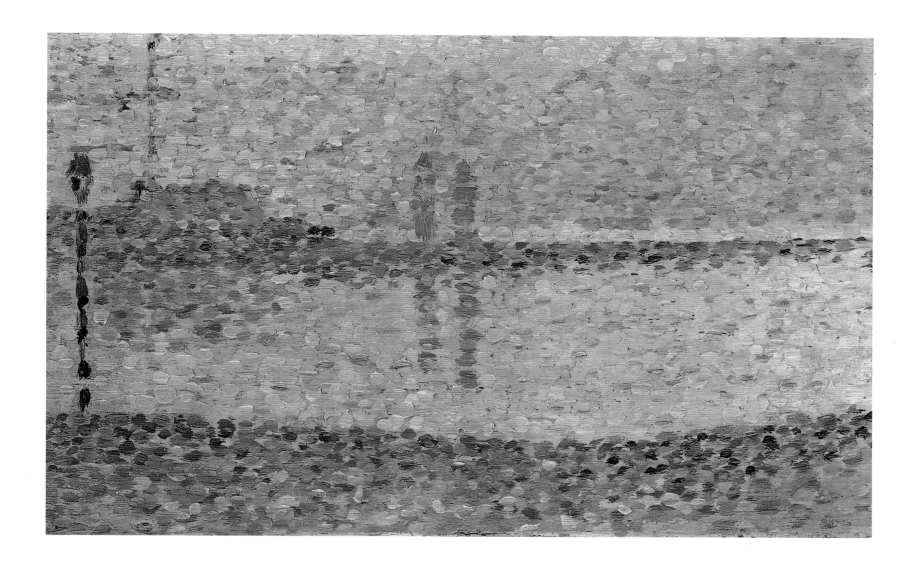

Study for 'The Channel at Gravelines', 1890

Oil on panel
6¼×9⅞ inches (16×25 cm)
Musée de l'Annonciade, St Tropez

The seascapes painted at Port-en-Bessin appear to have been completed without the aid of small preparatory sketches or drawings. None, at least, is known to have survived. If Seurat was so confident of his approach in 1889 that he could start work immediately on the definitive paintings, in 1890 he resorted to the practice of making preliminary studies before starting his larger paintings. This luscious study was painted as a preliminary to *The Channel at Gravelines, Evening* (page 162). In it the main elements of the scene are established: the gently curved foreground and lamppost at the left edge; the opposite bank with its architectural mass; and the open expanses of sea and sky. In the completed painting Seurat has eased the curve of the near shore and moved the two sailboats to the center of this panel. In their place he has added the two anchors to the extreme right and increased the area of sky. The

most striking features of this panel, however, are the paint application and the rich range of colors used by Seurat. Paul Signac later criticized Seurat for his technique of the late 1880s, in applying the paint in a series of small dots. For Signac this resulted in a mechanistic quality and a grayness of tone. Others, too, had noted a certain dullness in some of Seurat's canvases. Such criticism is invalid as far as this panel is concerned. Although the paint has been applied in small touches, there is a richness in the handling which recalls some of the panels of the early 1880s. Each mark can be clearly identified, even where they overlap. The range of colors, from deep blues via delicate pinks to vibrant reds, is almost reminiscent of a mosaic effect. These changes curiously foreshadow developments in Neo-Impressionist art in the 1890s, for example H E Cross's *Evening Air* of 1894.

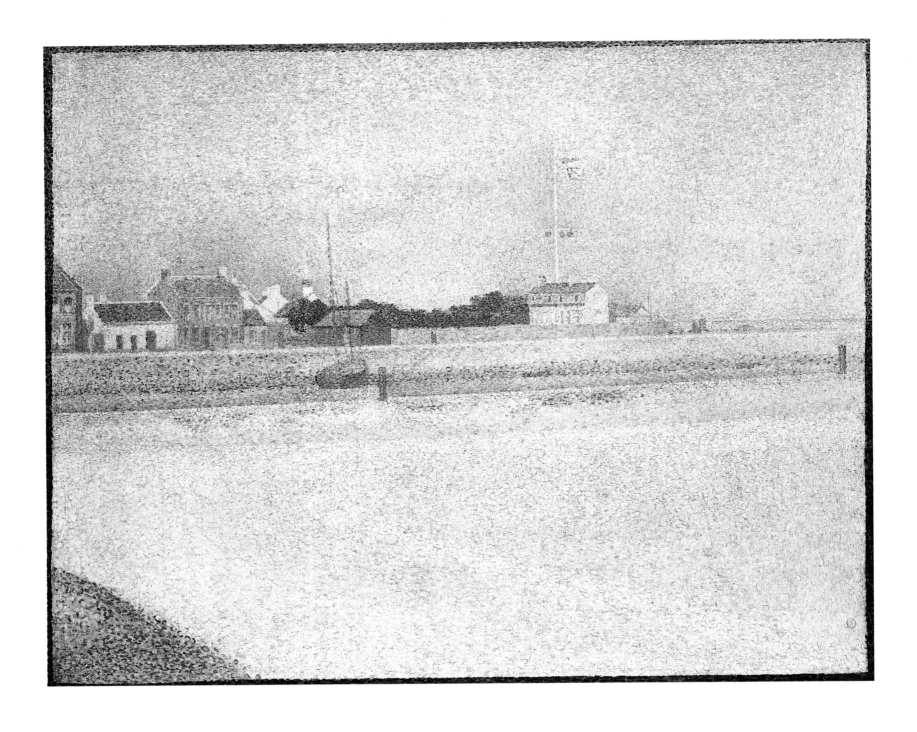

The Channel of Gravelines, Grand Fort Philippe, 1890

Oil on canvas
25½×31⅞ inches (65×81 cm)
Berggruen Collection, on loan to the
National Gallery, London

Seurat made his summer visit to the coast in 1890 to the distinctly unfashionable port of Gravelines, located on the Channel coast midway between Calais and Dunkerque. Gravelines was the most northerly port that Seurat visited and he probably chose to go there in June 1890 precisely because of its isolation. With the birth of his son and an increasing tetchiness concerning the secrecy of his painting technique, Seurat was keen to escape from Paris. During his stay he painted a number of sketches, completed some drawings and embarked on four major paintings that he continued to work on after his return to Paris. The four paintings were clearly intended to be seen as a related group; their subjects are connected by the constant reference to the small channel that linked Gravelines with the sea, and they are similar, although not identical, in scale. Seurat, himself, encouraged such an interpretation as they were exhibited twice as a group before he died; firstly in Brussels in February 1891 and then in Paris in March

1891. On each occasion they were displayed in a sequence which showed that Seurat depicted in the paintings not only specific sites but also different times of the day, from early morning until sunset.

This painting is the first in the sequence with the scene bathed in an even, early morning light. The composition is reminiscent of his two paintings of Le Crotoy painted the previous year. The wide, open foreground and the vast expanse of sky are separated only by a thin sliver of land forming a dominant horizontal axis in the middle of the canvas. A small triangle of grass in the bottom left-hand corner, paralleled by a lighter strip of sand, leads the eye into the painting and towards the narrow channel. To prevent the eye wandering off the right edge of the painting Seurat has included the bollard to act as a vertical form to force the eye back into the painting. With the evenness of the light and the calmness produced by the open composition Seurat has captured the delicacy and subtlety of early morning.

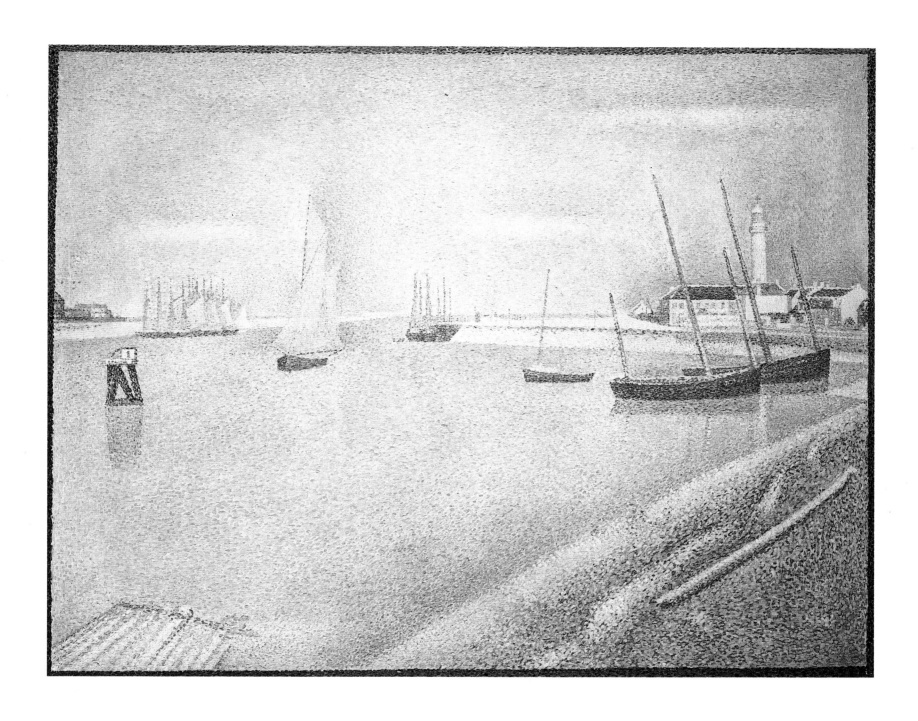

The Channel of Gravelines, Towards the Sea, 1890

Oil on canvas
28¾×35⅝ inches (73×93 cm)
Kröller-Müller Museum, Otterlo

In this painting Seurat has turned his sight towards the sea. The foreground is dominated by the harbor area, dramatically defined by the diagonal formed by the grassy area in the right foreground of the painting. The harbor wall reappears as a second diagonal in the middle distance creating the rhomboid form of the harbor area. On the left edge the open expanse of water is defined by the floating wooden structure in the immediate foreground, by the channel marker in the middle distance, and the combination of sailboats and the promontory of land in the far distance. The houses on the extreme left of the painting are those depicted in the first of this sequence of paintings, *Grand Fort-Philippe.* Even though the composition is far more dramatic than the previous example, contemporary photographs reveal that Seurat remained remarkably faithful to the scene in front of him, possibly only exaggerating the height of his viewpoint. This has the effect of emphasizing the angle of the harbor wall while, at the same time, flattening the foreground features to enhance the decorative qualities of the picture surface.

The light is evenly spread throughout the painting with very little evidence of shadow suggesting that the scene depicted is one of late morning or midday with the sun high in the sky. At first sight the evenness of the brushmarks seems to add to the harmony of the painting but closer inspection reveals how Seurat varied his touch. The treatment of the grassy foreground, for example, reveals a variety of brushmarks that radiate outwards from the right-hand corner of the canvas and then move upwards to define the pipe lying on the ground and the path beyond it. Color, too, is used to enhance the composition. The blue-greens of the water in the harbor are darkened where they meet the grassy bank where the ocher coloring is lightened in tone. Likewise, the blue of the sky is artificially darkened in order to contrast with the sails of the boat located in the center of the painting.

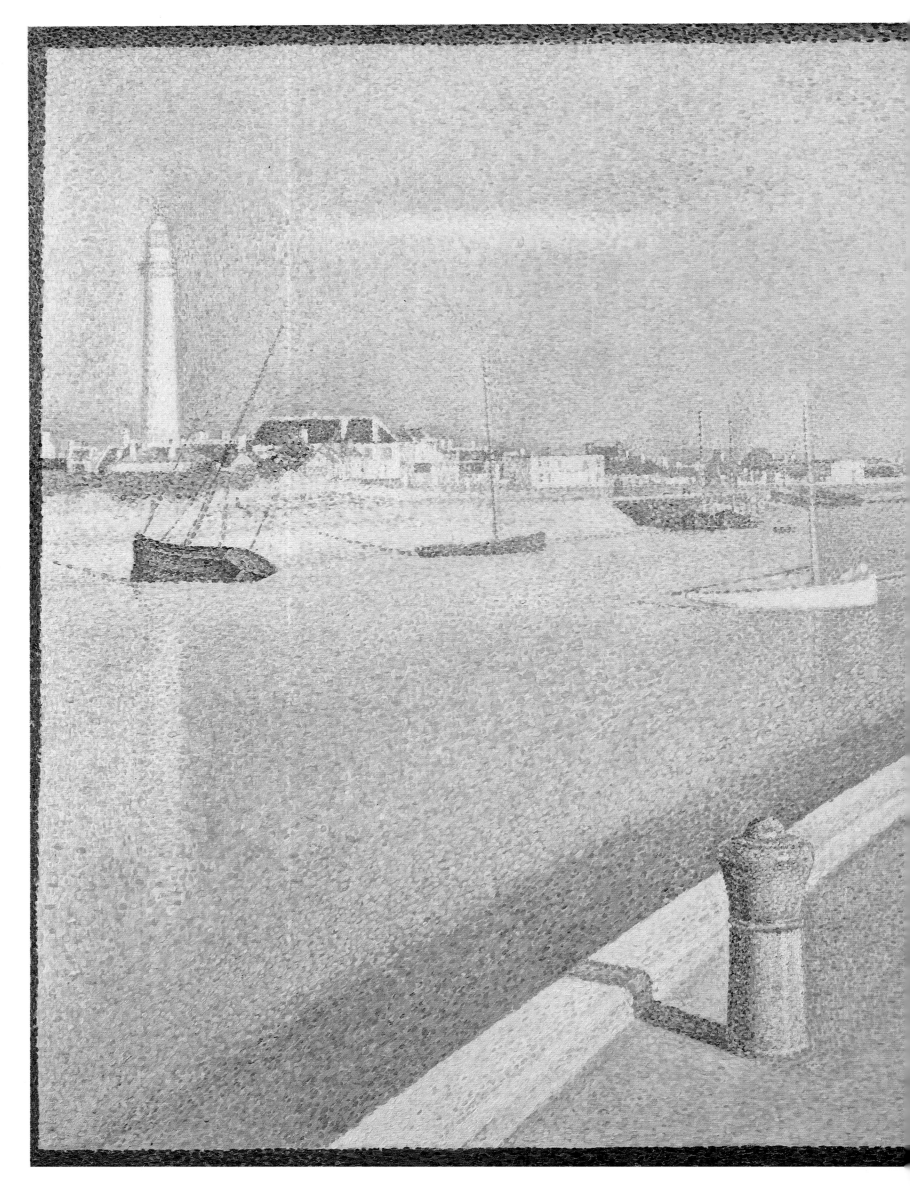

The Channel of Gravelines, Petit Fort-Philippe, 1890

Oil on canvas
28⅞×36¼ inches (73×92 cm)
© 1991 Indianapolis Museum of Art
Gift of James W Fesler in memory of
Daniel W and Elizabeth C Marmon

Emile Verhaeren, the Belgian Symbolist poet and friend of Seurat, praised the Gravelines paintings for the precision of their harmonies and their moods of tranquility and calmness. Such tranquility can be clearly seen in this example. In this painting, the third in the sequence of this series, Seurat turned his gaze away from the sea and instead the view is inland, looking back towards the hamlet of Petit Fort-Philippe. Although the Gravelines paintings all depict the stillness associated with a hot summer's day, the compositional form of this painting sets it apart from the others in the series. The sweeping diagonal of the harbor wall makes this painting the most vibrant and dynamic painting in the series. The great curve of the pathway sweeps the viewer's eye into the distance. The harmony of this rhythm is repeated by the curve of the shadow cast by the harbor wall and by the gentler curve of the opposite bank. In contrast, a very determined vertical harmony is achieved by the repetition of the forms of the masts of the boats, the lighthouse and its reflexion, and by the dominance of the bollard in the immediate foreground. This bollard almost becomes surrealist in its splendid isolation.

Such dynamism, however, is contrasted with the absence of any activity within the painting. With the lengthening shadows it is possible to identify this painting as a mid-afternoon scene. Yet any reference to the workings of the port are completely ignored; all the boats, with one exception, are moored with their sails down. As with the other Gravelines paintings there is no sign of any human activity. The absence of a human presence adds to the timeless mood that these paintings possess.

The Channel of Gravelines,
Evening, 1890

Oil on canvas
25½×32¼ inches (65×82 cm)
Collection, The Museum of Modern Art,
New York
Gift of Mr and Mrs William A M Burden

The last of the Gravelines paintings. A twi-
light scene in which the elements of the
seascape are reduced to a bare minimum
and the composition is made up of a series
of broad horizontal bands running across
the picture surface. As in *Grand Fort-
Philippe* (page 162) the view is one taken
from the opposite side of the Gravelines
channel. In this example, however, Seurat
has eliminated much of the foreground by
moving closer to the wall enclosing the
channel. The horizontal bands of land,
water, and sky are set off against the build-
ings and the elements of naval architec-
ture, the lamppost to the left, and the twin
anchors to the right. For all its apparent
simplicity this painting was the most
planned of the series. Four conté drawings
and one color sketch were completed as
preparatory studies.

The colors used in this painting can be
related to those in *Le Chahut* (page 157), an
indoor scene of café entertainment. Both
contain areas of deep blues, red-oranges
and vibrant green touches to establish the
overall effect of artificial or fading light.
The foreground coloring of this example
contrasts dramatically with the lightness of
the sky. Seurat, it would appear, was more
concerned with the overall effect of failing
light and has sacrificed fidelity to natural-
istic lighting effects in order to capture the
mood of the end of the day. Such concerns
suggest a close affinity with the nocturnes
of Whistler, many of which had been ex-
hibited in Paris by the end of the 1880s.

All four of the Gravelines paintings have
painted borders, in darker tones, and
originally had large painted frames. One
critic suggested that the dark frames en-
hanced the glowing tones of the painting
while Emile Verhaeren had likened their
use to Wagnerian stage effects, where a
well-lit stage was offset by darkness all
around. Sadly, none of the original frames
survives.

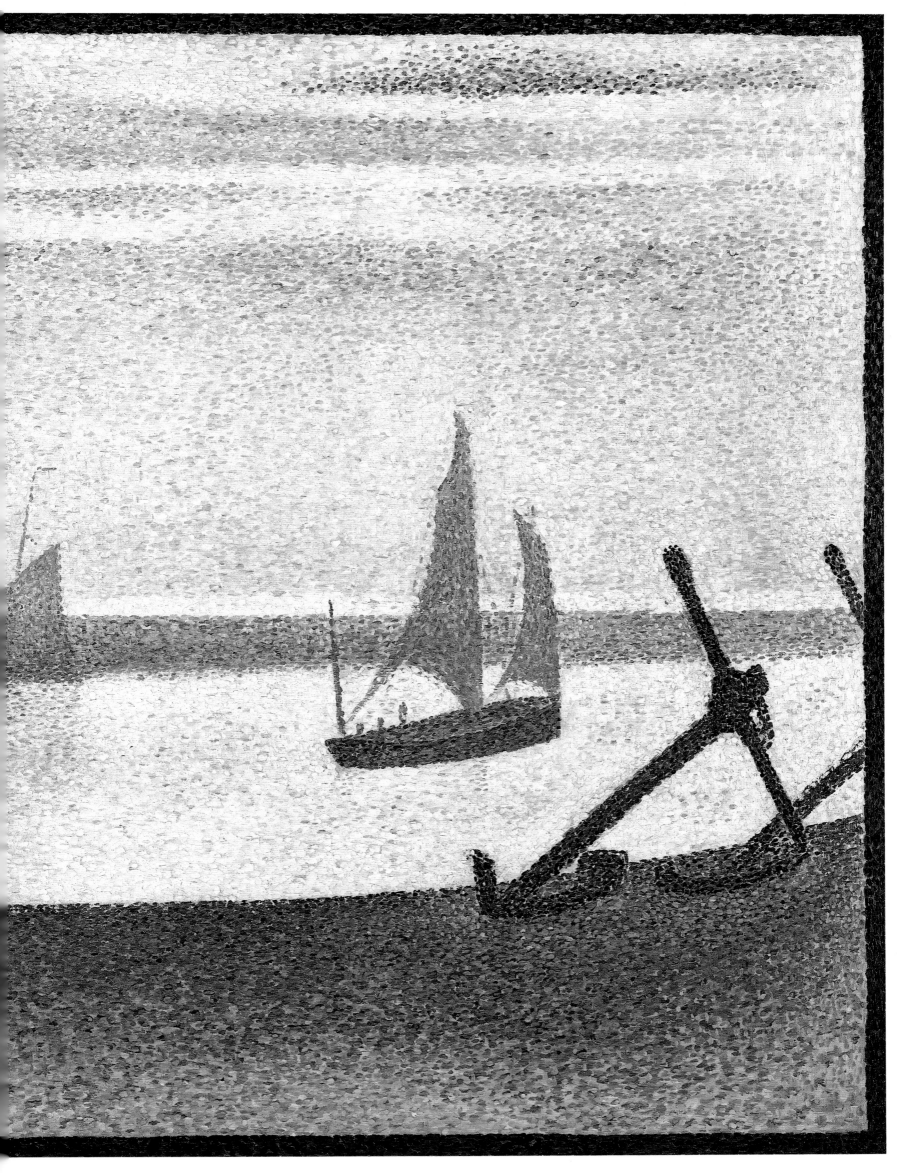

Study for 'Le Cirque', 1890-91

Oil on canvas
21⅝×17¾ inches
(55×45 cm)
Musée d'Orsay, Paris

This study, one of seven for *Le Cirque*, provides a valuable insight into Seurat's working method in the early 1890s, and into the specific development of his last major figure painting. In this color study the main elements of the painting have been sketched in: the dominant position of the clown in the foreground; the ringmaster to the right edge; the performing acrobat; and the bare-back rider balancing precariously on the white horse. Significant changes were made between the completion of this sketch and the final painting. The arm, to the left of the clown, presumably belonging to an assistant, has been removed from its position in the sketch and replaced by the left hand of the clown to create a more balanced, symmetrical arrangement in the finished painting. The curtain, now only held by the clown's right hand, is replaced by a baton in his left hand. A second clown has been added behind the figure of the ringmaster. However, the main compositional forms are established here. Particularly evident is the grid of blue lines outlining the major forms. It has been shown that Seurat made use of an elaborate grid structure, with rectangular and diagonal divisions, and the tiered levels of the spectators' seats provide some evidence of this, an effect much enhanced in the completed painting. The brushmarks show how Seurat made use of their directional force by emphasizing the lines of movement. This is most evident in the way that they radiate outwards from the clown.

Le Cirque, c. 1890-91
Oil on canvas
72⅞×59 inches (185×150 cm)
Musée d'Orsay, Paris

Le Cirque was exhibited unfinished at the salon of the Société des Indépendants, with the Gravelines marines, and was on display when Seurat died in March 1891. Circus subjects had become popular with artists in the 1870s and 1880s, particularly the Cirque Fernando which is the circus featured in this painting. Located on the boulevard Rochechouart, it was conveniently close to Seurat's studio and it had already featured in the paintings of Degas and Toulouse-Lautrec. Degas painted his famous picture of Miss Lala performing her highwire act in 1879, while Lautrec captured a horse-riding act in his painting of 1888, *At the Cirque Fernando* (page 29). Certainly Seurat would have been familiar with these sources, but it was the poster designs of Jules Chéret which provided an immediate influence on him. Seurat had a long interest in the popular arts, he collected popular broadsheets and was interested in their similarity to primitive art,

particularly Egyptian art. He was fascinated by the decorative effects found in Chéret's posters (page 26), in the flatness of the forms and their arabesque designs which foreshadow the Art Nouveau movement of the 1890s. The combination of the stiffness of the figures in popular broadsheets and the free-flowing forms of Chéret's posters can be seen in the contrast between the static spectators and the animated performers. One critic referred to the 'absolute passivity' of the audience. As in *La Parade de Cirque* (page 132), the spectators are made up of a cross-section of Parisian society, from the wealthy placed close to the ringside to the working classes peering over the balcony at the top. Social hierarchy has been inverted. Manipulating and introducing the whole scene is the clown in the foreground. Located between the viewer and the circus interior, he unravels the whole spectacle, performers and audience alike.

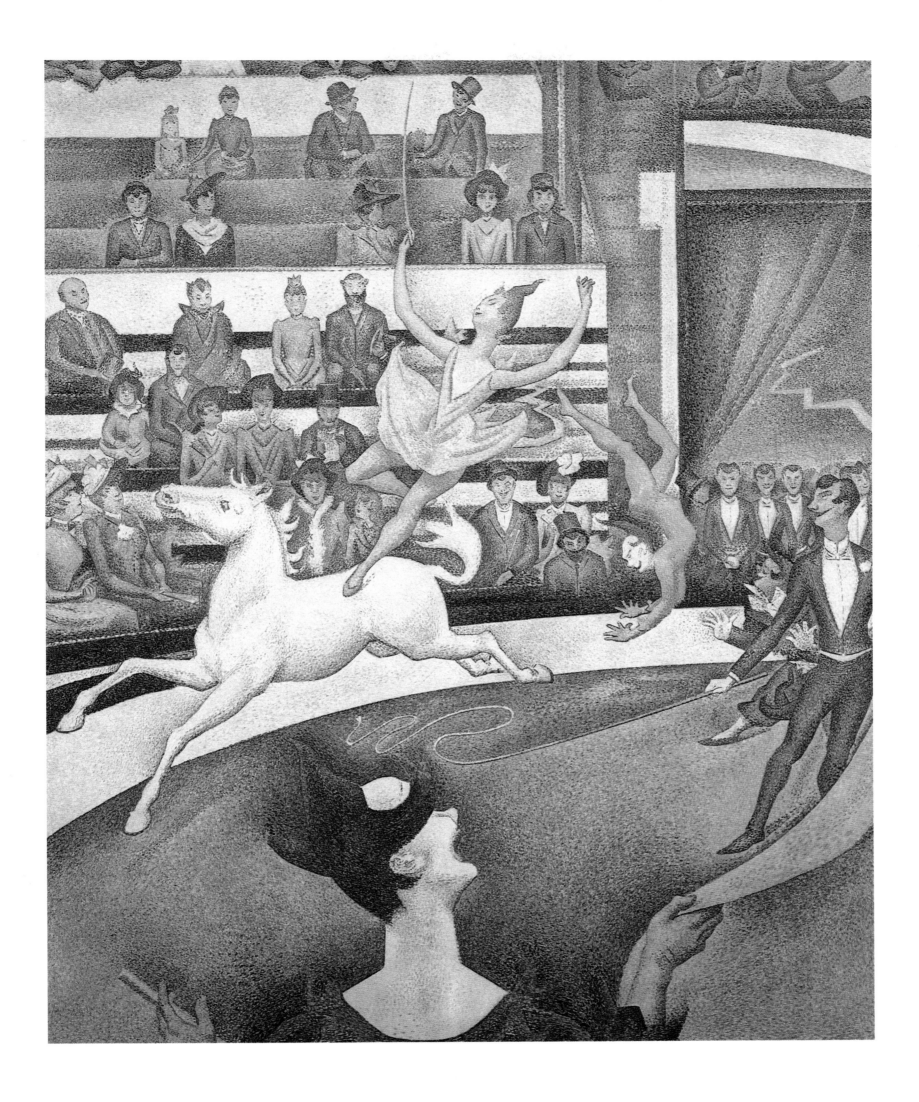

Le Cirque, 1890
Detail
Oil on canvas
Musée d'Orsay, Paris

In his late paintings Seurat appears to have rejected the overriding concerns of his paintings of the mid 1880s when he developed his chromo-luminist ideas. Through a combination of his own observations of other artists' work and his study of theoretical sources, he had tried to emulate the effects of natural light in order to create bright, luminous paintings. A concern for naturalism remained a central interest. During 1886 and 1887 Seurat experienced certain anxieties concerning his artistic aims. These apprehensions were summarized by Gustave Kahn, speaking for Seurat: 'If I had been able to find scientifically and through the experience of art the law of pictorial color, can I not discover an equally logical, scientific, and pictorial system which will permit me to coordinate colors?' Seurat found an answer in the writings of Charles Henry, a young scientist, and the two probably met some time in 1886. Henry had in 1885 published his ideas in a book, *A Scientific Aesthetic,* in which he explained his theories on the emotional values of line and color. Seurat quickly absorbed Henry's ideas and started to incorporate them into his paintings. Henry suggested that warm colors expressed moods of gaiety and happiness, and these colors were made up of those in the range of red, orange, and yellow. This detail shows that *Le Cirque* is predominantly painted in a combination of these colors. In order to heighten their effect, Seurat has made much use of touches of blue, and its complementary of orange, and although blue appears in the shadows in other areas it is applied in a more arbitrary manner. Concerns for naturalism have given way to a determination to suggest through color, combined with Henry's ideas concerning the direction of lines, the mood and atmosphere of the event.

Index

Figures in *italics* refer to illustrations; all works of art are by Seurat unless otherwise indicated

A la Gaîté-Rochechouart 129
Adam, Paul 16, 21, 93, 109, 127, 142
Alexandre, Arsène 8
Alexis, Paul 16, 72
Aman-Jean, Edmond 9, 11, 30
anarchist activities 7, 20, 25, 26, 147
Angelus by J F Millet 11
Anglers, The 60-61
Angrand, Charles 29, 106, 134, 150
Appert, Leon 60
Apple Picking by Camille Pissarro 10
Art Nouveau 26, 145, 150, 170
At the Cirque Fernando by Henride Toulouse-Lautrec 28, 29
Aux Ambassadeurs: Mlle Bécat by Degas 23, 23, 128, 129

Baignade, Asnières, Une 7, 8, 10, 11, 19, 50, 52, 59, 72-73, 79, 90, 103, 121, 131, 134
 detail 74-75
 studies
 Rainbow 64-65
 Seated and Reclining Figures, Black Horse 66-67
 Seated Boy with Straw Hat 11
 Seated Youth 68-69
 Final Compositional Study 70-71
Banks of the Seine (Island of the Grande Jatte) 134-35, 146
Bar at he Folies Bergères by Manet 25
Barbizon painters 8, 11, 31, 32, 47, 50
Bathers, The by Pierre Auguste Renoir 21
Beach and a Boat, Gravelines, The 160
Beach of Bas-Butin, Honfleur, The 110-11
Beaubourg, Maurice 14, 149
Bec du Hoc, Grandcamp 14, 100-01, 137
Bécat, Emilie 23, 23, 25
Bernard, Emile 6, 19
Boccioni, Umberto 36
book cover design 154, *154*
Boy Seated on the Grass 50-51, 52
Breton Women by Bernard 19
Bridge and the Quays, Port-en-Bessin, The 140-41, 145
Brussels exhibitions
 1887 113, 114; 1889 129, 134, 141; 1891 148, 166

café-concerts 22-23, 23, 24, 25, 26, 128-29, 155-59, 162
Caze, Robert 16
Cézanne, Paul 10, 60
Chahut, Le 22, 25, 26, 28, 128, 129, 132, 145, 156-57, 162
 detail 158-59
 studies 155, 156
Channel of Gravelines, Evening, The 162-63 study 161
Channel of Gravelines, Grand Fort-Philippe 162, 166, 167
Channel of Gravelines, Petit Fort-Philippe 164-65
Channel of Gravelines, Towards the Sea 167
Chéret, Jules 26, 26, 149, 158, 170
Chevreul, Michel-Eugène 54, 86

Christophe, Jules 16, 94
chromo-luminism style 14, 19, 57, 172
Cirque, Le 9, 26, 132, 145, *170-71*
 detail 172-73
 study 169
Clark, Sir Kenneth 32
Copy after 'The Poor Fisherman' 30
Corner in a Café-Concert by Edouard Manet 24, 25, 128
Corner of a Dock, Honfleur 112-13
Corot, Camille 32, 42, 44, 63
Courbet, Gustave 45
Courbevoie 14, 79, *102-03*, *120-21*
Cross, Henri-Edmond 11, 20, 161
Customs House at Pourville by Monet 15

Darzens, Rodolphe 76
Daubigny, Charles-François 31
de Goncourt, Edmond and Jules 150
de Médicis, Catherine 59
Degas, Edgar 7, 19, 23, 23, 25, 28, 128, 129, 170
Delacroix, Eugène 45
Delaunay, Robert 160
Dimanche, Le by Roger Jourdain 18
Dimanche la Grande Jatte (1884), Un 9, 12-13, 14-15, 16, 19, 20, 21, 83, *90-91*, 99, 100, 103, 122, 123, 125, 127, 131, 134, 141
 details 92-97
 Lady Fishing 17
 Woman with a Monkey 83
 studies 80-87; final study 88-89
Doux Pays by Piere Puvis de Chavannes 9-10, *9*, 72
Drawings of the Human Face by Humbert de Superville 21
Dubois-Pillet, Albert 11, *12*, 19, 109

Ecole des Beaux-Arts, Paris 8, 9, 30, 42, 79
Eden Concert 128
Eiffel Tower, The 147
End of a Jetty, Honfleur 108-09
Entrance to the Outer Harbor, Port-en-Bessin, The 138-39
Evening Air by Henri-Edmond Cross 20, 161
exhibitions
 Brussels 1887 113, 114; 1889 129, 134, 141; 1891 148, 166
 Groupe des Artists Indépendants 1884 11
 Impressionist 1886 (Eighth) 8, 14, 19, 60, 90, 98, 100, 103, 105
 Nantes 1886 114
 retrospective of Seurat's work 1908 29
 Salon 79, 1878 19; 1881 9, 30; 1882 9; 1883 11; 1884 11, 72
 Sociéte des Artistes Indépendants 1884 12, 72; 1885 (cancelled) 12, 13, 99; 1886 90, 100, 105; 113; 1887 109, 123, 128; 1888 21, 22, 127, 129, 132, 136; 1890 22, 150, 156; 1891 26, 170
 Universal Exhibition 1878 60; 1889 147, 150

Factories at Asnières by Vincent van Gogh 19, *20*
Family Group (Condolences) 98
Fanatics of Tangier, The by Eugène Delacroix 45
Farm Women at Work 11, *46-47*
Fénéon, Félix 9, 11, 14-15, 16, 19, 20, 21, 22, 29,

42, 47, 57, 75, 90, 99, 109, 123, 131, 142, 148, 149, 150
Fisherman 7
Fishing Boats, Low Tide 99
Five Monkeys 17
Forest at Pontaubert, The 32-33
frames, painted 149, 162
Fry, Roger 6, 7, 150
Futurist group 36

Gas Tanks at Clichy, The by Paul Signac *13*
Gauguin, Paul 6, 7, 19
Geoffroy, Gustave 25
Georges Seurat by Ernest Laurent *6*
Girard, Les by Chéret 26, *26*, 158
Gleaners, The 11
Gleaners, The by J R Millet *10*, 11, 47
Goldwater, Robert 146, 152
Grandcamp 14, 28, 80, 99, *100-01*, *104-05*, 109, 117, 136, 137
Grandcamp, Evening 104-05
Gravelines 29, 160-67
Groupe des Artistes Indépendants 11
 1884 exhibition 11
Grues et la Percée, Port-en-Bessin, Les 137, 138

Hakone from 53 Stages of the Tokaido by Utagawa Hiroshige *15*
Haussmann, Baron 23, 39, 76
Hennequin, Emile 16, 105
Henry, Charles 22, 26, 119, 152, 154, 156
 A Scientific Aesthetic, book by 20-21, 131, 172
Hiroshige, Utagawa 15
Hogarth, William 7
Homme à Femmes, L' 154
Honfleur 28, 29, 108-19, 134, 141
Hospice and the Lighthouse, Honfleur, The 110, 114-15
House and Cart 56-57
Houses among Trees 54
Houses and Garden 42
Huysmans, Joris Karl 16, 98, 114

Impressionist painters 7, 8, 10, 11, 13, 23, 30, 31, 36, 50, 68, 75, 109, 114
 1886 Eighth Impressionist exhibition 8, 14, 19, 60, 90, 98, 100, 103, 105
industrial scenes 11, *12*, *20*, *36-37*, 39, *64-75*, *120-21*
Ingres, Jean 9, 123, 125

Japanese prints, influence of 14, *15*, 28, 100, 110
Jeune Femme se Poudrant 29, *151*
 detail 152-53
 study 150
Jongkind, Johann Barthold 99, 117
Jourdain, Roger *18*, 19
Joze, Victor 150, 154

Kahn, Gustave 7, 9, 22, 26, 30, 109, 114, 119, 123, 132, 142, 158, 172
King, Edward 25
Knobloch, Madeleine 29, 148, 150, 152

Ladies of the Chariots, The by James Tissot 27, 28

Laurent, Ernest 6, 48, 79
Lazare, Louis 39
Le Crotoy, Downstream 148, 149
Le Crotoy, Upstream 149
Le Raincy 9, 36, *38-41, 55*
Lehmann, Henri 9
Lequien, Justin 9
Lucerne at Saint-Denis 106-07
Luncheon of the Boating Party by Pierre-Auguste
 Renoir 134
Lundi, Le by Roger Jourdain *18*

Man Leaning on a Parapet 34-35
Man Painting his Boat 62-63
Manet, Edouard 23, *24, 25, 59*, 128
'Maria', Honfleur, The 113, *116-17*
marines (seascapes) 14, *28-29, 99, 100-01, 104-05,*
 108-19, 136-45, 148, 149, 160-67
military service 8, 9, 31, 35
Millet, Jean-François 10-11, 32, 45, 47, 50
Modern Chromatics, book by Ogden Rood 15-16,
 57
Monet, Claude 13-14, *15*, 19, 31, 36, 63, 75, 99,
 100, 110, 136, 137
Moreas, Jean 16
Moulin de la Galette by Pierre-Auguste Renoir 23
Mower, The 44
Munch, Edvard 122
Musique aux Tuileries by Edouart Manet 59

Neo-Impressionism 6, 7, 11, 13, 14, 15, 16, 19, 20,
 28, 29, 86, 99, 106, 124, 137, 154, 155, 160,
 161
nudes 21, *48-49, 122-27*

optical mixture theory 14-16, 47
Painter at Work, The 78-79
Parade de Cirque, La 22, 25, 26, 28 *132-33*, 136,
 170
 sketch *131*
 study: *The Trombone Player 130*
Petit Boulevard group 6
Picasso, Pablo 6
Pissarro, Camille 8, 9, *10*, 16, *25*, 31, 36, 47, 50,
 52, 75, 147
Place de la Concorde, Winter *43*
Pleasures of Summer by Signac *20*
Pont de Courbevoie, Le *120-21*, 146

Poor Fisherman, The by Puvis de Chavannes *8, 9,
 30*; *copy after*, by Seurat *30*
Port-en-Bessin *2-3*, 29, *136-45*, 161
Port-en-Bessin, Sunday 144-45
Port-en-Bessin, The Outer Harbor, Low Tide 136
Port-en-Bessin, The Outer Harbor, High Tide, 138,
 142-43
Poseuses, Les 21-22, 136 (Small Version) *126-27*
 studies
 Model from Behind 125
 Model from the Front 123
 Model in Profile 124
 Standing Model 122
Purist group 6
Puvis de Chavannes, Pierre *8, 9, 9,* 10, 11, 16, 30,
 72, 79

Recollection of Mortefontaine by Corot 32
Rembrandt 48
Renoir, Pierre-Auguste *21*, 23, 134
Roger-Marx, Claude 147, 150
Rood, Ogden 47, 57
 Modern Chromatics, book by 15-16, 57
Rousseau, Théodore 31, 32
Rue Saint-Vincent, Montmartre: Spring, The 76-77
Ruins of the Tuileries, The 43, *58-59*
Russell, John 6, 138

Sacred Wood, The by Pierre Puvis de Chavannes *30*
Saint Michel d'Aiguilhe in the Snow by Albert
 Dubois-Pillet *12*
Salon exhibitions
 1878 19; 1881 9, 30; 1882 9; 1883 11; 1884 11, 72
Scientific Aesthetic, A, book by Charles Henry
 20-21, 131, 172
seascapes *see* marines
Seine, River 12, 13, 16, *18*, 19, *64-75, 80-82, 84-97,*
 102-03, 117, *118-19, 120-21, 134-35,* 146
Seine at Courbevoie, The 102-03
Seine Estuary, Honfleur, Evening, The 118-19
Seurat family 6, 9
 father 9, 36, 39, 55
 mother 9, 29
Sheepfold by Moonlight by J F Millet 11
Signac, Paul 6, 8, 11, 13, *13*, 14, 16, 19, 20, 22, 26,
 29, 106, 109, 113, 114, 124, 127, 136, 150, 161
Société des Artistes Indépendants 11-12, 19
 exhibitions: 1884 12, 72; 1885 (cancelled) 12, 13,

99; 1886 90, 100, 105, 113; 1887 109, 123,
 128; 1888 21, 22, 127, 129, 132, 136; 1889
 148, 149; 1890 22, 150, 156; 1891 26, 170
Standing Female Nude 48-49
Stonebreaker, The 45
Stonebreaker and Other Figures, Le Raincy 40-41
Stonebreakers, Le Raincy 38-39, 41
Suburb 36-37, 41
suburban scenes 11, *36-37,* 39, *40-41, 45, 64-75,*
 102-03, 106, 120-21, 134-35
*Sunday on the Grande Jatte see Dimanche – la
 Grande Jatte, Un*
Sunset 31
Superville, Humbert de 21, *21,* 22, 22
Symbolist movement 9, 16, 22, 109, 110, 114, 119,
 142
Synoptic Table by Humbert de Superville *22*

Temps Gris, La Grande Jatte 134, *146*
theories influencing Seurat ·
 Chevreul's law of simultaneous contrast of color
 54, 86
 Henry's emotional values of line and color
 20-21, 22, 26, 119, 131, 152, 154, 156, 172
 Rood's chromatics 15-16, 47, 57
 Humbert de Superville's emotional value of
 linear expression 21, *21,* 22, 22
Tissot, James 27, 28
Toulouse-Lautrec, Henri de 6, 25, 28, *29,* 170
Tuileries Palace, Paris 43, *58-59, 59*
Turpitudes Sociales, Anarchie by Camille Pissarro
 25, 147

Universal Exhibitions, Paris
 1878 60; 1889 147, 150

Valpinçon Bather, The by Ingres 125
van Gogh, Theo 6, 128, 156
van Gogh, Vincent 6, 7, 19, *20*, 106
Verhaeren, Emile 7, 113, 114, 129, 149, 162,
 165
Vidal, Jules 99

Watering Can in the Garden at Le Raincy 55
Weber, Louise 25
Whistler, James McNeill 119, 162
Woman Seated on the Grass 52-53
Wyzewa, Teodor de 7

Acknowledgments

The publisher would like to thank the designer, Martin Bristow, the picture researcher, Kathy Schneider, the indexer, Pat Coward, and the editor, Aileen Reid. We would also like to thank the following individuals, agencies, and institutions for supplying the illustrations:

Albright-Knox Art Gallery, Buffalo: page 156 (General Purchase Fund, 1943)

From the Private Collection of Mr and Mrs Walter H Annenberg: page 146

The Art Institute of Chicago: pages 23 (William McCallin McKee Memorial Collection), 29 (The Joseph Winterbotham Collection, 1925.523), 70-71 (Adèle R Levy Fund), 82 (Gift of Mary and Leigh Block), 90-91 (Helen Birch Bartlett Memorial Collection), 92, 94-95, 96-97 (all three Helen Birch Bartlett Memorial Collection)

Madame Huguette Berès, Paris: page 30

Berggruen Collection, on loan to the National Gallery, London: 64-65, 84-85, 98, 126-127, 162

Bristol Museum and Art Gallery/Bridgeman Art Library: page 31

Courtauld Institute Galleries, London, Courtauld Collection: pages 49, 120-121, 151, 153, 160/ Bridgeman Art Library: page 155

Detroit Institute of Arts: page 149 (Bequest of Robert H Tannahill)

Mrs M Feilchenfeldt, Zurich: page 16

Fine Arts Museums of San Francisco: pages 1, 147

Fitzwilliam Museum, Cambridge: 77, 87

Fogg Art Museum, Harvard University, Cambridge, Massachusetts: page 129 (Grenville L Winthrop Bequest)

Foundation E G Bührle Collection, Zurich: page 131

Formerly Galerie Jan Krugier, Geneva: pages 58-59, 154

Glasgow Art Gallery and Museum: pages 50-51, 54

Solomon R Guggenheim Museum, New York: pages 43 (photo: David Heald, © 1991 The Solomon R Guggenheim, Collection), 46-47 (photo: David Heald, © 1991 The Solomon R Guggenheim Foundation), 52-53 (photo: David Heald, © 1991 The Solomon R Guggenheim Foundation), 56-57 (photo: David Heald, © 1991 The Solomon R Guggenheim Foundation)

Indianapolis Museum of Art: pages 164-165 (Gift of Mrs James W Fesler in memory of David W and Elizabeth C Marmon)

E W Kornfeld, Bern: page 7

Kröller-Müller Museum, Otterlo: pages 108-109, 112-113, 144-145, 157, 159, 163

The Metropolitan Museum of Art, New York: pages 17 (Purchase, Joseph Pulitzer Bequest, 1955, from the Museum of Modern Art, Lillie P Bliss Collection), 44 (Robert Lehman Collection, 1975), 88-89 (Bequest of Sam A Lewisohn, 1951), 122 (Robert Lehman Collection), 132-133 (Bequest of Stephen C Clark, 1960)

The Minneapolis Institute of Art: pages 2-3, 140-141 (The William Dunwoody Fund)

Musée du l'Anonciade, St Tropez/Réunion des Musées Nationaux: page 161

Musée d'Art Moderne, Troyes: pages 36-37, 60-61 (both photos Daniel Le Nevé)

Musée des Beaux-Arts, Tournai/Réunion des Musées Nationaux: 110-111

Musée Bonnat, Bayonne: page 9

Musée Crozatier, Montpellier: page 12

Musée d'Orsay/Réunion des Musées Nationaux: pages 6, 8, 10 (below), 123, 124, 125, 142-143, 168, 171, 172-173

Musées Royaux des Beaux-Arts, Brussels: pages 134-135

Museum of Art, Rhode Island School of Design, Providence: page 27

Museum of Fine Arts, Houston: page 150 (on extended loan from the John A and Audrey Jones Beck Collection)

Collection, The Museum of Modern Art, New York: pages 26 (acquired by exchange), 40-41 (Lillie P Bliss Collection), 104-105 (Estate of John Hay Whitney), 118-119 (Collection of Mr and Mrs David M Levy), 138-139 (Lillie P Bliss Collection), 166-167 (Gift of Mr and Mrs William A M Burden)

Museum of Modern Art, Prague: pages 116-117

Courtesy of the Trustees of the National Gallery, London: pages 24, 72-73, 74

The National Gallery of Art, Washington: pages 114-115 (Collection of Mr and Mrs Paul Mellon), 137

National Gallery of Scotland, Edinburgh: pages 66-67, 69, 106-107

The New York Public Library: page 15 (above) (Astor, Lennox, and Tuden Foundations)

The Norton Simon Art Foundation, Pasadena, California: pages 38-39 (M.68.28.P)

Ohara Museum of Art, Kurashiki: page 10 (above)

Philadelphia Museum of Art: pages 78 (A E Gallatin Collection), 130 (Henry P McIlhenny Collection, in memory of Frances P McIlhenny), 15 (below) (The William L Elkins Collection), 20 (below) (Mr and Mrs Carroll S Tyson Collection)

The Phillips Collection, Washington DC: page 45

Private Collection/Bridgeman Art Library: pages 33, 42, 44, 56, 102

Private Collection, New York, on loan to the Metropolitan Museum of Art, New York: page 34

Alexander Reid and Lefevre Ltd, London: page 99

Roger-Viollet, Paris: pages 19, 28 (below)

The Saint Louis Art Museum, St Louis, Missouri: pages 20 (Gift of Mrs Mark C Steinberg), 136 (Museum Purchase)

Smith College Museum of Art, Northampton, Massachusetts: page 83

Stavros Niarchos Collection/Bridgeman Art Library: page 148

Tate Gallery, London: pages 62-63, 100-101

Courtesy of the Trustees of the Victoria and Albert Museum: 18 (both), 20 (above), 22, 25 (original drawing, Private Collection, Geneva)

Vincent van Gogh Foundation/National Museum Vincent van Gogh, Amsterdam: page 128

Courtesy of Mrs John Hay Whitney, New York: pages 80-81

Weidenfeld Archive: pages 14, 28 (above)

Yale University Art Gallery: page 11

176